DUE DATE

			Printed in USA

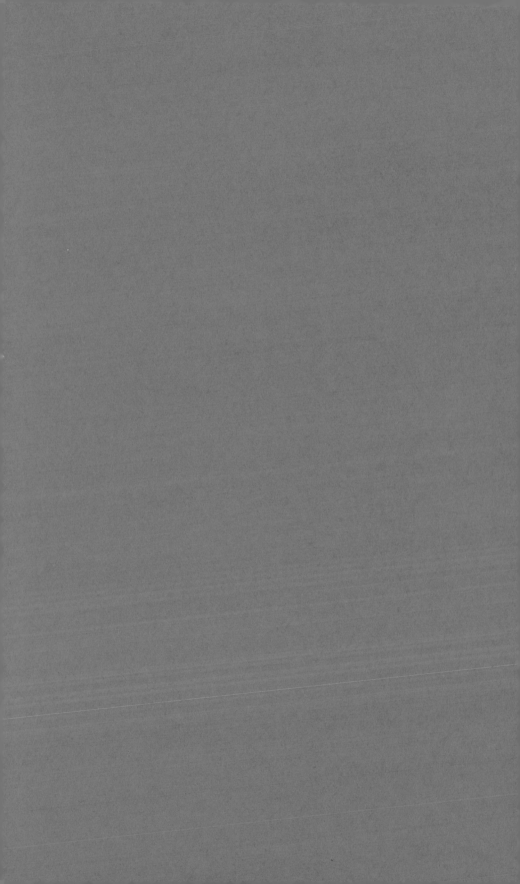

THE EARLY YEARS

OF NATIVE AMERICAN

ART HISTORY:

THE POLITICS OF

SCHOLARSHIP

AND COLLECTING

THE POLITICS OF

SCHOLARSHIP AND

COLLECTING

Edited by Janet Catherine Berlo

A McLellan Book

UNIVERSITY OF WASHINGTON PRESS

SEATTLE AND LONDON

UBC PRESS VANCOUVER

The Early Years of **Native American Art History**

This book is published with the assistance of
a grant from the McLellan Endowed Series Fund,
established through the generosity of Martha McCleary
McLellan and Mary McLellan Williams.

CONTENTS

ILLUSTRATIONS

PREFACE

The past decade has witnessed a dramatic reevaluation of the paradigms of both anthropology and art history. Those of us who study ethnographic arts have a foot in each of these worlds, drawing from the methodologies of both disciplines but depending heavily on the information collected by previous generations of anthropologists. As scholars increasingly question the meaning and validity of the ethnographic endeavor, so too must we, as historians of ethnographic art, vigilantly examine the premises on which our knowledge and interpretations are based.

My own interests in historiography, methodology, and theory led me to organize two symposia in order to examine some of these issues. The first, "Reevaluating Our Predecessors: Ethnographic Art Historians Look Back," was held at the College Art Association national meeting in Los Angeles in February 1985. In addition to Ira Jacknis and Diana Fane, who presented papers on topics they amplify in this volume, participants included Deborah Waite (on A. C. Haddon and Oceanic art) and Suzanne Blier (on Melville Herskovits and Dahomean art). The second symposium, "Native American Art History: Reassessing the Early Years," was held at the Native American Art Studies Association meeting in Ann Arbor, Michigan, in October 1985. Besides the papers by Aldona Jonaitis and Margot Schevill on topics related to their essays in this volume, we had presentations by Margaret Hardin on Ruth Bunzel and Zuni potters, Bruce Bernstein on Alfred Kroeber and Pomoan basketry, and Dorothy Washburn on Lila O'Neale and design analysis.

The positive response of other scholars at these two conferences, and the issues raised by Cecelia Klein's panel, "Institutions and the Aestheticization of 'Primitive Art,' 1897–1950," at the College Art Association meeting in Houston in 1988, led me to conclude that there was merit in assembling a publication on some significant early contributions to Native American art history. (Two papers from the Houston session are included in this volume: W. Jackson Rushing on the Museum of Modern Art's 1941 exhibit of Native American art, and Aldona Jonaitis on Boas, Swanton, and Haida art.)

These essays present only some high points of the early years of Native art studies. Many more scholars, movements, and issues—some of which

are mentioned in my introductory essay—deserve attention. Coverage is limited by the research interests of those scholars included here, and by the competing professional obligations of others who were invited to participate but were not able to do so.

The five art historians (Berlo, Cohodas, Fane, Jonaitis, and Rushing) and the two anthropologists (Jacknis, Schevill) whose contributions form this volume all hope that our collective efforts will be part of the ongoing dialogue about the history of the disciplines of anthropology and art history, and that we will provoke more interest in the history of Native American art history in particular.

Janet Catherine Berlo
St. Louis
September 1991

JANET CATHERINE BERLO

1

INTRODUCTION

THE FORMATIVE YEARS OF NATIVE

AMERICAN ART HISTORY

French philosopher Jean-Paul Sartre once observed that "the social scientist and his 'object' form a couple, each one of which is to be interpreted by the other; the relationship between them must be itself interpreted as a moment of history" (Sartre 1963:72). In this volume, the 'objects' are literally that: the art objects of Native American cultures. The social scientists are those early anthropologists, museum curators, dealers, and collectors who sought to interpret and possess those objects. The multiple levels of understanding and misunderstanding, appropriation and reappropriation, that characterized these transactions are the focus of our study.

The period covered by the contributors to this volume extends from the last quarter of the nineteenth century to 1941: from the initial large-

scale collecting of American Indian art objects in the 1880s to the arrangement in a pivotal exhibit at the Museum of Modern Art in 1941 of the objects that Frank Cushing, Franz Boas, Stewart Culin, and their successors collected. These years witnessed the first apotheosis of Native American art objects, from ethnographic curiosities to objects reified by their installation in America's premier institution of artistic modernism. Today, as part of a reassessment of method, paradigm, and scholarship in anthropology and the history of art,[1] such objects are undergoing a second apotheosis. As Sartre said that we must, we are examining them anew in order to understand the relationship between scholar and subject.

My object in this introduction is twofold: to pull together the various strands of the six essays that follow, and to provide a broader historical picture into which we might place the activities of Culin, Boas, O'Neale, d'Harnoncourt, and the other individuals whose work is examined by my colleagues. While the history of Native American art history remains to be written, this volume embarks upon the task. This essay is a prolegomenon to such an enterprise. Perforce incomplete, it sets the stage for future, more in-depth work. I do not provide an exhaustive coverage of the events of the early years of the study of Native American art, but rather a discussion of some major intellectual trends and contributions.

The Late Nineteenth Century: Laying the Groundwork

The second half of the nineteenth century was the period in which museums and institutions established their great ethnological collections. Only now, more than one hundred years later, are we beginning to come to terms with what this era reveals about the history of our cultural tastes as well as the history of anthropology. As several essays in this collection demonstrate, our constructs about what comprises Indian art were largely molded by these institutions and their collecting policies. Because several recent studies document these institutional histories, here I shall refer to them briefly, for this essay concerns not the history of collecting but the history of Native American art history.[2] The essays by Diana Fane, Ira Jacknis, and Aldona Jonaitis will consider aspects of institutional histories in more detail.

The Smithsonian Institution was established in 1846, the Peabody Museum at Harvard ten years later.[3] In 1869, New York's American Museum of Natural History was established,[4] and other regional institutions arose in the following decades. In 1879 the Bureau of American Ethnology at

the Smithsonian sponsored the first large-scale collecting expedition to the Indian pueblos of New Mexico and Arizona. The last quarter of the nineteenth century and the first decade of the twentieth formed the great era of collecting. Scholars, scientists, and entrepreneurs were all collecting bits and pieces of Native American heritage. Some acquisitions were factual—data on linguistics, religion, and social structure. Some were material—baskets, hide paintings, religious icons. For the past one hundred years these bits and pieces, facts and objects, have been arranged and rearranged in a changing mosaic in which we have constructed an image we claim represents Native American art and culture. We now realize that this image tells us at least as much about the collectors as it does about the materials collected.

It is important to understand that Cushing, Culin, Boas, and their contemporaries in the field were in search of the past as they collected both objects and information from Indian peoples. They sought out the "oldest" and the "most authentic." They saw that Indian culture was in peril, and believed that they should save its vestiges for science. Diana Fane's essay on Stewart Culin and The Brooklyn Museum considers the scholarly and ethical implications of this "salvage paradigm." As we only now realize, the collectors' actions had complex ramifications for the societies they studied.

Ironically, such actions both "preserved" and "destroyed" the "past" (all these terms, of course, must be recognized as relational, judgmental, and approximate). Of the "scramble for Northwest Coast artifacts" between 1875 and 1929, Douglas Cole reports, "By the time it ended there was more Kwakiutl material in Milwaukee than in Mamalillikulla, more Salish pieces in Cambridge than Comox. The city of Washington contained more Northwest Coast material than the state of Washington and New York City probably housed more British Columbia material than British Columbia herself" (1985:286). The Smithsonian's taking of 6,500 pots out of Zuni and Acoma within six years (1880–85) destabilized pottery making traditions, as design sources were removed from the pueblos (Batkin 1987:30). By the time of Ruth Bunzel's fieldwork at Zuni in 1924, the "stagnation and inferiority" of the pottery was evident (Bunzel 1929:5). On the other hand, Franz Boas's meticulous recording of ceremonies, myths, language, and art forms in the Pacific Northwest has left a rich legacy that Northwest Coast peoples actively mine today as they reinterpret or revive aspects of their cultures.

One problem confronting modern scholars as we deal with the vast

amounts of material and information collected in the great age of museum-sponsored field research by the Smithsonian, the American Museum of Natural History, the Field Museum in Chicago, the Peabody Museum at Harvard, and other institutions is that the pieces housed in their storerooms have become canonical objects. We have too often treated them as the "authentic" American Indian art, rather than recognizing that each derives from a particular historical moment in a long and changing history of Native American art. As Jonathan King has observed in his critique of the canon of "tradition" (1986:70):

> Most of the principal North American collections of Indian artifacts were created between 1860 and 1930, in large museums in eastern and central North America. It is inevitable, therefore, that most of the standards by which traditionalism in Indian art is judged depend upon these collections for purposes of definition and comparison. The late nineteenth and early twentieth centuries, however, saw enormous upheaval in Indian North America. . . . And ironically, this was the peak period of collecting. As a result, the most traumatic period in Native American history has provided the material basis for the definition of what is traditional and what is not. Basketry, bead costume, and carving from this time exist in such large quantities that they are used as a general, though often unstated, yardstick by which the unconscious standards of traditionalism are set.

King goes on to discuss the fallacy of creating the "ideal type" by which the art of particular cultures is recognized. The essays in this volume demonstrate the various ways in which our predecessors created ideal "types" or canons for particular art forms; in some cases, the "creation" of the canonical was quite literal.

Washoe basketry dealers Abe and Amy Cohn marketed Louisa Keyser (under the name Dat So La Lee) and her baskets as quintessentially Washoe, as Marvin Cohodas shows. Ironically, Louisa Keyser was a strikingly innovative artist. Although the Cohns marketed her *degikup* as a traditional Washoe basket shape, it was Louisa Keyser's own invention, and one that sparked the creativity of other Washoe basket makers (Cohodas 1986:207). For us, as well, it has come to typify Washoe basketry even though it is an invented tradition.

Stewart Culin, whom the Zuni nicknamed Inotai ("Old Things"), was relentless in his pursuit of the old and the sacred at Zuni. His longing for the old was so overwhelming that if the authentically old was unavailable,

replicas of old masks and figures would do. Diana Fane charts how such replicas became canonical objects in their own right.

Analogous processes were at work on the Northwest Coast as well. Haida artist Charles Edenshaw was highly individualistic in his artwork, yet Jonaitis relates in this volume that as a consequence of white patronage, "Edenshaw became a major force in the process of defining what Haida art was." This is precisely the role that Louisa Keyser played in regard to Washoe basketry. Like the replicas that Culin bought or commissioned from the Zuni, Charles Edenshaw's replicas of Haida sculpture "became the model for this art rather than simply models of it."

We can trace this process in other regions. When Smithsonian anthropologist James Mooney began work with the Kiowa in Oklahoma in 1891, he commissioned small-scale replicas of painted tipis. These were based on the memories of aged informants, for by that date only one painted tipi remained among the Kiowa (Ewers 1978:8). These miniature tipi models were exhibited at the St. Louis World's Fair in 1904, and later at the Smithsonian. Some of them, in turn, have been models for more recent recreations of Plains tipi painting (New 1973).

The miniaturization process, as Jonaitis observes, reduces a complex culture to a doll-like, controllable scale. We might consider Claude Lévi-Strauss's observations on miniaturization in art (1966:23): "By being quantitatively diminished, it seems to us qualitatively simplified. More exactly, this quantitative transposition extends and diversifies our power over a homologue of the thing, and by means of it the latter can be grasped, assessed, and apprehended at a glance." Moreover, he observes that miniatures are not "just projections or passive homologues of the object: they constitute a real experiment with it" (p. 24). Perhaps in these cases the anthropologist's true role as a sort of metatourist emerges; like the tourist, the anthropologist brings home a replica, a miniature, a simulacrum (see also MacCannell 1976).

The scholars who commissioned models and replicas of no longer extant "prime objects" sometimes ignored the contemporary arts being made by the people whose pasts they were busy salvaging. For example, Haida argillite carving, one of the most widespread Haida arts of the late nineteenth century, was for the most part spurned by anthropologists and other serious collectors of that era. Today, in contrast, we see it as an art that reveals much about the historical moment in which it was created, as well as the complex web of acculturations taking place in the second half of the nineteenth century.[5]

Just as anthropologists commissioned replicas, Native artists also had reasons to replicate past artworks. The large-scale collecting craze for California basketry at the end of the nineteenth century prompted Indian artists to produce replicas of earlier baskets. The artists subtly changed the forms and designs of the prime objects, yet satisfied the collector's yen for the "traditional" (see Washburn 1984). As Washburn has analyzed, these innovative replicas often were part of the great collections given or sold to museums. Thus they, in turn, became the yardstick by which other objects were measured. As James Clifford reminds us, "art collecting and culture collecting now take place within a changing field of counterdiscourses, syncretisms, and reappropriations, originating both outside and inside 'the West'" (1988:236).

The turn of the century marked not only the age of great collections of objects but a time of outstanding collections of data as well. Many of the great ethnological studies from this era contain much useful information about art and its social uses. Judged by modern standards, few of them provide any sort of sophisticated analysis of the meanings of art. Yet works such as Matilda Coxe Stevenson's *The Zuni Indians* (1904), Franz Boas's *The Social Organization and Secret Societies of the Kwakiutl Indians* (1897a), and John Swanton's *Contributions to the Ethnology of the Haida* (1905) remain gold mines of information. During that era, scholarly research devoted solely to art was almost exclusively classificatory or descriptive in nature. Techniques and formal attributes were catalogued. Examples of this include Washington Matthews's pioneering study of Navajo weaving (1884) and Otis Mason's *Aboriginal American Basketry* (1904). Briefer contributions published in anthropological journals usually are factual or technical. Essays concerned with ideas, methods, or theory are few in number. William Henry Holmes's several essays on "Aboriginal art" deal with aspects of evolution in technique and the development of technological skills (1890, 1892a, 1892b).

Such studies were part of a larger scholarly discourse on art and anthropology. This discourse had two components: (1) an interest in the evolutionary history of ornamental forms, prominent in German art historical writing in the late nineteenth century,[6] and (2) an offshoot of this, concentrating on the evolutionary histories of tribal arts. Works representative of the second component were the influential *Evolution in Art* (1895) by the British scholar A. C. Haddon, who had trained as a biologist, and German scholar Ernst Grosse's *The Beginnings of Art* (1897). For Haddon, a Darwinian evolutionary model of artistic development allowed him to seriate orna-

mental forms. For Grosse the idea of "technic forms," or ornament derived through technique, was the key to understanding ethnographic art. With this topic of scholarly discussion in the air, it is evident why so many American scholars concerned themselves with technical issues, evolution in form, the "motor habits" of the artist, and similar matters.

It is against this background that Boas's 1897 article "The Decorative Art of the Indians of the North Pacific Coast" emerges. This is a pivotal work in the history of Native American art. It stands virtually alone as an essay that takes up issues of iconography, representation, meaning, and abstraction in art. Evincing a highly sophisticated understanding of the range of options open to an artist in Northwest Coast society, Boas demonstrated that artists could juxtapose realism with abstraction. As Jonaitis has pointed out, Boas's study served to dispute simplistic evolutionary approaches to artistic development (1988:208–10). But as we shall see, it remained for his students to take the leap into studies of artists as individuals within Native American societies.

Merchants and Collectors

Concurrent with the establishment of great institutional collections of American Indian art and scholarly research on such topics, there was a rise in interest in American Indian art on the part of traders and private individuals. There was, of course, no clear-cut dividing line between the two worlds, for a number of important early studies were written by individuals who were not scholars, and many privately amassed collections were sold to institutions. A thread of popular or amateur interest has always run through studies of American Indian art, and middlemen have sometimes had key roles to play.

George Wharton James, for example, was not a scholar, but a collector and popular writer on American Indian topics. His Indian Basketry (1901) sold more than 10,000 copies during its first year of publication (Arreola 1986:14). The book helped fuel the collecting craze, as did his later work on Navajo weaving, Indian Blankets and Their Makers (1914).

The role of merchants or middlemen varied considerably from region to region and from decade to decade. Their effects on Native art production, technique, style, and iconography are still being charted. As Wade and McChesney have shown (1980:9,75–88), the trader Thomas Keam encouraged Hopi potters in the 1880s and 1890s to mass-produce their wares for tourist consumption. Keam was responsible for the introduc-

tion of new styles, the painting of Kachina figures on ceramics, and the reproduction of ancient pottery wares. The influence of the trader on the development of Navajo textile arts has been well documented by Rodee (1981). Traders C. N. Cotton, J. B. Moore, and Lorenzo Hubbell were directly responsible for changes in Navajo weaving because of their interest in Turkish carpet pattern types, their influence on the weavers' dye and yarn choices, and their concern with having prototype designs available for the Navajo weaver to examine.

Marketing decisions were almost always behind such actions. Marvin Cohodas's essay in this volume on the marketing of Washoe basketry demonstrates the extremes to which such marketing strategies could be taken. He shows how the history and "documentation" of Louisa Keyser's (Dat So La Lee's) baskets were frequently invented by Abe and Amy Cohn. Under their direction, the scholarly museum-style practice of numbering and tagging each basket with ethnographic documentation was subverted into a fiction whose only purpose was to increase sales and raise prices. Yet such fictions, once promulgated, rapidly became part of the corpus of knowledge about American Indian artists, as Cohodas demonstrates.

The financial stakes for the skilled trader or collector could be impressively high. One should not forget that at the end of the nineteenth century and the beginning of the twentieth, as now, American Indian art was big business. For example, the trader Thomas Keam amassed a collection of 2,400 examples of Hopi ceramics, from archaeological wares to modern commercial pots, which was purchased in 1892 by the Hemenway Expedition for $10,000. It was later given to the Peabody Museum at Harvard (Wade and McChesney 1980:12). Navy officer George Emmons collected over 4,000 pieces of Tlingit art which were purchased by the American Museum of Natural History in several lots between 1888 and 1893 for a total of $37,000 (Jonaitis 1988:87, 108, 112). Rodee reports that "in 1908, an otherwise slow, slightly depressed year for the national economy, [Navajo rug trader Lorenzo] Hubbell grossed $45,000 in the rug business" (1981:67). As Cohodas relates, Abe Cohn sold one of Louisa Keyser's baskets for $1,400 in 1914, and kept interest and prices high by constructing stories of having refused offers as high as $2,500 for a single one of her works.

During these early years, it was the collectors who were interested in named artists, signed pieces, and the cult of the individual, because this fueled interest in the purchase of high-priced works. But it remained to

the scholars to plumb the real meaning of artistic individuality in Native American cultures.

Artistry and Individuality

Faint glimmers of scholarly interest in Native American artists as individuals can be found in Boas's 1897 essay "The Decorative Art of the Indians of the North Pacific Coast." This interest grew during the first two decades of the twentieth century, as individuality and art style emerged as concerns in Boasian circles. Ira Jacknis quotes from a letter to James Teit from Boas in 1909 about their ongoing basketry research: "I wish you could get from as many women as possible, quite accurately, just what designs they make, and also the critique of other women of their work." As Jacknis shows, Herman Haeberlin was the first one to take up this challenge. He, more than anyone else in the early years of this century, championed the study of the individual artist in tribal society. In his essay published posthumously in *American Anthropologist*, Haeberlin set forth the challenge (1918:263):

The only plea I wish to make is that we study the formal principles in primitive art by methods comparable to those applied in the esthetics of our own. We are likely to look on primitive art simply as an ethnographic element and to limit our study to its relations with the other elements of a cultural unit. This I have called the extensive line of research. By an intensive study of primitive art we become conscious of the essential identity of problems in primitive art and in our own. Surely both lines of study may become mutually helpful. The study of primitive art has the great advantage of an ethnological perspective in which the cultural relations, I mean borrowings, assimilations, specialization of cultural elements, are far more plastically outlined than they are in the history of our own art. On the other hand the esthetic study of our art is privileged by being able to become individualistic and biographical, so to say, thanks to the detailed documentary evidence bearing on its historical development. It is true that this may become an evil when the student is not able to look beyond the historical details and see the broad underlying principles of cultural relations. But in the study of primitive art it is just this biographical feature of the history of modern art that we need for stimulation.

Haeberlin's interest in these ideas is clearly evident in the jointly authored monograph he worked on, *Coiled Basketry in British Columbia and Surrounding Region* (1928), so thoroughly discussed by Jacknis in this volume. This was a model for the better known studies of artistry and individuality by Bunzel (1929), O'Neale (1932), and Reichard (1934, 1936, 1939a, 1939b) that followed. The publication dates of these studies make it appear that they cluster, suggesting a particularly cogent interest in the individual artist in the late 1920s. Yet Jacknis's discussion of the complicated and belated publication history of the Salish basketry monograph (as well as Haeberlin's 1918 essay, quoted above) demonstrates conclusively that Haeberlin's ideas had primacy. Haeberlin, at Boas's urging, was the first to grapple with the issue of the individual artist in society. Moreover, Boas suggested Haeberlin's work to Ruth Bunzel as a model for her ensuing work with Pueblo potters. Notably, Lila O'Neale reviewed *Coiled Basketry in British Columbia* for *American Anthropologist* (1930). As Margot Schevill points out in her essay, reading this monograph sparked O'Neale's interest in the viewpoint of the Native artist.

During the summers of 1924 and 1925, Columbia University graduate student Ruth Bunzel lived and worked with Native American potters at Zuni and other pueblos in New Mexico and Arizona. Her resulting monograph, *The Pueblo Potter* (1929), has long been held up as a standard in the study of artistry, individuality, and ethnoaesthetics. While issues of technique continued to be important in her work (as they had been for the previous generation), it is the interplay of individual creativity with style and technique that was the focus of her attention. Bunzel laid out the various design principles in pottery at Zuni, Acoma, Hopi, and San Ildefonso (pp. 13–48). She then turned to what she called "the personal element in design" (i.e., individual creativity), discussing sources for design, Native criticism of pottery styles, methods of instruction, and the range of variability in an individual's artistic repertory (pp. 49–68). Bunzel was the first to set forth principles of aesthetics in Pueblo arts, paving the way for recent attempts.[7]

In the summer of 1929, Lila O'Neale, a University of California graduate student, embarked on her trip to the Klamath River to study the basketry arts of Yurok-Karok women. Though a student of Alfred Kroeber's, she had intellectual interests more in line with her contemporaries at Columbia in New York than with her mentor at Berkeley (who had been Boas's first doctoral student).

Kroeber had a great interest in California Indians in general and in bas-

ketry in particular, as his own publications demonstrate.[8] Yet his interest in art *as* art was slight. The very last line of his Pomo essay stresses the "tremendous predominance of unmotivated custom and habit over conscious, utilitarian, artistic, or religious purpose" (1909:249). Kroeber's concern with motor habit and custom as the motivating currents in decorative arts was rooted in nineteenth-century European intellectual history, as I have already mentioned in discussing Haddon, Semper, and others. Kroeber was not interested in individual members of tribal society, artists or otherwise. In his 1915 article "Eighteen Professions" (in which he puts forth his key ideas about society), his sixth profession states: "the personal or individual has no value, save as illustration."[9] Yet the work of his student Lila O'Neale showed great sympathy for the role of the individual, and for individual as well as group aesthetic standards (1932). In her interviews with forty-seven basket makers, O'Neale covered much the same ground that Bunzel had with Pueblo potters. Both Bunzel and O'Neale pioneered the practice of eliciting native aesthetic standards through discussion of art objects (or photographs of such). Dorothy Washburn (n.d.:4) has pointed out that O'Neale's discussions with her informants about design analysis of works of various tribes

> pinpointed one of the central problems in ethnographic research: what is it in culture—specifically in aspects of material culture— which a people uses to differentiate themselves as an ethnic group from other ethnic groups? Much has been written about symbols and styles as ethnic markers, but little about whether it is the shape, color, motif configuration, etc., of the symbols that allows an informant to judge whether a given object is from their culture or not.

The weavers' comments suggest that it is the proper configuration of motifs that signals a local rather than a foreign design, a correct one rather than an incorrectly composed one (p. 5).

The methods of Bunzel and O'Neale were to become paradigmatic for more recent generations of scholars of ethnographic art.[10] Curiously, Bunzel's and O'Neale's monographs, which today we consider pivotal works in the history of Native American art studies, were not reviewed in *American Anthropologist* when they were published.[11]

The work of Gladys Reichard, another Boas student, further elucidated the role of the artist in traditional society. The development of her interest in these topics can be traced in two articles she wrote early in her career. In one, she addresses the issue of artistic play and variation in the techni-

cally repetitive art forms of beadwork and embroidery (1922). In another, she cites the influence of Haeberlin and Bunzel on her own thinking and stresses the importance of the individual in determining stylistic and technological change (1928:460–61). Reichard's own fieldwork on art focused on the weaver and sand painter in Navajo society. Reichard's three volumes on Navajo weaving (1934, 1936, 1939a) were written for a popular audience. While they shed light on many aspects of Navajo culture, they are especially instructive for their focus on several individual weavers and their lives. Reichard is not the omniscient narrator in these studies, but the neophyte participant-observer, learning from Navajo experts how to weave. Charles Amsden, in his review of *Navajo Shepherd and Weaver*, wrote (1938:725):

> Dr. Reichard is the sixth person to make a major contribution (quantitatively speaking) to this general topic. Matthews, Hollister, Pepper, James, Amsden, preceded her; each doing what he considered a pretty comprehensive study. They, being men, almost necessarily wrote as observers of this feminine craft, and their writings have the weakness, the omissions, of the by-stander's version of what happened. Dr. Reichard, a woman, first of all learned how to weave, then wrote about it as a weaver. We have long known how Navaho weaving looks; now, thanks to her, we know how it feels. She writes of the labor, the errors and frustrations and minor triumphs that lie behind the finished product on which her male predecessors fixed their admiring eyes.

Reichard's volumes on sand painting (1939b; Newcomb and Reichard 1937) place this medicinal and artistic tradition within the larger framework of Navajo religion. Yet in these studies the individual artist still has his place. The 1937 volume includes chapters on "Painters and Painting," "Artistic Devices," and "Composition." In the 1939 study, one chapter is devoted to the sand painter and chanter Miguelito and another to the idea of artistry in general.[12] Soon after the important works by Bunzel, O'Neale, and Reichard were published, the study of art and individuality fell out of favor in anthropology, and attention turned to other issues.

The Aesthetic Appropriation of Indian Art

The serious interest in ethnoaesthetics, individual creativity, and artistic motivation on the part of scholars such as Bunzel,

O'Neale, and Reichard arose concurrently with the larger public interest in Indian art in general and individual Indian artists in particular. The interrelations between the scholarly anthropological sphere and the general, artistic one remain unclear. A thorough study of the early twentieth century and its ethos is sorely needed; such an analysis would shed light on the complex uses to which American Indian arts have been put by white society in this century. Here I shall mention only a few strands of this complex cultural fabric. Others are taken up by Fane and Rushing in their essays.

The twenty-five-year period before 1941 was an era in which the history of the marketing of Indian art and artists was intertwined with the history of the concentration of these arts in art museums and galleries—an appropriation that Jackson Rushing has called the aestheticization of Native American art. The greater visibility given to Native arts and artists led to a heightened interest in Native American art on the part of modern artists as well as the general public. These events were somewhat separate from the scholarly work on American Indian artists just discussed.

I have already mentioned the very early mythologizing of the Washoe basket maker Louisa Keyser, analyzed by Marvin Cohodas in his essay. While many aspects of this process were total fiction, it fed an interest in the personality of the "real" Indian artist. By the 1920s, San Ildefonso potter Maria Martinez was signing her pots and those of some of her colleagues in response to the demands of the Anglo marketplace (Marriott 1948:227–35); others soon followed suit. J.J. Brody has documented the rise of a tradition of signed paintings in the Pueblo area and in Oklahoma during this era (Brody 1971:chapters 3–5). As Jackson Rushing points out, one of the purposes of the Museum of Modern Art exhibit in 1941 was to show that American Indian art was a living tradition; signed works by contemporary painters such as Fred Kabotie and Oscar Howe were featured in the show.

Yet these artists had received recognition in the art world prior to the MOMA show. In 1931 the "Exposition of Indian Tribal Arts" in New York featured such paintings as well. Its catalogue (Sloan and La Farge 1931) included an essay by Alice Corbin Henderson on "Modern Indian Painting" in which works by Fred Kabotie and Awa Tsireh were illustrated. Ten years earlier, the periodical *Art and Archaeology* had published an article on "Native American Artists" (Hewett 1922) which featured paintings by these same two young painters. These paintings were concurrently exhibited by the Society of Independent Artists in New York (Hewett 1922:109).

Art and Archaeology was a monthly magazine endeavoring to provide a popular yet intelligent view of art from all places and eras. During its two decades of publication (1915–34), articles on modern art were published next to articles on America's archaeological treasures. From Pompeii to Pueblo pottery, from Corinth to Chichen Itza, world art was presented in serious and egalitarian fashion. In addition to the article on Kabotie and Tsireh, *Art and Archaeology* included ones on the Southwest Indian Fair and Pueblo pottery (Chapman 1925, 1927) and Navajo sand painting and weaving (Overholt 1933; Arnold 1929).

During these same years, the encyclopedic survey books of art history began to cover non-European arts, including North American Indian art. This trend started in Europe. Eli Faure's *Histoire de l'art* (1909–21) includes Africa, Oceania, and the Americas. The highly respected Propylaen Kunstgeschichte published von Sydow's expert *Die Kunst der Natur-Volker und der Vorzeit* (1923) in its series. By 1926, the American author Helen Gardner had joined the movement to include "primitive" art in art history survey texts. Her influential *Art Through the Ages* (1926) not only has a chapter on "aboriginal American art" but declares in the first sentence of the preface (p. iii) her commitment to a global approach to art history: "The purpose of this book is to introduce the reader to certain phases of art—architecture, painting, sculpture, and the minor arts—from the remote days of the glacial age in Europe, through the successive civilizations of the Near East, Europe, America, and the Orient to the twentieth century." Thus the aestheticization of Native American art that was taking place in the museum world (so thoroughly documented by Rushing's essay in this volume) was part of a larger movement encompassing every level of the art world—museum exhibits, popular interest in Native American art, interest in Native art on the part of avant-garde artists.

Even before the pivotal MOMA exhibit in 1941, many modern artists, in both the United States and Europe, not only were aware of Indian art but were avid students and collectors of it. Georgia O'Keeffe began her sojourns to New Mexico in 1929, and by 1930 her work exhibited at An American Place in New York showed dramatic evidence of her new southwestern interests (Lisle 1980:187). By the time of O'Keeffe's arrival, Taos had long been a mecca for artists interested in the Indian heritage (see Eldredge et al. 1986).

In the 1920s, Surrealist artists in Europe were especially drawn to Alaskan Eskimo and Northwest Coast masks, and incorporated some of these

forms in their own paintings (Cowling 1978:486). By the time such material was exhibited in the Galerie Surrealiste in 1927, several of the artists were already familiar with ethnographic collections in Berlin and London. Moreover, many of them owned copies of the profusely illustrated Bureau of American Ethnology annual reports and used them as source material for their own art (Cowling 1978:487). A number of Surrealist exiles arrived in New York in the late 1930s and early 1940s. The 1941 MOMA show, as well as the great collections of the American Museum of Natural History, the Museum of the American Indian, and The Brooklyn Museum fed their interest. Indeed, in 1944, several Surrealist artists planned to collaborate on a book about Eskimo art, but no publisher could be found for such a project (Cowling 1978:494).

As Jonaitis has pointed out (1981), American Indian art served a Surrealist agenda in several ways. The Surrealists hungered for a sort of collective mythmaking, for a communion with the "totemic mind" (Paalen 1943:18). They celebrated such qualities in Northwest Coast and Eskimo art in particular. But once again, their writings and their interest in Native art represent a sort of parallel track to the more scholarly interest in American Indian art. And, as is evident in so many other instances discussed in this volume, they used Native arts to serve their own purposes.

Conclusion

James Clifford has proposed that modern ethnographic study is an "ethnography of conjunctures," in which culture is "not a tradition to be saved, but an assembled code of artifacts always susceptible to critical and creative recombination" (1988:9–12). All of the contributors to this volume examine various "assembled codes of artifacts." Analyzing the diverse ambitions and approaches of Culin, Boas, Swanton, Haeberlin, O'Neale, Abe and Amy Cohn, and René d'Harnoncourt, we see the history of American Indian art history in terms of shifting truths, falsehoods, appropriations, scholarly formulations, and public responses— different conjunctures for different historical moments.

In our own historical moment, we too continue to try to comprehend, apprehend, and display the arts of Native American peoples, both past and present. The last quarter of the twentieth century is clearly an era in which self-evaluation and a self-critical stance are central to the enterprise of encountering other cultures and their arts. Examination of motives,

premises, ideologies, and social agendas has never been stronger. Yet despite our best efforts, no doubt our truths will be critiqued as yet another layer of social fictions by successive generations of scholars.

NOTES

1. Among the most insightful of these critiques are Clifford (1988), Clifford and Marcus (1986), Alpers (1977), Fabian (1983), Werckmeister (1982), and Rees and Borzello (1988).

2. *Objects and Others*, a collection of essays edited by George Stocking (1985), discusses issues in the history of institutional collecting. Cole's *Captured Heritage* (1985) focuses on the collecting of Northwest Coast art in particular.

3. Curtis Hinsley has written on the history of both the Smithsonian Institution (1981) and the Peabody Museum (1985).

4. For a brief overview of the history of that institution and a thorough examination of the history of the Northwest Coast collections there, see Jonaitis (1988).

5. Barbeau was the first to look at argillite carving in depth (1953, 1957). For recent studies of Haida argillite carving, see Wright (1985) and Sheehan (1981).

6. See Gottfried Semper (1878–79) and Alois Riegl (1901–23), two of the most influential of these writers.

7. For a recent study of Pueblo pottery focusing on individual potters, see Trimble (1987); on Zuni pottery, see Hardin (1983). For a sophisticated analysis of Zuni aesthetics in art and performance, see Tedlock (1984). For a critique of Bunzel's premises, see Hardin (n.d.).

8. See, for example, the impressive but incomplete list of his publications in the bibliography of the California volume of the *Handbook of North American Indians* (Heizer 1978:746–47), as well as Kroeber (1905, 1909, 1924).

9. Eric Wolf has criticized Kroeber's linguistic studies for their indifference both to meaning and to the individual: in Kroeber's work "there are, in fact, no people" (Wolf 1981:57). In an unpublished essay on Kroeber and Pomo basketry, Bruce Bernstein criticizes Kroeber for limiting his interests to issues of design and technology and for having forced a diverse body of material into a neat yet artificial tribal construct (Bernstein, n.d.).

10. In Africa, in particular, interest in the individual artist and native exegesis became current in the 1960s and 1970s. Robert Farris Thompson, for example, has been lauded for his work on Yoruba sculptors and potters and their native categories for artistic criticism (1969, 1973). In this, he is clearly the heir of Haeberlin, Bunzel, and O'Neale. Their approach has become increasingly common, as volumes like Biebuyck's *Tradition and Creativity in Tribal Art* (1969), d'Azevedo's *The Traditional Artist in African Societies* (1973), and Barbara Johnson's *Four Dan Sculptors* (1986) attest.

11. *The Pueblo Potter* was reprinted as a Dover paperback in 1972 and remains in print.

12. Both sand painting volumes and *Navajo Shepherd and Weaver* (1936) were re-

printed as affordable Dover paperbacks in the 1970s, making them accessible to a new generation of students and artists. All are still in print.

BIBLIOGRAPHY

Alpers, Svetlana
 1977 "Is Art History?" *Daedalus*, Summer 1977, pp. 1–13.
Amsden, Charles
 1938 Review of Reichard, *Navajo Shepherd and Weaver*, in *American Anthropologist* 40:724–25.
Arnold, Ethel
 1929 "The Blanket of Chief White Antelope," *Art and Archaeology* 28:45–52.
Arreola, Paul
 1986 "George Wharton James and the Indians," *Masterkey* 60(1):11–18.
Barbeau, Marius
 1953 "Haida Myths Illustrated in Argillite Carvings," *National Museum of Canada Bulletin* 127.
 1957 "Haida Carvers in Argillite," *National Museum of Canada Bulletin* 139.
Batkin, Jonathan
 1987 *Pottery of the Pueblos of New Mexico: 1700–1940.* Colorado Springs: Taylor Museum of the Colorado Springs Fine Arts Center.
Bernstein, Bruce
 n.d. "Alfred Kroeber and the Study of Pomoan Basketry." Manuscript.
Biebuyck, Daniel, ed.
 1969 *Tradition and Creativity in Tribal Art.* Berkeley: University of California Press.
Boas, Franz
 1897a *The Social Organization and Secret Societies of the Kwakiutl Indians.* Report of the U.S. National Museum for 1895, pp. 311–788. Washington, D.C.
 1897b "The Decorative Art of the Indians of the North Pacific Coast," Bulletin of the American Museum of Natural History 9:123–76.
Brody, J. J.
 1971 *Indian Painters and White Patrons.* Albuquerque: University of New Mexico Press.
Bunzel, Ruth L.
 1929 *The Pueblo Potter: A Study of Creative Imagination in Primitive Art.* New York: Columbia University Press.
Chapman, Kenneth
 1925 "The Indian Fair," *Art and Archaeology* 18:215–24.
 1927 "Post-Spanish Pueblo Pottery," *Art and Archaeology* 23:207–12.
Clifford, James
 1988 *The Predicament of Culture: Twentieth-Century Ethnography, Literature, and Art.* Cambridge: Harvard University Press.
Clifford, James, and George E. Marcus, eds.
 1986 *Writing Culture: The Poetics and Politics of Ethnography.* Berkeley: University of California Press.

Cohodas, Marvin

 1986 "Washoe Innovators and Their Patrons," in *The Arts of the North American Indian*, ed. Edwin Wade, pp. 203–20. New York: Hudson Hills Press.

Cole, Douglas

 1985 *Captured Heritage: The Scramble for Northwest Coast Artifacts*. Seattle: University of Washington Press.

Cowling, Elizabeth

 1978 "The Eskimos, the American Indians, and the Surrealists," *Art History* 1(4):484–500.

d'Azevedo, Warren L.

 1973 *The Traditional Artist in African Societies*. Bloomington: Indiana University Press.

Eldredge, C. C., J. Schimmel, and W. H. Truetter

 1986 *Art in New Mexico, 1900–1945*. New York: Abbeville Press.

Ewers, John C.

 1978 *Murals in the Round: Painted Tipis of the Kiowa and Kiowa-Apache Indians*. Washington, D.C.: Smithsonian Institution Press.

Fabian, Johannes

 1983 *Time and the Other: How Anthropology Makes Its Object*. New York: Columbia University Press.

Faure, Eli

 1909–21 *Histoire de l'art*. Paris.

Gardner, Helen

 1926 *Art Through the Ages*. New York: Harcourt, Brace, and Company.

Grosse, Ernst

 1897 *The Beginnings of Art*. New York.

Haddon, A. C.

 1895 *Evolution in Art*. London.

Haeberlin, Herman

 1918 "Principles of Esthetic Form in the Art of the North Pacific Coast," *American Anthropologist* 20:258–64.

Haeberlin, Herman, J. A. Teit, and H. A. Roberts, under the direction of Franz Boas

 1928 *Coiled Basketry in British Columbia and Surrounding Region*. Annual Report of the Bureau of American Ethnology for 1919–1924, 41:119–484.

Hardin, Margaret

 n.d. "Zuni Potters and *The Pueblo Potter*: An Assessment of Bunzel's Contributions." Manuscript.

 1983 *Gifts of Mother Earth: Ceramics in the Zuni Tradition*. Phoenix: Heard Museum.

Heizer, Robert F., ed.

 1978 *California*, vol. 8 in *Handbook of North American Indians*. Washington, D.C.: Smithsonian Institution Press.

Hewett, Edgar

 1922 "Native American Artists," *Art and Archaeology* 13:103–11.

Hinsley, Curtis M., Jr.

 1981 *Savages and Scientists: The Smithsonian Institution and the Development of American*

Anthropology, 1846–1910. Washington, D.C.: Smithsonian Institution Press.

1985　"From Shell-Heaps to Stelae: Early Anthropology at the Peabody Museum," in *Objects and Others: Essays on Museums and Material Culture*, ed. G. W. Stocking, pp. 49–74. Madison: University of Wisconsin Press.

Holmes, William H.

1890　"On the Evolution of Ornament: An American Lesson," *American Anthropologist* 3:137–46.

1892a　"Studies in Aboriginal Decorative Art, I," *American Anthropologist* 5:67–72.

1892b　"Studies in Aboriginal Decorative Art, II," *American Anthropologist* 5:149–52.

James, George Wharton

1901　*Indian Basketry*. Privately Printed, Pasadena.

1914　*Indian Blankets and Their Makers*. Chicago: A. C. McClurg.

Johnson, Barbara

1986　*Four Dan Sculptors*. San Francisco: Fine Arts Museums of San Francisco.

Jonaitis, Aldona

1981　"Creations of Mystics and Philosophers: The White Man's Perceptions of Northwest Coast Indian Art from the 1930s to the Present," *American Indian Culture and Research Journal* 5(1):1–48.

1988　*From the Land of the Totem Poles: The Northwest Coast Indian Art Collection at the American Museum of Natural History*. New York and Seattle: American Museum of Natural History and University of Washington Press.

King, Jonathan C. H.

1986　"Tradition in Native American Art," in *The Arts of the North American Indian: Native Traditions in Evolution*, ed. Edwin Wade, pp. 65–92. New York: Hudson Hills Press.

Kroeber, Alfred L.

1905　"Basket Designs of the Indians of Northwestern California," University of California Publications in American Archaeology and Ethnology 2(4):105–64. Berkeley.

1909　"California Basketry and the Pomo," *American Anthropologist* n.s. 11(2):233–49.

1915　"Eighteen Professions," *American Anthropologist* n.s. 17(3):283–88.

1924　*Basket Designs of the Mission Indians of California. Anthropological Papers of the American Museum of Natural History* 20(2):149–83. New York.

Lévi-Strauss, Claude

1966　*The Savage Mind*. Chicago: University of Chicago Press.

Lisle, Laurie

1980　*Portrait of an Artist: A Biography of Georgia O'Keeffe*. New York: Seaview Books.

MacCannell, Dean

1976　*The Tourist: A New Theory of the Leisure Class*. New York: Schocken Books.

Marriot, Alice

1948　*Maria: the Potter of San Ildefonso*. Norman: University of Oklahoma Press.

Mason, Otis T.

1904　*Aboriginal American Basketry*. Report of the U.S. National Museum for 1902. Washington, D.C.

Matthews, Washington

1884 "Navajo Weavers," Annual Report of the Bureau of American Ethnology for 1881–82, 3:375–91. Washington, D.C.

New, Lloyd

1973 Painted Tipis by Contemporary Plains Indian Artists. Anadarko: Oklahoma Indian Arts and Crafts Cooperative.

Newcomb, Franc, and Gladys Reichard

1937 Sandpaintings of the Navajo Shooting Chant. New York: J. J. Augustin.

O'Neale, Lila

1930 Review of Haeberlin et al., Coiled Basketry in British Columbia and the Surrounding Region, in American Anthropologist n.s. 36:306–8.

1932 Yurok-Karok Basket Weavers. University of California Publications in American Archaeology and Ethnology 32(1):1–184.

Overholt, Mary Elizabeth

1933 "Pictures in Sand," Art and Archaeology 34:262–65.

Paalen, Wolfgang

1943 "Totem Art," Dyn 4–5:7–38.

Rees, A. L., and F. Borzello

1988 The New Art History. Atlantic Highlands, N.J.: Humanities Press International.

Reichard, Gladys

1922 "The Complexity of Rhythm in Decorative Art," American Anthropologist n.s. 24:183–208.

1928 "Form and Interpretation in American Art," Proceedings of the 23rd International Congress of Americanists, pp. 459–62.

1934 Spider Woman: A Story of Navajo Weavers and Chanters. New York: Macmillan.

1936 Navajo Shepherd and Weaver. New York: J. J. Augustin.

1939a Dezba, Woman of the Desert. New York: J. J. Augustin.

1939b Navaho Medicine Man. New York: J. J. Augustin.

Riegl, Alois

1901–23 Die spatromische Kunst-industrie. 2 vols. Vienna: K.K. Hof- und Staatsdruckerei.

Rodee, Marian

1981 Old Navajo Rugs: Their Development from 1900 to 1940. Albuquerque: University of New Mexico Press.

Sartre, Jean Paul

1963 Search for a Method. New York: Vintage Press.

Semper, Gottfried

1878–79 Der Stil in den technischen und tektonischen Kunsten. Munich: Bruckmann.

Sheehan, Carol

1981 Pipes That Won't Smoke, Coal That Won't Burn: Haida Sculpture in Argillite. Calgary, Alberta: Glenbow Museum.

Sloan, John, and Oliver La Farge

1931 Introduction to American Indian Art. New York: Exposition of Indian Tribal Arts, Inc.

Stevenson, Matilda Coxe
 1904 The Zuni Indians. Annual Report of the Bureau of American Ethnology for
 1901–2, 23:3–634.
Stocking, George W., Jr., ed.
 1985 Objects and Others: Essays on Museums and Material Culture. Madison: University
 of Wisconsin Press.
Swanton, John
 1905 Contributions to the Ethnology of the Haida. Jesup North Pacific Expedition
 5(1). AMNH Memoirs 8:1–300. New York.
Tedlock, Barbara
 1984 "The Beautiful and the Dangerous: Zuni Ritual and Cosmology as an
 Aesthetic System," Conjunctions 6:246–65.
Thompson, Robert Farris
 1969 "Abatan: A Master Potter of the Egbado Yoruba," in Tradition and Creativity
 in Tribal Art, ed. Daniel Biebuyck, pp. 120–82. Berkeley: University of Cali-
 fornia Press.
 1973 "Yoruba Artistic Criticism," in The Traditional Artist in African Societies, ed.
 Warren d'Azevedo, pp. 19–61. Bloomington: Indiana University Press.
Trimble, Stephen
 1987 Talking with the Clay: the Art of Pueblo Pottery. Santa Fe: School of American
 Research.
Von Sydow, Eckart
 1923 Die Kunst der Natur-Volker und der Vorzeit. Berlin: Propylaen Kunstgeschichte.
Wade, Edwin L., and Lea S. McChesney
 1980 America's Great Lost Expedition: The Thomas Keam Collection of Hopi Pottery from
 the Second Hemenway Expedition, 1890–1894. Phoenix: Heard Museum.
Washburn, Dorothy K.
 n.d. "Lila O'Neale: Early Pioneer in Design Analysis." Manuscript.
 1984 "Dealers and Collectors of Indian Baskets at the Turn of the Century in
 California: Their Effect on the Ethnographic Sample," Empirical Studies of
 the Arts 2(1):51–74.
Werckmeister, O. K.
 1982 "Radical Art History," Art Journal, Winter 1982, pp. 284–91.
Wolf, Eric
 1981 "Alfred L. Kroeber," in Totems and Teachers: Perspectives on the History of Anthro-
 pology, ed. Sydel Silverman, pp. 35–64. New York: Columbia Univer-
 sity Press.
Wright, Robin
 1985 "Nineteenth Century Haida Argillite Pipe Carvers: Stylistic Attribu-
 tions," Ph.D. dissertation, School of Art, University of Washington,
 Seattle.

ALDONA JONAITIS

2

FRANZ BOAS,

JOHN SWANTON,

AND THE NEW HAIDA

SCULPTURE AT THE

AMERICAN MUSEUM OF

NATURAL HISTORY

In the contemporary era, an analysis of Native American art can no longer take the form of description by a supposedly transparent describer, nor of interpretive narration by an invisible and value-free narrator. It must approach its object, the artwork, by addressing the numerous historical influences from the time of its creation, and possibly even before that significant moment, through the period during which it was appropriated (by collection, photography, or description), investigating how this representation became part of the dominant group's perception of the culture that produced the artwork. In this paper I will use this approach to study the recreation of Haida art by Charles Edenshaw (fig. 1) for the American Museum of Natural History during the Jesup North Pacific Expedition (1897–1902). I hope to demonstrate that in this process, Franz

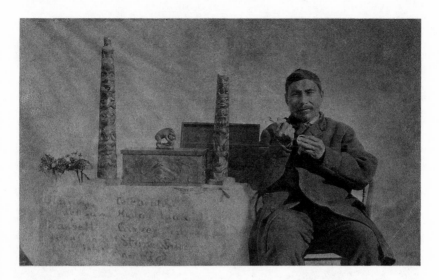

Figure 1. *Charles Edenshaw (1839–1920) displaying his argillite carvings.*
(Courtesy Canadian Museum of Civilization, 88926)

Boas (fig. 2) and John Swanton (fig. 3), the most sensitive and progressive of whites, despite their conscious intentions to celebrate Indian art and promote the equality of all races, nevertheless ended up contributing to the design of an invented culture and reinforcing a process in which the display of Indian art functioned in a larger context of major ideological significance that had less to do with Native Americans than with communicating the power, authority, and dominance of the elite class—largely to immigrant workers.

Antonio Gramsci's notion of cultural hegemony is useful in initial attempts to understand this process. In the view of this Italian theorist, the dominant group uses cultural symbols to win the support and loyalty of those subservient peoples who embrace as the "truth" the ruling class's values and attitudes. In his words, social hegemony is "the 'spontaneous' consent given by the great masses of the population to the general direction imposed on social life by the dominant fundamental group; this consent is 'historically' caused by the prestige (and consequent confidence) which the dominant group enjoys because of its position and function in the world of production" (Gramsci 1971:12). Gramsci's name and the subject of hegemony frequently arise in discussions of this sort; but since his writings deal with the European working class and its reactions to capitalist dominators, his approach must be altered somewhat when considering the specific context of American Indian culture.[1]

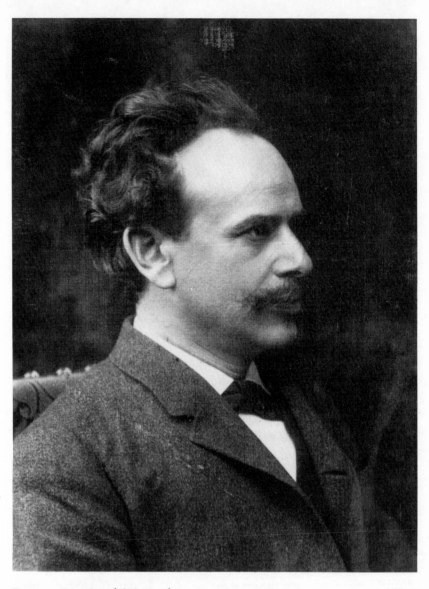

Figure 2. Franz Boas (1858–1942).
(Courtesy American Museum of Natural History, 2A5161)

Figure 3. John Swanton (1873–1958).
(Courtesy Smithsonian Institution, 45,200)

Also of significant value to this study is Stephen A. Tyler's "Post-Modern Ethnography: From Document of the Occult to Occult Document," in *Writing Culture: The Poetics and Politics of Ethnography* (1986), edited by James Clifford and George E. Marcus. Drawing from contemporary writers such as Jurgen Habermas (1984) and Jean François Lyotard (1984), Tyler proposes that ethnography can no longer be considered part of science's search for truth and universal knowledge, based on an ideology of the observer who writes about the observed with authenticity and accuracy, but is a dialogue that has various participants. He suggests that a "new kind of holism" emerges from an understanding of the dialogue between the author/ethnographer, his text/ethnography, and the reader (pp. 132–33).[2] We might add that in the study of ethnographic art, included among the textual elements is the object of art itself. To understand the mechanism bringing together the author, the text, and the reader (or more properly, the viewer), it is necessary to look at the institution that collected and then displayed this art.

Recently several scholars have studied the role museums have played in assembling and disseminating ethnographic information. George Stocking, editor of the fascinating collection of essays *Objects and Others* (1985: 4–5), notes that objects in museums are always subjected to a recontextualizing process in which they become "survivals" of a number of pasts: that of the culture from which they were removed, that of any previous exhibitions in which they were displayed, and that of the past history of their current setting. Museum displays are not simple presentations of attractive or interesting objects, but often expressions of relations of cultural power. Initially created by "others" and now possessed by "us," these objects implicitly embody the act of transfer.

James Clifford (1985:239–40), in the same book, points out, after Stewart (1984), that collecting and exhibiting ultimately create an illusory representation of the world formed by objects now "standing for" abstract concepts, such as a "dance mask" of a particular ethnic group. This classification process, in which objects thus "make sense" to a viewer, ignores the actuality of their appropriation (that is, "making one's own") and dehistoricizes them. We might say that museums first make a choice as to what abstract ethnographic concepts they wish to reify, and then decide which of the wide range of material objects they will use to do so. And sometimes the museum personnel "improve" the objects by physically altering them or even by creating novel pieces out of available fragments (Freed 1981). Those objects, so chosen, become suffused with an air of

"authenticity"; they become, to the white viewer, the "real" art of an ethnic group.[3] Just as the "primitive" has been invented, so too is "primitive art" a made-up notion.

The question of authenticity is a compelling one, and is closely linked to the moment the object was appropriated. Clifford has speculated on this topic and suggests that authenticity is not an objective fact but "has as much to do with an inventive present as with a past, its objectification, preservation, or revival" (1985:242). Authenticity, since the time of Boas, has tended to represent objects in the context in which they were situated just prior to collection (Clifford 1988:228). There has been, since Boas's time, a measure of desperation in this representation of salvaged artifacts, for the "relatively recent period of authenticity is repeatedly followed by a deluge of corruption, transformation, modernization" (Clifford 1987:122; see also 1988:202).[4] Boas, Swanton, and others tried diligently to "rescue" the artworks of the peoples they studied before this deluge. Ironically, the culture they were trying to salvage was by no means "traditional," if that word is assumed to connote "pristine" (see Jonaitis and Inglis, in press).

Indeed, "traditional American Indian art" is an invented notion. As Jonathan King (1986:69–70) states, most museum collections on which we typically base our definitions of Native American art were created between 1860 and 1930, a time of severe cultural upheavals among most Indian groups. Regardless of this reality, many museums—and the literature based on their collections—present art collected and in many cases produced during this period as "authentic and traditional" Indian art, timeless and eternal. "Basketry, bead costume and carving from this time exist in such large quantities that they are used as a general, though often unstated, yardstick by which the unconscious standards of traditionalism are set" (King 1986:70).[5]

Virginia Dominguez, in a review article of four books (1986), has proposed some very suggestive ways of looking at how the activities of collectors such as those described by Douglas Cole in *Captured Heritage: The Scramble for Northwest Coast Artifacts* (1985) affected the representation of ethnographic artwork. She points out that it was the collectors and ethnographers, not the Indians themselves, who determined that these objects embodied Native American "tradition," and that such a notion of "heritage" or "tradition" was a nineteenth-century Euro-American invention. The entire process of collecting ethnographic objects, from the moment of acquisition to the time of display, despite the intentions of the collectors and the displayers, does not result in accurate representa-

tions of the "Other" but in "referential indices of the Self" (Dominguez 1986:554).[6]

Several intriguing ideas are thus offered in the recent literature discussed above, and I hope to bring them together in my discussion of the American Museum of Natural History's exhibition of Charles Edenshaw's Haida artworks. Of considerable value to my analysis is the concept of "wrapping" put forth by the literary theorist and critic Frederic Jameson (1991:101ff.). In his view, the interpretation of a text involves deciphering the process through which an old text has been "wrapped" by new layers of meaning: a second layer incorporates the first to create a new entity, a two-or-more-part whole with a "resonance" between the component parts. It is the process of peeling off these various levels of significance that exposes the multifaceted meaning revealed by a text.[7] Jameson's methodology affords us a way of understanding the newly created Haida sculpture, presented to a New York City audience, as having been "wrapped" in such a way to create a new form of art, neither strictly Indian nor completely devoid of Indianness. In effect, a new entity has been formed composed of artworks created by a Northwest Coast Indian, displayed in a major New York City institution, and viewed by immigrants. It was this composite entity that functioned to communicate to the museum's audience a rich complex of values, attitudes, and visions about race, class, and progress.

Franz Boas, John Swanton, and Charles Edenshaw

At the turn of the century, the American Museum of Natural History displayed some new Haida art made specifically for that institution.[8] The principal parties involved were Franz Boas, John Swanton, and Charles Edenshaw. Boas is widely known as the major force in revolutionizing American anthropology, transforming it from nineteenth-century racist-evolutionist practices into a relativistic, culture-specific science. As curator of the Anthropology Department at the American Museum from 1895 to 1905, Boas organized the Jesup North Pacific Expedition to acquire data that would prove his antievolutionist principles (Jonaitis 1988).[9]

Among the men Boas sent to the Northwest during the Jesup Expedition was John Swanton, a recent Harvard Ph.D. who worked among the Haida on the Queen Charlotte Islands from 1900 to 1901 (Collins 1968). Always a firm supporter of Boas's anthropological theories, Swan-

ton wrote Boas a thoughtful letter from the field after reading the text of the "Mind of Primitive Man" (May 12, 1901).[10] In a perceptive and sensitive analysis of racism, Swanton described how deep-set dogmas govern the thinking of many people. Any attack on this "ultimate and absolute truth" was bound to engender intense feelings. He goes on, "now it seems to me that the Indian is not . . . from a white standpoint, lying, cruel, immoral or thievish as the white man is. It seems to me rather that the qualities we often designate in this way are results deduced in a perfectly logical manner from his [i.e., the white man's] own super-conscious premise . . . which premise it has never ever occurred to him to question." Later, as the outgoing president of the Washington Anthropological Society (Swanton 1917), Swanton launched an explicit attack on social Darwinism, which Boas certainly must have appreciated.

Charles Edenshaw (1839–1920), a member of a noble Haida family, served as informant for many anthropologists. He met Boas in Port Essington in 1897, where he explained facial designs, illustrated Haida images such as the sea creature Wasco (drawn on American Museum of Natural History stationery; fig. 4), and narrated myths (Thomas 1967:4). An outstandingly talented artist, he was commissioned to make art for both the American Museum and the Chicago Field Museum (Cole 1985:195–96). Such commissions would not have been considered inappropriate among the Haida, who had a long tradition of producing art for sale, not only argillite carvings but also wooden masks and sculptures (Wright 1982; Holm 1981:176, 180).[11]

Although Northwest Coast artists often manifested some personal creativity in their work, Charles Edenshaw's art was unusually individualistic. In Bill Holm's view, Edenshaw was a master of his tradition, but "had developed a very personal version of that tradition" (Holm 1981:182). Edenshaw's originality distinguishes his art from that of his contemporaries as well as from older Haida art. Comparing Edenshaw's totem pole models with those of another artist from whom Swanton also commissioned models for the American Museum, Holm states that John Robson's carvings "seem somewhat more static, [but] they also more truly represent the character of the full sized Haida poles" (Holm 1981:190). Peter Macnair (Macnair et al. 1980:70) suggests that Edenshaw's sculpture manifests "a vigour and personality seldom found [in work] made by most other artists" and a "depth of expression." Macnair thinks that this quality may be an expression of Edenshaw's despair at the social disintegration about him at that time. Others have noticed this originality in his art. Accord-

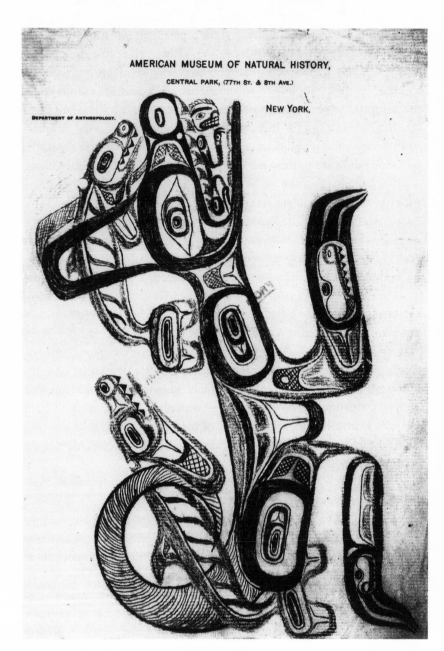

Figure 4. Edenshaw drawing of *Wasco*, done in 1897.
(Courtesy American Museum of Natural History, 6830)

ing to Susan Thomas (1967:10), his lively narrative style may have resulted from his activities as a narrator of myths for ethnographers; Alan Hoover (1983:67) suggests that Edenshaw may have been motivated to satisfy the tastes of his white customers, who favored pieces with stories that all could understand. Regardless of motivation, it is interesting that Boas, Swanton, and others worked especially closely with a unique and particularly creative artist. As a consequence of this white patronage, Edenshaw became a major force in the process of defining what Haida art was.

When Swanton met Edenshaw, "traditional" Haida culture was a thing of the past. During the late eighteenth century, abundant wealth had poured into the Queen Charlottes as a consequence of the seaborne fur trade; this wealth encouraged a flourishing of art and ceremonialism that characterized the so-called traditional culture about which Boas and Swanton were most interested in learning. By the mid-1850s, years after the depletion of the sea otters in the area, the Haida were making annual voyages to the boomtown of Victoria on the southern end of Vancouver Island; here they encountered other ethnic groups as well as numerous whites. In 1862, they brought back to the Queen Charlottes from Victoria a vicious smallpox epidemic that severely reduced the population and created extreme social stress. Within ten years, most traditional villages had been abandoned and most survivors of the epidemic had moved to the two remaining villages, Skidegate or Masset. By this time, the Haida had adopted Western dress, no longer tattooed their bodies, and had stopped wearing labrets. Missions began to convert them to Christianity, and the 1884 anti-potlatch bill outlawed their major ceremonial (see Duff 1964; Fisher 1977). As Margaret Blackman (1976, 1981:27–28) has astutely pointed out, even though several Haida traditions continued between 1875 and 1900, albeit in altered form, Swanton and Boas were not interested in things like the tombstones that substituted for the mortuary cult; they wanted to learn about the preacculturated Haida art.

By the time Swanton arrived on the Queen Charlottes in 1900, many features that had been central to Haida culture fifty years earlier were now nowhere to be found. In a long and painful letter to Boas (September 30, 1900), he described how the population was down to seven hundred, and how no old houses stood, but were replaced by wooden frame structures with windows. Swanton blamed the missionaries for having suppressed the old dances and for their part in the destruction of the old houses; they were guilty of having destroyed "everything, in short, that makes life worth living."

Swanton's responsibilities as part of the Jesup North Pacific Expedition were to gather ethnographic data on social organization, myths, rituals, and religion and to collect Haida art for the American Museum of Natural History. Boas generally instructed Jesup Expedition collectors to obtain the oldest and most "authentic" pieces; for example, in an April 14, 1897, letter to George Hunt, he asked his Northwest Coast colleague to collect Kwakiutl masks from "one of the remoter villages, where they still have some of the old masks" (see also Cole 1985:152–53).

He similarly requested (June 5, 1900) that Swanton collect a large totem pole, memorial poles, grave posts, planks, painted blankets, dance aprons, shaman ivories, and horn spoons ("if fully explained and if particularly good"). Boas also asked that model houses, totem poles, memorial posts, and grave posts "with good information on the carving" be commissioned.[12] Another letter (November 15, 1900) stressed the need to acquire objects with good information, but also reiterated Boas's interest in model poles.[13]

Swanton kept Boas continually informed on the progress of his art commissions. Almost as soon as he arrived in Skidegate, he wrote explaining that a complete set of totem pole models at $10 each could be obtained (July 30). On October 9, he mentioned how someone had revived the art of spoon carving and was producing spoons "with stories," and that he was having crayon drawings made of tattooed animals "at $.15 each." Despite this letter stating that there were some real totem poles as well as grave posts still available (only the memorial posts were truly hard to locate), he did commission a model totem pole that was finished by January and purchased for $9 (January 16, 1901). He ultimately collected several models carved by Skidegate artist John Robson (Holm 1981:190).

After his stay in Skidegate, Swanton traveled north to Masset, where he met Charles Edenshaw, "the best carver here" (March 31, 1901), and commissioned some totem poles, a model house, and model canoes. By June, Edenshaw had finished the model of his uncle Chief Albert Edenshaw's Myth House at Kiusta (fig. 5), inhabited by his noble relatives prior to their abandonment of that traditional village (June 22, 1901). In addition to the complicated façade, including a central pole flanked by two side poles, is an interior screen depicting the wealth-giving spirit, Qo'naqada. The façade illustrates the so-called lazy son-in-law story in which a young man takes revenge on his mother-in-law, who has accused him of being

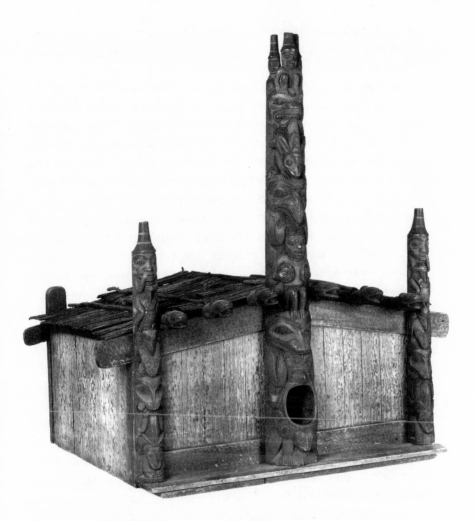

Figure 5. *Charles Edenshaw's model of Chief Albert Edenshaw's Myth House at Kiusta,*
carved in 1901. Photograph by D. Finnan
(Courtesy American Museum of Natural History, 16/8771)

lazy (Swanton 1905:106). A mythic being called bird-in-the-air helps this
man capture Su-san, a lake monster known for its ability to catch black
whales. They use young children as bait for this purpose. The man then
flays Su-san and wears its skin to catch enormous amounts of fish, which
he secretly places before his mother-in-law's door. Thinking she has ac-
quired immense power, the woman begins to call herself a shaman. When
her son-in-law reveals the truth, she becomes very shamed and dies. The
center pole depicts, from top to bottom, the children used as bait, the

man in Su-san's skin, the bird-in-the-air, the mother-in-law as a shaman, Su-san, and the black whale. The posts at the sides depict, from top to bottom, raven, bullhead, and grizzly bear (MacDonald 1983:190).

Edenshaw also made several model poles that now are part of the American Museum's collection (fig. 6). The left-hand pole was one that a chief of Those-born-at-Skedans might have had carved. The uppermost figure depicts a tattooed ancestress of the Eagle clan carrying a cane and wearing a hat with a frog, above which is an eagle. Her cane rests on a frog who in turn faces an eagle, another frog, a beaver, and yet another frog. The right-hand pole is a copy of one owned by a chief of the Eagle-House People and illustrates the Raven story. A beaver at the bottom owned the first house and adopted Raven. The small human figure on the beaver's stomach is Raven; above is Raven again, with a crescent moon surrounding his companion Butterfly. The grandfather of Raven, with a space-filling frog in his mouth, perches atop these creatures; while above, in turn, is Raven stealing the beaver's salmon-lake, illustrated as a crosshatched surface containing two salmon. A decorative frog peers out between Raven's ears and supports the segmented tiers of the top of a chief's dance hat. At the very top is Raven holding the moon in his bill (Swanton 1905:125).

In addition to creating models of houses and poles, Edenshaw was prepared to carve masks. Since Swanton wrote to Boas at one point (May 12, 1901) that the meaning of most masks seems to have been forgotten on the Queen Charlottes, this would have been especially useful in his efforts to obtain complete and accurate information on a mask.[14] In a letter written after he had returned from the field (May 31, 1902), Swanton informed Boas that Edenshaw was willing to make a mask for the American Museum. Boas responded enthusiastically (November 8, 1902), allocating $100 for the commission: "I leave the details of arrangement with Edenshaw to your judgement. Of course you will make it a fundamental condition that we must have the full explanation and if possible the accompanying song for each mask he makes for us."[15]

Once Swanton assumed his position at the Smithsonian, where he would remain for the rest of his life, he began to write the monograph *Contributions to the Ethnology of the Haida*, to be published as volume 5 of the Jesup North Pacific Expedition Memoirs (1905). As he worked on this book, he received suggestions from Boas on what should be included. For example, in a letter of February 13, 1903, Boas stated, "we have in the Museum a model of a shaman's grave, showing the corner posts and the shaman himself lying down, with nose-ornament and other objects in

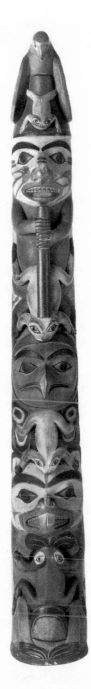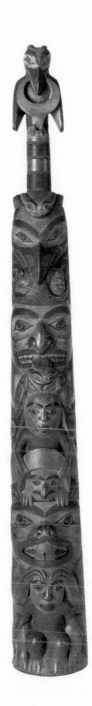

Figure 6. Wooden totem poles by Edenshaw, carved in 1901. Photograph by D. Finnan. (Courtesy American Museum of Natural History; left: 16/8768, right: 16/8767)

the grave. Do you think we might illustrate it?" The grimacing face and the skeletal body give this piece a more dramatic quality than one usually associates with Haida art. Swanton consented to publish this piece that had been carved for sale by the Haida artist Gwaytihl and collected by Israel Powell in 1882 (see Holm 1981:176), but not without some reservation, as one surmises from his comments in the text (1905:133–34):

> The Haida [shamans'] graves I myself have seen had similar carvings on the front posts, although differing in details. The bodies appear, however, to have been set up higher, with the knees drawn up close to the body. At any rate, the distance between the carved posts was very much less, so that the measurement from front to rear was greater proportionately.

Boas also asked Swanton to include in the book the blanket border designs he had asked Charles Edenshaw to draw in 1897 (fig. 7). The uppermost design, not drawn by Edenshaw, illustrates a sea grizzly bear, the next a hummingbird, the third a raven, and the fourth a beaver above a row of frogs. Swanton agreed to include these illustrations, but once again he qualified their accuracy (p. 143):

> All of these except fig. 1 of Plate XXIII are from crayon drawings made for Professor Boas by Charlie Edenshaw of Masset in 1897. The designs are probably too wide as compared to their length. Fig. 1 of Plate XXIII is taken from a real blanket of the Haida, and shows the approximate proportions of the designs, which run down the front edges of the blanket.

Although Swanton found it necessary to offer an explanation of this "new" Haida art published in his book, he did not do the same for the illustrations of model totem poles that he used abundantly as examples of crest art. He published only five archival photographs (plates IX–XII), taken in the late 1870s and early 1880s by photographers including O. C. Hastings, Richard Maynard, and Edward Dossetter (such as fig. 8, which illustrates the Monster House in Masset; he doubtless had access to many more photographs, since the Dossetter prints were in the possession of the American Museum), five drawings of full-scale poles and house posts, and illustrations of nineteen models, including the Kiusta house model. The two artists who made these models were Charles Edenshaw of Masset and John Robson of Skidegate.

Nowhere in the text does Swanton explicitly question the accuracy of

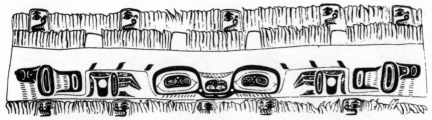

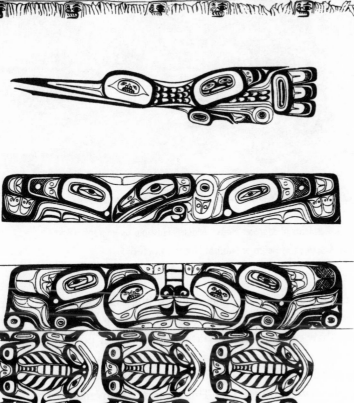

Figure 7. Haida blanket border (top) and Edenshaw drawing of Haida blanket borders (other three). From Swanton (1905), pl. XXIII, nos. 1–4

these models, most of which he describes as copies of poles that once stood in specific villages before certain named individuals' houses. His treatment of these models differs in no way from that of the drawings of genuine poles; in each case he identifies the object's owner, town, and the images depicted. It is interesting that in his 1927 publication *Primitive Art*, Boas also uses six model totem poles as examples of Northwest Coast style and symbolism, apparently concurring with Swanton as to their

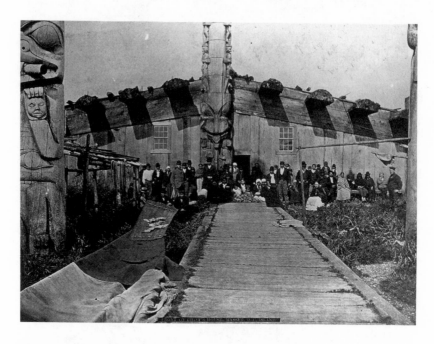

Figure 8. *Residents of Monster House, Masset. Hastings photograph, 1879.*
(Courtesy American Museum of Natural History, 334106)

accuracy and authenticity.[16] Despite this, it is worth noting that Swanton
does comment that the model in Plate III, fig. 3 (fig. 5), one he specifies as
an Edenshaw carving, "is not said to represent any pole actually put up,
but it was recognized as one that might have been used by Xotes, a chief
of Those-born-at-Skedans . . . the design being evidently considered his
property" (Swanton 1905:125). This is genuinely invented art.

What motivated Boas and Swanton to have these models made de-
spite Boas's clear concern for age and authenticity of objects? In the late
nineteenth and early twentieth centuries, models—both miniature and
full scale—were an accepted feature of museum exhibitions (Hinsley
1981:112; Hinsley and Holm 1976).[17] Boas had overseen the design and
production of numerous models, including that of "a Kwakiutl village,
scale ½" to 1 foot," based on a photograph of Newitti, as well as the figure-
group illustrating the use of cedar on the Northwest Coast (Jacknis 1984).
The model totem poles and houses under discussion here can be con-
sidered part of a larger effort on the part of the museum to illustrate as
clearly as possible the type of art produced by a remote people.

Even more important as a motivation for having these models made

was the pursuit of scientific accuracy, which shaped most of Boas's collecting activities and museum displays. Describing the Jesup Expedition to colleague George Dawson in 1899, Boas said (Jacknis 1985:89):

> The work which we are carrying on is by no means primarily collecting, but it is our object to carry on a thorough investigation of the area in which we are working. The specimens which we obtain are not collected by any means from the point of view of making an attractive exhibit, but primarily as material for a thorough study of the ethnography and archaeology of the region.

For Boas, it was the art object, coupled with its explanation, that provided the desired accurate and authentic ethnographic information.

Boas and Swanton both apparently had faith that Edenshaw and the others they commissioned would produce the kind of useful visual information that would enhance the scientific validity of their collections as well as their ethnographic writings.[18] It seems that few totem poles with verifiable stories still remained on the Queen Charlottes. The handsome old photographs were less valuable as scientific documents than the re-created poles, since the photographs did not come with explanations associated with the objects they illustrated. We can assume that Boas and Swanton believed it better to ask a trustworthy Native artist who knew enough about his own culture to recreate it than to attempt to interpret material the significance of which was forgotten, regardless of its age and authenticity. It is useful to point out that by being displayed at the American Museum and published in works such as *Contributions to the Ethnology of the Haida* and *Primitive Art*, Edenshaw's carvings became the model for this art rather than simply models of it. His artworks became validated, so to speak, by their appearance in scholarly publications, and established the norm for the style, even among later Native carvers.[19]

The Classification of Museums

Thus far we have described the initial elements of our investigation—the art objects themselves. To understand the significance of Haida art at the American Museum of Natural History, one must first situate the ethnographic museum in a context relative to other cultural institutions at the turn of the century, for it is by comparing it to the art museum on the one hand and the world's fair on the other that its social role comes most clearly into focus.

Figure 9. *Northwest Coast Indian canoe at the American Museum of Natural History in or about 1883, suspended from the ceiling above the bird collections.*
(Courtesy American Museum of Natural History, 487)

The purviews of cultural institutions were not always as clearly defined as they are today. Earlier in the nineteenth century, museums often lumped everything together; as Paul DiMaggio (1982a:34) put it: "Museums were modelled on Barnum's . . . : fine art was interspersed among such curiosities as bearded women and mutant animals." This sort of promiscuous association of unlike things is evident in the first displays at the American Museum, where as late as the 1880s the Northwest Coast canoe hung from the ceiling in line with a skeleton of a right whale, suspended above cases filled with stuffed birds (fig. 9). As time went on, ethnic art became separate from zoology within institutions like the American Museum, just as fine art became distinct from the popular variety.

By the late nineteenth century, different institutions were assuming responsibility for the presentation, dissemination, and creation of culture. Although the lines of separation among these institutions were often quite fuzzy, they do reveal a hierarchy of social validation that functions on the continuum from popular to exclusive: world's fairs, natural history

museums, fine arts museums. Although the audiences to whom these institutions directed their efforts came from different segments of society, whenever possible their institutionally specific messages stressed the superiority of the metropolitan ruling class and the correctness of its values. This could be done by entertainment at fairs, by education at natural science museums, and by selectivity at fine arts museums.

On one end of the continuum were the world's fairs attended by over 100 million people at the turn of the century (Rydell 1984:2). In his fascinating study of American expositions between 1876 and 1916, Robert Rydell (1984) describes how these institutions promoted, through their quasi-educational role, the values and ideas of the American ruling class, and offered the masses the "proper" interpretation of the question of race. These fairs were celebrations of progress (the source of capitalistic success), with a subtheme suggesting the racial superiority of the white progressors. They were suffused with an aura of scientific legitimacy but in effect were often combinations of wild west shows and circuses. At these events, displays of Native American art were complemented by displays of actual Indians, who lived in traditional houses and performed traditional ceremonies for the duration of the fair.[20] The Smithsonian Institution, responsible for much of the anthropological material presented at these fairs, buttressed "the legitimacy of the utopian artifacts created by the directors of the fairs. The fairs certainly popularized anthropological findings, and the science of man that reached the fair-going public had a distinct hierarchical message and served a hegemonic function" (Rydell 1984:7–8).

At the other end of the continuum were art museums. In the nineteenth century, paintings and sculptures served the purposes of the philanthropists who founded the art museums in several ways. Like the other art museums in this country founded in the 1870s in Boston, Philadelphia, and Chicago, the Metropolitan Museum of Art was established and supported by an urban elite eager to associate their power and wealth with beautiful European objects. As Alan Trachtenberg, in The Incorporation of America (1982:144–45), puts it: "The splendor of the museums conveyed an idea of art as public magnificence, available in hushed corridors through a corresponding act of munificence by private wealth. European and classical masterpieces epitomized the highest, purest art. Thus, museums established as a physical fact the notion that culture filtered downward from a distant past, from overseas, from the sacred founts of wealth and private power." These museums also managed to convey the assumption

that the patrons—largely Anglo-Saxon patricians—were more closely in touch with that admired European culture than were the Italians who had recently arrived in the United States![21]

The European art displayed in American museums served another purpose besides symbolizing the aristocratic pretensions of the monied classes. In a nation seemingly more and more disorderly as a result of immigration, labor unrest, and urbanization, the rich believed that institutions such as art museums could help preserve a sense of order and reinforce their social values. To them, art could express moral and spiritual ideals, thus transcending brutish material reality. Blessed with such capabilities, artworks could somehow dispose viewers with the inclination toward social harmony. In 1869 in *Culture and Anarchy: An Essay in Political and Social Criticism*, Matthew Arnold had written that educated men who truly understood art, and thus engaged in "a pursuit of our total perfection by means of getting to know, on all the matters which most concern us, the best which has been thought and said in the world," could redeem the remainder of society with their higher values (Horowitz 1976:3–7, 19).

In addition to providing this ephemeral spiritual model accessible only to the most learned citizens, art museums also served the more mundane, but equally significant, function of separating social classes. When the wealthy citizens of various American cities founded their art museums in the last quarter of the nineteenth century, they included some reference to public education in the charter. This reflected their expectation that the morally uplifting powers of these halls would help civilize the less educated visitors who were members of the laboring classes. By the beginning of the twentieth century, the goal of educating the immigrant in this way had been dropped. Indeed, at that time, art museums had been redefined as preservers of aesthetic virtues which the lower classes were incapable of understanding or appreciating. As the increasingly exclusive art museums became less accessible to the population at large, they became less interested in "education" and more in connoisseurship. "Fine" art, now distinguished in every way possible from popular art, ended up separating the upper class from other members of the social hierarchy, and fine art museums became symbolic expressions of the uniquely cultured elite's hegemony over the lower classes (DiMaggio 1982a, 1982b).[22]

Somewhat more accessible to the public, but also functioning in an ennobling and purifying way to counter the pervasive materialism of American society, was science. For some of the more idealistic philanthropists, scholarship and scientific research—for its own sake, not for economic

gain—were excellent means to exert an elevating influence on the popu-
lation (Horowitz 1976:25, 82). In theory at least, science, with its orderly
and systematic representation of the world, could be the sanctuary of the
ideal and transcendent, reflecting the beneficent natural law with its tacit
Darwinian affirmation of the worldly increases of the highly evolved elite.
The institutions that most effectively harbored, protected, and perpetu-
ated the sanctification of science and research in general were, of course,
the universities.[23]

Natural history museums had a scientific function related to that of
research-oriented institutions but also distinct from it. While universities
were engaged in the discovery of truth, museums were charged with dis-
seminating existing knowledge (Horowitz 1976:106). Indeed, despite any
such intentions of founding trustees, original research was not the central
concern of natural history museums, which for the most part viewed their
mission as educational. What mainly distinguished the natural history
museums from art museums at the turn of the century was the audience
to whom they were expected to impart knowledge—the noneducated
classes, especially immigrants. And it was the clearer and more explicit
connection with science, and the greater respectability that resulted from
this connection, that differentiated the natural history museums from the
fairs, which were also expected to educate people but in a rather more
entertaining fashion.

Education and the American Museum of Natural History

The ever more significant role of education at natural
history museums during the Progressive period is clearly evident in the
history of the American Museum. As Ira Jacknis (1985) has shown, the
museum's administration had become most unsympathetic to scientific
research, a stand that ultimately led to Boas's resignation from the insti-
tution and assumption of a full-time position at Columbia University. In
1905, the institution's director, Hermon Bumpus, asserted that "field ex-
peditions of the Museum must not be carried on for scientific purposes,
but only to fill gaps in the exhibition. . . . if accidental scientific results
can be had, they are acceptable, but . . . they must not be the object of
field-work" (Jacknis 1985:89).[24] Bumpus and President Jesup wanted clear
and easily understood exhibits that functioned primarily as educational
devices for the young and the uneducated.

Boas was more interested in doing research than promoting educa-

tional displays and found the new direction of the American Museum discouraging. He ultimately concluded that museums were not useful for scientific pursuits, and presented this opinion in his 1907 article, "Some Principles of Museum Administration," where he says that the museum was primarily successful at entertaining, and far less effective in education and research. Indeed, he thought that museums were useless for anything more than healthy and stimulating entertainment of the masses, and could not properly communicate scientific information about different cultures, because objects themselves are limited in the information they contain: "The psychological as well as the historical relations of cultures, which are the only objects of anthropological inquiry, can not be expressed by any arrangement based on so small a portion of the manifestation of ethnic life as is presented by specimens"; for this reason, "anthropological collections should be treated like collections of artistic industry and art collections rather than like collections illustrating natural sciences" (p. 928; see also Jacknis 1985).

At the turn of the century, it was believed by many white Anglo-Saxon Protestants that the most effective way to socialize the masses of newly arrived eastern and southern European immigrants in the "American way" was through education, both formally in the schools and informally through museum exhibitions (Brandauer 1988). As these immigrants flooded into the New York City slums, the Board of Education wrested school control from the neighborhood leaders, centralized it, and gave it to the urban elite. Under the guise of a more efficient, expert, nonpartisan system of education, this centralization allowed the white Anglo-Saxon upper class and upper middle class to determine the curriculum of the schools—the goal of which was to create obedient and loyal workers out of immigrant children. Textbooks written for this purpose instructed these foreigners on cleanliness, hard work, and proper manners. They described the goal toward which all should strive: to become like white, Anglo-Saxon Protestants.[25]

Part of the Progressivist ideology was to ensure that people no longer in school, particularly the immigrants, would have access to continuing education, and that was one role the American Museum could play expertly. In his report to the Dresden Museum, A. B. Meyer commented that of the twelve departments of the American Museum, "the department of public education stands at the head of the list, a circumstance which indicates the main object of the museum" (Meyer 1903:327). In 1909 the American Museum president, Henry Fairfield Osborn, wrote to a colleague:

"Theodore Roosevelt told me recently that he thinks the most important task before us is to properly educate these new Americans. He considers the Museum a vital agent in this work" (Jonaitis 1988:218). Since the "art" museum was turning its back on the lower classes in an attempt to reinforce the cultural superiority of the ruling class, the "science" museum thrust full speed ahead to perform a socially useful function that those men of wealth desired. In a sense, art became a sanctuary, while science became a civilizing force.

When in 1900 the museum opened its public auditorium, a series of talks by various notables described the climate of that time. The New York City controller, Bird S. Coler, praised the supplementary lecture system offered by the museum, which gave the 90 percent of New York City inhabitants who left school at fifteen "a chance to get ahead and make something of themselves in the world" (American Museum of Natural History 1900:40–41). A representative from the Board of Education, Supervisor of Lectures H. M. Leipziger, praised the wholesome recreation afforded by the museum, and suggested that the spread of scientific knowledge provided an "antidote against life's sorrows and a strengthening against temptations." Then he went on to compare the city's culture with that of the country the United States had so recently defeated in the Spanish-American war: "The character of our pleasure is an index of our culture and our civilization. . . . A nation whose favorite pastime is the bull fight is hardly on a plane with one that finds pleasure in the lyceum hall" (p. 42).

Native American Art at the American Museum

Although it is relatively easy to understand the educational function of museum displays of the natural environment of the surrounding region, it is somewhat less obvious what an immigrant in New York would have gained from looking at a display of Indians living thousands of miles away. To be sure, the notion that "knowledge is good" was certainly at work here, but Native American art played a particular educational role in this and other natural history museums. Somewhere between the European masterpieces at fine arts museums and the tidy lineups of rocks, fossils, and stuffed animals at natural history institutions were the artworks of recently colonized peoples. Since the "beautiful" was reserved for art museums, and the genuinely scientific for universities, Indian art at the American Museum, and other such institutions, held a precarious, almost liminal position.[26] At the turn of the century,

few would have credited Native American objects with encouraging an aesthetic or a scientific transcendental experience, or with providing the kind of reinforcement of social status that Renaissance painting afforded the elite.[27] Instead, the art in the ethnographic section of any European or American natural history museum served a significantly different purpose: to mediate between those remote peoples from exotic lands and the far more evolved whites who had colonized them. In the United States, those "remote peoples" were, of course, primarily Native Americans.

Anthropological displays in American natural history museums followed their European prototypes in presenting to the public materials from those peoples who inhabited their newly acquired territories. The museum thus became a monument to the nation's successful expansionist movement which enhanced the country's political powers while bolstering its economic prosperity (Frese 1960:12). In addition, the way natural history museum curators exhibited primitive art communicated—sometimes overtly, sometimes subtly—the superiority of white culture over the colonized natives. Like fine arts institutions, science museums symbolized the upper class's superior position: at the art museums the elite were shown as superior to other citizens of their city; at the natural history museums, this same stratum became members of an international elite who dominated the inhabitants of the colonized globe.

But more was communicated in natural history museums than the relatively overt expression of dominance and subservience. A subtle process occurred during which Indian culture itself, not just the artifacts produced within that culture, became a museum piece, a thing to be preserved. At the turn of the century it was widely believed that Native American culture was rapidly disappearing, and that every effort should be made to record whatever vestiges were left. As a consequence, ethnologists frequently ignored the contemporary culture of the people they visited in attempting to reconstruct what had been lost.

As Margaret Blackman (1981:2) observes, Swanton described a precontact Haida without mentioning their early twentieth-century towns, their clothes, or their customs.[28] His publications not only present a "traditional" culture he did not see but also illustrate some "traditional" art he had commissioned for the occasion. This self-conscious recreation of Haida culture and art, presented in museum displays as "authentic," although designed by Swanton and Boas to promote scientific understanding of Indians, contributed to a mythic notion of a never-changing group of Indians who would eventually die out. Boas and Swanton un-

knowingly contributed to this creation of a mythic entity, the timeless Northwest Coast Indian who had lived during the Indian golden age. Indeed, many museums at that time tried in their exhibits to depict a precontact group, at the "height" of its cultural flourishing, captured at a moment that would soon be lost in time. Preserved in museum displays as well as books were manifestations of an earlier time when "Indians were Indians," unspoiled by the taints of white culture.[29]

The image created and perpetuated at the turn of the century by museums (as well as by popular and scientific thought) of the unchanging Indian whose culture had flourished in the recent past but who would soon disappear must be understood in the context of the Victorian notion of material progress, so closely linked with moral virtue in the minds of white Anglo-Saxon Protestants of the era. It was a common belief that America's economic growth and greatness were due in large measure to its technological achievements. Andrew Carnegie in 1886 wrote: "The old nations of the earth creep on at a snail's pace; the Republic thunders past with the rush of the express." Interpreting this quote, historian T. Jackson Lears (1981:8) states:

> Carnegie [here] revealed a major foundation of the belief in progress: the idea that nations (like individuals) can never stand still. They must always be growing, changing, improving their material lot; life is a race to be won by the swiftest. . . . This notion . . . accounts for the relentless dynamism at the heart of capitalist development, spreading an obsessive need for change throughout modern culture. And for the most educated and affluent Americans in the late nineteenth century, "change" meant "progress."

It was clearly agreed by many that only white cultures evolved and developed; primitive cultures had no history and did not change, except in the direction of total demise (see Dominguez 1987:135). Art made before contact was genuine and authentic; art that gave evidence of external influence from whites was less "Indian" and thus inconsequential. Ethnographic museums unwittingly contributed to the perceived destruction of Native American societies by perpetuating this myth, rather than admitting that Indians, like whites, had a history manifested by internal changes that did not necessarily signify destruction. Swanton and Boas made serious efforts to "capture" Haida artwork by having Edenshaw reconstruct his past reality (see Dominguez 1986:550). How often do we hear it suggested that we capture the artistic reality of, say, Rembrandt and freeze his

paintings in time, allowing them neither influence nor historical process? Unlike the timeless and eternal primitive artist whose cultural demise was celebrated by some, mourned by others, but accepted by all, Rembrandt was part of an ongoing, forward-moving tradition that allowed for his predecessors to exert influence on him, and for him to exert influence on his successors.

Boas did recognize that a history of Northwest Coast art existed, and actually used such historical reconstructions of contacts, influences, and exchanges among the various ethnic groups to argue against evolutionism (see Jonaitis, in press). His art historical studies ceased, however, when whites began settling on the Northwest Coast.[30] As Jonathan King (1986:76–78) points out, the notion of "traditional" is a value-laden judgment reflecting stereotypes about Indians untouched by Western society. This concern for authenticity and purity is particularly ironic when one realizes that it is precisely white progress, so universally admired in other contexts, that caused the tainting so mourned. Moreover, a contradiction exists that suits the interests of the ruling classes: an Indian people are seen as being unable to progress and change because of their very nature; if they do progress and change by selective (or even nonselective) assimilation of elements of white culture, they become unacceptable as Indians.[31]

The Viewer

The American Museum of Natural History at the time of this study believed its mission to be education. Although its audience consisted of Americans from all classes, including the educated and monied, it was especially concerned with improving the intellectual level of newcomers to New York. It displayed artworks, despite the desire of Boas and Swanton for scientific accuracy, that represented a fragmentary picture of an invented culture, supposedly caught in time in its golden age. We have thus far studied the object, its creator, the patrons of its creator, and the institution that presented it to the New York City public. Now it is time to speculate on the experience of the viewer about whose education the American Museum was so concerned. Unfortunately, we have no record of any immigrant's responses to the American Museum's displays; we can only hypothesize possible responses.

Let us imagine a recent New York City immigrant, say a young woman, entering the American Museum of Natural History in the first decade of

this century to spend a day off by taking advantage of the illumination and uplift the institution so explicitly wished to provide. She comes by the elevated train from one of the city's neighborhoods, perhaps the Lower East Side, or Williamsburg, getting off the train in an upper-class community of town houses and large, ornate apartment buildings. The American Museum of Natural History, with its elegant facade and sweeping story-high external staircases, its high ceilings and vast interior spaces, sends a clear message: this is an important institution, one built from power and wealth. Whatever it contains must be important. The building and the institution it symbolizes (and this symbol includes the power and wealth of the trustees as well as that of the great nation itself whose name graces the museum) "wraps" the Haida art displayed in its North Pacific Hall.[32]

This large, impressive structure influences in different ways the Indian art it enfolds. It communicates not only that the art it holds is important but that the message transmitted to the viewer about that art is important. Probably the most important message concerns the notion of progress, or lack of it. Here the immigrant observes a culture out of time—one that had not embraced, as indeed her own European society is not embracing, the values and concerns of progress that the dominant white Anglo-Saxons put forth as the only values one should have. The Haidas had been demolished by the course of history, and now existed entirely within the context of this dominating institution, just as the ethnic identity of the immigrant should become a thing of the past, a human museum piece, so to speak, crafted from the best ethnic parts encased in the new American life where, above all, success and achievement are to be honored.

Among the other examples of Haida art she views are Edenshaw's carvings, newly created and pristine representations of an extinct culture. Neither decaying nor situated in the context of an abandoned village, these models both shield the viewer from the sad reality of a disintegrated culture and expiate the American leadership from any responsibility for destroying these societies, because the display includes no reference to the moment of Indian history when the white man came along. Although but a fragment of Haida reality, and a reconstructed one at that, these carvings are intended, and are accepted unquestioningly, as a means of making the foreign and exotic understandable.[33] Created by an artist whose originality and creativity have been noted by many, these are by no means "traditional" Haida pieces but white-sponsored recreations of the art Boas and Swanton thought should have been authentic. These are pieces made by a man whose carving embodies subtle but significant stylistic and nar-

rative differences from the art made by his ancestors and contemporaries. These poles and models are certainly different from Western artworks the typical viewer might have been familiar with, but because these are works by a native carver profoundly influenced by whites, they are not quite so exotic and inaccessible as they might have been had a more "traditional" carver made them.

Thus these displays became a filter through which the viewer saw and understood Haida culture. It is not irrelevant that this art is miniaturized.[34] Such reduction in scale renders large and bewildering monuments quite comprehensible. Miniatures also serve another purpose that Boas certainly would not have appreciated: they make small and doll-like the real-life cultures of others. Encased within such large and impressive institutions, these miniatures send forth this message: the culture of the whites who have built this institution is strong and powerful, far more so since it can render other cultures so insignificant.[35] Indeed, these small models of houses and totem poles seem so tiny compared with the hushed, magnificent corridors and baroque decorations of the museum building itself. As Stephen Tyler puts it (1986:131), "to represent means to have a kind of magical power over appearances, to be able to bring into presence what is absent. . . ." Thus, sympathetic as Boas and Swanton were, that very process of recreation under the tutelage of whites—the creation of a transformed reality meant to be displayed to New Yorkers—was one of power wielding.

Even the full-scale objects lose their monumentality in the context of the exhibition hall. Large pieces, such as bowls and statues, appear caged within glass cases, captured like wild animals in zoos. A specific instance of destruction of monumentality occurred at the American Museum at the turn of the century when an especially tall Haida pole was cut into three sections, ostensibly because no space in the museum was large enough to hold it. These three sections ended up lining the hall, fitting nicely into its design and working well with the other posts. Figure 10 shows the hall as it appeared in 1910; the lowermost third of this pole is in the middle of the photograph, while the uppermost third is to its right. The American Museum, probably quite unintentionally, but literally as well as symbolically, had tailored the integrity of the culture it was supposedly preserving. How unlikely it would have been for any Western art museum to cut up some monumental painting in order to have it "fit" into the institution's space.

The museum visitor could see, by observing the accessible Edenshaws

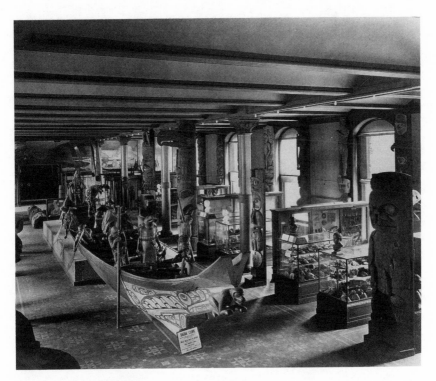

Figure 10. The Northwest Coast Indian Hall at the American Museum
of Natural History, c. 1910.
(Courtesy American Museum of Natural History, 33003)

as well as older pieces, the representation of an Indian golden age within
the context of the vast monumentality of the institution itself. The visitor
could also see that this Northwest Coast society that did not go anywhere
was now dominated, controlled, and made insignificant by that group of
American leaders that one ought to admire, respect, support, and emu-
late. In this process of "wrapping," the dominant culture has taken a
smaller one and presented it in a context in which that culture is now
validated by the dominant one, whose values that informed the domina-
tion itself are thus reinforced. An associated message comes across clearly
in all this: the reason for the lack of progress of these people—and the
ease with which they could be subjected—was that they were inferior,
perhaps racially so. In contrast, the observer might contemplate the natu-
ral superiority of the American elite, to whom gratitude was owed for the
achievements of the United States.

Of course, there was one problem with this: the subject of the educa-

tional process at the museum was the immigrant, who was lower on the evolutionary ladder than the white Anglo-Saxon Protestant leadership. There existed an internal contradiction within this message that pointed to the broader question of the significance and roles of non-WASPs in American society, and the continued interplay between leaders and led. The natural history museum defined the current beliefs on the relationships between the dominant society and Indians, and by extension between the dominant society and those who were not members of the ruling class. By entering an institution such as the American Museum, the individual might learn to accept the prevailing cultural definitions of race and class. The act of entering this museum was significant in that it represented a choice made by an individual: our young woman immigrant was not attempting to be accepted by an institution such as an art museum, which excluded her anyway, or seeking entertainment by joining the masses at a fair. Here she could join the upwardly mobile members of her class as they strove to use education to enter the American mainstream.[36]

Postscript

The Edenshaw models did not remain on permanent display at the American Museum of Natural History throughout the twentieth century. Over the decades that followed Boas's departure in 1905, successors removed objects from the Northwest Coast Hall to reduce what they saw as cluttered displays. As a result, neither the commissioned house model nor the model totem poles are on exhibit; they are kept in Anthropology storage, available to scholars but not to the public. It is possible that when the Northwest Coast displays are renovated, these Edenshaw models will be exhibited. Instead of being represented as authentic illustrations of Native culture, they will be shown as the products of a certain historical period, the creations of a talented Haida artist who responded to the requests of two white anthropologists.

In this essay, I have analyzed Northwest Coast art, in particular the Haida art reinvented by Charles Edenshaw, as an element in a multifaceted process that altered the art itself in a manner that Franz Boas and John Swanton could not possibly have imagined. But the story of Northwest Coast art and its interpretation does not end in the early twentieth century; indeed, the story never ends. There is never a final reading to the text of Haida art, which continues to be subjected to changing interpre-

tations by different audiences, for new social and political purposes.[37] Although always at the core of the new text are the elegant and masterfully carved totem poles and house models by Charles Edenshaw, more and more "wrapping" covers them, continually changing the art. Certainly their future presentation as historic documents of a particular period in American anthropology and museology will alter the models. This never-ceasing process prevents these artworks from stagnating—as they never did anyway—in some invented and mythic golden age.

NOTES

An early version of this paper was presented at the College Art Association Meeting in Houston, February 1988. I would like to thank Cecelia Klein, chair of the session "Institutions and the Aestheticization of 'Primitive Art,' 1897–1950," who gave me the opportunity to share these ideas with colleagues. A later version was presented at the conference "Culturas del Noroeste," sponsored by the Comision Nacional Quinto Centario in Madrid, July 1988. I would like to thank the Comision and my colleagues at the conference for their interesting comments on this paper. Finally, I would also like to thank Stanley A. Freed, Wayne Suttles, Alan Hoover, and Janet Catherine Berlo for their careful reading of the manuscript.

1. See Lears (1985) for further discussion on the theme of hegemony. See Bennett (1988) for a discussion of ruling-class cultural authority and the museum.

2. See also Resaldo (1989) and Geertz (1988) for more on this theme. McGrane (1989) and Kuper (1988) offer interesting historical analyses of these changes in ethnographic description. For compelling criticisms of some of these new approaches in anthropology, see Mascia-Lees et al. (1989) and Kapferer (1988).

3. Handler (1985:194), in the same book, poses a similar question. In the process of preserving material culture, institutions both fetishize that culture and make a statement about whose heritage is actually being preserved.

4. Ralph T. Coe's exhibition and catalogue, Lost and Found Traditions (1986), addresses the mistaken notion that American Indian cultures and artforms have vanished. Virginia Dominguez (1986) addresses the issue of the urgency of retrieving ethnographic art.

5. Native peoples have begun to object as well to the pursuit of the "traditional" that denies the contemporary Indian authenticity as a Native person. See Doxtator (1988) and Hill (1988).

6. See Durrans (1988) and Ames (1986) for interesting suggestions on how future museums might represent the "other." See also Jonaitis (1991).

7. Jameson's public lecture to the SUNY Stony Brook Humanities Institute, "Spatial Equivalents: Post-Modern Architecture and the World Systems," presented his ideas on "wrapping" in the context of a house built in the 1950s that an architect partly enveloped with new materials and new forms, creating a new building without dismissing or destroying the old one.

8. Diana Fane (1987) has recently presented several papers that discuss an analogous situation at the Brooklyn Museum, where Stewart Culin and Frank Cushing displayed several replicas of southwestern Indian art, some of which had been made by Cushing himself.

9. Boas also used art historical analyses to dispute the social Darwinism so prevalent at that time. See Jonaitis (in press) for more on this.

10. All correspondence quoted here can be found in the Anthropology Department Archives, American Museum of Natural History.

11. The Haida were not the only artists commissioned to create art for museums; Adrien Jacobsen asked "the most renowned wood carver among the Bella Bella" to make the chief's seat now in the Berlin Museum (Jacobsen 1977:26; Holm 1981:176).

12. Boas also asked Swanton to obtain information on the meaning and function of the raven rattle, as well as the difference between it and the globular rattle. In a letter of December 4, 1900, Swanton wrote that according to his informant, the original raven rattle was imported from the Nass River, and copies of the imported version made for later use. Nothing was known any more on the figures that populate the instruments, which were mainly used by chiefs. The globular variety was used by shamans, and the figures on these instruments represent the power of their owners.

13. Fillip Jacobsen, collecting for Boas on the west coast of Vancouver Island, also was instructed to collect traditional items (May 6, 1897). In Jacobsen's response to this, he also pointed out that he was "getting a few house models made" as well (June 22, 1897).

14. Swanton refers to the difficulty of identifying the meaning of masks in his statement in the AMNH Memoirs, "Of the scores of masks taken from the island, only one or a very few are satisfactorily identified. About others there is considerable difference of opinion" (1905:144).

15. Charles Edenshaw apparently also carved a mask modeled after one belonging to his uncle, Chief Albert Edenshaw; it is now in the Pitt Rivers Museum in Oxford, England (Swanton 1905:fig. 20).

16. These include figs. 206, 217, 235, 236, 237, and 245.

17. The Haida had also had a tradition of miniature-making in their argillite carvings which were made for sale to whites, who purchased them as curios. See Wright (1982), Sheehan (1981), Macnair and Hoover (1984).

18. This faith in Edenshaw's knowledge was not unquestioning. In his book, Primitive Art (1927:275), Boas describes Edenshaw's explanation of a box as "entirely fanciful."

19. Both Bill Reid and Robert Davidson, the most distinguished Haida carvers living today, credit Edenshaw as having been a major artistic inspiration (Shadbolt, 1986; Davidson, pers. comm., 1987).

20. At some fairs were other ethnological villages that housed peoples from Africa, Asia, and the Pacific. The prototype of such villages was the very popular one presented at the 1889 Paris Exhibition. See Rydell (1984) for more on these.

21. See Williams (1966) for more on how the refinements of art and culture were responses to the perceived vulgarities of modern society.

22. See Morton (1988:133–35) for a discussion of the hierarchical valuations of art and science museums.

23. An analysis of the role of the university, fascinating as it would be in this context, is beyond the scope of our discussion. For some insights into the relation between education and class structure in America, see Bowles and Gintes (1976) and Clark (1962).

24. This strong statement must be understood in the context of a serious clash of wills between Boas and Bumpus, which Ira Jacknis describes in his 1985 article.

25. For more on education in New York City at this time, see Cohen and Lazerson (1977:380–382), Carnoy (1974:245–46), and Tyack (1977:400–404).

26. Despite this general rule, science was occasionally called upon to justify ethnographic collecting. The responses of Frederic Ward Putnam, curator of the Peabody Museum of American Archaeology and Ethnology, to the disdain of several members of the Boston elite who questioned the "worthiness" of primitive culture and its lack of artistic qualities, was that his museum did not intend to display art, but to present the science of ethnology (Hinsley 1985:51–55).

27. James Clifford's (1985:242) distinction between a museum of art and a museum of ethnography is interesting in this context. According to him, in the art museum the place of the object in everyday life is irrelevant and its individualistic, original, and "beautiful" qualities are highlighted; in the ethnographic museum a sculpture, made by an unknown artist, is presented alongside other, often utilitarian artifacts from the same people and is "meant to be interesting."

28. McDonald (1984) demonstrates how Tsimshian ethnographies of the nineteenth century ignored the reality of this people's contacts with white society during this period. I am indebted to Alan Hoover for bringing this essay to my attention.

29. See Eric Wolf's Europe and the People Without History (1982) for more on the tendency of whites to describe the "other" as being without history. See Clifford (1986, especially pp. 109–19) on the ethnographic "golden age" concept, as well as an interesting analysis of "ethnography's disappearing object" (p. 112).

30. Of course, in recent years scholars have noted the significant influence of white culture on Northwest Coast artistic productions, such as the use of metal tools, the influx of wealth that led to more lavish ceremonialism and more art production, and the creation of certain artworks, such as argillite, explicitly for white trade.

31. For further discussion of the roles of museums in contemporary society, see MacCannell (1976), Ames (1986), and Cameron (1971).

32. See Hooper-Greenhill (1988:224–27) for a discussion of how the architecture of the museum affects the visitor.

33. See Clifford (1986:101) for an intriguing discussion of how ethnography attempts to render the different understandable to the reader by identifying similarities with his or her experience.

34. See Susan Stewart's *On Longing* (1984) for an interesting study of, among other things, miniatures.

35. See MacCannell (1976) for an interesting discussion of how museums control tradition.

36. These messages were, of course, not only heard at the American Museum, but repeated in numerous contexts including schools, places of worship, and the media.

37. See Jonaitis (1981) for an analysis of Northwest Coast art studies from 1930 to the late 1970s.

BIBLIOGRAPHY

American Museum of Natural History
 1900 *Annual Report.*
Ames, Michael M.
 1986 *Museums, the Public and Anthropology.* Vancouver: University of British Columbia Press.
Bennett, Tony
 1988 "Museums and 'The People,'" in *The Museum Time-Machine: Putting Cultures on Display*, ed. R. Lumley, pp. 63–86. London: Routledge.
Blackman, Margaret
 1976 "Creativity and Acculturation in Art, Architecture and Ceremony from the Northwest Coast," *Ethnohistory* 23:387–413.
 1981 "Windows on the Past: The Photographic Ethnohistory of the Northern and Kaigani Haida," *Canadian Ethnology Series Paper 74.*
Boas, Franz
 1907 "Some Principles of Museum Administration," *Science* 25:921–33.
 1927 *Primitive Art.* Oslo: Instituttet for Sammenlignende Kulturforskning, ser. B, 8. Cambridge: Harvard University Press.
Bowles, Samuel, and Herbert Gintes
 1976 *Schooling in Capitalist America: Educational Reform and the Conditions of Economic Life.* New York: Basic Books.
Brandauer, Aline
 1988 "Going Native: Spinden in the Brooklyn Museum." Paper presented at the College Art Association Meeting, Houston, Texas.
Cameron, Duncan
 1971 "The Museum, a Temple or the Forum," *Curator* 14:11–24.
Carnoy, Martin
 1974 *Education as Cultural Imperialism.* New York: Longman.
Clark, Burton R.
 1962 *Educating the Expert Society.* San Francisco: Chandler.
Clifford, James
 1985 "Objects and Selves: An Afterword," in *Objects and Others: Essays on Muse-*

ums and Material Culture, ed. George W. Stocking, pp. 236–46. Madison: University of Wisconsin Press.

1986 "On Ethnographic Analogy," in Writing Culture: The Poetics and Politics of Ethnography, ed. J. Clifford and George E. Marcus, pp. 98–121. Berkeley: University of California Press.

1987 "Of Other Peoples: Beyond the 'Salvage' Paradigm," in Discussions in Contemporary Culture, no. 1, ed. Hal Foster, pp. 121–30. Seattle: Bay Press.

1988 The Predicament of Culture: Twentieth-Century Ethnography, Literature, and Art. Cambridge: Harvard University Press.

Clifford, James, and George E. Marcus, eds.

1986 Writing Culture: The Poetics and Politics of Ethnography. Berkeley: University of California Press.

Coe, Ralph T.

1986 Lost and Found Traditions: Native American Art, 1965–1985. Seattle: University of Washington Press.

Cohen, Davis, and Marvin Lazerson

1977 "Education and the Corporate Order," in Power and Ideology in Education, ed. J. Karabel and A. Halsey, pp. 373–86. New York: Oxford University Press.

Cole, Douglas

1985 Captured Heritage: The Scramble for Northwest Coast Artifacts. Seattle: University of Washington Press.

Collins, Henry B.

1968 "John Reed Swanton," in International Encyclopedia of the Social Sciences, pp. 439–41. New York: Macmillan and the Free Press.

DiMaggio, Paul

1982a "Cultural Entrepreneurship in Nineteenth-century Boston: The Creation of an Organizational Base for High Culture in America," Media, Culture and Society 4:33–50.

1982b "Cultural Entrepreneurship in Nineteenth-century Boston, Part II: The Classification and Framing of American Art," Media, Culture and Society 4:303–22.

Dominguez, Virginia R.

1986 "The Marketing of Heritage," American Ethnologist 13:546–55.

1987 "Of Other Peoples: Beyond the 'Salvage' Paradigm," in Discussions in Contemporary Culture, no. 1, ed. Hal Foster, pp. 131–37. Seattle: Bay Press.

Doxtator, Deborah

1988 "The Home of Indian Culture and Other Stories in the Museum," Muse 6(3):26–28.

Duff, Wilson

1964 The Indian History of British Columbia: The Impact of the White Man. Anthropology in British Columbia, Memoir 5. Victoria: Provincial Museum of Natural History and Anthropology.

Durrans, Brian

1988 "The Future of the Other: Changing Cultures on Display in Ethno-

graphic Museums," in *The Museum Time-Machine: Putting Cultures on Display*, ed. R. Lumley, pp. 144–69. London: Routledge.

Fane, Diana

1987a Talk given at Native American Studies Association Meeting, Denver.

1987b Talk given at Columbia University Seminar in Primitive and Precolumbian Art.

Fisher, Robin

1977 *Contact and Conflict: Indian-European Relations in British Columbia, 1774–1890.* Vancouver: University of British Columbia Press.

Freed, Stanley A.

1981 "Research Pitfalls as a Result of Restoration of Museum Specimens," in *Research Potential of Anthropological Museum Collections*. Annals of the New York Academy of Sciences 376:229–45.

Frese, Herman Heinrich

1960 *Anthropology and the Public: The Role of the Museums.* Leiden: E. J. Brill.

Geertz, Clifford

1988 *Works and Lives: The Anthropologist as Author.* Stanford: Stanford University Press.

Gramsci, Antonio

1971 *Selections from the Prison Notebooks*, ed. and trans. Quintin Hoare and G. N. Smith. New York: International Publishers.

Habermas, Jurgen

1984 *The Theory of Communicative Action.* Boston: Beacon Press.

Handler, Richard

1985 "On Having a Culture: Nationalism and the Preservation of Quebec's *Patrimoine*," in *Objects and Others: Essays on Museums and Material Culture*, ed. George W. Stocking, pp. 192–217. Madison: University of Wisconsin Press.

Hill, Tom

1988 Transcript of address at "Preserving Our Heritage: A Working Conference for Museums and First Peoples. Outcomes and Recommendations. Executive Summary." Ottawa, Canada.

Hinsley, Curtis M., Jr.

1981 *Savages and Scientists: The Smithsonian Institution and the Development of American Anthropology, 1846–1910.* Washington, D.C.: Smithsonian Institution Press.

1985 "From Shell-Heaps to Stelae: Early Anthropology at the Peabody Museum," in *Objects and Others: Essays on Museums and Material Culture*, ed. George W. Stocking, pp. 49–74. Madison: University of Wisconsin Press.

Hinsley, Curtis, and Bill Holm

1976 "A Cannibal in the National Museum: The Early Career of Franz Boas in America," *American Anthropologist* 78:306–16.

Holm, Bill

1981 "Will the Real Charles Edenshaw Please Stand Up? The Problem of Attribution in Northwest Coast Indian Art," in *The World Is as Sharp as a Knife*, ed. D. Abbott, pp. 175–200. Victoria: British Columbia Provincial Museum.

Hooper-Greenhill, Eileen

1988 "Counting Visitors or Visitors Who Count?" in *The Museum Time-Machine: Putting Cultures on Display*, ed. R. Lumley, pp. 213–32. London: Routledge.

Hoover, Alan

1983 "Charles Edenshaw and the Creation of Human Beings," *American Indian Art Magazine* 8:62–67, 90.

Horowitz, Helen

1976 *Culture and the City: Cultural Philanthropy in Chicago from the 1880s to 1917.* Lexington: University Press of Kentucky.

Jacknis, Ira

1984 "Franz Boas and Photography," *Studies in Visual Communication* 10(1):2–60.

1985 "Franz Boas and Exhibits: On the Limitations of the Museum Method in Anthropology," in *Objects and Others: Essays on Museums and Material Culture*, ed. George W. Stocking, pp. 75–111. Madison: University of Wisconsin Press.

Jacobsen, Johan Adrien

1977 *Alaskan Voyage, 1881–1883: An Expedition to the Northwest Coast of America*, trans. Erna Gunther. Chicago: University of Chicago Press.

Jameson, Frederic

1991 *Postmodernism, or, the Cultural Logic of Late Capitalism.* Durham: Duke University Press.

Jonaitis, Aldona

1981 "Creations of Mystics and Philosophers: The White Man's Perceptions of Northwest Coast Indian Art from the 1930s to the Present," *American Indian Culture and Research Journal* 5(1):1–48.

1988 *From the Land of the Totem Poles: The Northwest Coast Indian Art Collection at the American Museum of Natural History.* New York and Seattle: American Museum of Natural History and University of Washington Press.

1991 "The Creation of an Exhibition," in *Chiefly Feasts: The Enduring Kwakiutl Potlatch*, ed. A. Jonaitis, pp. 20–62. Seattle: University of Washington Press.

In press "Franz Boas's Art History," in *A Wealth of Thought: Franz Boas on Native American Art.* Seattle: University of Washington Press.

Jonaitis, Aldona, and Richard Inglis

In press "Power, History and Authenticity: The Mowachaht Whaler's Washing Shrine," *South Atlantic Quarterly.*

Kapferer, Bruce

1988 "The Anthropologist as Hero: Three Exponents of Post-Modernist Anthropology," *Critique of Anthropology* 8(2):77–104.

King, J. C. H.

1986 "Tradition in Native American Art," in *The Arts of the North American Indian: Native Traditions in Evolution*, ed. Edwin L. Wade, pp. 65–92. New York: Hudson Hills Press.

Kuper, Adam

1988 *The Invention of Primitive Society.* London and New York: Routledge.

Lears, T. J. Jackson
1981 *No Place of Grace: Antimodernism and the Transformation of American Culture, 1880–1920*. New York: Pantheon Books.
1985 "The Concept of Cultural Hegemony: Problems and Possibilities," *American Historical Review* 90:567–93.
Lyotard, Jean François
1984 *The Postmodern Condition*. Minneapolis: University of Minnesota Press. Translation of 1979 work.
MacCannell, Dean
1976 *The Tourist: A New Theory of the Leisure Class*. New York: Schocken Books.
MacDonald, George
1983 *Haida Monumental Art*. Vancouver: University of British Columbia Press.
McDonald, James
1984 "Images of the Nineteenth-Century Economy of the Tsimshian," in *The Tsimshian, Images of the Past: Views for the Present*, ed. M. Seguin, pp. 40–54. Vancouver: University of British Columbia Press.
McGrane, Bernard
1989 *Beyond Anthropology: Society and the Other*. New York: Columbia University Press.
Macnair, Peter, and Alan Hoover
1984 *The Magic Leaves: A History of Argillite Carving*. Victoria: British Columbia Provincial Museum.
Macnair, Peter, Alan Hoover, and Kevin Neary
1980 *The Legacy*. Victoria: British Columbia Provincial Museum.
Mascia-Lees, Frances E., Patricia Sharpe, and Colleen Ballerino Cohen
1989 "The Postmodernist Turn in Anthropology: Cautions from a Feminist Perspective," *Signs: Journal of Women in Culture and Society* 15(1):7–33.
Meyer, A. B.
1903 "Studies in the Museums and Kindred Institutions of New York City, Albany, Buffalo, Chicago, with Notes on some European Institutions," Report of the U.S. National Museum for the Year Ending June 30, 1903, pp. 311–608.
Morton, Alan
1988 "Tomorrow's Yesterdays: Science Museums and the Future," in *The Museum Time-Machine: Putting Cultures on Display*, ed. R. Lumley, pp. 128–43. London: Routledge.
Rosaldo, Renato
1989 *Culture and Truth: The Remaking of Social Analysis*. Boston: Beacon Press.
Rydell, Robert
1984 *All the World's a Fair: Visions of Empire at American International Expositions, 1876–1916*. Chicago: University of Chicago Press.
Shadbolt, Doris
1986 *Bill Reid*. Seattle: University of Washington Press; Vancouver: Douglas & McIntyre.

Sheehan, Carol
 1981 *Pipes That Won't Smoke, Coal That Won't Burn: Haida Sculpture in Argillite.* Calgary, Alberta: Glenbow Museum.

Stewart, Susan
 1984 *On Longing: Narratives of the Miniature, the Gigantic, the Souvenir, the Collection.* Baltimore: Johns Hopkins University Press.

Stocking, George W., Jr., ed.
 1985 "Essays on Museums and Material Culture," in *Objects and Others: Essays on Museums and Material Culture,* ed. George W. Stocking, pp. 3–14. Madison: University of Wisconsin Press.

Swanton, John
 1905 *Contributions to the Ethnology of the Haida.* Jesup North Pacific Expedition 5(1). AMNH Memoirs 8:1–300. New York.
 1917 "Some Anthropological Misconceptions," *American Anthropologist* 19:459–70.

Thomas, Susan
 1967 "The Life and Work of Charles Edenshaw: A Study of Innovation." Master's thesis, University of British Columbia.

Townsend Gault, Charlotte
 1987 "The Interpretation of Kwakiutl Food Vessels." Paper given at the Native Art Studies Association of Canada, Halifax.

Trachtenberg, Alan
 1982 *The Incorporation of America: Culture and Society in the Gilded Age.* New York: Hill and Wang.

Tyack, David
 1977 "Centralization at the Turn of the Century," in *Power and Ideology in Education,* ed. J. Karabel and A. Halsey, pp. 397–411. New York: Oxford University Press.

Tyler, Stephen A.
 1986 "Post-Modern Ethnography: From Document of the Occult to Occult Document," in *Writing Culture: The Poetics and Politics of Ethnography,* ed. J. Clifford and George E. Marcus, pp. 122–40. Berkeley: University of California Press.

Williams, Raymond
 1966 *Culture and Society: 1780–1950.* New York: Harper and Row.

Wolf, Eric
 1982 *Europe and the People Without History.* Berkeley: University of California Press.

Wright, Robin
 1982 "Haida Argillite: Made for Sale," *American Indian Art Magazine* 7:48–55.

DIANA FANE

3

NEW QUESTIONS FOR

"OLD THINGS"

THE BROOKLYN MUSEUM'S

ZUNI COLLECTION

We might therefore say, begging forgiveness, that the archetypal collection is Noah's Ark, a world which is representative yet which erases its context of origin. The world of the ark is a world not of nostalgia but of anticipation. While the earth and its redundancies are destroyed, the collection maintains its integrity and boundary. Once the object is completely severed from its origin, it is possible to generate a new series, to start again within a context that is framed by the selectivity of the collector (Stewart 1984:152).

When the first exhibition of American Indian art "selected entirely with consideration of esthetic value" was organized by the Exposition of Indian Tribal Arts, Inc., in 1930, the curators looked to mu-

seum storerooms rather than to the Indian communities for the "master-pieces" that defined the regional styles and exemplified a distinctly Native aesthetic.[1] The early ethnographic collections were uncritically accepted as comprehensive inventories of lost worlds, a veritable fleet of Noah's arks.[2] By definition everything inside was old, authentic, and "other." The challenge was to separate the beautiful and the decorative from the homely and utilitarian.[3] Once this task had been accomplished, American Indian art had a history.

In giving "thousands of white Americans their first chance to see really fine Indian work exhibited as art," the curators of this exhibition, which opened in New York in 1931, also intended to give "the Indian a chance to prove himself to be not a maker of cheap curios and souvenirs, but a serious artist worthy of appreciation and capable of making a cultural con-tribution that will enrich our modern life" (Sloan and La Farge 1931:53). Museum specimens were juxtaposed with "good" contemporary arts in order to demonstrate that Indian art had a future as well as a past. Or, more accurately, that it had a future *because* it had a past. Indian art was characterized as "old, yet alive and dynamic" (p. 7). Its vitality derived from its associations with earlier, purer times. Indian artists could go for-ward only by looking backward at the models preserved, for the most part, in museums located far from the living Indian communities.

A second exhibition prepared by Frederic H. Douglas and René d'Harnoncourt for the Indian Arts and Crafts Board of the U.S. Depart-ment of the Interior and held at the Museum of Modern Art in 1941 (see Rushing, this volume) confirmed the equation of the definitive Indian artistic heritage with selected museum holdings.[4] The exhibition and the book that accompanied it were divided into three parts: Prehistoric Art, Living Traditions, and Indian Art for Modern Living. Significantly, almost all the objects in the Living Traditions section were borrowed from muse-ums, and collection dates provided the only chronology. These ranged from 1838 to 1939, with the majority clustering around the turn of the century, when the great ethnological collections were formed.[5]

The pattern established by these pioneer exhibitions for the definition of American Indian art and the construction of its history has proved to be long lasting: "Whose labor made the ark is not the question: the ques-tion is what is inside" (Stewart 1984:152). Each generation of art historians and museum curators has taken the ethnological collections as a starting point and reevaluated and reclassified the contents according to contem-porary aesthetic criteria.[6] As James Clifford has pointed out: "The salvage

paradigm, reflecting a desire to rescue 'authenticity' out of destructive change, is alive and well. It is found not only in ethnographic writing but also in the connoisseurships and collections of the art world and in a range of familiar nostalgias" (1987:121).

A first step in getting beyond the salvage paradigm is to reexamine it and consider some of the questions that have been ignored: Whose labor made the ark? How and why was it made?[7] What were the canons of selection that guided the early collectors in the field? To what totality do the terms *representative* and *comprehensive* refer? A consideration of the collecting process inevitably leads to new questions about the objects. Who were the makers, owners, and vendors, and what part did they play in the formation of the collection? What shifts in values and meanings occurred when the objects changed hands?

Stewart Culin and the Zuni Collection

The Zuni collection at The Brooklyn Museum provides a perfect opportunity to address some of these questions. Acquired in the field between 1903 and 1907 by R. Stewart Culin (1858–1929), the first curator of ethnology at Brooklyn, the collection in many ways exemplifies the attitudes and assumptions underlying the competitive and frenzied collecting activity of the Museum Age (1875–1920). Furthermore, the collection is unusual, if not unique, in the extent and detail of its documentation.[8] Each year Culin submitted a profusely illustrated typewritten report to the trustees. Written in the style of a personal travel diary with daily entries, these reports provide a fascinating record of a competitive collector's triumphs and failures in the field. They are supplemented by other kinds of institutional documentation (ledger books and catalogue cards) as well as by personal letters, photographs, and scrapbooks that came to The Brooklyn Museum as part of Culin's estate. The following account is based on this archival material, much of which has only recently been made available.[9]

The Department of Ethnology at the Brooklyn Institute of Arts and Sciences (now The Brooklyn Museum) was established in 1903 and specifically charged with representing "the works of men on the American continent exclusive of those by people of European descent who have come to America since 1492."[10] In other words, Indian things. Stewart Culin, formerly of the Free Museum of Science at the University of Pennsylvania, took up the position of curator of ethnology that same year.

Culin was no stranger to the scientific community in Brooklyn. He had lectured at the institute several times for the Department of Archaeology (subsequently subsumed by the Department of Ethnology) and had proved to be an engaging speaker.[11] Professionally, however, he was something of an enigma. Contemporary newspaper accounts referred to him variously as an ethnologist, an archaeologist, and a Chinese scholar. They also cautioned that "coming from no university, possessing no degree,"[12] he was not to be spoken of as Dr. Culin. The confusion in the press about Culin's profession and credentials in part reflects the uncertain status of museum anthropology in the first part of this century, but it also reveals something about Culin himself. He was, even for the times, a man with little formal training and remarkably broad interests.[13] The bibliography he submitted to the Brooklyn Institute with his application for the position of curator consisted of forty-three entries including such diverse topics as "Chinese Secret Societies in the United States," "Street Games of Boys in Brooklyn," and "Primitive American Art." His professional memberships ranged from the Moravian Historical Society to the Contemporary Club of Philadelphia.

Uniting Culin's diverse interests was a passion for objects. He was first and foremost a museum man committed to what he called the "language of things." His professed goal was to make things tell him their story and then coax and arrange them to tell this story to the world (Culin 1927:42). His training as a spokesman for material culture came primarily from his participation in the great expositions at the end of the nineteenth century, such as the Historic Exposition in Madrid in 1892 and the World's Columbian Exposition in Chicago in 1893. In lieu of academic laurels, Culin had gold medals testifying to his expertise as an exhibitor.

At the 1893 exposition Culin first met Frank Hamilton Cushing (1857–1900), the romantic and controversial ethnologist who had resided in the village of Zuni from 1879 to 1884. The history of The Brooklyn Museum's Zuni collection properly begins with a consideration of this man.

Frank Hamilton Cushing and the Zuni

Born in 1857, Cushing was just one year older than Culin and even more unorthodox in his training. As a boy in western New York he became fascinated with Indian artifacts he found on the ground, and began to experiment with reproducing them. His own youthful collections and replicas served, almost exclusively, as the basis for his

ethnological education. In 1875 his precocious efforts were recognized by Spencer F. Baird, the assistant secretary of the Smithsonian, who invited him to Washington to assist Dr. Charles Rau in preparing the Indian collections of the United States National Museum for exhibition at the Centennial Exposition in Philadelphia. This assignment gave him the opportunity to study a wide range of Indian artifacts, including some from the Southwest.

In 1879 Cushing was appointed a member of the first collecting expedition sent to the Southwest by the newly created Bureau of Ethnology. The party included James Stevenson, his wife, Matilda Coxe Stevenson, and the photographer John Hillers. The purpose of the trip was to "report on archaeological remains, continue Powell's and Hayden's geological surveys, study architecture and domestic arrangements, and collect ethnographic specimens from the Native Americans of New Mexico and Arizona" (Parezo 1985:12). Zuni was the first destination. Cushing went no farther, choosing to make Zuni the object of sustained research; he took up residence in the governor's house, learned the language, adopted Zuni dress, and became a member of the tribal council and the Bow Priesthood. His innovative approach (subsequently known as the "participant-observation" method in anthropology) was not without cost to his emotional and physical health. Alternately romanticized and vilified, he found himself at the center of a number of legal, ethical, and professional disputes.[14]

Culin met Cushing a decade after his Zuni residence "when broken in health if not in spirit, he lived in civilization as a wild bird might in captivity." The meeting, according to Culin, "was an event" in both their lives. The two men remained "in close community, working together on problems that have ever concerned the minds of man."[15] Zuni figured prominently in these discussions.

The meaning and value of Cushing's work at Zuni have been the subject of much scholarly debate,[16] in part because the autobiographical nature of his writing has made it difficult to separate the facts about Zuni from Cushing's interpretations.[17] But in terms of his relations with Culin, this is not a problem. It is precisely the combination of man and subject, hopelessly intertwined, that we need to understand. For it was not Zuni but Cushing's compelling re-creation of the Zuni that Culin chose to feature in his installation at The Brooklyn Museum.

To appreciate the nature and extent of Cushing's influence on Culin, it is necessary to review the salient features of Cushing's Zuni research. First

there is the choice of Zuni itself as a subject worthy of prolonged study.[18] Although Cushing did not initiate the trip to Zuni, and his motives for staying there were mixed (Hinsley 1981:194–95), he came to believe that the Zuni were the "Indians of Indians," [19] "the most highly developed yet characteristic and representative of all these people" (1896:325). These claims, as well as Cushing's long residence in the pueblo and participation in its government and religion, put Zuni in a special category. No other pueblo village had been the object of such a lengthy and purposeful investigation.

Second there is Cushing's emphasis on an archaic Zuni buried within the modern town. The pueblo Cushing celebrated was not the confused and impoverished village where the men wore "clothing of gaudy calico and other thin products of the loom of civilization" (Cushing 1896:339), but an ancient archetype, untouched by modern man. Where others saw change and disintegration, Cushing saw traces, all the more precious because tenuous, of the generative stage of civilization.[20] Language provided the key. "The entire language is freighted with fossil concepts," wrote Cushing, "and in studying closely the structural organism of these dead ideas one finds how they were born and grew, and that they were more often than not both implanted and made to grow by the hands alone" (1892:309). Paradoxically Cushing used language to go beyond words and thus communicate with the artifacts and gestures that were early man's primary means of expression.[21] "Ours is a New World," he wrote to Culin in 1894, "where things speak as in time primaeval, and our museums become books and histories or should become so, for the History of Man in America is, thank Heaven, a natural history and an unwritten one!" [22]

Finally, there is Cushing's unique method of presenting his research. Mimicking the "dramaturgic tendency" he considered a pervasive feature of Zuni life, Cushing performed his archaic version of the Zuni both within the pueblo and at scholarly meetings and public lectures and expositions. He became an actor in the Zuni dramatic tradition, which had as its "chief motive the absolute and faithful reproduction of creative episodes—one may almost say, indeed, the revivification of the ancient" (1896:375). Appropriately attired in an anachronistic costume consisting of a dark blue woolen shirt (figs. 11, 12) and buckskin trousers ornamented with silver buttons,[23] Cushing demonstrated the old arts,[24] sang the old songs (the women's as well as the men's),[25] and told the old stories in an attempt to re-create the Zuni past and make it live again.

Thus Cushing presented his most complex and ambitious interpreta-

Figure 11. F. H. Cushing's Zuni shirt. Handspun wool, commercial yarns, silver buttons. Length 26 in., width 58 in.
(Courtesy Brooklyn Museum, 30.799, Estate of Stewart Culin, Museum Purchase)

tion of the Zuni through the medium of his own person. Thomas Eakins's portrait of Cushing (fig. 13), painted in 1895, conveys the poignancy and fragility of this achievement. Cushing's description of the Indian's stance against the modern world could well apply to his own weary, introspective figure: "The Indian . . . lives less in the present than in the past. His spirit loves to roam through the dark, wild vistas of antiquity and dream of the marvels which he devoutly believes caused all things to become as they are. To him the youth of the world with its beautiful visions of the to be, is fled, and be he ever so young he is a dotard" (1974:55).

The reviews of Cushing's performance as a Zuni were mixed. Matilda Coxe Stevenson, who had accompanied her husband and Cushing on the Smithsonian's collecting expedition in 1879, considered it an affected and exaggerated display and discredited Cushing's work whenever the opportunity arose.[26] Stewart Culin, on the other hand, was completely convinced: "Cushing, or Tenatsali, his Indian name by which I prefer to call him, could think of everything in the universe with the mind of a sav-

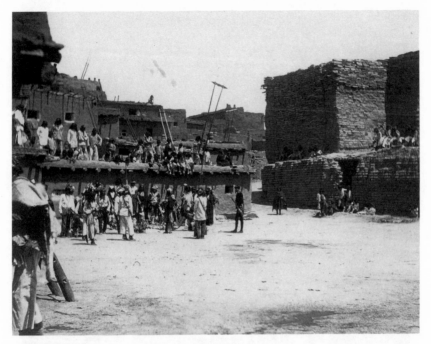

Figure 12. Dances and ceremonies of the Zuni Indians. F. H. Cushing, *standing to the right of the central group, is wearing his Zuni costume. Photograph by Taber.* (Courtesy Peabody Museum, Harvard University)

age and unlike the savage could express his thoughts in the most perfect English I have ever heard spoken. He knew the world's secrets; he knew the world's arts as the primitive savage alone knows them."[27]

To Culin, Cushing was not just an Indian but a "vanishing Indian," a precious and elusive repository of unwritten lore. His work was tragically incomplete. Although he had published on various aspects of Zuni life, he never produced the comprehensive study the scholarly community expected.[28] Similarly, he collected many artifacts (Parezo 1985), but never installed them systematically in a museum showcase. When he died suddenly in 1900, his colleagues regretfully acknowledged that much that he knew was "buried with him forever" (McGee et al. 1900:376). Culin alone decided "to try to pick up and recover the broken clue." It became the dream of his life "to go to Zuni and complete the work."[29]

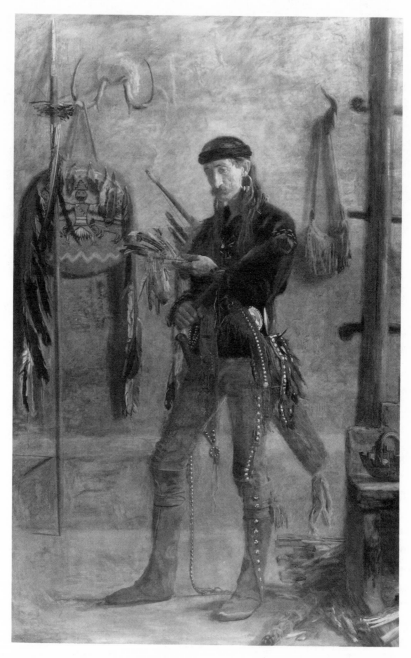

Figure 13. Frank Hamilton Cushing, *oil painting by Thomas Eakins, 1895.*
90 in. by 60 in.
(Courtesy Gilcrease Institute of American History and Art, Tulsa, Oklahoma)

70 | Diana Fane

Collecting Cushing's Legacy

In 1902, on a collecting trip for the University Museum in Philadelphia, Culin made his first trip to Zuni with a copy of Cushing's posthumously published book, *Zuni Folk Tales*, as a talisman in his bag. The frontispiece was a photograph of Cushing (fig. 14). The Zuni, Culin reported, "were very much interested in the portrait. . . . and upon being told that I was his friend, they called me Cushing *an-kui* and introduced me by this title wherever I went."[30] The sobriety of the picture is noteworthy. Cushing is seated, dressed in a three-piece suit, very much the observer rather than the participant. It is precisely this aspect of Cushing's work that Culin was determined to validate and preserve for posterity.

The trip convinced Culin that the Zuni heritage was neither stable nor completely intact. Native customs were changing and artistic traditions deteriorating. He noted "numerous inartistic innovations,"[31] for example, in the quality of the pottery, and predicted the "ultimate extinction" of this art. Inferior baskets were being produced and the art of making stone implements had disappeared.[32] Heirloom pieces were commanding higher and higher prices, and there was stiff competition for them, from both European and American collectors. Culin was not too late, but there was no time to lose.

The Brooklyn appointment in 1903, with guaranteed expedition funds and administrative independence, gave Culin the opportunity to make a Zuni collection his top priority. Arguing, in words that echoed Cushing's, that Zuni was "the largest and in many respects the most important of the surviving Indian towns" (Culin 1904:21),[33] he set out immediately for the Southwest.

Culin collected at Zuni in 1903, 1904, and 1907, spending sufficient time each year to tour the nearby ruins, shrines, and farming villages, observe new developments such as the dam and school being built at Black Rock, and renew old acquaintances. Usually he stayed at the home of Andrew Vanderwagen, a missionary turned trader whom Culin had met on his first trip to Zuni in 1902. Culin was also on friendly terms with several other members of the Anglo-American community, including Douglas Graham, a trader and government farmer, and longtime resident of Zuni. Graham's adopted Zuni son Nick served as Culin's principal interpreter and guide in his rounds of the village.

"Collectors are people with a tactical instinct," Walter Benjamin has noted, "their experience teaches them that when they capture a strange

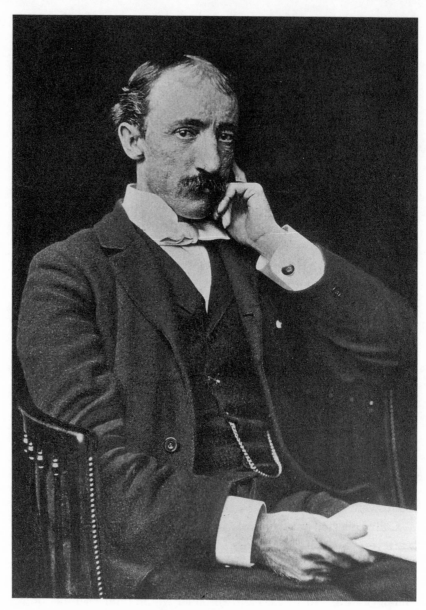

Figure 14. F. H. Cushing. Frontispiece to Zuni Folk Tales.
Photograph by Patty Wallace

city, the smallest antique shop can be a fortress, the most remote stationery store a key position" (1976:63). A self-proclaimed master of the art of collecting, Culin began modestly, going from door to door, inquiring for "old things," a tactic that earned him the nickname "Old Things" (Inotai),[34] and yielded a random assortment of objects, including used household implements, tools, clothing, and toys. As word of his interest spread, people began to come to him, and he set up shop in a little room adjoining Vanderwagen's stable. The Zuni, Culin wrote to the director at Brooklyn, were "crazy to sell, and for many things 5 cents, the smallest coin was enough."[35] The women, in particular, welcomed an opportunity to convert domestic discards into cash: "they carried their stuff wrapped in blankets or in the bosoms of their dress. They brought me many things that the men would not sell, things which they had gathered in the dark inner rooms; things long disused, of which they did not know the significance or value."[36]

Through the old, Culin hoped to get at the sacred, which he considered the "real" art of the North American Indian.[37] Although the women provided him with bits and pieces of religious paraphernalia, they did not offer the objects he was most interested in—masks and dolls. Even Cushing had been unable to obtain these items;[38] thus they were essential to the success of Culin's mission. Culin had been frustrated in his attempts to buy masks in 1902, and was told that their sale was punishable by death. In 1903 the situation proved to be somewhat different.

Poverty and disease had taken their toll on the religious leaders of the community. Ceremonial goods were in circulation, but not openly, and not generally among the Indians. A brisk business in religious artifacts had sprung up among white traders and missionaries in response to museum demands. At Zuni, Culin's friend Vanderwagen had cornered the market. During his seven-year residence, he had collected the "entire contents of 3 shrines," purchased heirloom pots, and supported a secret cottage industry in the production of masks and dolls in his basement. By August 1903, Vanderwagen's collection contained seventy-five dolls and twenty-three masks, made to order by three Zuni artisans.[39]

Competition for this collection was keen. The 1904 world's fair in St. Louis set a whole new wave of collecting in motion. Matilda Coxe Stevenson, in particular, was determined to claim Zuni as her own. She had accompanied her husband and Cushing to Zuni in 1879 and, after her husband's death in 1888, had continued his research. In a letter to Culin written in December 1903, the trader Thomas Keam warned him that this

formidable lady was on her way to Zuni and "will doubtless secure all there is in sight."[40]

Culin urged the Brooklyn Institute to buy the Vanderwagen collection, arguing that its contents had been "coveted by every visitor and collector in Zuni since Cushing's time."[41] His appeals, which included a vivid account of the Zunis' outrage on discovering their treasures in Vanderwagen's basement, were calculated to galvanize the museum administration into action. The emphasis was as much on the collection's contraband status and romantic associations as on its contents. Here were the missing pieces, the links to the past, everything that was "unobtainable" in Zuni. Here also was the beginning of the end of Zuni: "Judging from what is occurring on other reservations and in other towns, the sale of this material marks the breaking up of old Zuni, and the dissolution—from one point of view—of the most interesting Indian village in the Southwest."[42] After some hesitation about the price, the museum approved the purchase of the entire collection for $1,028. The sale established a close working relationship between Culin and Vanderwagen, and the missionary continued to look after the curator's interests until Culin's final visit to Zuni in 1907.[43]

That the Vanderwagen dolls and masks were made expressly for sale to the museum posed no problem for Culin in terms of their authenticity. He considered commissions a valid and scientific method of collecting— the only means by which an "intelligent collector" could obtain artifacts that were no longer made or were not for sale. Recalling his attempts to find Indian games for his comprehensive publication on the subject (1907), Culin acknowledged that "at best today they can only be reproductions made by the Indians themselves. The old things have gone. They cannot be ordered from the Indians, but can only be secured by an intelligent collector who knows what he wants. The Indians themselves do not know. They have forgotten. Here and there are very old men who do not speak English who are able to revive some of the lost arts, but they can be reached only through such a collector as I have described."[44]

Whereas Cushing was a practitioner of Native arts, Culin was a patron. But they shared a common goal—revitalization of the past. Writing to Cushing in 1894, Culin justified commissions as an essential part of this process. The museum's object, he stated "is manifestly conservation and instruction. The conservation should extend not only to the material object, but to its traditions, and where these have been lost, it should be

74 | Diana Fane

the duty of the curator to endeavor of [sic] revive them, thereby converting what may be regarded as dead specimens into live ones."[45]

In Zuni, Culin commissioned a wide range of artifact types in order to complete his collection and animate its contents. Some of the pieces were made on the spot, with materials at hand. Others required considerable time, expense, and planning. The red felt for a dance shield (fig. 15), for example, was not available in Zuni and had to be ordered from the trader Lorenzo Hubbell at Ganado, Arizona. Culin always played an active role in these productions, researching the original form, providing the "correct" native materials, and supervising the process of fabrication. The finished artifacts inspired discussions among the Zuni about the past, and sometimes led directly to another commission. Objects Culin summoned up from Zuni artisans' memories of earlier times included games, prayer sticks, dance paraphernalia, jewelry, agricultural implements, tools, and costumes.

One of Culin's most ambitious commissions was a replica of Cushing's Zuni outfit. He managed to find the blue woolen shirt, "one of the two or three left in town," but "the buckskin trousers ornamented with silver buttons, had entirely disappeared."[46] Culin described this sartorial enterprise in detail in letters to the museum's director, in his annual expedition report, and in a dramatic narrative account of collecting in Zuni, entitled "Blue Beard's Chamber," in which he revealed that he was fully aware of the ironies inherent in the collecting process.

"I would," wrote Culin, "spare no expense. I would revive an entire group of industries in a single order."[47] This largess resulted in a series of unanticipated purchases and negotiations. First he had to send to a department store in Denver for Indian-tanned deerskins, which then had to be dyed. Next he had to find a tailor and provide him with the traditional materials and tools, such as sinew and a bone awl. It was the silver buttons, however, that proved to be the greatest obstacle. Culin found he needed "more than the entire volume of the town's currency" and had to enlist the aid of the silversmith. The smith explained that "his century-old forge with its Spanish Moorish accordion-shaped bellows was obsolete; his sandstone moulds and steel dies and punches made from old files had to be replaced. He would be glad to accommodate me, but first I would have to buy his old forge, and purchase him a new one." Culin was only too happy to purchase the old forge, which had been noted in the literature as early as 1853,[48] and promptly bought everything includ-

Figure 15. Zuni dance shield. Hide, pigments, wool fabric, feathers, cotton string.
Diameter 23½ in.
(Courtesy Brooklyn Museum, 03.325.3504, Museum Expedition, 1903)

ing the smith's underclothes. "In thus removing one of the landmarks of the pueblo," Culin remarked, "I would be reviving old industries with a vengeance!"

Culin's Zuni Exhibitions

The Brooklyn Institute's first Zuni exhibition opened to the public in 1905. It included practically everything Culin had collected, artfully arranged as an encyclopedic inventory of Zuni life. The press responded to the collection in terms that could only have come from Culin himself: "This collection is the largest and most comprehensive ever made of Zuni Indian objects. . . . It is a complete epitome of their religious, social, and technological life, and does for this tribe what the great collection in Chicago does for the Navajo."[49] The focal point of the display was the Eakins portrait of Cushing (fig. 13). From the start Culin had envisioned the portrait as part of his installation. "I think it likely we can get Aiken's [sic] portrait of Cushing and Cushing's Zuni costume from Mrs. Cushing, if we attempt to make Zuni a feature in our American collections," he wrote to the director from the field in August 1903.[50] In 1904 the trustees authorized him to approach the artist's widow to request the loan of the picture for the Department of Ethnology.[51]

By including Cushing's portrait in his Zuni exhibition, Culin effectively fulfilled his own prophecy, made shortly after Cushing's death, that "the story of this extraordinary man would be added to the legends of the pueblo, and his unwritten myth take its place among the stories of the ancient town."[52]

Subsequently, Culin reinstalled his Zuni collections several times. In 1907 he used them to represent the Pueblo people in contrast to the Navajo in the Southwestern Indian Hall, and in the late 1920s he arranged them along with the department's African, Oceanic, and Asian holdings in a new gallery entitled the Rainbow House. The Rainbow House was Culin's most artistic installation, the embodiment of all "his collections and ideas" (1927:42). Each culture was displayed against a background color that evoked its essential characteristic. To the Zuni, Culin assigned the color pink, symbolic of dawn, in deference to their "devotion to the vital principles of life and creation" (p. 43). Culin thus situated the Zuni at the very origins of history. "I was in fact old," he remarked on the occasion of the opening of the Rainbow House, "beside the oldest member of

the tribe, but I learned something of the secret of youth and its happiness from them" (p. 43). The portrait of Cushing, his principal guide to the Zuni past, remained prominently displayed amid the surviving artifacts.

Reevaluating Culin's Legacy

"The very effort of salvage," David Lowenthal has noted, "is self-conscious and crisis-starred. And it encumbers the landscape with artifacts which no longer attest a living antiquity but celebrate what is dead. Emphasis on preservation typically substitutes a separable and saleable past for 'traditional' stream-of-time continuity" (1985:405). Culin did not find a Zuni heritage, he created one from an odd assortment of discards, heirlooms, and replicas. He did not revive traditions, he extended and diverted them in order to obtain exhibitable objects. "Old things" appeared as a response to his demand, from the rubbish heap, the workshop, or the back rooms of trading posts. By a strategy of selective omissions as well as commissions, Culin put together a totality in which each object played a vital and signifying role within the orderly space of the museum display case.

Under Culin's successor, Herbert J. Spinden, the focus of the department switched from ethnology to art. The objects now took precedence over the story they were collected to tell. The Zuni collection proved to be a rich resource of "masterpieces" for in-house exhibitions as well as loan shows. Zuni objects were borrowed from Brooklyn for both the 1931 and the 1941 exhibitions in New York. The same Zuni mask (fig. 16) is illustrated in the publications that accompanied these shows.[53] It is one of the masks made in Vanderwagen's basement expressly for sale to the museum.

Would the curators of these exhibitions have selected the mask if they had known it was a commissioned piece? The fact that the question never came up is telling and shows the power and tenacity of the narrative that Culin presented.

It is ironic that it is Culin's own documentation that has made it possible for us to go behind the ethnographic fiction he created and question its validity. We must recognize, however, that this documentation is as valuable a part of Culin's legacy as the collection itself. Knowledge of the circumstances of acquisition allows us to begin to address questions of authorship, ownership, and patronage that have previously been ignored. It also forces us to recognize that Culin's collection is as much about "us"

Figure 16. Zuni mask. Cotton fabric, fiber, wool, feathers, painted wood and leather. Height 9⅝ in.
(Courtesy Brooklyn Museum, 04.196, Museum Expedition, 1904)

as about "them." Most important, it calls attention to the need to look beyond museum storerooms for an adequate history of Native American art. In all the years Culin collected in Zuni he was not able to purchase a single mask that had actually been used in a ceremony. Obviously the Zuni were effectively preserving their own artistic heritage.

NOTES

1. Sponsored and circulated by the College Art Association, the exhibition opened in New York at the Grand Central Art Galleries on November 30, 1931, and traveled to the "principal cities of the United States," on a tour "of about two years duration" (Sloan and La Farge 1931).

This paper draws on two papers delivered orally at conferences: "Stewart Culin and the 'Real' Art of the North American Indian," given in 1985 at the 73rd Annual Meeting of the College Art Association of America, Los Angeles, and "Rhetoric of Replicas: Frank Hamilton Cushing and Stewart Culin in the American South-

west, 1879–1911," given in 1987 at the Native American Art Studies Association 6th National Conference in Denver. I wish to thank Janet Berlo for her thoughtful comments on all versions of this paper.

2. The Smithsonian is generally recognized as the leader "in the development of systematic collections, gathered for a specific purpose and according to a definitive plan, which would make them representative of the material culture of a native society" (Parezo 1986:12). Other museums with early ethnological collections include the American Museum of Natural History in New York, the Peabody Museum of Harvard University in Cambridge, the Field Museum in Chicago, the University Museum in Philadelphia, and The Brooklyn Museum in Brooklyn. For recent reviews of the role these collections have played in Native American art histories see Feest (1984) and Sturtevant (1986).

3. John Sloan and Oliver La Farge explicitly state the problem in these terms: "Our museums have collected Indian manufactures with scientific intent, placing as it were, the choice vase and the homely cooking pot side by side. Bound by the necessity of giving a whole picture they have not been able to set forth their many beautiful specimens in an advantageous manner" (1931:5).

4. In comparing the "discovery" of American Indian art in America and Europe, Feest has pointed out that "the American approach was based on living arts and focused on the Southwest," while the "European approach was based on museum specimens and largely focused on the Northwest Coast" (1984:95). In fact, museum specimens were as central to the American approach but their prominence was obscured because they were used to promote contemporary arts.

5. The names of the collectors are also much more prominent than those of the artists. Washoe basket maker Dat So La Lee (Louisa Keyser) is the only artist identified in the captions in the Living Traditions section (1941:142). No date is given for the basket, however, nor for the artist, who had died in 1925. Two Haida Indians, John Wallace and his son Fred, are mentioned in the text, and the totem pole they carved for the San Francisco Exposition in 1939 is illustrated (1941:176).

6. This pattern is changing. Recent exhibitions, and their catalogues, that have taken the collector and the collecting circumstances into consideration include America's Great Lost Expedition: The Thomas Keam Collection of Hopi Pottery from the Second Hemenway Expedition, 1890–1894 (Wade and McChesney 1980), Inua, Spirit World of the Bering Sea Eskimo (Fitzhugh and Kaplan 1982), and The Way to Independence: Memories of a Hidatsa Indian Family, 1840–1920 (Gilman and Schneider 1987). Another new direction seeks "traditional" art outside of museum collections (although not outside of museum shops); Lost and Found Traditions (Coe 1986) is the most ambitious example of this approach.

7. Scholars from various disciplines have recently reviewed the history of ethnological collecting in general and of certain regions in particular. For a history of the Smithsonian, see Hinsley (1981); for a vivid account of collecting on the Northwest Coast, see Cole (1985); for Stewart Culin's California collection, see Bates and Bibby (1983); for a comprehensive review of Culin's American Indian collection see Fane et al. (1991); for essays on various aspects of the relationship

between museums and material culture, see Stocking (1985); for a critical review of collecting and authenticating practices, see Clifford (1988).

8. Nancy Parezo has noted the limitations of the documentation on the majority of systematic ethnographic collections. What is generally missing is not information on the individual pieces, but a record of the whole as an intellectual inquiry: "In no systematic collection . . . have the assumptions and theoretical framework that influenced what was collected been thoroughly documented. This information must be coaxed from publications, letters, accession papers, and field notes" (1987:32).

9. An inventory of the archival material and preliminary processing of a substantial portion of the Culin Archival Collection (hereafter cited as CAC) was funded by a National Science Foundation grant awarded in 1984. I am grateful to the NSF for their support and to Ira Jacknis for his work as a research associate on the grant. Funds for processing Culin archival material not covered by the NSF project were provided by the National Historical Publications and Records Commission in 1985. Deborah Wythe, the archivist at The Brooklyn Museum, and Lise Breen, research associate in the Department of African, Oceanic, and New World Art, have greatly facilitated my archival research.

10. Brooklyn Museum Archives, CAC, Departmental Correspondence, Franklin W. Hooper to Stewart Culin, February 24, 1903.

11. Brooklyn Museum Archives, Brooklyn Institute of Arts and Sciences, Department of Archaeology, Minutes (1889–1904), December 30, 1895. "On this date Mr. Stewart Culin of the University of Pennsylvania gave us an instructive talk upon the Museum of Archaeology of that institution. The subject was a peculiarly appropriate one owing to the approaching completion of our own new museum. Mr. Culin dealt entertainingly with methods of making an archaeological collection of the greatest popular interest and value."

12. Brooklyn Museum Archives, CAC, Scrapbook Clippings (1897–1913), "Stewart Culin Is Won by Brooklyn Institute," The Brooklyn Eagle, 1903.

13. Largely because his papers have not been accessible and his reputation was based on collections and exhibitions rather than on publications, Culin has remained a neglected figure in the history of museum anthropology. For a contemporary appreciation of him, see Dorsey (1913). Recently Culin's role in the development of The Brooklyn Museum has been reviewed (Ferber 1988), and his showmanship appreciated (Bronner 1985). A major exhibition, with an accompanying catalogue, of the North American Indian collections he acquired for the museum entitled Objects of Myth and Memory: American Indian Art at The Brooklyn Museum, opened at the museum in October 1991. See Fane et al. (1991).

14. For overviews of Cushing's career from various perspectives see Green (1979), Mark (1980), and Hinsley (1981).

15. Brooklyn Museum Archives, CAC, Research & Writings: Lecture, "Bows and Arrows," n.d., p. 3.

16. Recent contributions to the debate include Hinsley (1983), Parezo (1985), Murray (1987), and Hovens (1988).

17. As Joan Mark has observed, Cushing's "My Adventures in Zuni," published in *Century Magazine* in 1882–83, "was more than it appeared at first to be. On the surface a simple account of his adventures, it was actually a careful description of the cycles of Zuni life interwoven with the story of his own slow penetration into it" (1980:101–2).

18. At least one other white resident of Zuni did not consider the pueblo worthy of study. Fear, prejudice, and exhaustion can be glimpsed behind the Reverend Taylor F. Ealy's laconic report on the Shalako ceremony of 1878: "Dec. 5th. Last night Mrs. E. and I went to see the minstrels or something. They danced, buried feathers, recited something like a creed; had an altar with pictures of sun, moon, stars, wolf, etc., etc. Six houses of the rich men are open to visitors and have 'muchas cosas' (many things) to look at, but I have neither the time nor am I willing to lose sleep at night running about sight seeing" (Bender 1984:93).

19. Brooklyn Museum Archives, Brooklyn Institute of Arts and Sciences, Department of Archaeology, Minutes (1889–1904), An Account of Mr. F. H. Cushing's Lecture upon the Zuni and Their Ancient Civilization, January 21, 1895.

20. Hinsley has pointed out the radical nature of Cushing's insight "—at direct variance with prevalent American attitudes at the time—that, far from being lost, Zuni history and beliefs lived on in the daily life of the pueblo" (1983:57).

21. Tzvetan Todorov, who noted that Cushing's study has "left its mark on research in this area" (1982:234), summarizes the search for an original gestural language as follows: "The fantasm of primitive language is at the same time a fantasm of the fading away of language, since things take the place of signs and the gap introduced by the sign between man and the world is finally reduced" (p. 236).

22. Brooklyn Museum Archives, CAC, Research & Writings: Correspondence, Cushing to Culin, October 1894.

23. By 1879, white cotton or calico shirts had replaced the dark woven wool shirt for everyday wear (Stevenson 1987). The wool shirts were presumably still worn for ceremonial occasions and can be seen in contemporary formal photographs of Zuni leaders. Neither the photographic nor the written record indicates that Cushing ever owned any Zuni cotton clothes. At many Zuni events, therefore, his dark woolen shirt made him stand out rather than blend in (see fig. 12). The Brooklyn Museum acquired Cushing's Zuni costume as part of Stewart Culin's estate in 1930.

24. Cushing relied on instinct as well as firsthand knowledge of Indian tools and methods to guide him in re-creating lost arts, and was constantly surprised and delighted by his own dexterity. "I have worked out every detail of the old art," he wrote to Culin about an early lithic tradition, "with astonishing results, astonishing even to me, an old arrow maker" (Brooklyn Museum Archives, CAC, Research & Writings: Correspondence, Cushing to Culin, December 23, 1894).

25. Brooklyn Museum Archives, Brooklyn Institute of Arts and Sciences, Department of Archaeology, newspaper clipping included in Minutes (1889–1904), January 21, 1895: "Mr. Cushing sang some of the odd verses recited at the festivals, chiefly by girls."

26. Jesse Green has cited Mrs. Stevenson's note on the back of a photograph

of Cushing as an "example of *counter*-mythologizing": "Frank Hamilton Cushing in his fantastic dress worn while among the Zuni Indians. This man was the biggest fool and charlatan I ever knew. He even put his hair up in curl papers every night. How could a man walk weighted down with so much toggery?" (1979:24). Mrs. Stevenson's sharp tongue put Cushing on his guard: "keep good watch on at least the bad things Mrs. Stevenson and others do and say of me. If they do and say bad things I want to know it. If they do not I want even more to know it, that I may know how to bear myself rightly and safely" (Brooklyn Museum Archives, CAC, Research & Writings: Correspondence, Cushing to Culin, September 24, 1893).

27. Brooklyn Museum Archives, CAC, Research & Writings: Lecture, "Bows and Arrows," n.d., p. 3.

28. Cushing created great expectations by presenting everything he published as a preliminary study. Culin expressed his bitter disappointment in Cushing's failure to produce the final work in a letter to M. C. Crawford: "I am putting up in the Museum the drawings Cushing and I made together. They embody remarkable discoveries that have never become known to the world. Cushing was to publish. I waited and he failed. There were good reasons, but that is not the point. He failed" (Brooklyn Museum Archives, CAC, Research & Writings: Correspondence, Culin to Crawford, January 20, 1922).

29. Brooklyn Museum Archives, CAC, The Indians of the Southwest, A Course of Lectures Delivered in the Museum of the Brooklyn Institute of Arts and Sciences, 1904, by Stewart Culin, Curator of Ethnology, p. 5.

30. Brooklyn Museum Archives, CAC, Report on a Visit to the Indians of New Mexico and Arizona in 1902 by Stewart Culin, p. 2.

31. Ibid., p. 16.

32. Ibid., p. 17.

33. The Hopi were Culin's first choice as the most important and representative of the Pueblo people, but he realized that they had already been "done" by George Dorsey with his exhibitions at the Field Museum in Chicago. "The Zuni," he explained in a lecture in 1904, "remained, so far as objective collecting, an unworked field. Led by both practical considerations and by sentiment, I chose it as the best source from which to draw our museum illustrations of the Pueblo culture" (Brooklyn Museum Archives, CAC, The Indians of the Southwest, A Course of Lectures Delivered in the Museum of the Brooklyn Institute of Arts and Sciences, 1904, by Stewart Culin, Curator of Ethnology, p. 10).

34. Brooklyn Museum Archives, CAC, Report on a Collecting Expedition Among the Indians of New Mexico and Arizona, May–September 1904, p. 22. In several other places Culin translates his Zuni name as "Old Thing." Whether singular or plural, the name vividly testifies to Culin's preoccupation with the past.

35. Brooklyn Museum Archives, CAC, Departmental Correspondence, Culin to Hooper, July 3, 1903.

36. Brooklyn Museum Archives, CAC, Report on a Collecting Expedition Among the Indians of New Mexico and Arizona, April–September 1903, p. 89.

37. Culin first discovered the "real" Indian art among the Navajo: "I lived once in a Franciscan monastery in the heart of the Navajo Indian country in Arizona.

It was there I came to know that the art of the Indian, represented by pottery-painting, basket-making, and blanket-weaving, the work of women, had little in common with his real art of which it is only the faintest reflex" (1927:47).

38. Brooklyn Museum Archives, CAC, The Indians of the Southwest, A Course of Lectures Delivered in the Museum of the Brooklyn Institute of Arts and Sciences, 1904, p. 10.

39. Brooklyn Museum Archives, CAC, Departmental Correspondence, Culin to Hooper, August 15, 1903.

40. Brooklyn Museum Archives, CAC, Research & Writings: Correspondence, Keam to Culin, December 24, 1903.

41. Brooklyn Museum Archives, CAC, Departmental Correspondence, Culin to Hooper, May 1, 1903.

42. Brooklyn Museum Archives, CAC, Departmental Correspondence, Culin to Hooper, August 15, 1903.

43. Obviously some members of the administration thought the number of dolls and masks in the first purchase from Vanderwagen were more than sufficient for the museum. In 1906 Culin was granted $500 for the purchase of ethnological specimens with the following restriction: "It is the desire of the Executive Committee that none of this amount be expended for the purchase of dolls and masks of the Southwestern Indians" (Brooklyn Museum Archives, CAC, Departmental Correspondence, Lucas to Culin, June 9, 1906). Culin did purchase additional dolls and masks from Vanderwagen, however, in 1907.

44. Brooklyn Museum Archives, CAC, Research & Writings: Correspondence, Culin to Mr. Mindt, November 9, 1925.

45. Southwest Museum, Hodge/Cushing Collection, folder 273, Culin to Cushing, October 4, 1894.

46. Brooklyn Museum Archives, CAC, Report on a Collecting Expedition Among the Indians of New Mexico and Arizona, April–September 1903, p. 93.

47. Brooklyn Museum Archives, CAC, Research & Writings: Blue Beard's Chamber, n.d. All the following quotations are from this nine-page typescript.

48. In his 1904 Report on the Department of Ethnology, Culin announced his plans for this important acquisition: "The largest single object thus obtained was the old silversmith's forge with all its accessories, which it is proposed to set up with a costumed figure of the smith in the Museum. This is the identical forge figured in Capt. Sitgreaves' report in 1853" (1904:22).

49. Brooklyn Museum Archives, Scrapbooks, microfilm, box 1 (1899–1915), The Brooklyn Eagle, May 31, 1905. The reporter was mistaken in referring to Chicago's Navajo collection. It was the Hopi collection at Chicago that served as Culin's model. "The collections from their (Hopi) towns, displayed in the museum in Chicago, surpass in extent and completeness any collections from a single tribe in any museum in the world." Brooklyn Museum Archives, CAC, The Indians of the Southwest, A Course of Lectures Delivered in the Museum of the Brooklyn Institute of Arts and Sciences, 1904, p. 5.

50. Brooklyn Museum Archives, CAC, Departmental Correspondence, Culin to Hooper, August 15, 1903.

51. Brooklyn Museum Archives, CAC, Departmental Correspondence, Mayer to Culin, April 4, 1904. The portrait remained on loan until 1928, when it was purchased by The Brooklyn Museum. In 1947 it was deaccessioned to the Thomas Gilcrease Institute of American History and Art in Tulsa, Oklahoma. For a recent interpretation of the portrait see Truettner (1985).

52. Brooklyn Museum Archives, CAC, Report on a Visit to the Indians of New Mexico and Arizona in 1902 by Stewart Culin, p. 18.

53. Sloan and La Farge (1931: Plate XXX); Douglas and d'Harnoncourt (1941:128). The mask represents a major character in the Shalako ceremony, whose most distinctive feature is the long horn invariably described as blue in color in the ethnographic literature. Although the Brooklyn mask's horn is unpainted, upon entering the art historical literature, it took on the expected color, thus becoming more "representative." The 1931 illustration boldly misrepresents the mask as polychrome. The 1941 publication is more subtle. The mask is illustrated in black and white, but the text—a quotation from Ruth Bunzel's 1929–30 publication on Zuni ceremonialism—describes the mask as having a long blue horn.

BIBLIOGRAPHY

Bates, Craig D., and Brian Bibby
 1983 "Collecting Among the Chico Maidu: The Stewart Culin Collection at
 The Brooklyn Museum," *American Indian Art Magazine* 8(4):46–53.
Bender, Norman J., ed.
 1984 *Missionaries, Outlaws, and Indians: Taylor F. Ealy at Lincoln and Zuni 1878–1881*.
 Albuquerque: University of New Mexico Press.
Benjamin, Walter
 1976 "Unpacking My Library," in *Illuminations*, ed. Hannah Arendt, pp. 59–67.
 New York: Schocken Books.
Bronner, Simon
 1985 "Museum Magician," *Pennsylvania Heritage* 11 (3):4–11.
Clifford, James
 1987 "Of Other Peoples: Beyond the 'Salvage' Paradigm," in *Discussions in Contemporary Culture*, no. 1, ed. Hal Foster, pp. 121–30. Seattle: Bay Press.
 1988 *The Predicament of Culture: Twentieth-Century Ethnography, Literature, and Art*. Cambridge: Harvard University Press.
Coe, Ralph
 1986 *Lost and Found Traditions: Native American Art, 1965–1985*. Seattle: University of Washington Press.
Cole, Douglas
 1985 *Captured Heritage: The Scramble for Northwest Coast Artifacts*. Seattle: University of Washington Press.
Culin, Stewart
 1904 "Report on the Department of Ethnology." Museums of the Brooklyn

Institute of Arts and Sciences Report upon the Condition and Progress of the Museum for the Year ending December 31, 1904 by Frederic A. Lucas, Curator-in-Chief.

1907 "Games of the North American Indians." Annual Report of the Bureau of American Ethnology, 24. Washington, D.C.

1927 "The Road to Beauty," *Brooklyn Museum Quarterly* 14(2):41–50.

Cushing, Frank H.

1892 "Manual Concepts: A Study of the Influence of Hand-Usage on Culture Growth," *American Anthropologist* 5:289–317.

1896 *Outlines of Zuni Creation Myths.* Annual Report of the Bureau of American Ethnology for 1891–1892, pp. 321–447. Washington, D.C.

1901 *Zuni Folk Tales.* New York: G. P. Putnam's Sons.

1974 "Zuni Breadstuff," *Indian Notes and Monographs* 7. New York: Museum of the American Indian Heye Foundation.

Dorsey, George A.

1913 "Stewart Culin," *American Magazine* 45(3):37.

Douglas, Frederic H., and René d'Harnoncourt

1941 *Indian Art of the United States.* New York: Museum of Modern Art.

Fane, Diana, Ira Jacknis, and Lise M. Breen

1991 *Objects of Myth and Memory: American Indian Art at The Brooklyn Museum.* Brooklyn and Seattle: Brooklyn Museum and University of Washington Press.

Feest, Christian F.

1984 "From North America," in *"Primitivism" in 20th Century Art*, vol. 1, ed. William Rubin, pp. 85–97. New York: Museum of Modern Art.

Ferber, Linda

1988 "History of the Collections," in *Masterpieces in The Brooklyn Museum.* New York: Brooklyn Museum in association with Abrams.

Fitzhugh, William W., and Susan A. Kaplan

1982 *Inua, Spirit World of the Bering Sea Eskimo.* Washington, D.C.: Smithsonian Institution Press.

Gilman, Carolyn, and Mary Jane Schneider

1987 *The Way to Independence: Memories of a Hidatsa Indian Family, 1840–1920.* St. Paul: Minnesota Historical Society Press.

Green, Jesse, ed.

1979 *Zuni: Selected Writings of Frank Hamilton Cushing.* Lincoln: University of Nebraska Press.

Hinsley, C. M., Jr.

1981 *Savages and Scientists: The Smithsonian Institution and the Development of American Anthropology, 1846–1910.* Washington, D.C.: Smithsonian Institution Press.

1983 "Ethnographic Charisma and Scientific Routine: Cushing and Fewkes in the American Southwest, 1879–1893," in *Observers Observed*, ed. George W. Stocking, Jr., pp. 53–69. Madison: University of Wisconsin Press.

Hovens, Peter

1988 "The Anthropologist as Enigma: Frank Hamilton Cushing," *European Review of Native American Studies* 1(1):1–5.

Lowenthal, David

1985 *The Past Is a Foreign Country*. Cambridge: Cambridge University Press.

McGee, W. J., et al.

1900 "In Memoriam: Frank Hamilton Cushing" (Contributions by W. J. McGee, W. H. Holmes, J. W. Powell, Alice C. Fletcher, Washington Matthews, and Joseph D. McGuire), *American Anthropologist* n.s. 2:354–80.

Mark, Joan

1980 *Four Anthropologists: An American Science in Its Early Years*. New York: Science History Publications.

Murray, David

1987 "They Love Me and I Learn: Frank Hamilton Cushing and Ethnographic Method," *European Review of Native American Studies* 1(2):3–8.

Parezo, Nancy J.

1985 "Cushing as Part of the Team: The Collecting Activities of the Smithsonian Institution," *American Ethnologist* 12(4):763–74.

1986 "Now Is the Time to Collect," *Masterkey* 59(4):11–18.

1987 "The Formation of Ethnographic Collections: The Smithsonian Institution in the American Southwest," *Advances in Archaeological Method and Theory* 10:1–47.

Sloan, John, and Oliver La Farge

1931 *Introduction to American Indian Art*. New York: Exposition of Indian Tribal Arts, Inc.

Stevenson, Matilda Coxe

1987 "Dress and Adornment of the Pueblo Indians," ed. Richard V. N. Ahlstrom and Nancy J. Parezo, *The Kiva*, vol. 52, no. 4.

Stewart, Susan

1984 *On Longing: Narratives of the Miniature, the Gigantic, the Souvenir, the Collection*. Baltimore: Johns Hopkins University Press.

Stocking, George W., Jr., ed.

1985 *Objects and Others: Essays on Museums and Material Culture*. Madison: University of Wisconsin Press.

Sturtevant, William C.

1986 "The Meanings of Native American Art," in *The Arts of the North American Indian: Native Traditions in Evolution*, ed. Edwin L. Wade, pp. 23–44. New York: Hudson Hills Press.

Todorov, Tzvetan

1982 *Theories of the Symbol*. Ithaca: Cornell University Press.

Truettner, William H.

1985 "Dressing the Part: Thomas Eakins's Portrait of Frank Hamilton Cushing," *American Art Journal* 17 (2):48–72.

Wade, Edwin L., and Lea S. McChesney

1980 *America's Great Lost Expedition: The Thomas Keam Collection of Hopi Pottery from the Second Hemenway Expedition, 1890–1894*. Phoenix: Heard Museum.

MARVIN COHODAS

4

LOUISA KEYSER

AND THE COHNS

MYTHMAKING AND

BASKET MAKING IN THE

AMERICAN WEST

We have long accepted as objective and accurate the con-
temporaneous accounts about turn-of-the-century Native American arts
and artists. Now, as we reevaluate writers in the context of their times,
we find that their work is generally based on evolutionist schemes, arts
and crafts ideals, and attempts to confine Native Americans within both
ennobling and degrading stereotypes. We also begin to see how much
these stereotypes still structure our thinking, and how they have contrib-
uted even more to the formation of popular misconceptions of Native
Americans, their art, and their culture.

As scholars and humanists we must challenge these erroneous popular
beliefs, but first we need to examine their sources. As a contribution to
unraveling the origins of popular misconceptions about Native American

basket weaving, this paper discusses the romanticized image surrounding the life and work of Louisa Keyser (d. 1925), better known as Dat So La Lee, as well as the Washoe basketry tradition she helped to create for the curio trade.

Native American Basketry and the Curio Trade

Increased urbanization and industrialization of the late nineteenth and early twentieth centuries led to a widespread cultural reorientation in the Western world. This process was nowhere more dramatic than in the American West, where the hardy frontier pioneer was abruptly replaced by the industrial urbanite. These disruptions in lifestyle and material culture involved equally dramatic attitudinal reorientation. Morality and purpose had been simpler for the pioneer, whose conquest of hostile territory was animated by a sense of heroism and self-righteousness, sparked partly by the resistance of Native American tribes to the appropriation of their lands. Twentieth-century morality became more ambiguous, as increasing social problems caused by the swelling urban population led to greater subtlety of social control. Native Americans, now pacified and either confined to reservations or loitering about white settlements, contributed to the ambivalent white self-image. Their degradation inspired both revulsion and paternalism in whites, as well as nostalgic idealization of traditional Indian life before contamination by Western civilization. In the larger context, the notion of the Native American as a noble savage was but one manifestation of the continuing romantic idealization of Nature and non-Western cultures that climaxed in late nineteenth-century Europe and America.

This nostalgia for the pure and noble Indian past fueled the curio trade, which, at its height in 1880–1930, filled museums and private collections with staggering quantities of Native American arts and artifacts. On the one hand, anthropologists tended to focus on men's arts, by encouraging Native men to create narrative images of myths and rituals, and by commissioning replicas of traditional ritual arts for museum collections (see Fane, this volume). On the other hand, women's arts, such as pottery, weaving, beadwork, and basketry, were preferred by private collectors, many of whom participated in the contemporaneous Arts and Crafts Movement (ca. 1880–1920).

Admiration for Native women's arts formed part of a general rejection of industrially mass-produced objects in preference for the handmade

and therefore unique piece. Among several ethnic groups exploited for their distinctive traditional craft arts, Native Americans represented the most powerful antithesis to industrialized urbanism. Women involved in the Arts and Crafts Movement felt a special bond with Native American women, with whom they shared an interest in creating pottery and textiles. Each group served to validate the other's claim to true artistry in domestic crafts, with white women admiring the cohesive social context in which Native women created their art, and Native women taking advantage of the economic value accorded women's craft arts in Euro-American society (Boris 1986:109, 122).

Native American basketry was accorded special importance in this idealization of Native culture and art. Under the evolutionary approach that dominated anthropological thinking in late Victorian times, baskets were thought to represent the first stage of women's art, brought to a level of sophistication before the invention of pottery and textile weaving. Baskets were considered to offer a view of a time when humans lived in closest harmony with nature. Irene Sargent, a leader in the Arts and Crafts Movement in the United States, in an essay on Native American basketry for the movement's premier publication, The Craftsman, clearly demonstrates how baskets were viewed by pointing to the great biblical myth of the noble savage: "In examining baskets from the hands of these women of the red race of America, we gain a retrograde vista into the times 'when Adam delved and Eve span,' such as can be afforded by no other extant objects" (Sargent 1904:321).

Native American basketry also exemplified a second tenet of the Arts and Crafts style: ornamentation must be true to the material and form of the object, so that aesthetic and utilitarian components exist in perfect balance. Of the basket weaver, Sargent writes: "She retains in her baskets the full measure of usefulness, while, at the same time, she inscribes upon them her personal translation of the world lying about her" (p. 333).

As basketry came to occupy an important place in the curio trade, artistic innovation among basket weavers in the Far West exploded, and white patrons responded with enthusiastic collecting and written analyses. A bittersweet nostalgia dominates this early literature on basket weaving. Consistent with the romantic idealization of the Native past, baskets made for sale were a priori considered inferior to earlier, traditional basket weaving for Native use. For most tribes, traditional basket weaving styles were poorly known, so the more refined products of the curio trade were instead adopted as the standard of tradition against which all other curio

products were judged. Most criticized were debasements fostered by the new commercialism, such as incorporation of letters or words into the design, or use of simplified or sloppy technique.

Among the many admirers and collectors of Native American basketry, George Wharton James was the most passionate and influential. He formed a basketry fraternity, published a short-lived periodical called The Basket (1903–4), and promoted instruction of whites in recreating techniques and designs of Native basketry art. Like other collectors, James appreciated baskets as much for what they were believed to embody as for their appearance. Consequently, his articles and his great text on Native American baskets (first privately published in 1901) are full of romantic excesses, including admiration for the artists and colorful interpretations of the designs. James's approach was countered by that of Otis T. Mason, who was involved concurrently in synthesizing the same material, culminating in the text published by the Smithsonian Institution in 1904. Mason's approach is more careful and academic, appropriate to his position as curator of ethnology at the U.S. National Museum.

Despite this inherent contrast between the two texts, of interpretive excess versus academic description and taxonomy, both Mason and James include a romanticized segment on the Washoe weaver Louisa Keyser, also known as Dat So La Lee. Both authors had been sent this material by Amy Cohn, Louisa's patron and promoter. Like many collectors and dealers of Native American art at that time, she considered herself an amateur ethnographer. However, Amy's symbolic analyses of Louisa's designs are insupportable. The interpretation of one design as representing different levels of chieftainship (Mason 1904:332; James 1909:247) is absurd for a tribe that lacked chiefs or any other form of permanent ranking. Mason could easily have checked this interpretation with Eugene Mead, former superintendent of the Indian training school in Washoe territory, and a major contributor to the National Museum's Washoe basketry collection on which Mason based his analysis. But he did not bother.

Mason's acceptance of Amy Cohn's fabrications may be explained by the greater trust and communication that existed between amateur and professional ethnographers at the turn of the century. Mason had no reason to distrust the woman who also sent him a Washoe vocabulary for the numbers one to one hundred, and an example of fish netting with a description of its manufacture.[1] However, we are not concerned here with Mason's gullibility, but with Amy Cohn's deception in formulating and promulgating misinformation on Louisa Keyser and Washoe basket weav-

ing. This study will dissect some of these fabrications, as was attempted in two previous publications (Cohodas 1982, 1986), and also endeavor to understand Amy's motivation in adopting such falsification.

Before tackling this problem, it may be helpful to sketch the relationship of Louisa Keyser and the Cohns to Washoe basket weaving for the curio trade. The Washoe occupy a string of valleys along the western edge of the Great Basin, and into the Sierra Nevada mountains around Lake Tahoe. They followed a hunting-and-gathering economy of seasonal transhumance, depending primarily on piñon nuts, wild grass seeds, and acorns, as well as fish, rabbits, and deer. With the discovery in 1858 of the Comstock Lode at the juncture of Washoe and Paiute territories, western Nevada's economy came to be dominated by silver mining. As swarms of miners and ranchers overran their territory and destroyed their subsistence resources, the impoverished Washoe were forced to turn to the white settlers for survival. This situation began to improve in the 1890s, as whites came to depend on the Washoe as a cheap labor force: Washoe women generally found employment as household laundresses, while Washoe men performed the outdoor ranching chores.

Abram Cohn (fig. 17), the son of a Prussian immigrant, owned the Emporium Company men's clothing store in Carson City, in the heart of Washoe territory. In 1891, Abe married Clarisse Amy Lewis (née McNaughton), a widow with three young daughters. Amy not only helped Abe in the store, but she also took up Indian culture as a hobby, and became especially interested in baskets. In the late 1890s, Abe and Amy decided to enter the curio trade, buying Washoe baskets no longer needed by their makers for resale in the Emporium. To ensure a continuing supply, the Cohns encouraged weavers to create basketry specifically for sale, thus stimulating the development of a new Washoe fancy basketry style. Louisa Keyser (fig. 18) was largely responsible for adapting elements of the highly admired Pomo and Maidu basketry styles from California to Washoe tradition, in order to create a more salable and artistic item. Louisa's most significant innovation was the degikup, a spheroid objet d'art, finely stitched with complex designs in red and black on a light ground.

Initially hired to do the washing, Louisa displayed a talent at basket weaving that was soon recognized by the Cohns, who encouraged her to spend more time on weaving and less on laundry. Gradually they developed a full patronage arrangement lasting over a quarter-century, until Louisa's death in 1925. Under the terms of this arrangement, the Cohns provided Louisa and her husband, Charlie Keyser, with food, clothing,

Figure 17. *Abram Cohn holding two of Louisa Keyser's degikup baskets:*
L.K. 96 (1923) *and* L.K. 43 (1906).
(*Courtesy Nevada State Museum*)

shelter, and medical care. In return, Louisa was expected to weave in exposed locations where she could attract customers, and her products became the Cohns' property.

In promoting baskets woven by Louisa Keyser (and other Washoe weavers), the Cohns obscured all factual information on Louisa's life with a

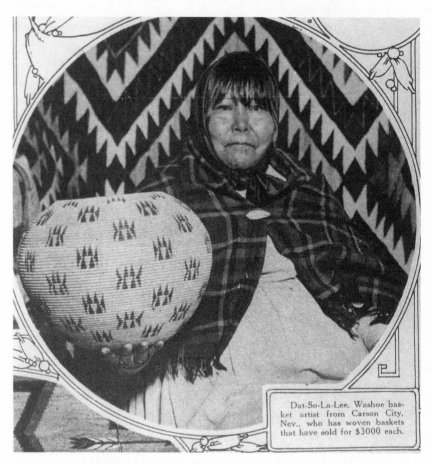

Dat-So-La-Lee, Washoe basket artist from Carson City, Nev., who has woven baskets that have sold for $3000 each.

Figure 18. *Louisa Keyser (Dat So La Lee) as she appeared in the Sunday magazine section of the St. Louis Globe-Democrat, along with an Isleta potter and Navajo weaver, November 16, 1919. Abe and Amy Cohn took Louisa to St. Louis to demonstrate basket weaving at the Exposition of Industrial Arts and Crafts. Amy Cohn died a month after returning.*

barrage of exaggerations and falsifications. These appear in pamphlets published by the Emporium Company, in the certificates issued with each basket sold, and in a wealth of newspaper articles. After subjecting all of these sources to detailed analysis, I am left to conclude that almost nothing the Cohns said was true. Advertising campaigns have long been used to help sell a product—Abe Cohn himself held a "going-out-of-business" sale in 1896—but these fictions far exceed commercial utility.

The Cohns were not alone in this falsification. S. L. Lee, highly re-

spected in Carson City as Nevada's leading physician, also fabricated information for the catalogue of his Indian collection, and added to the legend of "Dat so la lee" when she was on her death bed. This legend continues to have a powerful hold over popular culture in western Nevada, and it is repeated intact (Mack 1946; Cerveri 1962, 1968; Ewing 1983) despite attempts to dispel the fictions (Gigli 1967; Cohodas 1982; Stern 1983).

Amy Cohn as Patron

One of the most puzzling aspects of the Emporium literature is the role of Amy Cohn. Mason (1904:467) specifically credits his information on Louisa Keyser and Washoe basket weaving to Amy, and the photographs sent to the National Museum around 1900 attribute the Indian collection to her. Since Amy was concurrently volunteering ethnographic data to Mason, she must have enjoyed recognition for her active interest in Washoe culture and art. Yet as Washoe basketry became commercially successful, and Louisa Keyser achieved widespread recognition, Amy ceased to be acknowledged as patron or promoter. Emporium pamphlets instead credit Abe Cohn with the discovery and management of Louisa Keyser and promotion of Washoe basketry sales, as do the newspaper articles that appeared from time to time throughout Louisa's career. While photographs of Abe Cohn often illustrate articles on Louisa Keyser and Washoe basket weaving, Amy is never shown. In contrast to this public image, the archival materials, such as letters, photographs, ledgers, receipts, and pamphlets produced by the Emporium, all demonstrate that the major responsibility for patronage of Louisa Keyser and promotion of Washoe basket weaving rests with Amy Cohn.[2]

Baskets were never more than a sideline for Abe Cohn, whose major commodity until 1928 was men's clothing. Nor did basket weaving constitute an avocation, as his spare time was divided between mining interests and the accumulation of animals for the Emporium Zoo. His contribution to the basketry department of the Emporium appears to have been in pricing, advertising, and long-distance sales. His most intense involvement in promoting the basketry trade came near its inception: in March 1899, on one of his semiannual trips to San Francisco to buy clothing stock, Cohn took some cartons of baskets for display and sale in F. J. Sloan's department store. To add local color, he took seven Washoe men with him, but they were cited for loitering on the street.[3] The exploitation of Washoe men seems typical of Abe's approach. During the Christmas

season of 1898–99, he set up a display of live birds with baskets in the windows of the saloon next door. The display included a "live Indian sitting in front of his wigwam" (*Nevada Appeal*, December 25, 1898).

Amy pursued the display and promotion of Washoe baskets more vigorously and with much more success than Abe. In 1900, she took Louisa Keyser with a display of baskets to Tahoe City for the summer.[4] The exhibit attracted so much attention that she was invited to bring it to the California State Fair in Sacramento that August, and then to the Nevada State Fair in Reno in September.[5] This wide exposure brought Louisa Keyser's work sufficient acclaim to be featured in a long article in a San Francisco magazine (French 1900). In 1903, Amy returned to Tahoe City with Louisa to open a permanent curio store, the Bicose, and she continued to manage it with Louisa at her side every summer until her death in 1919. Amy also explored the possibility of a winter outlet for the baskets, taking a selection with her to Pasadena in December 1906, but this venture was not continued.[6] Louisa and the basket display accompanied the Cohns to St. Louis in 1919 to the Industrial Arts Exposition. They were accompanied by a young Washoe woman, Frances Brown, who appears to have been friends with both Louisa Keyser and Amy Cohn.

Until her death, Amy Cohn was also responsible for most of the promotion and documentation on Washoe basket weaving. Comparison of handwriting on signed letters reveals that it was Amy who wrote the certificates issued with each basket, including the lengthy interpretation of symbolism on the reverse, and it was Amy who devised and kept the unique ledger of Louisa Keyser's baskets (see below). Amy is also credited with commissioning most of the photographs of Louisa Keyser and the Emporium basket collection. The first of these, taken before March 1899, is the famous portrait photograph of Louisa Keyser with her earliest baskets, entitled "Queen of the Basketmakers," which was published by both Mason (1904: pl. 181) and James (1909: fig. 56). Amy is also credited with the next known photograph of Louisa, taken in 1900, probably at Lake Tahoe. It shows her in a tent hung with blankets, weaving the basket now known as L.K.24 or "Migration," which was included in the appendix James added to revise his text (James 1909: fig. 340).

Analysis of Amy's literary style, as revealed in letters, on the certificates, and in the 1909 article, demonstrates that she wrote all the important Emporium pamphlets on which the legend of Louisa Keyser is based. Letters written by Abe show that his education was insufficient for this task. Amy was not only better educated, but she had also dabbled in writing fic-

tion (*Nevada Appeal*, June 22, 1898) before turning her talents to promoting Washoe curios.

Amy worked continually to promote Louisa's basket weaving by lecturing in Carson City and on tour throughout southwestern Nevada. Her 1909 lecture to the Leisure Hour Club of Carson City was published as an article by the Nevada Historical Society (Cohn 1909). The Leisure Hour Club was typical of the late Victorian women's club movement in its devotion to promoting culture, primarily through literary study and recitation, as well as contributing to the Arts and Crafts Movement by cultivating a taste for beautiful, handmade objects of household decoration (Boris 1986:100). Amy's lecture to the Nevada Federation of Women's Clubs in Carson City, October 1913, led to a lecture tour of women's clubs in southern and western Nevada in the spring of 1914.[7]

Amy's talent at thrilling her audiences in these lectures is unanimously acclaimed. She would dress in the fringed buckskin of an "Indian Princess" to recite myths and legends in a stirring manner, and poetically explain the symbolism she divined in the basketry designs displayed to the audience. Even at her Tahoe City curio shop, her energy and enthusiasm were deemed noteworthy (Keller 1910). By contrast, Abe was much less impressive as a basketry authority. In his letter to Grace Nicholson in 1906, C. E. Van Loan describes Abe's explanation of the basketry by noting that "he can talk for an hour and every time he goes over it he uses the same words and the same gestures. I strongly suspect that he has the whole thing learned by rote."[8]

Abe and Amy Cohn also differed in the way they handled the Emporium fabrications. For example, in one of her pamphlets (ca. 1905), Amy mentions that Louisa appears to be going blind and may never complete another major basket (Emporium, n.d.B). Abe Cohn was well known for telling stories to anyone who visited the Emporium, and he appears to have embroidered heavily on this one. Van Loan reported of his conversation with Abe that Louisa had been to many oculists who despaired of saving her sight, and that her sister-in-law, Scees Bryant, had already gone blind (Van Loan 1906). We do not know the extent of eye problems either weaver may have had at that time, but we do know that neither went blind, and that both created several basketry masterpieces subsequently.

Amy's association with the Washoe and their basketry was both earlier and deeper than Abe's. Local residents have suggested, and her obituary confirms, that she was noted for making a hobby of studying Washoe culture (*Nevada Appeal*, December 19, 1919). The ethnographic information she

volunteered to Mason at the National Museum reveals the breadth of her interests. Amy also became friendly with several Washoe women, including Frances Brown, who accompanied the Cohns to St. Louis, and Alice Tom Washoe, who demonstrated her affection by naming her daughter Amy (Lana Hicks interview with Amy James, 1984). When Louisa was hired to do the washing in the Cohn home (Van Loan 1906), Amy must have been the one who supervised her work, because Abe was tending the store. Given Amy's prior interest in Washoe culture, it is likely that she was also the one who first became aware of Louisa's remarkable talent for basket weaving, not Abe as the Emporium propaganda asserts.

Amy's ledger of Louisa Keyser's baskets gives further indication of their close relationship. Entries show that Louisa often presented finished products to Amy as a kind of gift, whereas Abe was rarely the recipient of such attentions. Amy also kept a special collection of miniature baskets, which was not for sale. Since virtually every small piece that Louisa wove went immediately into the "Amy Cohn Miniature Collection," Louisa must have had this destination in mind from the start. By contrast, although Abe considered Louisa's larger masterpieces his property, he worked hard to sell them. He only hit on the idea of building a museum to display these works when it became clear that they could not be sold for anything near his perception of their value.[9]

Promotion and documentation of Louisa Keyser and Washoe basket weaving declined noticeably in quality after Amy's death, in 1919, and Abe's marriage to Margaret Jones a year later. Lengthy pamphlets were no longer produced; the records in the ledger became sloppy and inconsistent; and some pieces from the Amy Cohn Miniature Collection were sold. According to some residents of Lake Tahoe and Carson City in those years, Louisa and Charlie may have been poorly cared for after Amy's death.

What roles did Abe and Amy Cohn *actually* play as patrons of Louisa Keyser and promoters of the Washoe curio trade? Amy's Emporium publications claim that Abe was Louisa Keyser's sole patron, that he discovered her talent, and decided to befriend, support, protect, and promote her. Abe's actual role may have been twofold. First, he took care of many business aspects of the curio trade, such as pricing and advertising. Second, he attracted attention to the Emporium basketry department and Louisa Keyser through his gregarious personality, drawing in visitors and regaling them with humorous stories. The major newspaper articles on Washoe basket weaving derive from the special relationship Abe had with

the local editors. The articles are really about Abe, and are illustrated with photographs of him. Nevertheless, Amy deserves the major credit for promoting Washoe basket weaving, through her patronage of Louisa Keyser, her documentation on certificates, ledgers, and photographs, her public lectures, and her promotional pamphlets.

The paradox is Amy's responsibility for her own lack of recognition. Whereas she had taken credit for the basketry collection, photographs, and ethnographic information in her early (1899–1900) correspondence with Mason and James, she later gave all the credit to Abe in her pamphlets and lectures. Why did this vital and creative woman erase herself from the picture just when Washoe baskets were becoming a commercial success and Louisa Keyser was gaining a national reputation? Possible explanations will be explored in a later section.

The Ledger of Louisa Keyser's Baskets

The ledger, begun by Amy Cohn and continued after her death by both Abe and Margaret, is the most accurate and indispensable form of documentation surviving on Louisa Keyser and her art. Each basket is given a consecutive number, with the dates recorded on which the piece was begun and completed. Each has an interpretation of design and a title. Most also have some circumstance of the basket's acquisition by the Cohns and, if sold, a record of the purchaser. To this information is added a column of statistics, including dimensions and weight, materials and weaving technique, stitch count, and the number of days in manufacture. This amount of information is striking for the era, when little attention was paid to documentation of individual Native artists. However, despite its apparent objectivity, this ledger cannot be used without understanding its limitations and falsifications.

The ledger gives the impression that it was begun as soon as Louisa started weaving baskets for the Cohns. The first basket is recorded as having been started November 1, 1895. However, the compilation was not begun until at least twenty years later: references to sales as late as 1914 are included as part of the original entry on baskets woven long before that date. Amy appears to have begun the ledger in early 1918, less than two years before her death. Changes in the details of information, neatness, and spacing indicate that entries for baskets through 1917 were copied from certificates, while later entries were recorded as each piece was obtained.

The compilation of ledger entries from certificates does not in itself cast doubt on their veracity. But additional evidence demonstrates that much of the information is either incorrect or purposely falsified. For example, the dates on which major baskets were said to be completed often contradict other, more contemporaneous forms of information. Van Loan illustrates an Emporium photograph of the degikup numbered L.K.43 in a Los Angeles newspaper article (Van Loan 1906) published September 16, 1906, only eleven days after the basket was supposed to have been completed, according to the ledger entry. In fact, Van Loan probably obtained the photograph when he visited the Emporium and Bicose in August, before the recorded completion date. Local Carson City newspapers often note when Cohn put a newly finished Louisa Keyser degikup on display in the Emporium window, and these dates seldom accord with ledger entries. We must assume that the dates Amy recorded were estimates. In the case of L.K.43, the basket Van Loan illustrates, the recorded weaving dates are from September 6, 1905, to September 5, 1906, or precisely one calendar year, evidently an approximation.

Because Amy did not introduce the Emporium certificates until 1900, the ledger entries on Louisa Keyser's earlier works are incomplete. Of the first twenty-one entries, measurements are included only for the four baskets (L.K.1, 2, 3, 20) that remained in Carson City. Since Amy had no hope of reconstructing the order in which these early pieces had been woven, she began the ledger with three baskets that had been woven at different times, purchased by the Cohns's friend Dr. S. L. Lee, and were among those remaining in Carson City. Baskets numbered L.K.4 through 16 are more haphazardly ordered. Amy then recorded without number, and apparently as an afterthought, four twine-covered whisky flasks that she claimed in Emporium pamphlets had been among Louisa's first products. The entries for degikup L.K.18, 19, and 20 appear to be in the correct order. Because they were the first of Louisa's individual and spectacular style, were illustrated by Mason (1904: pl.180) and James (1909: figs. 119, 304), and were the most recently completed before the certificates were introduced, they were best remembered. But the entry following these more accurate records is completely out of place. Amy records as L.K.21 the goblet-shaped basket that appears with other early works in the "Queen of the Basket Makers" portrait. James (1915:37) suggests that this basket was among the first pieces of Louisa Keyser's work purchased from the Emporium, and it must have slipped Amy's mind until she was reminded of it by the photograph. Unfortunately, another early basket by

Louisa Keyser, which may have been sold from Sloan's store in 1899, was never photographed and remained forgotten, so that it does not appear at all in the ledger.[10]

Both the absence of certificates before 1900 and the resulting incorrect order of the first twenty-one baskets in the ledger are understandable. But Amy needlessly falsified the beginning and ending dates for weaving each piece. The spans indicated are simply rounded or averaged numbers: most are recorded as thirty days, while the others add up to either thirty-five or forty days, equally approximate. More important, Amy treated these hypothetical spans of time for weaving, and the fictitious order in which they were recorded, as if both types of information were accurate. On the basis of these estimated intervals, she fabricated specific calendar dates for the start and finish of each basket. By this method, she carried the patronage of Louisa Keyser back to November 1, 1895, which we now recognize as another fabrication. The actual date cannot be reconstructed, but the certificate/pamphlet issued by the Emporium in 1900 suggests that Louisa began weaving her first baskets for the Cohns in 1896 or 1897 (Emporium, n.d.A).

Such unreliability seems odd to us, for we think of a ledger as the best means to keep records straight and avoid distortions produced by faulty memory. But in the context of collecting Native American art at the turn of the century, these exaggerations and falsifications may not have been exceptional. The journal of his basket collection kept by Dr. Lee may have an even higher proportion of inaccuracies and fabrications.[11]

Emporium Propaganda: 1900–1925

The details of Louisa's life and career appear in pamphlets issued by the Emporium to advertise the collection, and in newspaper articles based on them. The first pamphlet (a combined pamphlet, certificate, catalogue, and vocabulary) was issued early in 1900, and contained a descriptive text entitled "The Queen of Basketry: Louisa Keyser" (Emporium, n.d.A). This description is more straightforward and less exaggerated than later ones, and it is the only one that refers to Louisa by her English name. Most of the fabricated context for Louisa and her baskets is presented in two later pamphlets. One, issued probably in 1905 (Emporium, n.d.B), has a text entitled "How the L.K. Baskets Are Made," while the next, issued in 1911–12, is called "Indian Art" (Emporium, n.d.C). The 1909 publication of the Leisure Hour Club lecture (Cohn 1909) contains

similar information and was an equal source for newspaper articles. The points contained in these publications are amplified and further exaggerated in the three articles that McNaughton based entirely on information supplied by the Emporium (1903, 1912, 1915).

In general, the Emporium propaganda was designed to make Louisa Keyser's art appear exceptional and yet traditional, and to make Louisa seem as colorful as possible. Its elements were contrived to present an image consistent with the whites' view of the Washoe as Indians. A discussion of this propaganda follows in three sections, and examines the exaggerations of Louisa's life and career, the falsifications surrounding the degikup, and the negative aspects of her appearance and personality.

Louisa's Life and Career

Emporium propaganda generally treated Louisa as an anachronism, a symbol of the superiority of Native life before white contact. This approach required exaggeration of the quality of Louisa's art, and obfuscation of her originality. Thus whereas Louisa introduced fine stitching as part of the transformation of Washoe basketry to a curio art form, and this innovation was imitated and even exceeded by other weavers (Cohodas 1979), the Emporium claimed that Louisa's technique was unique, that she was the "last of the great weavers," and consequently that true quality in Washoe art would die with her.

To exaggerate her capability, Amy claimed that Louisa could split a single willow branch into twelve to twenty-four threads. In fact, there was no shortage of willow to inspire such virtuosity, and in my experience the three-strand split still practiced by the Washoe is by far the most efficient. In order to further exaggerate her uniqueness, and suggest that as a traditional native artist Louisa was resistant to change and technology, the literature claims that Louisa accomplished this multistrand splitting by using her teeth and fingernails, with only a broken knife blade or bit of glass for cutting. The reader would have to be very gullible to believe that Louisa would not accept a new knife if it made her task easier.

To reinforce her appeal as a traditional weaver, Emporium literature repeatedly describes Louisa trudging over hills and mountains to collect her weaving materials. When this description first appeared (Emporium, n.d.B), it may have been accurate. However, it was consistently repeated to enhance Louisa's status as a symbol of traditional Washoe culture even when it no longer held true. Several Washoe interviewed believe that Louisa had other weavers bring her the materials, which seems

likely in view of her eventual year-round residence with the Cohns. Many commented on her inactivity, partly the result and partly the cause of her extreme weight. For example, in describing Louisa at her weaving, Keller noted: "She had a cane with which she hooked material. What she couldn't reach with the cane she asked us to hand her" (Keller 1910:75). Although Louisa is supposed to have been filmed in the process of collecting materials in the movie Abe had made of her in 1922, it was probably the only time in her later life that she attempted such an expedition.

The Cohns also exaggerated the prices paid for Louisa's baskets in order to reinforce the concept of her unique superiority. Claims that in 1888 her baskets sold for $50 apiece (Emporium, n.d.B), or that in 1906 they refused $2,500 for "Beacon Lights" (L.K.41) (Van Loan 1906), are patently false. In fact, the Cohns were thrilled to sell this piece for $1,400 in 1914. In this sale, G. A. Steiner bought over sixty additional baskets from the Emporium, bringing the total bill to $1,950.[12] However, the Cohns slyly suggested to the newspapers that the single basket had been sold for nearly $2,000 (Carson City News, April 1, 1914). Characteristically, this exaggeration was quite unnecessary. The true price paid for the basket was just as extraordinary for that time, and reporting it would not have changed the public's enthusiasm.

A more puzzling example of misleading statements occurs only in the pamphlet of ca. 1905 (Emporium, n.d.B). After lauding "Beacon Lights" (L.K.41) as the finest example of basketry art, Amy notes that Louisa might never complete another masterpiece because of failing eyesight. Unlike other propaganda statements, this one was not repeated in later Emporium publications, and may thus have had some truth to it. As mentioned above, Van Loan, who interviewed Abe Cohn in the summer of 1906, repeated the assertion with additional embroidery (Van Loan 1906:5). However, Van Loan's private letter to Grace Nicholson gives quite a different impression. He attributes the impending cessation of weaving to "regular drunkenness."[13] Were the Cohns attempting to cover up the possibility of Louisa's career ending in alcoholism by suggesting the more acceptable fate of blindness? Unfortunately, Van Loan's letter is also not entirely reliable. The negative comments on Abe Cohn as well as Louisa Keyser may derive in part from the antipathy Grace Nicholson held for them: she resented the Cohns' elevation of prices on Washoe baskets and their monopoly of Louisa's works.

Amy's ledger provides a third source of information on this crisis in Louisa's career.[14] "Beacon Lights," the masterpiece Louisa had completed

in 1905 that was illustrated in the Emporium pamphlet issued shortly thereafter, was almost twice as large as Louisa's previous works, and thus took twice as long to weave: fourteen months. From time to time, Louisa put this monumental work aside to weave small baskets that could be completed rapidly. This pattern of creating minor works while large baskets were still in progress continued for the remaining twenty years of her career. Abe later noted to Henrietta Burton: "She would make just one large basket a year and she needed much coaxing and encouragement. She spent the rest of her time in idleness or weaving miniature baskets" (Burton 1932:7). We may note also that Louisa's artistic approach was undergoing profound change at this time. In 1905, after weaving variations of the same pattern on all of her baskets for six years, she began introducing on the minor pieces the design arrangements that would later (after 1915) dominate her weaving until the end of her career. We might expect some aspects of disorientation to correspond with these changes of direction.

What then was the real source of the Cohns' anxiety? Was it merely that Louisa put off finishing her major baskets to take up the minor ones? Did Louisa take up the weaving of minor baskets to resist some pressure to continue the standard pattern on major works? Did she find that weaving larger works strained her eyes more than weaving simpler works? Or did she resort to liquor when uncertain about the direction of her weaving, or when eyestrain made it impossible even to create minor baskets? We may never know the real reason. However, this discussion illustrates a problem consistently encountered in reconstructing Louisa's life and career: the sources rarely corroborate each other. Each point of view seems to arise from a separate reality, producing small bits of information too disconnected to complete the puzzle.

The Degikup: History, Function, and Meaning

In contrast to the refined baskets of the twentieth-century curio trade, Washoe weaving at the end of the nineteenth century had been dominated by a coarse, utilitarian approach. In the late 1890s, adaptation of coiled basket weaving to the curio trade required Washoe weavers to achieve greater sophistication in both technique and design. Some weavers attempted to improve the aesthetic quality of their basket weaving while remaining within the parameters of traditional Washoe shapes and designs (Cohodas 1983:17–20). In contrast, Louisa Keyser adapted stylistic traits of nonutilitarian basket weaving from the Pomo and Maidu of Cali-

fornia to create a new Washoe form: the *degikup* (Cohodas 1982:132–36). By steadily increasing the fineness of her weaving technique, and by exploring the *degikup* form as a medium for the highest expression of Washoe basketry art, Louisa earned the Cohns' life-long patronage. By 1900 other weavers were making *degikup*, and by 1915 it had become the preferred shape for coiled basket weaving. Louisa's innovations of fine stitching and two-color patterns were likewise adopted by other weavers to form the foundation of Washoe curio style. Furthermore, these Washoe weavers not only utilized designs Louisa had borrowed from Californian wares, but they also borrowed or invented new designs on their own. Louisa Keyser thus deserves credit for originating the popular curio style of Washoe fancy basket weaving, both because she introduced the finely stitched, two-color *degikup* and because she inaugurated individuality and innovation for others to follow.

Emporium propaganda about Louisa's *degikup* was designed to obscure its recent, nonutilitarian origin and proclaim it a traditional form. Each new fabrication seems to have required another to support it, fulfilling the warning in Sir Walter Scott's poem *Marmion*: "Oh, what a tangled web we weave, / When first we practise to deceive!" It is possible to reconstruct a general sequence for these fabrications that accords with the dates on which they first appeared in Emporium publications or articles by McNaughton based on information from Amy Cohn. For brevity and clarity, these are presented below in the form of a hypothetical dialogue between a customer (the questions) and the Cohns (the answers).

QUESTION: Why haven't we seen any *degikup* before 1897?

ANSWER: When the Paiute defeated the Washoe around 1860, they forbade the Washoe to weave any fine or ceremonial baskets (McNaughton 1903:436).

QUESTION: If the Paiute prohibited weaving such baskets, why does Louisa Keyser make them?

ANSWER: Abe Cohn has promised to protect her from Paiute reprisals (Emporium, n.d.B [ca. 1905]).

QUESTION: Why didn't other weavers immediately take up *degikup* when Cohn offered his protection?

ANSWER: Only Louisa had inherited the right to weave *degikup* (Emporium, n.d.B).

QUESTION: What made her special? Why don't other weavers have the right?

ANSWER: She was the daughter of the leading Washoe, a chief, and she inherited the position of medicine-woman from her mother (McNaughton 1915:14).

QUESTION: How could Louisa remember the process of weaving degikup during all those years of Paiute prohibition?

ANSWER: She continued to weave them, but to protect her, a relative destroyed them all (McNaughton 1915:14).

Viewed diachronically, these fabrications show increasing emphasis on fabricating details of Louisa's life before contact with whites and before working for the Cohns, making her life and art appear more traditional.

These invocations of tradition and history can be easily disputed. In explaining the absence of the degikup by means of Paiute prohibition, the Emporium was adapting a popular story to a new purpose (Cohodas 1982:124–25). Although the Paiute had neither defeated the Washoe nor imposed a prohibition, Powers had used the same theory in 1875 to explain why the Washoe had not adopted the horse, unlike their Great Basin neighbors the Paiute and Shoshone (Fowler and Fowler 1970:124). Claims of special status for Louisa Keyser through her father are also false. The Washoe had not adopted the Plains Indian form of ranking, so they did not recognize chiefs or other permanent authority. Those who emerged as spokesmen for the Washoe in relations with white authority were called "captains," and Louisa's father was not one of them.[15]

The purpose of these fabrications is to take the credit for developing the degikup away from an individual in order to attribute it to the tribe. Whereas individual innovation suggested rapid change and present times, tribal origin placed the degikup in a changeless, traditional past. This shift was necessary to the curio trade, because buyers craved an aura of tradition to satisfy their nostalgia for a calmer and nobler past.

To compete with the mortuary function of the Pomo and Maidu spheroid baskets that had been Louisa's inspiration, Amy Cohn claimed a similar function for the degikup. She described a fictitious burial tradition in which a large storage basket was placed on the chest of a deceased male, his prestige demonstrated by the fineness of the degikup buried or burned with the body; a woman was only supposed to have a burden basket inverted on her grave to show that her life's work was done (Cohn 1909:76; McNaughton 1903:581). Anthropological sources reveal instead that Washoe tradition specified only the burial of the dead person's be-

longings, and the desertion of the house in which that person died. Such destruction prevented the potentially harmful ghost from returning to the living by way of the path of familiar property (Freed and Freed 1963:45). Washoe men used only a few objects made of basketry, such as the fish trap, while women made most basket types for their own use. Thus in a traditional Washoe burial we would find most baskets thrown into the grave of a woman, and almost none in the grave of a man, precisely the reverse of Amy's fabrication.

Emporium propaganda recalled the actual Washoe burial tradition only once, and long after the Washoe themselves had ceased conforming to it. Louisa's last *degikup*, requiring only a few more rows for completion, was buried with her. Abe Cohn reported to the papers that Louisa had requested this sacrifice in order to conform to tribal law. However, on two earlier occasions (1908 and 1918) Louisa had ignored this tradition by finishing baskets other weavers had left incomplete at their deaths. She actually finished two baskets begun by Scees Bryant, her brother's wife, a woman whose close kinship represented great potential for harm to Louisa if she had returned as a ghost.

There must be another reason for the burial of Louisa's basket with her. Many explanations could be suggested, but we have so little reliable information on her personality or beliefs that it is impossible to make an intelligent judgment. On the other hand, attributing the decision to Abe Cohn would be consistent with the Emporium approach of elevating Louisa as a symbol of traditional Washoe culture. For example, in opposition to Louisa's stated preference for her English name, the Cohns distinguished her from all other Washoe weavers by using the Washoe name, Dat So La Lee. For the same reason, Amy pushed back Louisa's birth date to 1834 (McNaughton 1915:14), falsely placing her in the period before the first contaminating white contact, and Amy also exaggerated the beginning of their patronage arrangement to 1884 (Emporium, n.d.B).

Further fabrications were necessary to make the designs on Louisa's *degikup* appear traditional. As Merriam,[16] Barrett (1917:22), and others have noted, the designs that characterized Washoe coiled basket weaving in the twentieth century were of recent introduction, primarily from California styles. To counter this, Emporium pamphlets consistently asserted that Louisa's designs represented a kind of family crest she had inherited. As a corollary, it was claimed that no weaver from another family was allowed to copy her designs. The reader of this propaganda would have

to have been very distant or very unobservant, since a quick look at the basketry display in the Emporium or Bicose would show that virtually every weaver imitated Louisa's designs!

The Emporium pamphlets also consistently mention that weavers never repeat the same design on another basket. This is first mentioned in the 1900 pamphlet, when Louisa had not yet produced the same combination of shape and design on more than one piece. That her approach was worthy of specific comment may derive from its opposition to the conventional view of basket weaving as a repetitive craft. However, in the miniature baskets, which Louisa first began weaving in 1905, she often produced duplicate combinations of form and pattern, and other weavers followed suit.[17] Rather than abandon the assertion that such duplication did not occur after it ceased being true, Amy repeated it more vehemently, now supporting it by invoking tribal law as sanction (Cohn 1909:76). In Emporium propaganda, invoking a fantasy of the past to obscure changes in the present requires that reality and fiction must draw increasingly apart.

Emporium propaganda asserted not only that the *degikup* designs were traditional but that they were symbolic. In a 1902 letter to Nicholson's buyer, C. S. Hartman, Amy wrote: "with each individual basket we give catalogue numbers, history, and description or definition of the symbols or hieroglyphics on them, and in every way endeavour to make each article an interesting relic."[18] In particular, Louisa was called the tribal historian, and her designs were said to encode the legends, history, and traditions of her people, in part to keep them from being forgotten. The contradictory evidence that the designs were of recent introduction, and even the denial of meaning by Louisa herself (Keller 1910:75), did nothing to dampen popular enthusiasm for the symbolic interpretations emanating from the Emporium. Furthermore, despite her claims that these designs recorded Washoe tradition, Amy applied the same vocabulary to baskets of other tribes sold in the Emporium.

Amy's approach to the interpretation of symbolism in basketry design may be reconstructed from the explanations she wrote on the certificates, especially those for Louisa Keyser's major works. Amy made numbered sketches of the motifs on the blank side of the certificate, and also wrote out identifications for each. In these identifications, she followed a strict vocabulary of her own invention, involving a standardized meaning for each motif. While designs made up of simple motifs, lacking in variation, could be explained simply, Amy felt constrained to account for any

variations of a single motif with much more complicated analyses. For example, she sketched four variations of the "flame" or "sunlight" motif on L.K.50,[19] called "The Signal Code," and she explained these variations (fig. 19).

In addition to these sketches and explanations of motifs, Amy sometimes provided an invented background in the form of an ethnographic record. Such descriptions always emphasize men's activities, ceremonials, inheritance, and status. Perhaps the most elaborate was occasioned by Louisa's innovative adaptation of the form of a twined burden basket to the coiling technique in the work numbered L.K.51. As with the *degi-kup*, Amy had to counter this introduction of a new form with a weighty defense of its traditional origin and function. Her colorful fabrication appears on the reverse of the certificate:

> Burden or carrying shape or form, a style of basket in this stitch made only by the favorite relative of the Chief, who was a good weaver in fact the most expert weaver of his family. Used in ceremonials preceding great or important undertakings or expeditions.
>
> It was placed in the center of the circle near the council fire. As each brave or person connected with the expedition passed the basket as they circled in their ceremonial maneuvers or dances, a gift or propitiatory offering was cast into it to gain success from the "Great-Good-of-All."
>
> These offerings became the property of the officiating Chief.
>
> The burden-basket shape symbolized the laying of their burdens or sorrows, fears and hopes, into the will of their spiritual Chief.

On the front of each certificate, Amy referred to her interpretations of basket meanings with a short title, and sometimes with a long sentence composed by stringing together the identifications of each motif from her vocabulary. For example, an explanation appears on the reverse of the certificate for the coiled burden basket L.K.51 (Fig. 20). From these identifications, Amy created the long title for this basket, recorded on the certificate front (Fig. 21): "Our men camped beside the roads and rivers, then assembled around the campfires, praising and extolling the shrewdness and skill of their hunters in obtaining game." Amy also abstracted from this long title a shortened form, "Extolling the Hunters," which appears on both front and reverse of the certificate, and by which the basket is now known.

The intent of these interpretations is evident from the vocabulary and

Figure 19. Certificate for L.K. 50. Amy Cohn's analysis of motifs:

A. Building a fire in the daytime, covering it with a blanket, then raising it, making the smoke swirl in many forms, each one a recognized symbol.

B. Building a fire at night, propping a blanket up on supports, or building in front of it a barricade of brush, and making the flames form signals.

C. Attaching cloths to sticks on poles and waving them in the sunlight.

D. Hanging cloths on the limbs of trees to wave signals.

Figure 20. Certificate for L.K. 51, written by Amy Cohn. Four of Louisa's major baskets were sent to G. A. Steiner in 1915 in the hope that he would purchase at least two, and thereby finance Abe's plan for a museum of Washoe basketry art. Steiner returned the baskets but kept the certificates.
(Courtesy Kennedy Mill Farm Corporation)

the pseudo-ethnographic explanations. First, the references are only to a supposed traditional past, not to the present reality of Washoe life. Second, there are no references to any aspects of life that would have been of concern to the women who made the baskets and used them in nurturing their families.[20] Instead, the mentions of hunting and war, of cults and rituals, refer specifically to male action and status. The same emphasis may be noted in Amy's fabrication of a mortuary tradition for the degikup. In both situations, the feminine, creative aspects of basketry are inverted to associate them with male destruction, competition, and prestige. Third, although the certificates and pamphlets claimed that Louisa was recording the myths and traditions of her people, references to known Washoe myths and ceremonies are notably absent. The many references to chiefs' compacts, tribal councils, and signal fires recall the idealized and romanticized vision whites at this time held of the Plains Indian warrior and his traditional culture.

The defeat of the Plains Indians who had heroically resisted white encroachment, and their subsequent humiliating confinement on reservations, may be at the heart of the nostalgia that fed the curio trade in the

Figure 21. Portion of reverse of the certificate for L.K. 51. Amy illustrates each design motif with an explanation derived from her own vocabulary. Louisa's reproduction of the Washoe twined burden basket in coiled weaving constituted an artistic innovation, to which Amy responded by fabricating a ceremonial use for this unique piece, as if it were a traditional form. Amy also mentions Louisa's inclusion of the braided rim finish, abandoned by most weavers during the florescence of Washoe curio weaving.
(Courtesy Kennedy Mill Farm Corporation)

late nineteenth and early twentieth centuries. Once they no longer posed a threat, their past could be rewritten to suit the needs of the present. The Plains warrior became the noble savage, living in harmony with nature while perfecting masculine attributes of bravery and pride. Whether one looked at his noble or his savage side, the Plains warrior remained an

image of power, the worthy if doomed antithesis to the effete and anxious city-dweller of our industrial age. The stereotypes of the Plains warrior with his feather bonnet and tomahawk, and his Indian princess with her fringed buckskin dress and braids, were popularized at this time throughout the United States and Europe, primarily through the dime novels and wild west shows. Perpetuated by the Hollywood film industry, the same stereotypes remain with us today, in their same antithetical role.

At the turn of the century, this romantic view of the noble Plains warrior also provided a means of dissociation from the degradation of current Indian life. The Washoe in particular, denied access to their subsistence resources, and with no reservation lands, survived as an impoverished and often pitiful few, existing on the fringes of white society. At best, they worked as ranch hands and washerwomen, and at worst they frequented the Chinese sections of towns and mining camps to obtain liquor and opium. The marketing of Washoe basketry as an ideal and poetic form of traditional art required that it be completely divorced from this current reality and identified with the fantasy of a nobler past. Thus the cover photograph of Amy's third pamphlet (Emporium, n.d.C), Indian Art, shows an "Indian Princess" with the title "A Western Idyll."

Amy knew how to take full advantage of the attraction this romantic vision of the Native American held for white popular culture. One report of her lecture on Washoe baskets states that she "appeared in the gorgeous costume of an Indian princess wearing many valuable pieces of bead-work into which the history, romance, sorrows, and joys of their tribes had been woven." At the climax of this presentation, "she recited some of the legends and traditions of the Indians with a dramatic fire that stirred and thrilled" (Carson City News, March 10, 1914).[21]

The interpolation of meaning into degikup designs was the key technique employed by Amy to identify contemporary Washoe curio weaving with the ancient warriors of the Plains. Discussions of these interpolations were thus given the greatest prominence in Emporium pamphlets and in Amy's public lectures. Her 1909 lecture to the Leisure Hour Club graphically illustrates the importance of design interpretation in separating the baskets from their present reality. Her lecture was only one part of a long evening dedicated to the fantasy of Indian culture, which included a reading of "Hiawatha." The climax was the tableau vivant for which Louisa Keyser herself was brought to pose. According to the newspaper report (Carson City News, February 26, 1909):

The picture in which Dat-so-la-lee posed was made trebly interesting because of two other figures. Mrs. Gladys Hofer, in a scarlet gown, recited an original poem by Mr. Vanderlieth in which the reasons for the designs in the basket were asked of the weaver. Her questions were answered by Miss Marguerite Raycraft, who represented the daintiest Indian maiden imaginable, and who is always the personification of grace. The answer is also the product of Mr. Vanderlieth's fertile brain.

As Louisa Keyser silently validated the interpretations of her basketry designs, invented and recited by members of another culture, she also embodied the antithesis of fantasy and reality that permitted the romanticizing of her art. Like most Washoe women of her time, Louisa was heavyset, dressed primarily in a print dress and scarf, and generally did not speak in public—precisely the opposite of the slender and graceful Marguerite Raycraft, who, as the Indian Princess, declaimed on basketry symbolism. Their juxtaposition at this event must have reinforced in the minds of the audience the superiority of their fantasy of traditional Indian life over the contemporary reality of Washoe existence.

Once transformed and regulated, other aspects of Washoe life also sparked the whites' curiosity. The final segment of this long evening of Leisure Hour Club activities devoted to Indian culture consisted of a presentation by students from the local Indian Training School. They demonstrated the products of crafts and trades that formed part of their compulsory curriculum.[22] Of course, these techniques of needlework and carpentry were of white origin, since the children were forbidden to perpetuate their Native culture.

In summary, by fabricating a traditional history, function, and meaning for the degikup, Amy Cohn identified it with the fantasy of a superior past that was the opposite of contemporary Washoe life. From the innovation of an individualistic Washoe woman to meet the needs of a contemporary curio trade, the degikup was transformed into a communal symbol of a glorious fictional past, emphasizing male activities modeled on the romantic ideal of the Plains warrior. For Louisa to become a symbol of this fictional past, she too had to be cleansed of white contamination, with her birth now placed in precontact times and her weaving said to be inherited by family right.

Amy's approach to the marketing of Louisa Keyser's degikup contrasts with that of Grace Nicholson, the other great promoter and patron of

Indian basket weavers. In many ways the two women were very similar. Like Amy, Grace Nicholson was a strong and independent woman. Orphaned at an early age, she was raised by her grandparents in Philadelphia, coming west to settle in Pasadena after their deaths. Like Amy Cohn, Nicholson selected talented weavers to patronize, and monopolized their entire output (McLendon and Holland 1979:112). Like Amy, Grace indulged in amateur ethnography and photographic documentation, and she even kept a ledger for part of her career. She also claimed that the baskets she sold represented authentic native tradition, in part because her clientele included museums as much as private collectors. However, unlike Amy, Grace Nicholson never romanticized her baskets, and did not bother to seek out possible meanings for the designs. Yet her sales were even more successful than Amy's. Perhaps the higher class clientele was put off by complex fabrications of function and meaning: G. A. Steiner paid the highest price for a *degikup* by Louisa Keyser that had no discussion of its symbolism, but refused to buy, even at a discount, two pieces sent on approval with very elaborate explanations.

Why then did Amy continue to elaborate the fabricated context for Louisa and her *degikup* and the fantastic explanations of its function and design? In part, Amy must have responded to the local cultural environment, which contrasted with that of Pasadena in its continuing pioneer flavor, and in the constant presence of Washoe Indians conflicting with ideal images of the Native American in his glorious past. In her fabrication of poetic and elaborate interpretations for the basketry designs, Amy took on the role of Louisa's precontact alter ego. In pursuing her vision of basketry as a symbol of the glorious past, Amy expressed her own personality and achieved some degree of public recognition. Identifying with this ideal fiction became her niche in society. Judging by contemporary reports, Amy was never more vital than when she appeared in the dress of an Indian princess and thrilled her audiences with recitations of Native myths and explanations of the poetic symbolism she divined in Washoe basket weaving. As a writer, Amy had the talent to convey her own vision to others in such a way that it would engulf them as well.

Louisa's Physical Appearance and Personality

On some topics, the exaggeration and falsification that dominate Emporium publications become quite derogatory. While Louisa is admired for those artistic and historical elements—real and fictitious—used to make her an impersonal symbol of Washoe life in a glorious past, those

elements defining her as an individual in contemporary context are derided. Here is the initial description from the 1900 pamphlet (Emporium, n.d.A):

A squaw, whom nature has endowed with considerable *avoirdupois*, but whose delicacy of touch and artistic ability none can dispute, posessed of child-like blandness, but gifted with much shrewdness and cunning, resorting to romancing and even weeping to gain a desired object. Hand symmetrically perfect, with fingers plump and tapering, she weaves daily her beautiful artistic creations, secretly vain and chuckling at the mere mention of any squaw that can compete with her.

This description involves a pair of clear oppositions. Physically, Louisa's weight is derided while her hands are admired. Spiritually, Louisa's personality is derided while her artistry is admired.

While later Emporium publications repeat the same points almost verbatim, some newspaper and magazine articles take this description as a departure point for further elaboration. In her 1912 article, McNaughton follows the order precisely but exaggerates the details (1912:19):

Fat and course-featured, and with long and straight hair hanging to her waist and banged across her forehead, nearly covering her beady black eyes, she certainly has few marks of beauty. Conceited to a wonderful degree, and possessing control of an ever-ready tear font when desiring to gain anything from her "boss" (as she designates Mr. Cohn), an inveterate liar, ever boastful and ungrateful, she has nothing to recommend her until the cunning work of her shapely hands is in evidence. Then the fat, repulsive old Indian squaw becomes a wonder-worker. One can hardly realize that such delicacy of touch and artistic creative genius could dwell in such a tenement.

The crudity of this attack only sets in bolder relief the emphasis on contrasting positive and negative qualities that served to describe Louisa Keyser.

The reason for emphasizing these contrasting qualities appears to be an expression of the different views that whites held of the Washoe. The same people who idealized and admired the native past also despised those Indians with whom they associated. While admiration for Louisa's artistry was part of this idealization of the Indian past, ridicule of her appearance and personality was part of the deprecation of the Indian present.

This association is clearly expressed in a 1911 newspaper article. Entitled "Sorrow Bows the Proud Head of the Famed Dat-so-la-lee," (*Carson City News*, December 28, 1911), this article was prompted by Charlie Keyser's sentencing to three weeks in jail for alcohol abuse. Instead of discussing Charlie's problem with alcohol, the article satirically speculates on Louisa's loneliness and sorrow, contrasting it with an idyllic life of the past. Characteristically, those passages describing this idyllic past combine the idealized view of the Native American in harmony with nature with a positive description of Louisa as a traditional artist: "The ponies are cropping the bunch grass from the hillside while on a large flat rock which draws the rays of the morning sun, her soul-mate lies upon his shirt-front and sleeps the hours away. There is an air of contentment in the scene, and she plaits her basket with brain-tipped finger. . . ." Although this idyllic past is described ostensibly to contrast with Louisa's sorrow at her husband's imprisonment, the present situation is described largely in terms of Louisa's weight and personality: "Her sylph-like form of over twenty-three stone in weight careens like a bark at sea as her pent-up emotions overflow and she finds solace in the woman's dowry of tears."

Such fanciful descriptions of Louisa Keyser represent only one example of the general approach to stereotyping Native Americans that sustained the curio trade in the early twentieth century. This widespread symbolic paradigm involved stereotyping both past and present, artificially reinforcing the contrast between the two. Just as the positive aspects of traditional life were magnified to create an idealized and romantic vision of the noble warrior and his princess in harmony with nature, so too the negative aspects of modern life were selected and exaggerated to create a despicable image of the contemporary Native American as coarse, stupid, violent, and generally drunk. The wonders of the past were thus enhanced by contrast to the debasement of the present.

As products of Western civilization, most of us are familiar with such black-and-white polarization. For example, the existence of heaven and hell cannot be substantiated, yet their opposition long served to concretize the positive and negative feelings we have about ourselves, each other, our society, or the environment in which we live. Closer to the point are medieval morality plays, or even Shakespeare's masterpieces, which express such oppositions as the more two-dimensional characters who surround the three-dimensional "Everyman."

In the Far West, at the turn of the century, the whites who created and used such stereotypes of the Native American may have been placing

themselves in this same middle ground as Everyman. They could feel inferior to the Native American of a pure and noble past, but superior to those of a tainted and debased present. Perhaps they used such stereotypes to rationalize their exploitation of the Indians and takeover of their lands, or to externalize ambivalent feelings about themselves as individuals and as a society. If so, how they actually felt about Indians would be incidental. This would explain how the artistry and originality Natives put into their curios could become secondary to the aura of tradition that buyers attributed to them.

Louisa's personality was also targeted for derision in anecdotal newspaper articles that described Abe's clashes with her. Typical is the 1911 article entitled "Abe Cohn Is in Serious Trouble Once Again" (*Carson City News*, October 7, 1911). Framing a long description of Louisa and her career that is paraphrased from Emporium publications, the first and last paragraphs of the article relate Abe's anecdote concerning Louisa's discomfort on the stagecoach bringing her back from summer residence at Tahoe City. These two paragraphs, along with the subtitle, appeared as follows:

> Mrs. Louisa Keyser, the well known
> artist, gives tongue lashing to manager
> of the Emporium.

Last evening, when the Glenbrook stage arrived, a big fat squaw was unloaded with the assistance of several men, and after she had been safely landed on terra firma, she gave a grunt of satisfaction and bundled herself off to give a lecture to Abe Cohn on the ways of the White people and the way she was abused. Cohn saved himself from the tirade by handing the buxom lady a half dollar and vanishing out the back door of his store. . . .

For the next few days, it will be comical to watch the antics of Cohn, for Mrs. Keyser came down from Glenbrook last night, mad as a march hare, and life will not be sweet for Abe until he has managed to explain to her that only one seat in a stage can be given to any one passenger.

These passages offer several familiar stereotypes, such as the shrewish wife who delivers a tongue-lashing, or the selfish and immature child who greedily accepts a bribe. But these stereotypes represent but one pole of a dichotomy in which Abe Cohn, with his rational, adult male behavior, represents the opposite. Recourse to such obvious negative stereotypes suggests that the article is trying to associate Louisa with

some element both wives and children have in common. For example, both are subordinate to the adult male who heads a family and becomes responsible for their physical and financial well-being. Likewise, in her patronage relationship with the Cohns, she relinquished power over her life in return for financial security. This arrangement allowed the Cohns to fabricate her public image, which they based on such stereotypes. But whereas Amy was primarily concerned with placing Louisa's artistry in a traditional past that contrasted with the debasement of the present, Abe's anecdotes express his power over Louisa through ridicule.

Unlike the stagecoach anecdote, which was never reprinted by the press, two other stories incessantly repeated by Abe Cohn and others have become fixed in the legend of Dat So La Lee. One concerns the train journey to St. Louis in 1919. Louisa is supposed to have become tired of traveling by the time they reached Kansas City and to have decided to walk back home. The joke was that she would have to be very stupid not to know she had come too far to walk back, just as in the stagecoach story she was supposedly unaware that a single ticket purchased a single seat. The other familiar anecdote concerns the corset Louisa asked Abe to order for her. She angrily returned it when it did not transform her into the slim beauty of the advertisement. Again, the laugh is on Louisa for thinking that a corset would make her bulky form appear thin.

These stories may not seem very funny to us, and they are certainly no longer believable, but at the time they were popular and considered accurate. White people liked to think of Indians as being unable to cope with white technology, because it helped validate their sense of superiority. The fact that Louisa was intelligent, and had made the best of white presence in Washoe territory, did not affect the public's treatment of her. Instead, her visibility allowed her to stand in for the tribe as a whole: she became the scapegoat for all negative feelings that whites had for Washoe.

The popularity of Abe's anecdotes goes far beyond an exaggeration of Louisa's personality and their patronage relationship. The highly visible relationship between this particular white man and a Washoe woman was exaggerated to function as a symbol of the total relationship between whites and Washoes. This example of cultural interaction was also expressed in terms of a domestic relationship between men and women, in order to focus on patterns of dominance and submission. The public's interest in such power relationships is evident from the article on Charlie Keyser's imprisonment for drunkenness (*Carson City News*, December 28, 1911). In their domestic relationship, Charlie is referred to as Louisa's

"liege lord and master." In their cultural interaction, Charlie, during his stay in prison, becomes a "servile slave to payless masters," while Louisa must submit to "the might and majesty of White man's Law."

Since women are supposed to be dominated by men, and Washoe are supposed to be dominated by whites, the submission of a Washoe woman to a white man was the perfect paradigm.[23] Abe was seen as the paternalistic figure of authority, while Louisa became the manipulative dependent. Abe willingly complied with this public need, relating anecdotes about Louisa that are the same type men often tell to ridicule their wives. The patronage relationship between Abe and Louisa was treated in the newspapers as a caricature of a marriage. In fact, a "tall tale" that appeared in a Carson City newspaper in 1913 (*Carson City News*, March 26) creates a fantasy of the first meeting between Abe and Louisa by recalling a European legend of doomed lovers, casting Abe as Tristan to Louisa's Isolde.

Although we may recognize the reasons for these exaggerations of Louisa's personality and relationship with Abe Cohn, we must still wonder how much truth there was in the negative traits attributed to her. Abe may well have encouraged Louisa to be childish and manipulative if that was the only way he would deal with her needs. How could we ever know, since the pamphlets and newspaper articles are purposely distorted?

Fortunately, there is one negative anecdote for which we can reconstruct Louisa's side of the story. It concerns the Leisure Hour Club meeting of February 1909, in which Amy Cohn lectured and Louisa posed in a tableau. Louisa was evidently uncomfortable and impatient at the long wait for her stint at the end of the evening. A local resident remembered that she was in mourning at the time (Elsie Chichester, pers. comm., 1983); and in fact, although the precise date cannot be determined, Louisa's brother, Jim Bryant, had died within the previous year.[24] Adding to her grief, her stepson, Charlie Keyser, Jr., had shot his wife to death a month before, and was in prison awaiting certain conviction and execution. Considering these personal tragedies, Louisa's ill-temper at waiting through the long function is understandable.

Whereas such behavior would be excusable in another person, it seemed so appropriate to the stereotype of Louisa's childish personality that it was selected for public comment and reinterpretation. Here is what the newspaper reported: "It is said that for every fifteen minutes delay, Mr. Cohn was compelled to add a yard of calico to the stuff promised her for a new dress and as she waited over two hours for her 'stunt' on the

program, it is safe to conjecture that she will have sufficient goods to make two dresses" (*Carson City News*, February 26, 1909). Although this story may sound logical, it should be remembered that Abe Cohn was not in attendance that evening. Louisa had come with her true patron, Amy Cohn, who would thus have been responsible for any necessary mollifying. Yet the newspaper story focuses on the fictitious marriagelike relationship between Abe and Louisa, fulfilling the established stereotype by depicting Abe bribing the peevish Louisa.

In summary, the references to Louisa's physical appearance and personality, in both Emporium pamphlets and newspaper articles, emphasize contrasts that must be interpreted as symbolic oppositions. In her pamphlets and lectures, Amy Cohn contrasted Louisa's artistic hands with her excessive weight, and her artistic talent with her manipulative personality. The purpose of these oppositions was to associate Louisa's art with an ideal vision of the traditional past by dissociating it from the debasement of contemporary Washoe culture and curio trade. On the other hand, Abe's contribution, highlighted in the newspapers, was to contrast his authority and rational behavior with Louisa's powerlessness and irrationality. Although Abe told the negative anecdotes primarily to increase the amount of prestige and attention he received, he was feeding into the popular conception of their patronage relationship as a symbol of Washoe submission to white authority, seen in terms of domestic relations between women and men.

Yet Abe and Louisa did make a likely pair. Abe's jovial, attention-seeking personality was the perfect foil for Louisa's retiring, taciturn, and sometimes emotional nature. Both took on the role of sideshow hawkers, with Louisa's public weaving and Abe's humorous storytelling designed to draw customers into the shop and keep them interested long enough to buy a Washoe curio. Van Loan's article (1906:5) makes this dual attraction clear. In Carson City, he was taken to the Emporium not so much to see the baskets as to hear Abe's "spiel" (as Van Loan called it). At Lake Tahoe, he recalled the unsurpassed beauty of Louisa's baskets as he met her at the steamer pier, on her way to a Washoe "pow-pow" in a childish funk.

Later Fictions on Louisa's Early Life

In creating a false aura of tradition for Louisa and her degikup, Amy tended increasingly to fabricate details of Louisa's early life, before contact with whites and especially before beginning her patronage

relationship with the Cohns. These efforts were renewed by Abe Cohn and others around the time of Louisa's death, resulting in the addition of several elements to the Dat So La Lee legend.

When Louisa was on her death bed in November 1925, Dr. S. L. Lee finally "revealed" the derivation of the name Dat So La Lee. Noting that Washoe often took the name of their employers and protectors, and recalling his earlier claim to have befriended and patronized Louisa before she came to work for the Cohns, Lee explained that she must have used his name, transposing "Doc" to "Dot" and then making syllables out of his initials (*Nevada Appeal*, November 4, 1925). Of course, waiting until Louisa was too infirm to object casts doubt on the veracity of his claim. In fact, Washoe took English names from their employers, not Washoe names. Moreover, the Washoe recognize the name (which they pronounce "Dats'-ai-lo-lee") as a Washoe term meaning "big hips." Lee's claims to pre-Emporium patronage are likewise unsubstantiated: the baskets in his collection woven by Louisa Keyser were all acquired from the Emporium in 1899–1900, well after she began weaving for the Cohns.

Abe Cohn also had a story to tell of Louisa's early life and his influence on it. The most complete narrative of these fictional events was first compiled in the report Henrietta Burton prepared for the Bureau of Indian Affairs in 1932, based entirely on interviews with Abe. This narrative has since been repeated and further elaborated in most of the newspaper and magazine articles on Louisa Keyser written since that time (see, for example, Mack 1946; Ewing 1983).

Abe's fictional narrative of Louisa's early life begins with the story of her meeting, in 1844, with John C. Fremont, the first white man to record his journey through Washoe territory and contact with the Washoe. Louisa is supposed to have been with a nephew, who was kicked by a soldier's rearing horse. By way of apology, Louisa was given some brass buttons which she treasured throughout her life and took to her grave. According to this narrative, shortly before her death Louisa guided Cohn to the spot in Eagle Valley where the meeting took place.

As with the other narratives, this fiction has generally been accepted despite its historical impossibility. As Gigli (1974:5) notes, Fremont did not pass through Eagle Valley. Also, Louisa was afflicted with dropsy in later years, and could not even walk a block without resting (Nancy Bowers, pers. comm., 1983), so it is unlikely that she guided Cohn anywhere. In order to accommodate this meeting, Cohn had to revise her year of birth back to 1829, thus contradicting Amy's assertion that Louisa was born in

1834. Both dates are exaggerated: Louisa's birth cannot be pinpointed, but it must have been between 1845 and 1855, so Louisa was probably not yet born when Fremont made his historic contact.

While Amy's exaggeration of her birth date to 1834 had served to place Louisa's origin in a precontact setting, this later story of her meeting with Fremont also incorporates the two themes earlier developed around the selection of Louisa Keyser to represent the entire Washoe tribe. First, Louisa is here placed in the significant moment of first recorded contact which separates Washoe prehistory from Washoe history, and thus symbolically separates their glorious and idealized past from their debased present. Second, the tale involves the usual opposition of an active white man and a submissive Washoe woman to express cultural dominance.

The longer narrative documenting Louisa's early relationship with Abe Cohn is divided into two episodes. The first, dated to 1871, reports that Louisa, known as Dabuda,[25] was hired by Abe's father, Harris Cohn, owner of a general store in the mining town of Monitor, California. While performing her domestic chores and caring for young Abe, Louisa tells him the tales and traditions of her people, awakening in the boy a lifelong interest in Indian culture. The second episode supposedly takes place in 1895, when Abe owns a clothing store in Carson City from which he sells baskets, and where Louisa, called Dat So La Lee, takes him four whiskey flasks that she has covered with twining. Recognizing her exceptional ability, Abe tells her to return to the weaving of the ceremonial *degikup*, promising his protection from Paiute reprisals. A longer version of this tale elaborates their dramatic reunion, as Abe finally realizes that this old Indian woman is actually the beloved Dabuda of earlier days.

Stern attempted to investigate this picturesque fabrication, finding only that no Harris Cohn owned a store in Monitor (Stern 1983:294–95). However, other contradictions render the entire sequence a fabrication. For example, a more accurate estimate of Louisa Keyser's birth would make her only five to ten years older than Abe, so she is unlikely to have helped raise him. And Abe was only one year old when his family moved to Virginia City (Gerald Cohn, pers. comm., 1989). Also, earlier Emporium propaganda (Emporium, n.d.B; Van Loan 1906:5) asserted that the Cohns' first contact with Louisa was when they hired her to do their washing.

This story is remarkably similar in structure to the tale of Louisa's meeting with Fremont. Both rely on the opposition of a white man and a Washoe woman to represent the dominance of white over Washoe, and both juxtapose the glorious Washoe past with the debased present. But

separation of this narrative into two episodes makes the contrast of past and present much clearer, and allows for a reversal of the pattern of dominance and submission. In the first episode, Louisa represents the native traditions of the Indian past which the whites of Carson City admired, so she appears as the figure of greater power or respect when she tells stories to the boy as she cares for him. A reversal occurs in the second episode, when she becomes dependent on Abe's protection and patronage. Now she represents the submission of present-day Washoe to benevolent white authority.

The same reversal characterizes the earlier fictionalized account of the initial contact between Abe and Louisa. This story appeared as a humorous "tall tale" in a 1913 newspaper, and casts Abe as Tristan to Louisa's Isolde (*Carson City News*, March 26, 1913). Although in the first part of the story Louisa is the powerful and wild native princess about to slay the helpless Abe, she voluntarily relinquishes her independence and follows Abe to Carson City, where she ends up as his humble artist-servant.

All three stories emphasize the reversal of power relationships to accommodate the whites' ambivalent view of the Native American as both brave warrior and drunk. All of these stories draw on the more widespread currency of the noble savage, a romantic image which is also at the heart of the European legend of Tristan (or Tristram). In the Western mind, progress is both inevitable and a moral imperative whereby man increasingly dominates nature, bending it to his rational will, thereby transforming it into culture. In American fiction, the Native American, whether noble or savage, is always doomed by his own cultural limitations to be pushed aside by the march of Western civilization (Billington 1981:106–7).

Riley notes that the Indian Princess is the female version of the noble savage type (1984:32). Whether an Irish Princess (like Isolde) or an Indian Princess, the choice of the feminine personality to personify nature, or man-in-nature, allows the legend to function as a parable for cultural evolution. Thus a stable character of nineteenth-century American fiction is the humble Indian Princess who aids the white man in his quest and thereby assures her own domination and often her own destruction (Billington 1981:108; Johnson 1892). The humorous and popular stories of Abe and Louisa represent a twentieth-century adaptation of this archetypal construct, still designed to reinforce notions of the moral and intellectual superiority of Western civilization, and thereby to rationalize the domination of Native Americans and appropriation of their lands. Focus-

ing on these issues of greater moment to Nevadans, the stories about Abe and Louisa have very little to do with basketry or the curio trade.

The Image and Impact of Amy Cohn

The Emporium propaganda, discussions of Louisa Keyser's art, her personality, and her relationship with the Cohns were all manipulated to fit preconceived stereotypes about differences between the past and present of the Washoe, and their relationship with whites. Through this manipulation, the paradigm of the white male patron and the Washoe female artist was represented as the caricature of a marriage, with the mature and benevolent Abe patiently cultivating the immature and ungrateful Louisa.

Where could Amy fit into this paradigm? She did not fit the stereotype of a patron, since she was a woman. And she certainly did not fit the stereotype of a late Victorian wife, despite occasional attempts by newspaper writers to force her into that mold. Amy was not only creative and intelligent, she was anything but dependent or immature. She survived young widowhood with three small daughters,[26] and went on to promote a new curio tradition, manage a successful curio store, lecture on tour, write pamphlets and articles, and generally carve out a place in Nevada's history. She headed the local Red Cross chapter for a time, and the title of her obituary refers to her as "one of Nevada's most brilliant women" (*Nevada Appeal*, December 19, 1919). Significantly, whereas Margaret Jones Cohn's death certificate lists her profession as "housewife," Amy's identifies her as an "author."

Notwithstanding her passion for Native American culture, her participation in the fantasy of the noble savage, and her unique career, Amy's approach to the promotion and patronage of Washoe basket weaving does conform to some widespread trends in late Victorian America, especially in the Far West. Boris's analysis (1986) of the Arts and Crafts Movement in the United States highlights several points of similarity. For example, she notes that "the arts and crafts movement drew upon an already existent network" which was "the women's club movement—devoted to traditional humanistic culture, self improvement through group study, and social philanthropy" (p. 100). Amy's first public lecture, in 1909, was to just such an organization, the Leisure Hour Club. Her lecture in 1913 was to a regional meeting of the Nevada Federation of Women's Clubs, and her subsequent lecture tour in 1914 involved a string of women's clubs

throughout southern and western Nevada. Clara McNaughton also published an article on Louisa Keyser in the *General Federation of Women's Clubs Magazine* (1915). In 1919, the Cohns took Louisa to the Industrial Arts Exposition in St. Louis, a fair that was specifically organized around the arts and crafts ideology of elevating taste in home decoration by emphasis on handmade objects. That Amy subscribed to the ideology of the Arts and Crafts Movement is also suggested by the Cohns's validation of Louisa Keyser as a true artist, a title that could not be applied to a Native American woman basket weaver outside of this context (see Boris 1986:109).

During more than two decades of traveling and working together, a strong relationship must have developed between Amy Cohn and Louisa Keyser. In her study of frontier women, Riley discovered that friendships between Native and white women were common in the West, as women were more inclined toward mutual aid, trust, and interdependence than were the aggressive and competitive males of both cultures (Riley 1984:174–84). Riley notes that this significant factor of frontier life was generally overlooked in favor of stereotyped relationships and violent imagery that dominated the dime novels and wild west shows (Riley 1984:251). Thus the lack of information on the relationship between Amy and Louisa is not surprising.

The context in which Amy developed her career may also explain why she underplayed her own role as trader and patron in her pamphlets and lectures, giving most of the credit to Abe. Amy was directing her promotional approach to the popular culture to which she belonged, not to an elite audience. To achieve acceptance in Carson City society, she may have felt constrained to support the public view of the patronage relationship between Abe and Louisa.

Amy's responsiveness to the public taste for romanticized fabrications may be gauged not only from the continuing popularity of the Dat So La Lee legend in western Nevada, but also from her persistent influence on writers of national reputation.

Amy's most direct and potent impact was on George Wharton James. James had first used Amy's information on Louisa and her baskets in his original version of *Indian Basketry* (1901). After Amy developed certificates and more complex symbolic interpretations, she sent them to James, who incorporated the new material in his revised editions (1904, 1909).[27] James continued to discuss Amy's interpretations of basketry symbolism in his articles and lectures. When he did not have her interpretation of a particular piece, he invented his own using her vocabulary (James 1903b). He

also used her interpretations to formulate and promote his evolutionary theories on the origin of symbolism in art (1903a:645).[28]

As noted earlier, the contemporaneous texts on Native American basket weaving by Mason and James contrast in their academic versus popular tone. James's romantic approach has continued primarily in texts and catalogues that encompass a broad range of Native American art, such as Dockstader's (1966) survey, Coe's (1976) bicentennial exhibit catalogue, and Furst and Furst's (1982) detailed text. Typically, one or more of Louisa Keyser's *degikup* are illustrated with a short accompanying text that follows Emporium propaganda, recording one or both of Louisa's Washoe names—with no mention of her English name—and transcribing from the certificate the length of time in weaving and the extended title representing the symbolic interpretation.

In such general sources, each of these elements is further exaggerated. For example, Coe (1976:211) extends the years of Louisa's birth and death, recording her life span as 1831–1926. Coe also mistakenly records that Louisa went blind after completing L.K.61 in 1918 (1976:211),[29] apparently unaware that she completed over sixty additional works and retained her sight until death. Furst and Furst (1982:88) mistakenly transpose the weaving time for L.K.57 from seven months to seven days, an impossible assumption. As with other authors, Coe's (1976:211) attribution to Louisa Keyser of a Washoe basket in a different style betrays the legacy of the Emporium's one-sided promotion of this single artist.

Amy's interpretation of symbolism in Louisa's basketry designs has captured and held public attention. Unaware that these meanings were fabricated, many authors have happily reproduced what seemed unique insights into Native thought. Both Dockstader and the Fursts were impressed by the abrupt or choppy quality of the extended titles, which we have seen were composed by stringing together the interpretations of individual symbols according to Amy's vocabulary. Dockstader's pragmatic explanation was that such titles demonstrated the difficulty of translating Native symbolism into English (1966: #148), while the Fursts react more romantically in comparing it to Japanese haiku poetry (1982:88)!

The large body of academic literature on Native American basket weaving produced since Mason's work has diverged more sharply from James's popular approach. Anthropological texts generally treat baskets much like ceramic shards: classifying them according to shape, function, and technique, and recording lists of design motifs. These texts fail to recognize historical change, the impact of white culture especially on the curio

trade, or the innovations of individual artists, because they operate on the assumption that tribes, not people, make baskets. Barrett's lengthy essay (1917) on Washoe basketry sticks to the usual discussions of shape, technique, design, and so forth. Although he visited Carson City as well as Carson Valley, he makes no mention of the Emporium, the Cohns, Louisa Keyser, or even the weavers who were his informants and from whom he purchased baskets. Only in the last decade have academic authors begun to analyze change and individual contributions in order to clarify the historical contexts of Native American basket weaving (Bates 1982; Cohodas 1979, 1982, 1983, 1986), utilizing the strength of both anthropological and historical approaches for a more comprehensive result.

NOTES

1. Amy Cohn's correspondence with Otis T. Mason is on file in the Anthropology Archives of the U.S. National Museum of Natural History, Smithsonian Institution, Washington, D.C.

2. Materials related to the Emporium may be found in the Anthropology Archives of the U.S. Museum of National History, in the Archives of the Nevada State Museum in Carson City, in the Nevada Historical Society in Reno, and in the George Wharton James papers on file in the library of the Southwest Museum, Los Angeles.

3. This trip is documented by brief mentions in Carson City newspapers, including the *Nevada Appeal*, March 24 and May 1 and 22, and the *Carson City News*, April 8, 1899.

4. Mentions of this Tahoe exhibit may be found in the *Nevada Appeal*, May 23 and 25, June 3 and 27, and July 24, 1900.

5. The exhibit in Sacramento is mentioned in the *Carson City News*, August 30, and the *Nevada Appeal*, August 8 and 28, 1900. The exhibit in Reno is mentioned in the *Carson City News*, September 21, 25, 27, and the *Nevada Appeal*, September 20 and 26, 1900.

6. Amy's trip to Pasadena is mentioned in the *Nevada Appeal*, November 22 and December 15, 1906.

7. Amy's 1913 lecture in Carson City and 1914 lecture tour are reported in the *Nevada Appeal*, February 28 and March 7, 1914, and in the *Carson City News*, October 22 and November 1, 1913, and February 8, 15, and 28, and March 10, 11, and 15, 1914.

8. Van Loan to Nicholson, October 6, 1906, on file with the Grace Nicholson Papers at the Huntington Library, San Marino, California.

9. Reference to the plans for building a museum occurs in the *Nevada Appeal*, August 2, 1915, while the background on Cohn's attempts to sell baskets to support this venture appears in correspondence between Abe Cohn and G. A. Steiner

in 1915–16. Photocopies of this correspondence were generously provided by William Huff.

10. This basket (Cohodas 1983: fig. 16) is now in the Lowie Museum of Anthropology (catalogue no. 1-72860). David and Gertrude Shoemaker of Oakland, California, purchased the work as a "Dat-so-la-lee," but without certificate.

11. The journal of Lee's collection is in the archives of the Nevada State Museum, Carson City.

12. A copy of the bill of sale was provided by William Huff.

13. See note 8.

14. Amy's records in the ledger of Louisa Keyser's baskets also reveal a reorientation at this point. The basket entered in the ledger as L.K.38 was actually woven four years earlier, between those numbered L.K.25 and 26. The next baskets entered, L.K.39 and 40, are minor pieces, which usually do not receive their own numbers. The following basket is "Beacon Lights," the large masterpiece which is the subject of so much comment. Mysteriously, this degikup is given two numbers, recorded as L.K.41–42.

15. In a probate hearing on her brother Jim Bryant (also called Mon Bly), Louisa testified that her father's name was Da-da-u-on-ga-la. Louisa did not know her mother's name. This ignorance is common when the mother dies in childbirth, which may have occurred in Louisa's case.

16. Unpublished, typed manuscript in C. Hart Merriam file on Washoe Basketry, Bancroft Library, University of California at Berkeley.

17. The Cohns also sold a duplicate pair of baskets by "Suzie" to G. A. Steiner in 1914.

18. Amy Cohn to C. S. Hartman, March 17, 1902, on file in the Grace Nicholson Papers at the Huntington Library, San Marino, California.

19. Explanations on L.K.50 and 51 are taken from certificates in the G. A. Steiner collection. Abe Cohn had sent these baskets to Steiner, who returned them but kept the certificates. William Huff provided photocopies.

20. In one example the references to war and male activities are updated. A long explanation is included in the ledger for Louisa Keyser's baskets of a piece begun by her sister-in-law Scees Bryant, and finished by Louisa after Scees's death. The ledger states that the basket's motif, interpreted as "birds," refers to the participation of Scees's son Hugh in World War I. When Louisa began finishing the piece, she used the motif that Amy interprets as "men," so the design was now interpreted as "the boy had joined the forces of many other men" (Burton 1932:64).

21. Canadian half-Mohawk poet Pauline Johnson also gave recitations dressed as an Indian Princess (Keller 1981) in the late nineteenth and early twentieth century. She does not appear to have reached Nevada, but Amy may have been influenced by her reputation or by that of an American cultivating a similar act.

22. Public school instruction in the arts and crafts was one of the most pervasive influences of the Arts and Crafts Movement, which promoted it as a method of cultivating discipline in America's youth (Boris 1986:83) and as a method of socializing and controlling ethnic groups (Lears 1981:64). In the Indian schools,

where students were imprisoned against their will and beaten if they spoke their native language, these manual exercises formed a powerful tool of acculturation.

23. The selection of Louisa to represent Washoe submission is evident from the overall treatment of Washoe in the Carson City newspapers. Other than Louisa Keyser, the only Washoe frequently mentioned by name was Captain Pete, spokesman for the Carson Valley Washoe. Captain Pete was treated with great respect and fairness, because of his supposed rank; whereas Louisa was selected for stereotyping and derision, since she lacked such status.

24. With Louisa's parents, her other siblings, and her own children long dead, Jim had been the only member of her immediate family to survive into maturity, and they were quite close. Louisa often lived with Jim and his wife, Scees Bryant, who became her closest disciple in the art of basket weaving. After Scees's death in 1918, Louisa took in their son, Hugh.

25. Confirmation that Louisa had been known as Dabuda comes from the Eugene Mead collection of Washoe baskets, now in the U.S. National Museum of Natural History, Smithsonian Institution. Mead credits his Louisa Keyser basket to "Da-boo-de."

26. When Amy's husband died in 1883, her daughters were three (Reine) and one (the twins, Vera and Zoe). Census accounts differ as to whether Amy was twenty-two or thirty at the time. As yet, no reliable information has surfaced on how she survived and supported her children for the next eight years, before marrying Abe Cohn in 1891, but there are indications that she may have turned her home into a boarding house.

27. James appears to have remained quite friendly with the Cohns. He often stayed at Lake Tahoe and even wrote a book on the area (James 1915), and he accepted from the Cohns one of Louisa Keyser's finest degikup (L.K.49) as a gift.

28. James's claim that his interpretations derived from "many years of close personal contact with the Indians" (James 1903a:644) may now be discounted.

29. Fallon (1975:28) also recorded that Louisa had lost her sight after weaving L.K.61. The source of this misinformation is not known.

BIBLIOGRAPHY

Barrett, Samuel A.
 1917 "The Washo Indians," *Milwaukee Public Museum Bulletin* 2(1):1–52.
Bates, Craig D.
 1982 *Yosemite Miwok/Paiute Basketry. American Indian Basketry* 8. Portland.
Billington, Ray A.
 1981 *Land of Savagery, Land of Promise.* New York: W. W. Norton.
Boris, Eileen
 1986 *Art and Labor: Ruskin, Morris, and the Craftsman Ideal in America.* Philadelphia: Temple University Press.

Burton, Henrietta K.

1932 "A Study of the Methods Used to Conserve the Art of Washoe Indian Basketry." Manuscript prepared for United States Department of the Interior, Office of Indian Affairs, Division of Extension and Industry. [Text on file in Nevada State Museum Archives, Carson City. Photographs on file in Anthropological Archives, United States National Museum of Natural History, Smithsonian Institution.]

Carson City News

1909 "Basketry Was Theme of Talk," Carson City News, February 26, p. 4.

1911 "Abe Cohn Is in Serious Trouble Once Again," Carson City News, October 7, p. 1.

1911 "Sorrow Bows the Proud Head of the Famed Dat-so-la-lee," Carson City News, December 28, p. 1.

1914 "Mrs. Abe Cohn Won Honors in Goldfield," Carson City News, March 10, p. 1.

1914 "Greatest Price Has Been Paid for the Greatest Washoe Basket," Carson City News, April 1, p. 1.

1915 "Abe Cohn Building for Indian Baskets," Carson City News, August 4, p. 1.

Cerveri, Doris

1962 "Queen of the Washoe Basketmakers," Indian Life, pp. 30–31.

1968 "Dat-so-la-lee, Queen of the Basketmakers," Real West, November, pp. 39–42.

Coe, Ralph T.

1976 Sacred Circles: Two Thousand Years of North American Indian Art. London: Arts Council of Great Britain.

Cohn, C. Amy

1909 "Arts and Crafts of the Nevada Indians," Nevada Historical Society Biannual Report. Reno.

Cohodas, Marvin

1979 Degikup: Washoe Fancy Basketry, 1895–1935. Vancouver: Fine Arts Gallery, University of British Columbia.

1982 "Dat so la lee and the Degikup," Halcyon. Reno.

1983 Washoe Basketry. American Indian Basketry and Other Native Arts 12. Portland.

1986 "Washoe Innovators and their Patrons," in The Arts of the North American Indian: Native Traditions in Evolution, ed. Edwin L. Wade, pp. 203–20. New York: Hudson Hills Press.

Dockstader, Frederick J.

1966 Indian Art in America: The Arts and Crafts of the North American Indian, 3d ed. Greenwich, Conn.: New York Graphic Society.

Emporium Co., The

n.d.A "The Queen of Basketry: Louisa Keyser" [1899–1900]. Carson City.

n.d.B "How the L.K. Baskets are Made" [1905–6]. Carson City.

n.d.C "Indian Art" [1911–12]. Carson City.

Ewing, Russell E.

1983 "Her Crown Was Willow," Nevada Magazine, January–February, pp. 30–31.

Fallon, Carol

1975 *The Art of the Indian Basket in North America.* Lawrence: University of Kansas Museum of Art.

Fowler, Don D., and Catherine S. Fowler

1970 "Stephen Powers' 'The Life and Culture of the Washo and Paiutes,'" *Ethnohistory* 17 (3–4):117–49.

Freed, Stanley A., and Ruth S. Freed

1963 "A Configuration of Aboriginal Washo Culture," *University of Utah Anthropological Papers* 67.

French, Herbert A.

1900 "Dat-so-la-lee, A Washoe Basket Maker," *The Saturday Wave,* August 25, p. 13. San Francisco.

Furst, Peter T., and Jill L. Furst

1982 *North American Indian Art.* New York: Rizzoli.

Gigli, Jane Green Hickson

1967 "Dat So La Lee, Queen of the Washo Basketmakers," *Nevada State Museum Popular Series* 3. Reprinted [1974] in Donald Tuohy and Doris L. Rendall, eds., *Collected Papers on Aboriginal Basketry.* Nevada State Museum Anthropological Papers 16:1–27.

James, George Wharton

1901 *Indian Basketry.* Privately Printed, Pasadena. Also 1902, 1903, 1904, and 1909.

1903a "Indian Basketry: Its Poetry and Its Symbolism," *National Education Association, Report for 1903,* pp. 644–45.

1903b "Letter to the Editor on the Subject of American Indian Basket Work," *International Studio,* August 20, pp. 144–46. [May have been reprinted from *The Traveller.*]

1915 *The Lake of the Sky: Lake Tahoe.* Pasadena.

Johnson, Pauline

1892 "A Strong Race Opinion on the Indian Girl in Modern Fiction," *Toronto Sunday Globe,* May 22. Reprinted in Keller 1981:116–21.

Keller, Betty

1981 *Pauline: A Biography of Pauline Johnson.* Vancouver and Toronto: Douglas and McIntyre.

Keller, Clara D.

1910 "Life at Lake Tahoe," *Los Angeles Times, Illustrated Weekly Magazine,* July 17, pp. 74–75.

Lears, T. J. Jackson

1981 *No Place of Grace: Antimodernism and the Transformation of American Culture,* 1880–1920. New York: Pantheon Books.

Mack, Effie Mona

1946 "Dat-so-la-lee," *Nevada Magazine,* February, pp. 6–8, 33; March, pp. 7–9, 32–33, 38.

McLendon, Sally, and Brenda Shears Holland

1979 "The Basketmaker: The Pomoans of California," in *The Ancestors: Native*

Artisans of the Americas, ed. Anna Curtenius Roosevelt and James G. E. Smith, pp. 104–29. New York: Museum of the American Indian.

McNaughton, Clara
 1903 "Nevada Indian Baskets and Their Makers," *Out West*, March–April, pp. 433–39, 579–84.
 1912 "Native Indian Basketry," *New West*, October, pp. 17–20.
 1915 "Dat-so-la-lee," *General Federation of Women's Clubs Magazine* 14(2):14–15.

Mason, Otis T.
 1904 *Aboriginal American Basketry*. Report of the U.S. National Museum for 1902. Washington, D.C.

Nevada Appeal
 1919 "One of Nevada's Most Brilliant Women Answers Last Summons," *Nevada Appeal*, December 19, p. 1.
 1925 "Derivation of Name Dot-sola-lee Revealed," *Nevada Appeal*, November 4, p. 1.

Riley, Glenda
 1984 *Women and Indians on the Frontier, 1825–1915*. Albuquerque: University of New Mexico Press.

Sargent, Irene
 1904 "Indian Basketry: Its Structure and Decoration," *The Craftsman* 7:321–34.

Stern, Norton B.
 1983 "Abram Cohn of Carson City, Nevada, Patron of Dat-so-la-lee," *Western States Jewish Historical Quarterly* 15(4):291–97.

Van Loan, C. E.
 1906 "$1500 Asked for One Basket Made by Washoe Indian Squaw," *Los Angeles Examiner*, September 16, p. 5.

5

"THE ARTIST

HIMSELF"

THE SALISH BASKETRY

MONOGRAPH AND THE BEGINNINGS

OF A BOASIAN PARADIGM

The Forty-First Annual Report of the Bureau of American Ethnology is a neglected classic in the study of primitive art. The title page suggests a reason: *Coiled Basketry in British Columbia and Surrounding Region*, by Herman K. Haeberlin, James A. Teit, and Helen A. Roberts, under the direction of Franz Boas. By the time this collaborative work was published in 1928, two of its authors—Teit and Haeberlin—were dead. Along with the patron of the research, Homer E. Sargent, each played an important but limited role in the final outcome. These facts help explain the monograph's mixed character and why it was not published until two decades after its inception, thereby blurring its significance. For it was one of the first studies to focus on the role of the individual in primitive art, and to consider the art in relation to the thoughts and actions

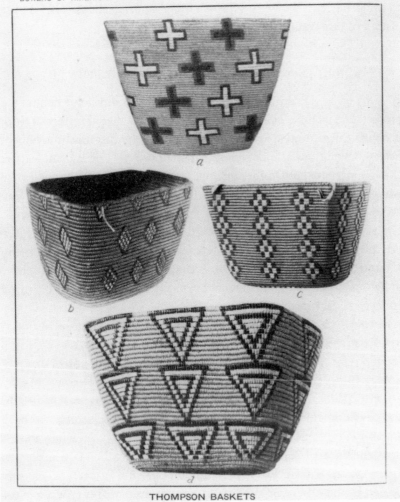

THOMPSON BASKETS

Figure 22. Thompson Indian baskets. *Annual Report of the Bureau of American Ethnology* no. 41: pl. 25

of its makers—approaches later popularized by Ruth Bunzel (1929), Lila O'Neale (1932), and Gladys Reichard (1936).

By focusing on the story of the basketry monograph, this essay explores an important "paradigm shift" in the study of the tribal arts. After reviewing Boas's thinking on the role of the individual in primitive art, it examines the research he directed on coiled Salish basketry (fig. 22), discusses the writing of the monograph, briefly reviews its distinctive

features as a study of the individual artist, and concludes with a look at its importance to the work of Boas's other students and its place in the history of American anthropology.[1]

Boas on the Role of the Individual in Primitive Art

Franz Boas (1858–1942) was the guiding force behind the project, and its mixed character partly reflects his own transitional work dealing with primitive art. Boas's position in the historical movement from an evolutionary approach to a "psychological" one is complex and ambiguous. Nurtured in the late nineteenth-century German intellectual world, Boas entered an ongoing debate on the nature of Native American decorative art (Thoresen 1977). His initial work was conditioned by his critique of social evolutionism; while rejecting a universalistic progressivism, he maintained its interest in reconstructing historical development. Although the work of the later Boas and his students on the role of the individual artist was quite different in emphasis, it assumed this historical concern as background.[2]

During Boas's active research career, there were three major "models" in American studies of primitive art.[3] The first was the *evolutionary* approach (ca. 1880–1905) followed by the scientists of the Bureau of American Ethnology (BAE) and the U.S. National Museum (Powell, Holmes, Mason, Fewkes, Mallery, and Thomas), which addressed questions of the origins and development of designs. The second, the *historical-diffusionary* approach (ca. 1895–1915), was a product of the work of Boas, his colleagues, and his first generation of Columbia University students (Kroeber, Lowie, Wissler, Spier, Dixon, Barrett, Farrand, Teit, Lumholtz, and Laufer), largely supported by the American Museum of Natural History. This group focused on the linkage between form and meaning and the spread of motifs and styles across cultural boundaries. Boas was able to participate in still another, *psychological* (ca. 1910–1935), approach. With a second generation of Columbia students (Haeberlin, Bunzel, Reichard, Herskovits, Brenner, and O'Neale), he turned his attention to issues of cultural change, the integration of culture, and the role of the individual.

These three models of course mirror general approaches to culture, but the point is that the change was gradual and overlapping. Both the evolutionary and historical approaches share certain assumptions, as do the historical and psychological ones. We can see these intellectual connections embodied in publications by Boas, who from one of his first major

works, "The Decorative Art of the Indians of the North Pacific Coast" (1897), to one of his last, Primitive Art (1927), slowly worked out the implications of his thinking. The proper metaphor here is of the unfolding and elaboration of a pattern. Boas's thought was not sharply discontinuous, but gradually evolving (Stocking 1974:17–18).[4]

Seeds of Boas's distinctive "psychological-technical" theory of art may be found in his first writings on the subject, but they do not really take root until around 1908. In the essay on Northwest Coast decorative art (1897), Boas speaks to the evolutionist assumption that primitive decorative art went from initially realistic representations to conventionalized, even geometric, designs (cf. Haddon 1895). He seems to accept this position, though he maintains that on the Northwest Coast conventionalization had not gone all the way to geometry: the animals depicted are still recognizable as such. A major principle of this art is the distortion of the animal design to fit the form of the "decorative field" on the object. This Boas shows quite elaborately and at length—the beginning of his technical or "formal" approach to art. Here, as in later articles, he spends much time on establishing the connections or lack of them between form and meaning, a central evolutionary concern.

In the 1897 essay Boas did seek to "discuss the mental attitude of the artist" (p. 123) that led to these changes in animal form, but he apparently meant this only in a general sense, describing aspects of the art as problems to be solved by the artist. We often find him placing himself in the position of the artist; for instance, he says that the identifying parts of an animal are so essential to the artist's mind that "he considers no representation adequate in which they are missing" (p. 126) or that "it is the ideal of the native artist to show the whole animal, and that the idea of perspective is entirely foreign to his mind" (p. 176). The basic principles of the art are presented as goals in the artist's mind and procedures of his work. Yet it is doubtful whether at this point Boas had actually observed a Native artist at work or had talked to one, for his most intensive artistic fieldwork came only later that summer. Thus the individual in early Boas is a type, not a specific person.[5]

When Boas summarized his work and the work of his students[6] in "The Decorative Art of the North American Indians" (1903) and in "Primitive Art" (1904b), a guide leaflet for the American Museum of Natural History, he stressed the problems of the evolutionist development from realism to convention, discussing the relation between form and meaning and its historical development. However, in the former article Boas first ap-

plied to art his developing model of the primitive mind. He believed that, in different ways, forms were prior to meanings. Like so much else of culture, the interpretations Natives gave to designs were what he called "secondary elaborations."

Going beyond the usual BAE museum studies, often of archaeological materials, Boas sent students such as Alfred Kroeber to living Native peoples to inquire about their explanations of cultural phenomena. Although the individual Boas speaks of in the following passage is a generalized tribal "personality," at least it is a personality derived from living, thinking people (1903:563):

> The explanations of decorative design given by the native suggest that to his mind the form of the design is a result of attempts to represent by means of decorative art a certain idea. We have seen that this cannot be the true history of the design, but that it probably originated in an entirely different manner. . . . Native explanations of laws, of the origin of the form of society, must have developed in the same manner, and therefore cannot give any clue in regard to historical events, while the association of ideas of which they are the expression furnishes most valuable psychological material.

Boas was unclear as to just how this psychological material was valuable, but it was crucial in denying the expected links between object and conventional image. Boas could show that each tribe interpreted forms according to a different "style" of interpretation, with different associations, echoing his own German historicist concepts of cultural integration and the "genius of a people" (cf. Stocking 1968:214 and 1974:6–8).

While Boas's next work on primitive art, his notes on George T. Emmons's Chilkat Blanket (1907), is a further refinement of his formalist analysis, in the seminal "Alaskan Needlecases" article the following year he firmly centered his theory of art in the play of technical virtuosity. The article is truly a transitional classic—ending one line of thought and beginning another. Its initial thrust as a critique of evolutionary assumptions is usually remembered, yet by 1908 this was no longer new to the Boasians. What was innovative was the major role given to the artistic activity of the individual: these "decorative forms may be largely explained as results of the play of the imagination under the restricting influence of a fixed conventional style" (1908:588–89). Furthermore, Boas regards the processes of conventionalization, or the reading-in of realistic associations, as mental—mental not in the universal sense, but in the local,

group sense as manifested in individual action. These interpretations are, of course, "secondary." Paralleling his insistence on the conservative categories of traditional thought is Boas's emphasis on the fixity of form and its influence on the primitive artist, the source of "style" for Boas.

As evidence of the play of imagination, Boas refers to the carefully wrought pattern of the Thompson Indian beaded legging fringes, which he first noticed in 1900. Locating the sources of art in the maker, not the observer, Boas points out that this complex rhythmic design must be a manifestation of the aesthetic pleasure felt by the artist in creating it, for the pattern is not perceptible when the leggings are worn. A similar effect is noted for the imbricated baskets in which the careful and regular color stitches are also missed by the viewer. The implications of this are that "on the whole the pleasure given by much of the decorative work of primitive people must not be looked for in the beauty of the finished product, but rather in the enjoyment which the maker feels at his own cleverness in playing with the technical elements that he is using. In other words, one of the most important sources in the development of primitive decorative art is analogous to the pleasure that is given by the achievements of the virtuoso" (1908:592). This play of imagination is also found in interpretations. He concludes that we must take these other "psychic processes" into account for a clear understanding of the history of art. This remained Boas's basic position in all his remaining writings on the subject—his review of MacCurdy's *Chiriquian Antiquities* (1911b), his considerations of "The Representative Art of Primitive Peoples" (1916), and his summarizing treatise of 1927, *Primitive Art*, with an emphasis in these later works on the development of form out of the regular, rhythmic effects of technique.

There is little that is theoretically new in *Primitive Art*; it is mainly an elaboration, with extensive new evidence, of the position Boas had worked out from 1908 to 1916. In contrast to Boas's usual, minutely specific ethnography, this is a popular book explaining the general conditions of primitive art (although there is the long chapter on Northwest Coast art, a revision of his 1897 study). The individual, of course, remains at the center of the theory that art comes from the virtuosic play with the products of regular motor patterns. However, here again we meet a generalized person.

Finally, in his chapter on style (1927:155), Boas considers the problem of the individual as he and his students were then conceiving it, with his usual self-inhibiting critical caution (cf. Stocking 1974:14–16):

We have to turn our attention first of all to the artist himself. Heretofore we have considered only the work of art without any reference to the maker. Only in the case of slovenly work have we referred to the artisan. It has appeared that his behavior as revealed in his work helped us to understand the fate of the designs. We may hope, therefore, that in the broader question also knowledge of the attitude and actions of the artist will contribute to a clearer understanding of the history of art styles. Unfortunately, observations on this subject are very rare and unsatisfactory, for it requires an intimate knowledge of the people to understand the innermost thoughts and feelings of the artist. Even with thorough knowledge the problem is exceedingly difficult, for the mental processes of artistic production do not take place in the full light of consciousness. The highest type of artistic production is there, and its creator does not know whence it comes.

Boas then goes on to deny that "the expression of individual feeling" and "the freedom of the creative genius" are absent among tribal styles, which seem so rigid to us. A little anecdote that follows (p. 156), about a bedridden Kwakiutl painter who could only think of his art, is one of the rare appearances of a real person in Boas's work.

In considering the relation between traditional style and personal creativity, Boas insists on the heavy weight of tradition: "The general character of the artistic productions of man, the world over, shows that the style has the power of limiting the inventiveness of the productive genius" (p. 156). Yet, anticipating modern generative notions, Boas claims that this basic sameness is not due to direct copying, but to the multiple recombination of a small number of elements: "The patterns are so simple and require only a small number of standardized movements which are combined in a variety of ways. The method of work corresponds strictly to our methods of writing in which also a number of standardized movements occur in a multitude of combinations" (pp. 156–57).

When informants are questioned about the sources of their new designs, they claim that they are really new, not just the recombination of old elements. Among American Indians these innovations are called "dream designs," and give important insights into the process of invention and composition (pp. 157–58):

It expresses a strong power of visualization which manifests itself when the person is alone and at rest, when he can give free play to the imagination. . . . The few individuals who create new forms in this

manner have probably a good control over the technique and wide command over a multitude of current forms. In the one case which has been investigated with some care by James Teit the woman who created new basketry patterns was also one of the best technicians and had full command over the greatest variety of forms.

Naturally, in all societies these abilities are differentially distributed: "Some have command of the full range of forms, while others are satisfied with a small number which they repeat over and over again" (p. 158).

This, then, was Boas's conception of the individual primitive artist as of the mid-1920s, before any of his students had published intensive studies on the subject. His art theory was a special application of his general theory of culture as expounded, for example, in several articles (1901 and 1904a) that became part of The Mind of Primitive Man (1911a). The basic assumption was that individual thought and actions largely follow the traditional models of culture, resulting in the general conservatism of primitive society. Both the actions and their mental associations tend to become habitual and automatic, thus removing them from conscious awareness. Finally, the creative, innovative individual will be rare and exceptional. We also see the importance of technical excellence, not shared by all, which was the basis of "art" for Boas.[7]

The Salish Basketry Research

The basketry research of James Teit, though conceived and completed years before, had in 1927 still not been published. Under the direction of Boas, this study was to be Boas's only major research along his new "psychological" lines, yet he himself wrote only a preface and a conclusion. We turn now to the long, complex, unfortunate, and previously untold history of this important work.

As we have seen, between 1908 and 1910 Boas's interests took on a decided psychological cast.[8] Stocking (1974:v–vi) sees the year 1911 as a point of culmination for Boas, with major publications in linguistics and in physical and cultural anthropology; and Boas himself (1936:311) placed his shift from historical problems to more psychological ones "around 1910." Certainly the change had occurred by the time of the 1920 essay "The Methods of Ethnology" (although students like Kroeber and Wissler followed out diffusionary interests for a decade longer). However, at least in the aesthetic sphere, Boas had moved on to these newer issues by 1908, as seen in the "needlecases" article.

This theoretical shift coincided with new opportunities for fieldwork, which Boas was quick to exploit. In March 1907, Homer E. Sargent, a wealthy patron and collector, agreed to fund Boas's research among the Salish of British Columbia, to be conducted in the field by James A. Teit, a white resident among the Thompson Indians. As he had done with the Kwakiutl George Hunt and other natives, Boas had Teit send him ethnographic material which he, Boas, would then analyze and publish. A year later, in April 1908, Sargent proposed to Boas an elaborate study of basketry, to be modeled after Emmons's monograph, *The Basketry of the Tlingit* (1903),[9] heavily illustrated, based on careful, full, and sensitive fieldwork. Thus the initial impetus for the basketry study was Sargent's.[10]

Homer Earle Sargent, Jr. (1875–1957), is an obscure but fascinating figure in the history of American anthropology. While he had no real scientific interests of his own, his enthusiasm and generous patronage were quite significant in the growth of the discipline in these early years. A consulting engineer for the Westinghouse Electric Company, Sargent lived for many years in Chicago. He probably inherited his interest in the Indians from his father, a general manager for the Northern Pacific Railroad, who had spent a great deal of time among the Natives in the West. Sargent was an inveterate but discriminating collector. While he picked up some items on personal trips through Western wilds, most seem to have been acquired from dealers or agents like Teit.

Sargent eventually left Chicago to spend his summers in Minnesota and winters in Pasadena. At the turn of the century Pasadena was a center for the Arts and Crafts Movement, with its interests in Indians and Orientalia. So popular were Native American baskets as decor in the contemporary home that a "basket craze" swept the country during these years (Gogol 1985; Washburn 1984). One of Sargent's Pasadena friends, Grace Nicholson, was the principal local dealer of Indian baskets as objects of art as well as ethnology. Other members of this arts community, dubbed the "Arroyo culture," were Charles F. Lummis, George Wharton James, and Adam Clark Vroman (Starr 1985:99–127). While rooted in this broad-based movement of aesthetic appreciation, Sargent's interests in baskets soon led him to scientific support.[11]

James Alexander Teit (1864–1922), born in the Shetlands, had come to America as a young man and settled in Spences Bridge, British Columbia. His first wife was one of the local Thompson Indians, whose language he learned fluently (fig. 23). Although he derived some of his income from a general store and an apple orchard, Teit's principal support came from

Figure 23. James Teit and his wife, Lucy Antko, c. 1896.
(Courtesy American Museum of Natural History, 11686)

guiding hunters and from an increasing amount of ethnological research. Boas met him in 1894 and selected him for work with the Plateau Salish for the Jesup Expedition. In 1902 Sargent hired Teit as a guide, was favorably impressed with the Scotsman's deep knowledge of the local Indians, and through this meeting learned of his work with Boas. Teit also worked for Edward Sapir and the Canadian Geological Survey, as well as making collections for museums in New York, Chicago, Ottawa, and Victoria. A socialist, Teit devoted much time in his later years to lobbying for Indian rights (cf. Boas 1922; Banks 1970; Wickwire 1988).

From his earliest work for Boas, Teit had been collecting baskets and interviewing weavers, particularly about the names and meanings of designs (Banks 1970:151). But with the Sargent commission of 1908, he began to focus more intently on basketry, guided by Boas's developing theoretical interests. At the beginning of 1909, Boas wrote him:

> In noting down the details of the method of weaving used by different women, will you not be as specific as possible? You mention for instance that some of the women, who are not very expert, make only two or three designs. I wish you could get from as many women as possible, quite accurately, just what designs they make, and also the critique of other women of their work. Take for instance, a basket from your collection that is not done very regularly and get the women who are really good basket weavers to criticize the work. I think in this way the points that we are after will come out very clearly.
>
> It seems to my mind that the error in the whole treatment of the design question in recent literature lies in the fact that designs have been treated too formally and too little from the point of view as they appear to the makers.[12]

Although some work was done on the paper over the next few years, intensive work, by Boas at least, did not start until March 1915, when Boas finally felt himself able to devote time to the project.[13] By autumn, F. W. Hodge of the Bureau of American Ethnology, had agreed to publish the study, and plans were made to study museum collections and prepare illustrations.[14] With his customary division of labor, Boas placed the basketry paper in the hands of one of his students, as he did not regard the fieldworker Teit capable of theoretical analysis.[15] By the end of the year Boas had arranged for this student, Herman Haeberlin, to examine the museum baskets.[16]

Haeberlin (fig. 24), one of Boas's most brilliant students, is little remembered today because of his early, tragic death at the age of twenty-seven (he was born in Ohio in 1891). He may truly be considered the first of Boas's second generation of students, when his interests had shifted to culture change, cultural integration, and the role of the individual. According to Margaret Mead, Boas would often point out Haeberlin's thesis as a model (1959a:14, 290), and "the phrase 'the best graduate student since Haeberlin' was a ready one to several tongues" (1959a:14). Boas's letters and his obituary for Haeberlin (1919) reveal the close relationship between student and teacher.

Haeberlin chose to go to his ancestral home of Germany for advanced study.[17] After meeting Boas in Berlin in 1913, he returned to America the following year to study at Columbia, submitting a doctoral dissertation in 1915 on cultural integration among the Pueblos (and thus initiating the extensive Boasian research in the region). In his thesis Haeberlin, following Boas and in opposition to Kroeber, claimed that "the psychic and the historical are but two different aspects of the same thing" (1916:8), unifying these two thrusts of Boas's anthropology. He concluded that cultural integration among the Pueblos was psychological (p. 51), anticipating the similar problems and positions of Benedict, Mead, and Herskovits in the 1920s, all criticizing the Viennese Kulturkreislehre (cf. Stocking 1976:13–16).

For the basketry monograph, Haeberlin supplemented his study of museum collections with fieldwork among the related Salish of Puget Sound during part of the summer and fall of 1916 and the summer of 1917. The two sources were effectively combined when Haeberlin used the technique of showing weavers photographs of museum specimens in order to generate aesthetic commentary directed to specific objects.[18] But his severe diabetes cut short these trips, and death followed early in the spring of 1918.

Beyond psychology, Haeberlin's primary interest was in the aesthetic realm, as seen in a formal analysis of Pueblo decorative art done while in Berlin (Boas 1919:72). This flair for formal analysis was revealed in his "preliminary sketch" of the "Principles of Esthetic Form in the Art of the North Pacific Coast," published posthumously in 1918. Taking aesthetic systems as a legitimate subject of ethnological investigation, Haeberlin proposed an "intensive" study of formal principles of Northwest Coast art, presaging a structuralist approach.[19] Stressing the essential unity of primitive art with our own, Haeberlin defends the use of intuition in the analysis of either kind of art.

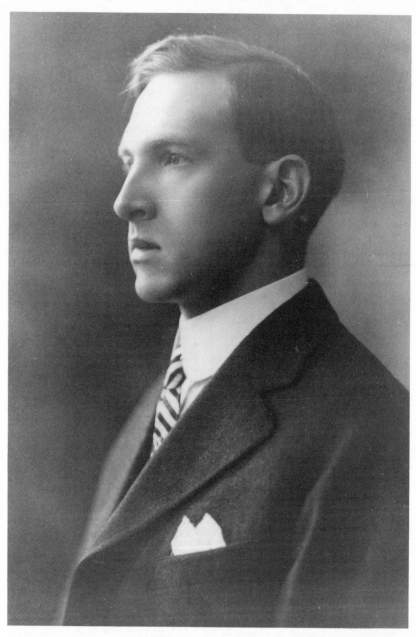

Figure 24. Herman Haeberlin. Reproduced from Frederica de Laguna, ed., Selected Papers from the American Anthropologist, 1888–1920, *American Anthropological Association, Washington, D.C.,* 1960

More important for our concerns, he advocated that primitive art be studied in the same manner as the art of so-called civilized societies: individually and biographically. In a classic passage for the emerging paradigm of primitive art studies, he wrote: "We tend too much toward conceiving the art of a primitive people as a unit instead of considering the primitive artist as an individuality. It is necessary to study how the individual artist solves specific problems of form relations, of the combination of figures, and of spatial compositions in order to understand what is typical of an art style" (1918:263–64).

Evidence of Boas's interests at the time and of his direction of the project can be found in his correspondence. Concerning the personal distribution of designs among the women of Puget Sound, Boas wrote to Haeberlin in 1916:

What I should like to know, is, of course, what designs are made by each particular woman and how do they criticize designs, and how do they instruct the young girls in the making of basketry and basketry designs. I also wish that if you have the chance to observe basketry making by an expert basket-maker, you would try to observe as carefully as possible the regularity and speed of her movements, how many stitches she makes per minute, and how far the piercings and pullings, etc. is [sic] done with great regularity. The question in my mind is, particularly, what relation there is between the regularity of movement and the regularity of appearance of the finished work.[20]

Here we see Boas seeking empirical evidence for his theory that art comes from the formal rhythm and regularity of a virtuoso craftsman, as well as for the way artists regard and describe their work and that of others.

Earlier that same year, Boas wrote to his colleague Berthold Laufer, curator of anthropology at the Field Museum, requesting photographs of specimens:

All that is required at the present time is to have the form and the design sufficiently clear, so that the Indians can recognize the basket and can tell us where it was made, and if possible who made it. One of the points we want to get is personal contact with the makers of the baskets, in order to solve certain points in regard to the relation between technique and decoration, and for this purpose the fullest possible collection will be necessary.[21]

Boas summed this up for Sargent in 1918: ". . . the essential part of the report will be a study of the collections. Mr. Teit has, however, given information on the peculiarities of individual basket makers that will be of very great importance."[22]

When Haeberlin died, Boas, though greatly saddened, lost no time in finding a replacement so that the basketry monograph might soon come to fruition. He chose a young woman who had been working in his office, Helen H. Roberts (1888–1985). Though trained as a concert pianist, she had become interested in archaeology on visits to New Mexico, and in 1916 came East from Chicago to study with Boas. After completing a museum study of Apache basketry (not published until 1929) and working on the Salish basketry paper, she became one of the leading ethnomusicologists of the interwar years (Frisbie 1989).[23]

The final manuscript was the product of many hands: it was written by Roberts, based on the field notes of Teit (who had died in 1922), and the museum and field studies of Haeberlin, under Boas's direct supervision. After four years of concentrated work, the manuscript was completed by mid-1919 and sent to Washington, with the exception of some illustrations and additions on rhythm and symmetry.[24] However, the BAE staff dragged their feet, out of their general antipathy toward him, claimed Boas, and not just for the stated lack of funds. After several years Boas withdrew the paper, and it was accepted for publication by the Field Museum. Later it was returned to the BAE, but in the process the plates became separated from the captions, and it took much time and effort to correct the situation. In the end, some plates had to be omitted because they could not be identified. After twenty years of gestation, the work was finally published in 1928.

The Salish Basketry Monograph

Coiled Basketry in British Columbia and Surrounding Region followed the standard pattern of the time for monographs on basketry, especially its explicit model, Emmons's *The Basketry of the Tlingit* (1903). After a historical introduction came chapters on the gathering and preparation of materials, techniques and structure, and forms and proportions. The discussions of decoration consisted of sections on methods of ornamentation, design fields, design elements, application of the design to the field, and the interpretation of geometric designs. The study concluded

with a look at basketry of the neighboring tribes of the Thompson Indians, the principal subject, with final remarks by Boas.

This monograph is without doubt the most thorough study of American Indian material culture made up to that time (and perhaps since). Including such supplementary information as trade, care, and repair, presented in great detail, the work contains new kinds of data, such as complete Native terminology, a museum study of working methods as seen in proportion and applications of designs to the field, and the selection of designs. All this was based on extensive interviews with informants, with a series of informant biographies, centered on "proficiency, variety of patterns used, so-called personal designs and devices" (O'Neale's review, 1930:306).

This new kind of study was emphasized in Boas's preface: "The problem that I set myself was an investigation into the attitude of the individual artist toward his work. Much has been written on the origin and history of design without any attempt to study the artist himself. It seemed to me necessary to approach the problem from this angle" (p. 131). This focus was explored primarily in three aspects: technique, form, and the selection of decorative motifs. For all the emphasis on the individual artist, however, there is much of the older historical model in this work. The report opens and closes, in the sections written by Boas, with studies of distribution and suggestions of possible history, and it contains much of the older evolutionist problem of the relative priority of realistic versus geometric designs.

Throughout the technical description are statements about informants' differing on definition and criticism, such as the comment that experts "occasionally criticize work as being too rigid, though as a rule this is considered a 'good fault,' except in very small pieces, flexibility being more often the reason for disapproval" (p. 163). Moreover, an attempt is made to describe the skills of different weavers, bearing on Boas's interest in the virtuosic origin of design (e.g., on beginners, p. 159). For instance, some forms and techniques are restricted to only a few skilled, creative individuals (pp. 176, 179, 190).

Haeberlin's formal analysis of the burden-basket is very instructive, for he compares informants' statements of correct proportions to the actual proportions. Haeberlin found definite evidence of the force of tradition, for most baskets conform to a fairly narrow range. Yet informant opinion varied widely, and many informants had no conscious standard. "Further-

more, some of the most obvious proportions between dimensions have never been observed by the people themselves, and in regard to others the claims of the makers are contradicted by actual observation" (p. 212).

As Boas had long noted (in 1903), these secondary, conscious rationalizations were of great psychological interest. Here the authors noted: ". . . there is psychologically a vast difference between the ability to appreciate the proportions of a finished product and the faculty of analyzing such proportions and defining the principles upon which they should be judged" (p. 213). This evidence of unconscious patterning, so strong in language, was also found by Ruth Bunzel in her study of Pueblo potters (1929:53) and noted by the linguist Edward Sapir in his review of her book (1929). The basketry monograph is thus one of the first discussions of what later became a topic of debate in anthropological aesthetics—the issue of the "unvoiced aesthetic" and its relation to a formal and explicit critical tradition (Sieber 1973:428).

Haeberlin had conducted a museum study of the inevitable problems weavers encountered in applying design elements to the decorative field (fig. 25). For instance, often they would start a design and run out of space for it. The solution "furnishes material for a most interesting and instructive study of inventive faculties, resourcefulness, and artistic taste of these Indians" (p. 259). Some women paid more attention to these matters: "There are undoubtedly some standards of taste to which all the basket makers adhere as closely as they can, but naturally considerable variation occurs in the abilities of different women, such as would occur among ourselves, and each woman is likewise free to exercise her own ingenuity in working out the adaptations of her design to its field" (p. 260).

The section showing the greatest attention to individual creativity is "The Selection of Designs" (p. 300):

> The individual woman plays no small part in the establishment of the basketry style of her tribe, especially if a certain degree of liberty is allowed her to follow her own inclinations, and this seems to be the case in the Thompson region. The women are not restricted in their selection of designs but make any number; most of them from time to time undertake patterns with which they have previously been unacquainted; others invent variations of old elements which they have used before, and some do both. During a woman's life-time certain designs and variations may perhaps be considered to belong to her in a sense that they are her particular inventions, but knowledge

Fɪɢ. 54.—Corner of basket

Figure 25. Corner of a basket, illustrating the problems the artist encounters in applying the design to the field. Annual Report of the Bureau of American Ethnology no. 41: fig. 48

concerning origins is soon lost by the majority, especially after the designs have been copied or changed by others.

The authors describe the spread of designs throughout the tribe, the learning of designs, individual repertory, and the invention of new designs, particularly in dreams.

Boas's conclusions are disappointing, mostly dealing with historical concerns. As Lila O'Neale perceptively noted in her review, one would have wished that Boas had discussed at greater length the avowed aim of the study—an investigation of "the attitude of the individual artist toward his work." Boas's few comments on the subject emphasize the limitations on personal creativity: "the scope of forms . . . shows that the range of individual invention is strictly limited by the traditional style"; regarding design, "The power of invention of the artist is obviously under the control of tradition" (p. 386, 387). O'Neale adds that these comments are

directed only to form and design and not to conscious interpretation (1930:307), revealing again Boas's emphasis on the unconscious, formal, and traditional sources of artistry. Of the last, Ruth Benedict observed: "In problems of individual mental life Boas was most specifically interested in the tyranny of custom" (1943:33).

Conclusion

Despite its long gestation, the monograph on Salish basketry did have an important impact on primitive art studies. It was an inspiration, direct or indirect, for four volumes: Ruth Bunzel's *The Pueblo Potter* (1929), Anita Brenner's *The Influence of Technique on Decorative Style in the Domestic Pottery of Culhuacan* (1931), Lila O'Neale's *Yurok-Karok Basket Weavers* (1932), and Gladys Reichard's *Navajo Shepherd and Weaver* (1936). Note the titles; with the exception of Brenner, who addressed slightly different issues, all refer to the *maker*, not the product (fig. 26). In addition, Bunzel and Reichard learned the respective crafts in their attempt to understand these exotic art forms.

Ruth Bunzel had been a secretary in Boas's office when, in 1924, he suggested that she work on the problem of "the relation of the artist to his work." Boas gave her a copy of the basketry manuscript to use as a model, but Bunzel felt that "it had nothing to do with what I conceived my problem to be although it contained many points on such matters as the influence of technique on design and analysis of style that stood me in good stead later" (in Mead 1959b:34). While much of the basketry monograph's detail and historical analysis must have put Bunzel off, her book reveals many of the same approaches and methods. More explicit was Lila O'Neale's study. Though not a student of Boas's, O'Neale studied at Berkeley with Alfred Kroeber, Boas's first Columbia Ph.D. student. Perhaps because she was dealing with basketry from a related region, O'Neale follows closely the earlier work, and it was she who reviewed it in the pages of *American Anthropologist* (1930) (see Schevill, this volume).

Gladys Reichard was an especially important figure in this approach, as she had analyzed both visual and literary materials (1943). In addition to her work on Navajo weaving, she considered the problem of individual style and creativity in the mythology of the Coeur d'Alene Salish (1947). Ruth Benedict dealt with the same issue for Zuni mythology (1935), and Melville Herskovits discussed the problem in his work on African and Afro-American art. Anita Brenner's study, submitted as a doctoral dis-

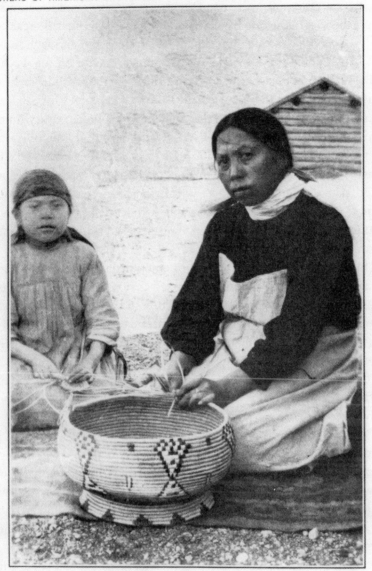

Figure 26. *Salish woman making a basket. Annual Report of the Bureau of American Ethnology no. 41: pl. 2*

sertation at Columbia, was one of the few works that directly addressed Boas's theories of the origins of design. She and Haeberlin had separately analyzed a corpus of Mexican prehistoric pottery, and although in this case artists could not be interviewed, Brenner focused on the way the individual's motor patterns might have influenced the resulting style.

In characterizing the intellectual relation of Boas and his students, George Stocking has suggested that "much of twentieth-century American anthropology may be viewed as the working out in time of various implications in Boas's own positions" (1974:17). As he also noted, "the character of development or rebellion was usually to take one aspect of Boasian assumption and to carry it farther than Boas himself would accept." The Salish basketry monograph, with its application of a general "culture and personality" approach to primitive art studies, was a perfect example of this.

This study, in its content and history, embodied the shift in fundamental paradigms in American anthropology, from a critique of evolutionism to historical development to issues of culture and personality. Yet, as in his photographic work (Jacknis 1984:52), Boas laid out the territory which he left to his students to explore and develop. Boas originated the basketry research and supplied its intellectual and theoretical underpinnings, but he did not carry it out himself. Moreover, though he highlights the role of the individual artist in the preface, most of his conclusion is devoted to historical concerns.

One of the features distinguishing the anthropology of Boas and his students is that the arts, broadly considered, were central to their theory of culture. Building on strains of German romanticism passed on through Boas, these anthropologists viewed culture as an aesthetic system writ large—a historically constructed pattern of form and meaning (cf. Handler 1983). And of all the issues in the study of primitive art during these later years, roughly 1915 to 1945, the role of the individual was the most important. These concerns went beyond intellectual problem or abstract theory. Many of the Boasians had aesthetic interests (though personal visual talents were noticeably absent): Boas played the piano and was fond of classical German literature; Sapir, Benedict, and Mead wrote poetry; Sapir was also a musician and composer. And the issue of the individual in society was privileged for many by their life experiences (German Jewishness and liberalism for Boas, femaleness for Benedict, aestheticism for Sapir; cf. Handler 1986). As one of the first studies in this new direction,

the monograph on coiled Salish basketry possessed an importance well beyond its seemingly obscure subject.

NOTES

1. This essay is a revision of a 1976 course paper for George Stocking, University of Chicago, and was presented in condensed form at a symposium organized by Janet Catherine Berlo, "Reevaluating Our Predecessors: Ethnographic Art Historians Look Back," at the 1985 meetings of the College Art Association. In addition to Professors Berlo and Stocking, I would like to acknowledge the assistance and helpful comments of Marlene Block, Charles Briggs, Douglas Cole, Raymond Fogelson, Carol Hendrickson, Aldona Jonaitis, Nancy Munn, Margot Schevill, and Wendy Wickwire. Thanks are also due for permission to reproduce correspondence in the Franz Boas Professional Papers, American Philosophical Society, and the Department of Anthropology Archives, Field Museum of Natural History (FMNH). Unless otherwise noted, all correspondence cited comes from the Boas Papers.

2. In this regard it is important to keep in mind Boas's personal chronology. At the time of his first major art publication in 1897, he was nearing forty; when his famous needlecases article appeared in 1908, he was fifty; when he published his 1927 summary of primitive art, he was one year short of seventy. This is why many nineteenth-century assumptions can be found in Boas's thought, and why it was up to his younger students to explore the implications of the psychological approach.

3. These dates, of course, must be approximate. Particularly, we find each model lingering on in the following years, as scholars who entered the paradigm when it was new, and they were young, get older and continue to work on material gathered years before.

4. Although Bunzel overstates the monolithic quality of Boas's thought, she does point to an important unity: "So consistent was his theoretical position that it is frequently hard to tell whether a paper was written in 1888 or 1932. His mind was not closed to new ideas. He created no closed systems; he saw research as a progression through constantly emerging problems to ever widening horizons" (1960:404).

5. We also find psychological phrasing in Boas's earlier note entitled "The Decorative Art of the Indians of the North Pacific Coast" (1896), which was integrated into the later study. Observing that some totemic forms were being applied when there was no "desire" or "intention" of making a totemic connection, Boas wrote: "The thoughts of the artist were influenced by considerations foreign to the idea of totemism. This is one of the numerous ethnological phenomena which, although apparently simple, cannot be explained psychologically from a single cause but are due to several factors" (1896:102–3). This, of course, was Boas's reply to Otis T. Mason in the context of a famous debate on museum exhibits (1887a, 1887b, cf. Stocking 1974:1–5), but notice the *psychological* phrasing.

6. Much of this work was sponsored by the American Museum of Natural History, especially its Jesup Expedition to the Northwest Coast, 1897–1902. Boas's own account of "Facial Paintings of the Indians of Northern British Columbia" (1898) is a continuation of the problems of his 1897 study, as are his comments on art in Teit's Thompson Indian study (1900), though there he first notes the problem of rhythmic patterns.

7. As Charles Briggs points out in a very stimulating but unfortunately unpublished essay (1975), culture for Boas was inherently conservative, guiding and constraining perception and action. Thus change and creativity came from individual action against these forces.

8. Boas settled into this position over these two years. In September 1909 he returned to the site of his first teaching job—Clark University, founded by the psychologist G. Stanley Hall, and home to Freud in America. For a twentieth anniversary celebration, Boas gave a lecture entitled "Psychological Problems in Anthropology," published the following year and incorporated into The Mind of Primitive Man (1911a). This lecture shows the centrality of psychological problems to Boas's conception of anthropology, recalling earlier articles (1901, 1904a). Moreover, it shows his idiosyncratic view of psychology. In this lecture he avoids the problems of social as well as individual psychology for the strange third problem of "the psychological laws which govern man as an individual member of society" (1910:244). By this Boas seems to mean general, universal principles of human perception and thought. He is particularly interested in the way individual thought is molded by different social models. In the sphere of art this was the priority of group style over individual creation. Thus when he talks of the individual in culture, it is usually a generalized individual, as we found in his earlier art studies. For Boas on the influence of traditional forms, see the essays on the Chilkat blanket (1907:373), Alaskan needlecases (1908:588, 590), and the review of MacCurdy's Chiriquian Antiquities (1911b:242–45).

9. Emmons's monograph (1903) anticipates Boas's later work in several ways, and not just in Sargent's sense, of a detailed study of basketry with all the forms and designs illustrated. In addition to this detail of form and construction, Emmons paid particular attention to the individual weaver and her work habits. For instance, discussing variation in baskets, Emmons writes: "The greatest differences are wholly individual, and show in the fineness of weave, arrangement and choice of color, and combination of designs" (1903:231).

Although Emmons continually notes the conservatism of the weavers (pp. 249, 260, 262), his awareness of individual inflections also anticipates Boas: "Neither are the designs tribal or individual. They are common to all. It is true that in certain localities and at certain periods a preference for some patterns always seems to have existed. Individuals also have their preferences. Indeed, in the latter case it is commonly seen; and it is a great advantage to the weaver to work over the same lines until the process becomes mechanical, just as a painter copies the same picture again and again, producing better results at a less cost of labor and time" (p. 262). Emmons also notes the selection of designs and the source of new ones. Of course, in this as well as in Emmons's later Chilkat Blanket (1907) there is prob-

ably an influence from Boas, as in the interest in the relation of design to field. While Boas helped edit both these manuscripts, all evidence suggests that these passages were solely Emmons's.

10. Sargent to Boas, April 24, 1908.

11. For a general statement on his collecting, see Sargent's letter to Boas, May 9, 1908. In addition to his many donations to museums, Sargent supported Boas's archaeological work in the Valley of Mexico (which included studies by Anita Brenner and Herman Haeberlin). Sargent was a modest man; he did not want a certain collection in the Field Museum to be named after him, because he had not collected it but only put up the money (Sargent to Laufer, March 17, 1916, FMNH). Similarly, he assured Boas that he was not interested in the Teit-Haeberlin work as a "write-up" of his collection (Sargent to Boas, March 22, 1916). Sargent had the utmost faith in Boas's work, never interfered (in fact appeared never really to understand its theoretical import), and funded the work as generously as he was able. For biographical data on Sargent, see the donor's file in the Department of Anthropology, FMNH.

12. Boas to Teit, January 22, 1909.

13. Boas to Sargent, March 30, 1915.

14. Boas to Sargent, September 25, 1915.

15. Boas to Sargent, March 1, 1916, September 17, 1917, and October 24, 1917.

16. Boas to Sargent, December 8, 1915.

17. His major subjects were political history and economics at the University of Heidelberg, 1910–11; and history and economics, later anthropology and psychology, at the University of Leipzig, 1911–13. In Berlin he came under the influence of Lamprecht, Wundt, and Bastian, all men with ties to Boas and all interested in psychology.

18. The use of photographs in the field as aids for studies of material culture has a relatively long history in anthropology. Boas himself had used paintings and photographs on his first trip to the Kwakiutl in 1886 to help him better identify the Jacobsen collection in Berlin (Jacknis 1984:5). Another important precursor for the Salish basketry research was Samuel Barrett's study of Pomo basketry (1908), conducted in 1904. Like his teacher, Kroeber, he attempted to get native interpretations of designs: "The general method pursued during the work was to question informants . . . concerning the 840 patterns shown on the photographs of 321 Pomo baskets. . . . At the same time the Indians were also questioned concerning the designs on baskets they had, whenever this was possible. By securing good clear photographs of baskets it was found that informants had no difficulty in recognizing the designs, and that they were able to name them as easily as when they had the actual baskets before them. In this manner it was possible to obtain a greater range of information than otherwise could have been secured" (1908:135). It appears that Haeberlin and Teit used a combination of actual baskets and photographs to elicit informant commentary (cf. Krebs 1975 for a review of the film elicitation technique).

19. Although this formalist-structuralist approach clearly derives from Boas's work (e.g., 1897 and 1907), Haeberlin subtly criticizes his mentor for seeing art in

terms of "technical mastery" alone, instead of stressing the freedom of "artistic imagination" (1918:261).

20. Boas to Haeberlin, October 17, 1916.

21. Boas to Laufer, May 26, 1916, FMNH.

22. Boas to Sargent, February 7, 1918.

23. A good archival source is an interview tape-recorded December 5, 1979, American Folklife Center, Library of Congress; cf. Gray and Hickerson (1988).

24. Problems of rhythm and symmetry were at the heart of Boas's "technical" theory of art. A virtuoso craftsman would derive decorative patterns from the rhythmical actions of his motor patterns. In addition to this special interest in the Salish basketry paper (see Boas to Teit, May 13, 1919, where he requested informants' statements on symmetry), Boas used the work of Teit on Thompson beaded leggings (Boas 1900), Peruvian textiles as reported by Charles Mead (1906)—in an investigation suggested by Boas—and the review of the problem by Gladys Reichard (1922).

BIBLIOGRAPHY

Banks, Judith Judd
 1970 "Comparative Biographies of Two British Columbia Anthropologists: Charles Hill-Tout and James A. Teit." M.A. thesis, University of British Columbia.
Barrett, Samuel A.
 1908 *Pomo Indian Basketry*. University of California Publications in American Archaeology and Ethnology 7:133–308.
Benedict, Ruth
 1935 *Zuni Mythology*. Columbia University Contributions to Anthropology 21.
 1943 "Franz Boas as an Ethnologist." Memoirs of the American Anthropological Association 61:27–34.
Boas, Franz
 1887a "The Occurrence of Similar Inventions in Areas Widely Apart," Science o.s. 9:485–86.
 1887b "Museums of Ethnology and Their Classification," Science o.s. 9:587–89, 614.
 1896 "The Decorative Art of the Indians of the North Pacific Coast," Science n.s. 4:101–3.
 1897 "The Decorative Art of the Indians of the North Pacific Coast." Bulletin of the American Museum of Natural History 9:123–76.
 1898 "Facial Paintings of the Indians of Northern British Columbia." Memoirs of the American Museum of Natural History 1(1).
 1900 "Art," in *The Thompson Indians of British Columbia*, by James Teit. Memoirs of the American Museum of Natural History 2(4):376–86.
 1901 "The Mind of Primitive Man," *Journal of American Folklore* 14:1–11.

1903 "The Decorative Art of the North American Indians," *Popular Science Monthly* 63:481–98. Reprinted in Boas 1940:546–63.

1904a "Some Traits of Primitive Culture," *Journal of American Folklore* 17:243–54.

1904b "Primitive Art: A Guide Leaflet to Collections in the American Museum of Natural History," 15. American Museum of Natural History.

1907 "Notes on the Blanket Designs of the Chilkat Indians." Memoirs of the American Museum of Natural History 3(4):351–400.

1908 "Decorative Designs of Alaskan Needlecases: A Study in the History of Conventional Designs, Based on Materials in the U.S. National Museum." Proceedings of the U.S. National Museum 34:321–44. Reprinted in Boas 1940:564–92.

1910 "Psychological Problems in Anthropology," *American Journal of Psychology* 21:371–84. Cited in Stocking 1974:243–54.

1911a *The Mind of Primitive Man.* New York: Macmillan.

1911b Review of MacCurdy, *Study of Chiriquian Antiquities,* in Science n.s. 34:442–46. Reprinted in Boas 1940:541–45.

1916 "Representative Art of Primitive Peoples." *Holmes Anniversary Volume,* pp. 18–23. Washington, D.C.: Bryan Press. Reprinted in Boas 1940:535–40.

1919 "In Memoriam: Herman Karl Haeberlin," *American Anthropologist* 21:71–74.

1920 "The Methods of Ethnology," *American Anthropologist* 22:311–22. Reprinted in Boas 1940:281–89.

1922 "James A. Teit," *American Anthropologist* 24:490–92.

1927 *Primitive Art.* Oslo: Instituttet for Sammenlignende Kulturforskning, ser. B, 8. Cambridge: Harvard University Press.

1936 "History and Science in Anthropology: A Reply," *American Anthropologist* 38:137–41. Cited in Boas 1940:305–11.

1940 *Race, Language, and Culture.* New York: Macmillan.

Brenner, Anita

1931 *The Influence of Technique on Decorative Style in the Domestic Pottery of Culhuacan.* Columbia Contributions to Anthropology 13.

Briggs, Charles L.

1975 "'An Anthropologist's Credo': On the Opposition of Individual and Society in the Work of Franz Boas." Manuscript.

Bunzel, Ruth L.

1929 *The Pueblo Potter: A Study of Creative Imagination in Primitive Art.* New York: Columbia University Press.

1960 Introduction to "Franz Boas (1858–1942)," in *The Golden Age of American Anthropology,* ed. Margaret Mead and Ruth Bunzel, pp. 403–4. New York: George Braziller.

Emmons, George T.

1903 *The Basketry of the Tlingit.* Memoirs of the American Museum of Natural History 3(2):229–77.

1907 *The Chilkat Blanket.* Memoirs of the American Museum of Natural History 3(4):329–401.

Frisbie, Charlotte J.

1989 "Helen Heffron Roberts (1888–1985): A Tribute," *Ethnomusicology* 33(1): 97–111.

Gogol, John M.

1985 "1900–1910: The Golden Decade of Collecting Indian Basketry," *American Indian Basketry* 5(1):12–29.

Gray, Judith, and Joseph C. Hickerson

1988 "Helen Heffron Roberts, 1888–1985," *Folklife Center News* 10(3):10–11.

Haddon, Alfred C.

1895 *Evolution in Art*. London: Walter Scott.

Haeberlin, Herman K.

1916 "The Idea of Fertilization in the Culture of the Pueblo Indians." Memoirs of the American Anthropological Association 3(1).

1918 "Principles of Esthetic Form in the Art of the North Pacific Coast," *American Anthropologist* 20:258–64.

Haeberlin, Herman, J. A. Teit, and H. A. Roberts, under the direction of Franz Boas

1928 *Coiled Basketry in British Columbia and Surrounding Region*. Annual Report of the Bureau of American Ethnology for 1919-1924, 41:119–484.

Handler, Richard

1983 "The Dainty and the Hungry Man: Literature and Anthropology in the Work of Edward Sapir," in *Observers Observed*, ed. George W. Stocking, pp. 208–31. Madison: University of Wisconsin Press.

1986 "Vigorous Male and Aspiring Female: Poetry, Personality, and Culture in Edward Sapir and Ruth Benedict," in *Benedict, Rivers, Malinowski and Others*, ed. George W. Stocking, pp. 127–55. Madison: University of Wisconsin Press.

Jacknis, Ira

1984 "Franz Boas and Photography," *Studies in Visual Communication* 10(1):2–60.

Krebs, Stephanie

1975 "The Film Elicitation Technique," in *Principles of Visual Anthropology*, ed. Paul Hockings, pp. 283–301. The Hague: Mouton.

Mead, Charles W.

1906 "The Six-Unit Design in Ancient Peruvian Cloth," in *Boas Anniversary Volume*, ed. Berthold Laufer, pp. 193–95. New York: G. E. Stechert.

Mead, Margaret

1959a *An Anthropologist at Work: Writings of Ruth Benedict*. Boston: Houghton Mifflin.

1959b "Apprenticeship Under Boas," in *The Anthropology of Franz Boas*, ed. Walter Goldschmidt. Memoirs of the American Anthropological Association 89:29–45.

O'Neale, Lila M.

1930 Review of Haeberlin et al., *Coiled Basketry in British Columbia and Surrounding Region*, in *American Anthropologist* n.s. 32:306–8.

1932 *Yurok-Karok Basket Weavers*. University of California Publications in American Archaeology and Ethnology 32(1):1–184.

Reichard, Gladys A.

1922 "The Complexity of Rhythm in Decorative Art," *American Anthropologist* 24:183–204.

1936 *Navajo Shepherd and Weaver*. New York: J. J. Augustin.

1943 "Individualism and Mythological Style," *Journal of American Folklore* 57:16–25.

1947 *An Analysis of Coeur d'Alene Indian Myths*. Memoirs of the American Folklore Society 41.

Roberts, Helen H.

1929 *Basketry of the San Carlos Apache*. Anthropological Papers of the American Museum of Natural History 31(2).

Sapir, Edward

1929 "Design in Pueblo Pottery," review of Bunzel, *The Pueblo Potter*, in *New Republic* 61:115.

Sieber, Roy

1973 "Approaches to Non-Western Art," in *The Traditional Artist in African Societies*, ed. Warren L. d'Azevedo, pp. 425–34. Bloomington: Indiana University Press.

Starr, Kevin

1985 *Inventing the Dream: California Through the Progressive Era*. New York: Oxford University Press.

Stocking, George W., Jr.

1968 *Race, Culture, and Evolution: Essays in the History of Anthropology*. New York: Free Press.

1976 "Ideas and Institutions in American Anthropology: Toward a History of the Interwar Years," in *Selected Papers from the American Anthropologist, 1921–1945*, ed. G. W. Stocking, pp. 1–44. Washington, D.C.: American Anthropological Association.

Stocking, George W., Jr., ed.

1974 *The Shaping of American Anthropology, 1883–1911: A Franz Boas Reader*. New York: Basic Books.

Thoresen, Timothy H. H.

1977 "Art, Evolution, and History: A Case Study of Paradigm Change in Anthropology," *Journal of the History of the Behavioral Sciences* 13:107–25.

Washburn, Dorothy K.

1984 "Dealers and Collectors of Indian Baskets at the Turn of the Century in California: Their Effect on the Ethnographic Sample," *Empirical Studies of the Arts* 2(1):51–74.

Wickwire, Wendy C.

1988 "James A. Teit: His Contribution to Canadian Ethnomusicology," *Canadian Journal of Native Studies* 8(2):183–204.

MARGOT BLUM SCHEVILL

6

LILA MORRIS O'NEALE

ETHNOAESTHETICS AND THE

YUROK-KAROK BASKET WEAVERS OF

NORTHWESTERN CALIFORNIA

Lila Morris O'Neale—anthropologist, professor of deco-
rative art, and associate curator of the Museum of Anthropology, Uni-
versity of California at Berkeley (fig. 27)—was a pioneer in the kind of
fieldwork described by Clifford Geertz in his article "From the Native's
Point of View" (1977). This ethnoaesthetic approach, focusing on Native
aesthetics and criteria for excellence, has now become one of the ac-
cepted ways of pursuing anthropological fieldwork with contemporary
artists of the Indian Americas. Until recently the narrative was still in the
voice of the researcher, not the Native American. In the past decade, how-
ever, Native peoples have begun to speak more directly to the public,
sometimes by means of oral histories. Researchers and Native peoples

Figure 27. *Lila M. O'Neale. Photographer unknown, 1930s.*

work together on the text or film, rewriting or reinterpreting until the results are truly in the Native person's voice (Burgos-Debray 1984; Eber 1971; Blackman 1982, 1989).

O'Neale's doctoral dissertation on Yurok-Karok basket weavers (1932) presents the voices of the weavers and is a model of excellence. Contemporary Northern California basket weavers know of *Yurok-Karok Basket*

Weavers and refer to it as "*that* anthropology book" (Peg Mathewson, pers. comm., 1990). Indeed, it was one of the few comprehensive works on California basketry until recent times.[1] Although O'Neale was not an art dealer, an art historian, or a collector, she was interested in the Native American artist as an individual, and was in line with the new anthropological thought of her day.[2] In addition to identifying Karok or Yurok style baskets, she focused on the weavers as individual artists with personal tastes and idiosyncrasies. In her publication the weavers are identified by tribal affiliation and a number assigned to each one interviewed—the anonymity of informants practiced by social scientists until very recently.[3] Marvin Cohodas (1979) praises O'Neale's methodology and style analysis but comments that she did not reveal names of weavers or informants in the published text. The weavers' names, however, are listed in her field notes on file at the Bancroft Library, University of California at Berkeley (1930b).

Earlier publications on California basketry include those by Roland Dixon (1902), J. W. Hudson (1893), and A. L. Kroeber (1905). Kroeber focused on the Native names of basket designs and other classifications such as types of baskets, materials, and techniques. He developed a list of culture traits derived from northwestern California Indian basketry and utilized these characteristics for cross-cultural studies. As with other aspects of the Klamath River peoples' material culture, Kroeber found no differences between Yurok, Karok, and Hupa baskets (1905:116). Samuel A. Barrett, one of Kroeber's graduate students, adopted these classifications in his analysis of Pomo basketry (Barrett 1905). Kroeber integrated the findings of Barrett and Dixon in his 1905 publication. Reviewing Barrett's study in *American Anthropologist*, Kroeber concluded that among the Pomo there was a "tremendous predominance of unmotivated custom and habit over conscious utilitarian, artistic, or religious purpose" (1909:249). Lila O'Neale, also a student of Kroeber's, would expand and correct his conclusions by looking at the *process* of basket weaving and placing it in the context of Yurok-Karok life. By interviewing the weavers themselves, she discovered what Kroeber had missed: on the Klamath River, the weavers did practice conscious and motivated care in the creation of each basket, whether it was for religious or utilitarian purposes or for sale. O'Neale learned that innovation in design was ongoing and an inexhaustibly exciting topic for discussion.[4] *Yurok-Karok Basket Weavers* is unique and contemporary in tone and rich in information and continues to be utilized and admired by scholars, students, and teachers of

art history, anthropology, and Native American studies, by collectors and dealers, and by Native California basket weavers themselves.

Of Irish and English heritage, O'Neale was born on a farm in Buxton, North Dakota, and grew up in Minneapolis and San Jose.[5] At Stanford University she received a classical education, studying Latin, literature, and related subjects.[6] In 1909, she received her secondary diploma in household arts from the State Normal School in San Jose. Her first teaching assignment was not in English but as a manual training teacher in the Oakland public schools, part of the Arts and Crafts Movement (mentioned by Cohodas, this volume).

O'Neale also studied at Columbia Teachers College in New York on two occasions, in 1912–13 and 1915–16. Perhaps she encountered cultural anthropology and Franz Boas, or heard of A. L. Kroeber and his work on California Indians, during her New York years, but her records do not include any anthropology courses at Columbia University. She received a bachelor of science degree in household arts in 1916 and taught for the next ten years in Wisconsin and at the Oregon Agricultural College in Corvallis.[7] From the beginning of her teaching career, she focused on the history and development of textiles.

Dissatisfied or perhaps frustrated by the limitations of teaching household arts, O'Neale took a leave from her tenured teaching position in Oregon and enrolled at the University of California in Berkeley. She wanted to complete a master's thesis on lace in the Department of Household Arts, the same topic pursued by her lifelong friend and companion, Martha Thomas, who taught at San Jose State College. A. L. Kroeber, head of the Museum of Anthropology, and senior professor in the Anthropology Department, had just returned from fieldwork in Peru. He needed a textile analyst to work on the archaeological cloth he had recovered. O'Neale was recommended because of her experience with textiles. Taxonomic classification was the accepted mode for organizing data. With her specialized background and knowledge of textile construction and fibers, she was able to set up taxonomic categories for analysis, and Kroeber supplied the archaeological context. Thus began the first of many such collaborations over a twenty-year period. Upon his suggestion, O'Neale switched her thesis topic from lace to Peruvian archaeological textiles. Her thesis was entitled "Design, Structural and Decorative, with Color Distribution Characteristic of Ancient Peruvian Fabrics" (1927).

After receiving her master's degree in 1927, O'Neale decided to enter the doctoral program in anthropology and went to Kroeber for consulta-

tion. Despite his admiration for her textile skills, he did not encourage her to pursue a doctorate. Perhaps it was her age, for she was twenty years older than most graduate students and had a greater confidence, derived from her years in New York and her teaching experience (Cora Dubois, pers. comm., 1986). Or it may have been Kroeber's attitude toward teaching as described by his wife, Theodora (1970:209, 263–64): "He had no ambition to be a 'great' teacher or to be a guru to disciples. . . . Kroeber liked women but he was more discriminating about the women he liked than about the men. These women tended to be 'characters,' to be interesting and vital, to be intellectual and humane. . . . Kroeber did not like women who attempted to lionize him, or who made a cult of the Indian. He did not like women who 'fussed.'" It seems strange that Theodora did not include O'Neale in her discussion of Kroeber's women Ph.D. students. She was certainly not a fusser, and she and Kroeber became friends and colleagues.

O'Neale finished two years of course work, proving to Kroeber and others that she was a fine scholar as well as an accomplished textile analyst. She was ready for material culture studies among Native peoples of northwestern California, a far cry from Peruvian archaeological textiles. Kroeber had ongoing field studies with the Yurok, Karok, and Hupa (1905, 1925). Some of his associates and graduate students, such as Samuel Barrett, Edward Gifford, Pliny E. Goddard, T. T. Waterman, and later Harold Driver, Anna Gayton, and Cora Dubois, were engaged in fieldwork with California Native Americans. Kroeber suggested that O'Neale study the material culture of the Klamath River groups, which centered on basket weaving. At the age of forty-three, she set off in the summer of 1929 for the Klamath River. She was accompanied by Martha Thomas, who drove them in Martha's green Model T Ford. Kroeber had provided only the "skimpiest instructions," a map, and advice on where to stay (David Mandelbaum, pers. comm., 1983).

In only six weeks, O'Neale accomplished a marathon of travel and investigation. She interviewed all the basket weavers she could find, some fifty women including one family. The tribal representation was twenty-five Karok, sixteen Yurok, and seven Hupa weavers.[8] Forty-three of these interviews appear in her publication. The Hupa interviews, however, were deleted, although photographs of Hupa baskets are included. Researchers and Native Californians have wondered why O'Neale omitted this material.[9] O'Neale explains this decision in the introduction to *Yurok-Karok Basket Weavers* (1932:9):

For the purposes of this study no segregation of Hupa baskets was attempted. Some of them purchased under conditions rendering certainty of origin impossible are labeled "Hupa or Yurok." Two or three more tribe-conscious informants declared their baskets were like those of the other two tribes in all particulars, and then acknowledged an intuitive feeling for those undoubtedly their own. The results were about even: a triumphant guess on one was often matched by virulent criticism of another basket which could not possibly be theirs, but was so recorded. The fact is that they can tell a very few of their own baskets by design, none by workmanship (table 17). A predominant use of certain locally available materials and minor departures from the typical of a familiar region are clues, not determinatives.

Yurok and Karok weavers acknowledged that Hupa basket weavers were especially innovative in designs, shapes, and use of materials. O'Neale wrote of Yurok knowledge of Karok and Hupa: "The Hupa . . . always betray their advanced notions in some unusual feature . . . to a Yurok the Hupa are the innovators" (p. 140). Of Karok knowledge of Yurok and Hupa, she commented: "At present, the Karok enumerate the modern European details of ornamentation, ribbons, tinsel, and novelty effects in braids, which as substitutes for fur strips, feathers, and the other traditional embellishments have crept into Hupa dance regalia. The Karok say there is a similar trend in Hupa basketry and regret the cheapening" (p. 140).

It is clear that innovation was ongoing among the Klamath River groups in response to the collector craze initiated by anthropologists and dealers that was affecting all Native California basket weavers. Elsewhere in the text O'Neale comments about the prescribed design arrangements for Jump Dance baskets: "Or, the basket might be the work of a Hupa weaver, synonymous, from the Yurok-Karok standpoint, to saying that the work is touched by *modern extravagance*" (p. 70, my emphasis).

Although "high" men, or *wegern*, also wove baskets and nets, O'Neale did not include interviews with male basket weavers in her data.[10] Travel was frequently by canoe, for the weavers lived in camps along the shore of the Klamath River, inaccessible by automobile. O'Neale went from camp to camp, accompanied by interpreters who were also weavers (fig. 28). Her research goals were to "investigate the weaver's subjective attitude, to determine individual reactions to craft aspects" and "to relate the weaver

Figure 28. Lila M. O'Neale on the Klamath River.
Photographer may be Martha Thomas, 1929.
(Courtesy Bancroft Library)

to the conventions or to whatever variations seem to have taken place in form or pattern and to let her define in terms of the tenets of her craft the relative importance of its aspects" (p. 5). This approach contrasts with what Dorothy Washburn called "the pigeonhole divisions of culture that Western observers had developed to describe 'primitive' cultures. In this departure from traditional ethnographic field technique O'Neale was revolutionary" (n.d.:2).

O'Neale derived the idea for this approach to fieldwork, now known as ethnoaesthetics or native exegesis, from a publication she reviewed for *American Anthropologist* (1930a). This Bureau of American Ethnology paper, *Coiled Basketry in British Columbia and Surrounding Region*, published in 1928, was edited by Franz Boas. Included were field notes by James A. Teit, who interviewed weavers as early as 1909 (Jacknis, this volume). Of particular interest to O'Neale was Boas's statement in the preface: "The problem that I set myself was an investigation into the attitude of the individual artist toward his work. Much has been written on the origin and history of design without any attempt to study the artist himself. It seemed to

me necessary to approach the problem from this angle" (Haeberlin et al. 1928:131). Boas thought that in the literature the designs had been treated too objectively and formally. He instructed Teit to find out from the weavers what designs they made and also "the critique of other women of their work."

In her review of the coiled basketry book, O'Neale concluded: "The analysis of materials, preparation and design fields are conventional enough. It is only when these are viewed from the standpoint of an avowed intention to investigate the 'attitude of the individual artist toward his work' that a new approach becomes definitive" (1930a:306). O'Neale acknowledges, in the introduction to her dissertation, to "having freely adapted to a study of the tribes on the Klamath river whatever methods appeared to have been successful among the British Columbia tribes" (1932:5).

By the 1920s, ethnoaesthetics had been adopted as a fieldwork strategy by Boas's students working in the Southwest. Gladys Reichard learned to weave from Navajo weavers, and Ruth Bunzel was making pots under the direction of Pueblo potters (Reichard 1936; Bunzel 1929; see Berlo, this volume). Ruth Benedict was planning her first field trip to Zuni in 1924. Bunzel wanted to explore anthropology as a career, so she offered to accompany Benedict as her secretary (Mead 1959:33–34). Boas advised Bunzel to look at the relation of artists to their work, advice he was offering to all his students.[11] She learned to make pots, which conformed to Native standards, in two Pueblo villages. She was attempting to "enter fully into the mind of primitive artists; to see their technique and style, not as they appear objectively to students of museum collections, but as these appear to the artists themselves, who are seeking in this field of behavior a satisfactory and intelligible technique of individual expression" (Bunzel 1929:1).

Unlike Bunzel and Reichard, O'Neale did not interact with the Klamath River basket weavers as a participant-observer, one who would experience the entire basket production process firsthand. She talked with them individually, however, in their homes and in small groups. Thus she was able to observe all aspects of the basket making process. In order to learn the Native aesthetics, she showed them large photographs of 123 baskets of the Yurok, Karok, Hupa, and other northwestern groups from the collections of the Museum of Anthropology, the California Academy of Sciences, and private collections. This strategy, adapted from the coiled basketry paper,[12] gave the weavers the opportunity to reappropriate older

tribal information as represented in baskets. Some of the photographs are not well documented. The baskets represented were purchased or photographed in the field in the early 1900s by Kroeber, Pliny E. Goddard, and other collectors. In the spirit of salvage anthropology, they were attempting to acquire so-called traditional or authentic forms.[13] Aesthetic beauty, technical perfection, and especially "age" were the accepted criteria for good baskets. Authenticity was equated with use, and well-worn baskets were sought. In keeping with systematic ethnographic collecting and the search for authenticity practiced by anthropologists and dealers, Kroeber bought some of his baskets directly from the weavers, and from other collectors and dealers such as Brizzard's. O'Neale interviewed an older Yurok weaver: "Mrs. Sonie Baskey, a Yurok weaver (80 years old in 1929) from Weitchpec recalled how her mother sold Kroeber a large acorn basket, and remembered that he 'pays for everything in money.' It was the first time her mother had sold her baskets" (1930b).

Categories of baskets represented in the photographs included women's dress hats, fancy baskets, made-for-sale baskets, Jump Dance baskets, acorn soup and cooking baskets, openwork baskets, seed baskets, and baskets from neighboring tribes. Klamath weavers had been producing made-for-sale baskets since contact with the whites in the mid-nineteenth century, a result of the placer mining activities in the area. The mother of Mrs. Frank Reece (seventy years old in 1929) remembered that her mother sold footed bread baskets to the Chinese. Another weaver only made baskets for sale. She camped near a millionaire fisherman who bought everything she produced. As for fancy baskets, Mrs. Fanny Smoker told O'Neale that this new style—larger, more elaborately decorated and sometimes lidded—evolved from old-style trinket baskets because of white influence (O'Neale 1930b).

O'Neale reported on the reactions of the participants who were asked to segregate the images according to tribal affiliation and function, and then to comment on them (1932:8):

Each informant was shown every print. The method has obvious advantages. Different women reacted in greater or lesser degree to pictured objects of art they had known through two generations at least. . . . This eagerness (to examine the pictures) may be partly explained by recalling two facts: up to a comparatively recent time a woman's baskets were destroyed at her death, leaving no old ones to become objects of sentimental regard; and also, these same pic-

tures were of the very baskets obtained from their people within their own lifetime, some baskets they might even recognize. . . . the Yurok-Karok basket maker of any age is an enthusiast on the subject of her craft.

The women asked O'Neale for copies of the photographs of some of the baskets that interested them. These baskets might be replicated if the weaver thought they would sell well to the white buyers. Information elicited from the photograph sessions included technical details, special uses, and knowledge of the weavers who were associated with certain designs. A combination of form, material, color, and established patterns, not individual marks or motifs, signaled tribal affiliation. What emerged was a body of principles of taste—tribal lore passed down verbally from generation to generation. These principles were enforced by means of on-going discourse among the weavers about excellence in the production of baskets. No weaver was beyond criticism by her peers.[14] The photographs of made-for-sale baskets with innovative arrangements of marks or new shapes stimulated lively discussion.

The weavers explained that they became bored with replicating older "traditional" design arrangements that their customers considered "authentic." They would invent new arrangements of locally accepted design elements.[15] Collectors, such as Kroeber, purchased these baskets thinking they were "pure"—that is, without outside influences and created for use by the weavers (Washburn 1984:72). Other collectors and dealers, such as Grace Nicholson, encouraged Karok weavers Lizzie Hickox and her daughter Louisa to produce tightly woven baskets with traditional designs that signaled authenticity and were an appropriation of Karok basket design conventions (fig.29).[16] Nicholson contracted for all of Lizzie Hickox's output from 1908 to 1934. She also asked Hickox to collect baskets for her and offered twice as much for the baskets as Lizzie had paid for them. After 1934, Nicholson stopped coming to the Klamath River; and, coincidentally, without the impetus of the dealer's visits, Lizzie Hickox ceased weaving (Demott and Cohodas, n.d.). In O'Neale's interview section (1932:175), Hickox is informant No. 28 and Louisa is No. 29:

No. 28, a Karok in the Katimin district; about sixty years old; mother of No. 29. An exceptionally good weaver of a single type of small covered basket, modern in shape but with old designs in it. For a number of years every basket she has made has gone out of the re-

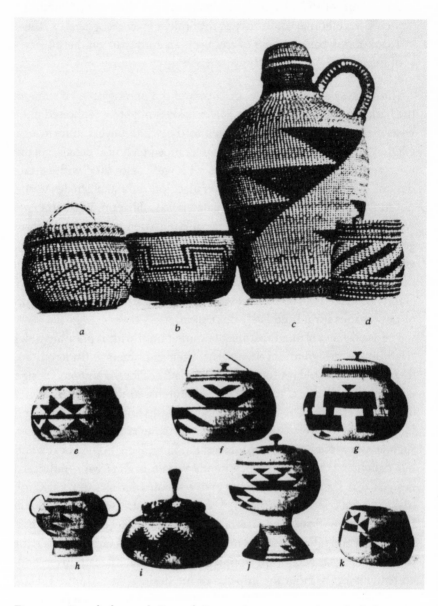

Figure 29. Fancy baskets. a–d: Group of objects made in response to demands of white buyers. e–k: Baskets with features and design variations showing European influence. The basket designated as "i" was made by Lizzie Hickox. Photographer and date unknown. (Courtesy Lowie Museum of Anthropology)

gion on contract. She is under no obligation as to sizes or number in a lot, but the patterns must be authentic, old. Her opinions on standards and conventional proportions are valuable; her own feelings with regard to quality were apparent in the discussions of each phase of basketry; she knew each from the angle of the best way to do things for the highest quality result. Everyone referred to her as a fine weaver, but her work is seen in the district too seldom to call forth detailed comments. Were she in active competition with other local weavers there would have been a good deal said of her divergence from traditional forms.

O'Neale adapted the organizational scheme of the coiled basketry paper to suit her research focus on the individuality of the weavers and their baskets. Because of her background as a teacher, O'Neale devoted the first chapter of her dissertation to learning and teaching the craft. Always a writer of few but well-chosen words, she refers the reader to Kroeber's *Handbook of the Indians of California* (1925) and to T. T. Waterman's *Yurok Geography* (1920) for environmental and other background material about the Klamath River peoples. Her twenty years of teaching had confirmed the notion that mastery of a technique influences the form of the object. She was interested in the process of weaving baskets and the way it was taught to young women. The fact that she was a woman allowed for an informality that was not possible with male investigators, such as Goddard and Kroeber, because of Yurok, Karok, and Hupa social practices. The women enjoyed talking about basket making with someone as knowledgeable as O'Neale. The photographs helped to generate conversations about design motifs, property marks, acceptable standards of workmanship, sources for materials, care of baskets, proportion and contour, color combinations, and techniques. Also discussed were male-female involvement in basket making, Yurok and Karok knowledge of each other's work and the work of outside tribes, influence of white patronage, and Yurok and Karok attitudes toward innovation. As already stated, many of these categories had been overlooked by Kroeber, who wanted to define more general cultural traits among California Indians for cross-cultural studies (Bernstein 1986:139–40).

In *Yurok-Karok Basket Weavers*, O'Neale explores these categories. In addition to reproducing the basket photographs shown to the weavers, she photographed the weavers preparing materials, and sitting with their baskets (figs. 30, 31). Some of the women are wearing dress hats. The first

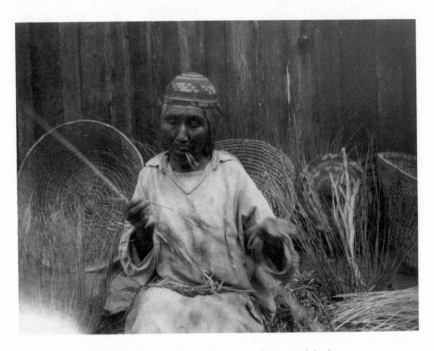

Figure 30. Nettie Ruben, Karok, peeling willow shoots for her stick baskets.
Photograph by Lila M. O'Neale, 1929.
(Courtesy Lowie Museum of Anthropology)

weaving attempts of two six-year-old Yurok weavers are pictured. Illustrations include drawings of "new," "old," "easy," "hard," and disputed designs; diagrams showing different stages of basket weaving; a design draft made on plain paper; and maps of localities of informants, locations of materials, and one showing distances that experts' reputations have traveled!

O'Neale included the forty-three interviews of Yurok and Karok weavers in an appendix. She questioned them about their own work and included the weavers' opinions of other weavers—a peer review. In addition, she added her evaluations of their ability.[17] Here are some examples (1932:169, 173):

No. 4 [Mrs. Kitty George], a Yurok at Sregon; about forty-five years old; a weaver with old traditions. She has taught her seven-year-old daughter as she herself was taught. I saw none of her work although she has a reputation as a dance basket maker. Her invented mark is shown in figure 18g. No. 5 said No. 4 makes all kinds of baskets; she

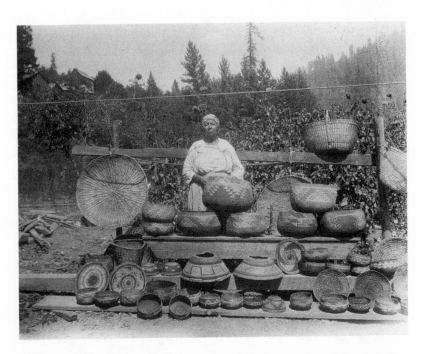

Figure 31. *Cooking and serving baskets used by Mary Jacobs, Karok, at the Karok New Year's making. Photograph by Lila M. O'Neale, 1929.* (Courtesy Lowie Museum of Anthropology)

also crochets. She uses old basket marks in her weaving. No. 6 said No. 4 makes fine porcupine quill caps. No. 12 had heard the husband boast of his wife's Jumping dance baskets.

No. 20 [Mrs. Nettie Ruben], Karok in the Panamenik district; about fifty-five years old; the professional basket maker of the up-river region. Because she grew up near Katmin and now lives in the Panamenik district, she is better known and more often spoken of than any other one weaver on the Klamath river. She has made every sort of basket but the Jumping dance basket, besides novel shapes and fancies for sale to tourists. In addition to the usual repertoire of closely woven types she is adept at stick weaving. She makes clothes and market baskets of all sizes from the two-inch gift sizes up. She does not make miniature close-twine baskets. . . . She has tried her hand at crocheting, has made arrows, paper flowers, and other non-basketry objects. According to general opinion, whatever No. 20 attempts is

well done. Since more women referred to her and the range of comments was widest in her case, it may be of interest not to summarize them in this one instance.

O'Neale goes on to repeat all the comments made by the weavers about Mrs. Nettie Ruben, one of the most admired weavers on the river.

The category of designs is presented in great detail. Weavers liked to talk about this topic. O'Neale's subheadings include correlations between basket types and patterns, prescribed design arrangements for basket types, prescribed treatment of design motifs, "old" and "new" marks, new designs, modified designs, and tribal taste in designs. There was no romanticizing about the meanings of motifs, a liberty exercised by Amy Cohn when she wrote or talked about Louisa Keyser's work (Cohodas, this volume). O'Neale found that design names were identification tags calling to the weaver's mind specific forms (fig. 32). They discussed each mark—the flint, snake, zigzag, and Wax'poo—in detail. Questions about possible symbolic meanings made the weavers feel self-conscious and ill at ease. Everyone knew all the old marks or was supposed to know them (p. 74).

Sources for new designs interested O'Neale as well as Teit, who recorded that among the Thompson Indians of British Columbia some patterns originating in dreams were as highly valued as traditional ones. In contrast, O'Neale writes that no one took seriously the idea of dream elements as a design source. When weavers admired or copied forms from outside their tradition, such as those from printed oilcloths, patchwork quilts, and commercial cottons, the question of good taste arose. Comments of disapproval about some designs were elicited: "Not ours, maybe from other peoples down river," "All mixed up looking," "There is no sense to it." Correct baskets were described as "ours," "good," "put together right," and "That weaver really knew how to do it right." Old baskets and fragments served as models, as would the photographs O'Neale promised the weavers. The new baskets, however, would not replicate the old ones exactly.[18]

O'Neale's research with the Klamath River basket weavers elaborated on what Boas had concluded in the coiled basketry monograph. He stated that "the range of individual invention is strictly limited by the traditional style" and that "the power of invention of the artist is obviously under the control of tradition" (Haeberlin et al. 1928:386). O'Neale also concluded that excellence and formal diversity of a given art style hinged on perfection of technique, and that innovation was an ongoing process stimulated

Figure 32. Design elements in frequent use. Illustration by Lila M. O'Neale, 1932.
(Y) indicates Yurok identification. (K) indicates Karok identification.
(Courtesy Lowie Museum of Anthropology):

a. flint (Y), flintlike (K)
b. snake (Y), long worm (K)
c. spread finger or spread hand (Y), frog hand (K)
d. sharp tooth (Y), points (K)
e. zigzag (Y and K)
f. sitting (Y), snake nose (K)
g. ladder (Y), cut wood (K)
h. wax'poo (Y), apxanko'ikoi (K)
i. foot (Y and K)
j. straight stripes (Y and K)
k. slant stripes (Y and K)
l. elk (Y), cut wood (K)

by the white buyers. Innovative forms were created by those weavers who knew all the forms and had mastered all the necessary techniques. By means of photo elicitation, O'Neale confirmed what had eluded Goddard and Kroeber—that is, which baskets had been made for sale and which were created for native use.

Kroeber acknowledged *Yurok-Karok Basket Weavers* to be "one of the most important and liveliest [reports] ever to be made in the field" (Kroeber Papers 1948). Lawrence E. Dawson, research anthropologist at the Lowie Museum of Anthropology, responding to my query about the influence of O'Neale's work on his own basket research, stated: "O'Neale helped me to distinguish between the many made-for-sale pieces in the collections [Lowie Museum] and the traditional baskets. I was able to obtain a clear picture of white influence through different media" (pers. comm., 1983). Dawson also commented that he learned about the "set of traditional baskets with all their culturally conditioned features" and that the idea of sets constituted the proper base material for comparative study.

O'Neale may have been one of the first researchers to isolate "tourist art" (Nelson Graburn, pers. comm., 1985), a topic that has attracted many scholars in recent years (Graburn 1976, 1984; Jules-Rosette 1984; Baizerman 1987). The Klamath River basket weavers were becoming separated from their subsistence patterns in which baskets played such an important role. It was a time of transition. Money was needed to negotiate goods in the nonnative world that surrounded them. Mrs. Rosy Jacks of Requa told O'Neale: "We made baskets every day. Only way to get clothes" (1930b). Another weaver sold through the local storekeeper. The late nineteenth century was a period of intense collecting of California baskets, not only by anthropologists salvaging "traditional" material, but by dealers and collectors. These intruders could be conceived of as "tourists" or what the Victorians called "travelers."[19] Made-for-sale or tourist art was being produced by the Klamath River weavers for this new market. O'Neale's book documents the reasons for these new forms from the weaver's point of view.

In addition, O'Neale's use of several layers of the weavers' comments about the baskets, in tandem with their evaluations of other weavers, biographical information, and her own evaluations of the weavers' abilities, is contemporary in method. Such an approach resembles the hermeneutic analysis of data in which sets of symbolic forms are compared with other sets, and various interpretations are explored (Geertz 1977). This

layering of information would prove useful in O'Neale's future ethno-aesthetic fieldwork on Papago color designations, with Maya weavers in Guatemala, and with Quechua potters in Peru (O'Neale and Dolores 1943; O'Neale 1945, 1976).[20]

In 1930, after receiving her Ph.D. in anthropology at the age of forty-four, O'Neale served as lecturer, later associate professor, in the House-hold Arts Department on the Berkeley campus.[21] While on a Guggenheim fellowship to Peru in 1931, where she was studying archaeological textiles from Paracas, O'Neale did fieldwork with pottery makers in Ayacucho and Huancayo. She dealt with the potters directly and observed them at work and at market. Native categories developed in *Yurok-Karok Basket Weavers* were again put to use. Published posthumously, the article "Notes on Pottery Making in Highland Peru" (1976) was a pioneering effort in ethnoarchaeological research. It was an attempt to provide clues about the relation between contemporary and pre-Columbian ceramic production.

O'Neale and her colleagues pushed to get Household Arts out of the College of Agriculture and into Letters and Science. She succeeded and became head of the newly created Department of Decorative Art. Research with archaeological textiles culminated in many publications (1933, 1934a, 1934b, 1935, 1936b, 1937a, 1937b). Two more ethnoaesthetic studies followed the basket and pottery fieldwork.

In 1936, O'Neale spent four and one-half months in Guatemala as part of a research project sponsored by the Carnegie Institution of Washington, D.C. Her assignment was to document the existing complex textile traditions of Maya weavers. Because of the paucity of archaeological textiles in Mesoamerica, another objective was to look for pre-Columbian survivals in textile technology, materials, and iconography, a research focus of her Peruvian ethnographic fieldwork. *Textiles of Highland Guatemala* was published in 1945 and is known as "The Bible" to those who study Guatemalan textiles. It provides a comprehensive background of this subject up to 1936. In addition to documenting the Native categories, O'Neale describes the dress of men, women, and children from 104 highland villages. Not able to visit all these villages in the short time she was in Guatemala, she used three other collections in addition to the one she made for the Decorative Art Department collection: the 1902 Gustavus Eisen collection in the University of California Museum of Anthropology, the Matilda Gray collection at the Middle American Research Institution, and the private,

well-documented collection of Mrs. Mildred Palmer of Guatemala City. Contemporary scholars who study Guatemalan textiles have built on the solid foundation provided by O'Neale over fifty years ago.

In collaboration with Juan Dolores, a Papago Indian and preparator at the Museum of Anthropology, O'Neale wrote about Papago color designations (1943). Dolores was Kroeber's close friend, and Kroeber had encouraged him to write about the Papago language (1913, 1923). O'Neale devised an innovative methodology for these sessions. She presented Dolores with colored papers from Milton Bradley's *Studio Book of Colored Papers* (1895), which included eighteen hues with five values each, in order to elicit familiar names for colors. Qualifying adverbs such as "almost," "very," and "very much" described the value of each hue. The Papago add prefixes or suffixes to the color name for this function. Dolores's list contained three dozen names, including the neutrals—blacks, whites, and grays.

Dolores's information revealed that Papago color terms were related to the context of the object described and were a "response" to the environment. It seemed that there was a separate, more recent, color category of Spanish origin that related to animals such as horses, mules, and dogs. O'Neale concluded that some color terminology was of late development among the Papago, and the expansion of Papago color designations was due to education and increased availability of colored objects and materials.

O'Neale's ability to elicit and organize this data, in tandem with Dolores's firsthand information, produced a native exegesis of Papago color terminology. It is a clear presentation, one that stands up under the scrutiny of contemporary scholarship (Jesse Sawyer, pers. comm., 1986). The article anticipated by more than twenty years the work of Berlin and Kay (1970), who were working toward semantic universals in relation to color categories. Using Munsell color chips, as O'Neale had utilized Bradley's book of colored papers, Berlin and Kay questioned one Papago informant who identified the same color sequence given by Dolores. O'Neale also anticipated the findings of Berlin and Kay on blue-green, or "grue" as they were to call it (1970:20). She identified greenish-gray and grayish-green, stating: "The Indian use of the word green to describe objects which to other observers are blue has often been cited. . . . yet the two colors are not assumed to be identical and no Papago would misunderstand the use of the color name" (O'Neale and Dolores 1943:395).

On Saturday, January 31, 1948, O'Neale gave her last examination. Within

twenty-four hours she was in Permanente Hospital with a strain of pneumonia that was resistant to penicillin. She died Monday, February 2, at the age of sixty-two.[22]

The legacy of Lila M. O'Neale's innovative fieldwork and publications was passed on to some contemporary archaeologists, anthropologists, art historians, textile specialists, and Native Californian basket weavers. Some of the scholars who have benefited directly from O'Neale's researches and field techniques include Mari Lyn Salvador (1978), Ann Lane Hedlund (1983), Hildegard Schmidt de Delgado (1963), Lynn Meisch (1986), Christine and Edward M. Franquemont (1987), Christine Conte (1984), Ann Pollard Rowe (1981), and this author (1980, 1985, 1986b, n.d.).

Did *Yurok-Karok Basket Weavers* have an impact on anthropological research in the 1930s?[23] Academic trends fluctuate and, by the late 1930s and 1940s, material culture studies were no longer in vogue. Emphasis was on social structure, linguistics, and other avenues of research. Time passes and the pendulum swings in the other direction. In 1967, Philip J. C. Dark lamented the lack of the "most elemental knowledge" about the domain of art within a native culture and the aesthetic values held that determine or delimit its form of expression (Dark 1967:131). Gene Weltfish, another student of Boas's who was encouraged to look at the relationship between artists and their work, expressed the need for a study of "life styles" or "ethnos" in the 1960s (Haselberger 1961:377–78). Citing *Yurok-Karok Basket Weavers*, published three decades earlier, Weltfish acknowledged the originality and perception of O'Neale's work. By the 1970s, anthropologists were again focusing on the material culture of Native peoples and the treasure troves of art objects created by their artisans. Fieldwork with indigenous peoples was becoming difficult, and information was needed that could be gained only by questioning the artists themselves.

Anthropological research has now caught up with O'Neale's innovative work. Some basket researchers elicit information by the use of photographs in the field, but they are not after the same Native categories and personal assessments that were O'Neale's research goals. Their goals have been to identify the weavers of certain older baskets (Bruce Bernstein, pers. comm., p. 190). Other fieldworkers use visual and written material as a vehicle for rapport, as did O'Neale. This material will be placed in a repository such as a library or tribal office for local use.[24]

Although photo elicitation is still a common fieldwork technique,[25] the use of videotape has become popular. Pam Blakely documented a

women's performance in East Central Africa with videotape and slides. Her presentation was entitled "Ethnoaesthetics of Women's Dance Ritual in African Funerals."[26] Through feedback interviews prompted by women viewing the video, she was able to elicit categories such as aesthetic terms the Bahemba use to describe and evaluate their own performances (Native exegesis).

In conclusion, although the terminology and technology in use today are not the same as when O'Neale was working on the Klamath River, in Guatemala, or in the Andes, the impulse to learn the Native's point of view has become the researcher's primary goal and obligation. Particularly, the grace, wit, and style that enhanced Lila M. O'Neale's ethnoaesthetic studies, as well as her other researches, will continue to serve as a model of excellence for future scholars of the Indian Americas, who study material culture and the artists who create it.

NOTES

In addition to those mentioned in the text, I would like to thank those persons who aided my research between 1983 and 1990: Ralph L. Beals, Adelle O'Neale Briere, Marvin Cohodas, Richard Conn, Lee Davis, Virginia Fields, Lucretia Nelson, Ed Rossbach, and Katherine Westphal.
 1. Recent contributions include Bates (1982), Bernstein (1985), and Cohodas (1979).
 2. The history of anthropology combined with feminist anthropological research is of great contemporary interest. See Babcock and Parezo (1988) among other publications. This direction of anthropological inquiry is the impetus for my work on O'Neale and other women anthropologists who study textiles and clothing, and on women fiber artists. I first became aware of O'Neale's scholarship in relation to my Guatemalan textile studies, and subsequently encountered Yurok-Karok Basket Weavers and her many other publications. I now work with collections in the Lowie Museum of Anthropology that she either gathered or curated.
 3. Anthropologists and other scholars are now writing narrative ethnographies in which the researchers are active participants, no longer concealed by the passive voice or the use of "one" or "we."
 4. O'Neale used interpreters, often weavers themselves, when necessary; some Karok weavers spoke English. She did not integrate Native words into the text as Kroeber had done. Contemporary basket researchers working with the Klamath River groups have questioned this omission (Peg Mathewson, pers. comm., 1990).
 5. For more biographical information on O'Neale, see Schevill (1986a, 1988). She had a liberated and educated mother, Carrie Higgins, who had been a school teacher, one of the few areas of employment available to women in the late nine-

teenth century. She served as a model of independence and self-reliance for her family (Briere, pers. comm., 1987).

6. O'Neale's classical education no doubt informed her writing style. In her obituary, colleagues Alfred Kroeber, Lea Van P. Miller, Barbara Armstrong, and Hope M. Gladding commented: "through all her writing, there moved a quality of incisiveness which enabled her to present bodies of intricate detail with a drastic directness" (Kroeber et al. 1948:66).

7. O'Neale's first publication, You and Your Clothes (1921), a witty, how-to-make-the-best-of-yourself article, appeared in the Oregon Agricultural College Extension Bulletin.

8. See O'Neale's field notes in the Bancroft Library.

9. After a session at the California Indian Conference in October 1988, at which I delivered a version of this paper, Peter Dix, a Yurok, asked me why the Hupa material was not included in O'Neale's book. Other colleagues have puzzled over this as well.

10. There is a story still told among the Yurok about O'Neale: some say that she dressed like a man when she first came to the Klamath River. She looked up Chagron George and Dewey George, probably a suggestion from Kroeber who knew them well. O'Neale questioned them about sweathouse activities and other restricted information which they evidently gave to her. Both of these men may have been "high" men, and, although biologically male, performed female tasks such as weaving special baskets. O'Neale's dress and demeanor may have given an impression of masculinity to the George men. When they learned that she was a woman, they were angry (Arnold Pilling, pers. comm., 1985; Thomas Buckely, pers. comm., 1986). None of the privileged information that O'Neale may have elicited from the Georges was included in her field notes or in her book.

11. During his long career as professor and chairman of the Department of Anthropology at Columbia University, Boas supported and encouraged women students. In 1920 he wrote to a colleague "I have had a curious experience: All my best graduate students are women" (Goldfrank 1978:18). Over twenty women received their Ph.D.s in anthropology from Columbia University. In 1935–37 Kate Peck Kent attended Barnard College. Boas took an interest in her and offered her a $300 scholarship which would enable her to visit American museums. Later she participated in an exchange program between art history and anthropology students at Columbia and from Belgium, also arranged by Boas and Franz Olbrecht. These were key experiences in Kent's early years which resulted in her becoming an anthropologist with an expertise on Southwest textiles. Many of her Museum Studies students from the University of Denver are now curators and researchers (Schevill 1989). Kroeber followed in Boas's footsteps regarding women Ph.D.s. I have written elsewhere of Kroeber and his relationship with O'Neale (Schevill 1986a).

12. Dr. Herman Haeberlin and James A. Teit showed the Thompson Indians drawings and photographs of baskets in museum collections in order to elicit information about specific features of the objects in Native terminology (see Jacknis, this volume).

13. Dorothy Washburn has written on the effect of dealers and collectors of Indian baskets at the turn of the century in California (1984) and on symmetry analysis of Yurok, Karok, and Hupa Indian basket designs (1986).

14. Laurence E. Dawson curated an exhibition of northwestern California baskets as part of a larger exhibition called Held in Value at the Lowie Museum of Anthropology in 1988. Some of these comments were suggested by the handout he prepared.

15. I asked my Maya weaving teacher in Guatemala how new designs and design layouts were generated among weavers who produce town or village-specific designs for family use and for sale. She used the word *inventar*. Repetition in any artform becomes tedious! (Schevill 1980).

16. It is fascinating to compare the Hickox-Nicholson relationship with that of Louisa Keyser (Dat So La Lee) and Abe and Amy Cohn (see Cohodas, this volume). Hickox became known as a weaver of miniatures, as well as other unique basket forms. One of her specialties was a fancy basket with a knobbed lid. Louisa Keyser integrated Pomo and Maidu basketry styles into Washoe baskets, and she "invented" a new style called the *degikup*, which the Cohns marketed as a "traditional" basket form. These individual weavers are known today by name, while scores of other fine native basket weavers remain anonymous.

17. This was another strategy that Boas asked Teit to pursue with the Salish basket weavers (see Jacknis, this volume). Today O'Neale's personal opinions on the weaver's work could be interpreted as ethnocentric. One should remember that O'Neale, as a teacher, was accustomed to evaluating her students' work. She knew basket weaving techniques as well as other textile techniques and therefore felt confident in her ability to judge excellence.

18. I do not know if O'Neale sent either photographs or copies of her book to the weavers. This is accepted contemporary ethnographic fieldwork practice—an effort not to appropriate totally cultural practices and information.

19. There is a growing body of literature on nineteenth-century travelers and collectors: Krech (1989), Hail and Duncan (1989), Schevill (n.d.), and the essays in this volume. Papers delivered by Barbara Hail, Shepard Krech III, and Molly Lee at the symposium "Out of the North" at the Haffenreffer Museum of Anthropology, Brown University, called attention to dealers, collectors, travelers, and tourists who ventured to remote areas and brought home small collections that now reside in various museums.

20. Jonaitis (this volume) refers to the metaphor of "wrapping" so-called traditional Haida art, the layering of an object with levels of meaning and interpretation. A composite entity is created. One could say that O'Neale "wrapped" the Yurok and Karok baskets with her synthesis of the multiple layers of information she elicited, and thus she created a new, enriched, visually charged entity without destroying the original. The basket itself remains, still visible in the photograph or on the museum shelf.

21. O'Neale did not carry on subsequent research with the Klamath River peoples after receiving her degree and entering into the academic world. Perhaps her teaching and administrative responsibilities were excessive. She did, however,

contribute articles on basketry and weaving to the *Handbook of South American Indians*. She also continued her research on Peruvian archaeological textiles, her first love.

22. Martha Thomas was at her side. Her sudden death was a tremendous shock to Kroeber, who was at Harvard University that year, and to all who knew her.

23. An extensive literature search did not produce a review of O'Neale's book. Later works on Peruvian and Guatemalan textiles were, however, reviewed.

24. The California Indian Library Collections project, under the direction of Lee Davis, has been in existence since 1988. Materials were gathered by Berkeley researchers in the early years of this century, and are now difficult to obtain. The goal is to pass on this material—Native California cultural heritage—to the Native groups. Materials are reproduced and then delivered. The collection is closed to the public while local people comment on and evaluate what they have received. It is a connection with their appropriated past. One would hope that O'Neale's book, long out of print, would become available again for the Klamath River weavers who are experiencing a revitalization of their artform. At various festivals, like the Foothill Regional Arts Festivals of 1988 and 1989, basket weavers are featured. The programs include photographs and biographies of them. Baskets now serve as identity markers, and they are created for demonstration purposes in workshops that take place at these festivals.

25. At the 1989 meetings of the American Anthropological Association, there were two sessions on photo elicitation organized by Ann Hedlund, Sandra Niessen, and Dorothy Washburn. Fifteen scholars participated.

26. Blakely's presentation was part of the Society of Visual Anthropology's sessions at the American Anthropological Association meetings in November 1989, as reported in the *Anthropology Newsletter*, January 1990, p. 22.

BIBLIOGRAPHY

Babcock, Barbara A., and Nancy J. Parezo
 1988 *Daughters of the Desert: Women Anthropologists and the Native American Southwest*, 1880–1980. Albuquerque: University of New Mexico Press.
Baizerman, Suzanne
 1987 *Textiles, Traditions and Tourist Art: Hispanic Weaving in Northern New Mexico*. Ph.D. dissertation, Department of Design, Housing and Apparel, University of Minnesota.
Barrett, Samuel A.
 1905 "Basket Designs of the Pomo Indians," *American Anthropologist* 7:648–53.
Bates, Craig D.
 1982 *Coiled Basketry of the Sierra Miwok*. San Diego: San Diego Museum Papers 15.
Berlin, Brent, and Paul Kay
 1970 *Basic Color Terms*. Berkeley: University of California Press.
Bernstein, Bruce
 1985 "Panamint-Shoshone Basketry, 1890–1960," *American Indian Basketry and Other Native Arts* 19:5–29.

1986 "Ethnographic Museum Collections and Their Use by Anthropologists," *Haliksa'i*. University of New Mexico Contributions to Anthropology 5:131–47.

n.d. "Alfred Kroeber and the Study of Pomoan Basketry." Paper presented at the Fifth National Native American Art Studies Association Conference, Ann Arbor/Detroit, 1985.

Blackman, Margaret B.

1982 *During My Time: Florence Edenshaw Davidson, A Haida Woman*. Seattle: University of Washington Press.

1989 *Sadie Brower Neakok: An Iñupiaq Woman*. Seattle: University of Washington Press.

Boas, Franz

1927 *Primitive Art*. Cambridge: Harvard University Press.

Bradley, Milton

1895 *Studio Book of Colored Papers*. Springfield, Mass.: M. Bradley Co.

Bunzel, Ruth L.

1929 *The Pueblo Potter: A Study of Creative Imagination in Primitive Art*. New York: Columbia University Press.

Burgos-Debray, Elizabeth

1984 *I. Rigoberta Menchu: An Indian Woman in Guatemala*. Trans. Ann Wright. London and New York: Verso Editions.

Cohodas, Marvin

1979 *Degikup: Washoe Fancy Basketry, 1895–1935*. Vancouver: Fine Arts Gallery, University of British Columbia.

Conte, Christine

1984 *Maya Culture and Costume: A Catalogue of the Taylor Museum's E. B. Ricketson Collection of Guatemalan Textiles*. Colorado Springs: Taylor Museum of the Colorado Springs Fine Arts Center.

Dark, Philip J. C.

1967 "The Study of Ethno-Aesthetics: The Visual Arts," in *Essays on the Verbal and Visual Arts*. American Ethnological Society Proceedings.

Delgado, Hildegard Schmidt de

1963 "Aboriginal Guatemalan Handweaving and Costume." Ph.D. dissertation, Department of Anthropology, Indiana University.

Demott, Barbara, and Marvin Cohodas

n.d. "The Art and Life of Elizabeth Hickox." Paper presented at the Fifth National Native American Art Studies Conference, Ann Arbor/Detroit, 1985.

Deuss, Krystyna

1981 *Indian Costumes from Guatemala*. Twickenham, England: CTD Printers.

Dixon, Roland

1902 *Basketry Designs of the Indians of Northern California*. Bulletin of the American Museum of Natural History 17(1). New York.

Dolores, Juan

1913 *Papago Verb Stems*. University of California Publications in American Ar-

chaeology and Ethnology 10:241–63. Berkeley.

1923 *Papago Nominal Stems*. University of California Publications in American Archaeology and Ethnology 20:17–31. Berkeley.

Eber, Dorothy, ed.

1971 *Pitseolak: Pictures Out of My Life*. Seattle: University of Washington Press.

Fields, Virginia M.

1985 *The Hover Collection of Karuk Baskets*. Eureka, Calif.: Clarke Memorial Museum.

Franquemont, Christine, and Edward M. Franquemont

1987 "Learning to Weave in Chinchero," *Textile Museum Journal* 26:55–78.

Geertz, Clifford

1977 "From the Native's Point of View: On the Nature of Anthropological Understanding," reprint in *Symbolic Anthropology*. New York: Columbia University Press.

Goldfrank, Esther S.

1978 *Notes on an Undirected Life, as One Anthropologist Tells It*. Flushing, N.Y.: Queens College Press.

Graburn, Nelson H. H.

1976 *Ethnic and Tourist Arts: Cultural Expressions from the Fourth World*. Berkeley: University of California Press.

1984 "The Evolution of Tourist Arts," *Annals of Tourism Research* 2:393–419.

Haeberlin, Herman, J. A. Teit, and H. A. Roberts, under the direction of Franz Boas

1928 *Coiled Basketry in British Columbia and Surrounding Region*. Annual Report of the Bureau of American Ethnology for 1919–1924, 41:119–484.

Hail, Barbara A., and Kate C. Duncan

1989 *Out of the North: The Subarctic Collection of the Haffenreffer Museum of Anthropology, Brown University*. Studies in Anthropology and Material Culture 5. Bristol, R.I.: Haffenreffer Museum of Anthropology.

Harrison, Margaret W.

1948 "Lila M. O'Neale: 1886–1948," *American Anthropologist* 50(4):657–65.

Haselberger, Herta

1961 "Method of Studying Ethnological Art," *Current Anthropology*, October, pp. 341–84.

Hedlund, Ann Lane

1983 "Contemporary Navajo Weaving: An Ethnography of a Native Craft." Ph.D. dissertation, University of Colorado, Boulder.

Hudson, J. W.

1893 "Pomo Basket Makers," *Overland Monthly* 21(126):561–78.

Jules-Rosette, Bennetta

1984 *The Messages of Tourist Art*. New York: Plenum Press.

Krech, Shepard

1989 *A Victorian Earl in the Arctic: The Travels and Collections of the Fifth Earl of Lonsdale, 1888–9*. London: British Museum Publications; Seattle: University of Washington Press.

Kroeber, Alfred L.

1905 "Basket Designs of the Indians of Northwestern California." University of California Publications in American Archaeology and Ethnology 2(4):105–64. Berkeley.

1909 California Basketry and the Pomo. American Anthropologist 11:233–49.

1925 Handbook of the Indians of California, no. 78. Washington, D.C.: Bureau of American Ethnology, Smithsonian Institution.

1976 Yurok Myths. Berkeley: University of California Press.

1927–48 ALK Papers. Bancroft Library, University of California, Berkeley.

Kroeber, Alfred, Lea Van P. Miller, Barbara Armstrong, and Hope M. Gladding

1948 "In Memoriam: Lila M. O'Neale, 1886–1948," University of California Faculty Bulletin 18(6):65–66.

Kroeber, Theodora

1970 Alfred Kroeber: A Personal Configuration. Berkeley: University of California Press.

Mead, Margaret

1959 "Apprenticeship Under Boas," in The Anthropology of Franz Boas, ed. Walter Goldschmidt. Memoirs of the American Anthropological Association 89:29–45.

Meisch, Lynn

1986 "Weaving Styles in Tarabuco, Bolivia," in The Junius B. Bird Conference on Andean Textiles, ed. Ann Pollard Rowe. Washington, D.C.: Textile Museum.

O'Neale, Lila M.

1921 You and Your Clothes. Oregon Agricultural College Extension Bulletin 333. Corvallis.

1927 "Design, Structural and Decorative, with Color Distribution Characteristic of Ancient Peruvian Fabrics." M.A. thesis, Department of Household Arts, University of California, Berkeley.

1930a Review of Haeberlin et al., Coiled Basketry in British Columbia and the Surrounding Region, in American Anthropologist n.s. 36:306–8.

1930b Fieldnotes on the Basketry of Northwestern California: 11 notebooks, Bancroft Library, University of California at Berkeley.

1932 Yurok-Karok Basket Weavers. University of California Publications in American Archaeology and Ethnology 32(1):1–184. Berkeley.

1933 "A Peruvian Multicolored Patchwork," American Anthropologist n.s. 35:87–94.

1934a "Peruvian 'Needleknitting,'" American Anthropologist n.s. 36:87–94.

1934b "The Paracas Mantle: Its Technical Features," Compterendu. International Congress of Anthropological and Ethnological Sciences 262. London.

1935 "Pequeñas Prendas Ceremoniales de Paracas," Revista del Museo Nacional 4(1):245–66. Lima.

1936a "Guatemalan Textile Investigation," Carnegie Institution of Washington Year Book 35:136–38. Washington, D.C.

1936b "Wide Loom Fabrics of the Early Nazca Period," in Essays in Anthropology in Honor of Alfred Louis Kroeber, pp. 215–28. Berkeley.

1937a "Textiles of the Early Nazca Period. Archaeological Explorations in Peru, Part II," in *Anthropology Memoirs* 2:117–218. Chicago: Field Museum of Natural History.

1937b "Middle Cañete Textiles. Archaeological Explorations in Peru, Part IV," in *Anthropology Memoirs* 2:268–73.

1945 *Textiles of Highland Guatemala.* Publication 567. Washington, D.C.: Carnegie Institution of Washington.

1948 "Basketry," "Weaving," in *Handbook of South American Indians*, vol. 5: *Comparative Ethnology of South American Indians.* Bulletin of the Bureau of American Ethnology 143.

1976 "Notes on Pottery Making in Highland Peru," *Nawpa Pacha*, ed. John H. Rowe and Patricia J. Lyon, 14:41–60. Berkeley: Institute of Andean Studies.

O'Neale, Lila M., and Juan Dolores
1943 "Notes On Papago Color Designations," *American Anthropologist* n.s. 45: 387–97.

O'Neale, Lila M., and A. L. Kroeber
1930 *Textile Periods in Ancient Peru: I.* University of California Publications in American Archaeology and Ethnology 28:23–56. Berkeley.

Reichard, Gladys
1936 *Navajo Shepherd and Weaver.* New York: J. J. Augustin.

Rowe, Ann Pollard
1981 *A Century of Change in Guatemalan Textiles.* New York: Center for Inter-American Relations. Seattle: University of Washington Press.

Salvador, Mari Lyn
1978 *Yer Dailege! Kuna Women's Art.* Albuquerque: Maxwell Museum of Anthropology, University of New Mexico.

Schevill, Margot Blum
1980 "The Persistence of Maya Indian Backstrap Weaving in San Antonio Aguas Calientes, Sacatepequez, Guatemala." M.A. thesis, Department of Anthropology, Brown University.

1985 *Evolution in Textile Design from the Highlands of Guatemala.* Berkeley: Lowie Museum of Anthropology, University of California.

1986a "Lila M. O'Neale," *Kroeber Anthropological Society Papers* 65–66:129–37. Department of Anthropology, University of California, Berkeley.

1986b *Costume as Communication: Ethnographic Costumes and Textiles from Middle America and the Central Andes of South America.* Studies in Anthropology and Material Culture 4. Bristol, R.I.: Haffenreffer Museum of Anthropology.

1988 "Lila M. O'Neale," in *Women Anthropologists: A Biographical Dictionary*, ed. Ute Gacs, Aisha Khan, Jerrie McIntyre, and Ruth Weinberg, pp. 275–81. Westport, Conn.: Greenwood Press.

1989 "Kate Peck Kent, 1914–1987," *Museum Anthropology* 13(2):3–8.

n.d. *Maya Textiles of Guatemala: The Gustavus A. Eisen Collection 1902.* Berkeley and Austin: Lowie Museum of Anthropology, University of California, and the University of Texas Press.

Washburn, Dorothy K.

1984 "Dealers and Collectors of Indian Baskets at the Turn of the Century in California: Their Effect on the Ethnographic Sample," *Empirical Studies of the Arts* 2(1):51–74.

1986 "Symmetry Analysis of Yurok, Karok, and Hupa Indian Basket Designs," *Empirical Studies of the Arts* 4(1):19–45.

n.d. "Lila O'Neale: Early Pioneer in Design Analysis." Paper presented at the Fifth National Native American Art Studies Association Conference, Ann Arbor/Detroit, 1985.

Waterman, T. T.

1920 *Yurok Geography.* University of California Publications in American Archaeology and Ethnology 16:177–314. Berkeley.

7

MARKETING THE

AFFINITY OF THE

PRIMITIVE AND

THE MODERN

RENÉ D'HARNONCOURT AND

"INDIAN ART OF THE UNITED STATES"

On January 22, 1941, New York's Museum of Modern Art unveiled "Indian Art of the United States," one of the most provocative and acclaimed exhibitions in the then-young life of that powerful institution.[1] Organized for the museum by the Department of the Interior's Indian Arts and Crafts Board under the direction of General Manager René d'Harnoncourt, the exhibition was a watershed event in the history of Euro-American proprietary interest in Native American art in the twentieth century. In the strictest sense, the exhibition was the fruition of two years of intensely focused work by d'Harnoncourt, his collaborator Frederic H. Douglas, curator of Indian Art at the Denver Museum, and architect Henry Klumb, who worked for the Indian Arts and Crafts Board (hereafter IACB). In fact, d'Harnoncourt had been refining both the

theory and the practice of preserving, promoting, and displaying "primitive" art and contemporary indigenous arts and crafts since the late 1920s.[2] The museum, in turn, made a complete commitment of its physical resources, allowing Klumb to convert all three floors into the installation spaces designed by d'Harnoncourt for his selection of objects. More than a thousand high quality ancient, historic, and contemporary works of art from the continental United States, Alaska, and parts of Canada were exhibited to illustrate d'Harnoncourt's premise that Indian art, which belonged "solely to this country" (Art Digest 1941:17), was "meeting the impact of the twentieth century with the resourcefulness and vitality that have always been among its outstanding characteristics" (d'Harnoncourt 1941:72).

Reviewing even a brief sampling of the art chosen by d'Harnoncourt provides a tantalizing glimpse of the audience's aesthetic experience. On display, for example, was the well-known Adena pipe (ca. A.D. 100), which was excavated at Chillicothe, Ohio, in 1901 and lent for exhibition by the Ohio State Museum.[3] The American Museum of Natural History lent a well-known and outstanding example of Nootka painting on wood, which had been made on Vancouver Island about 1850 and was collected by George T. Emmons in 1929.[4] Obviously there was a great temporal breadth in d'Harnoncourt's choice of materials. From the University of Pennsylvania Museum in Philadelphia he borrowed a rare wooden deer maskette (ca. A.D. 800–1400), which had been excavated from the shell mounds at Key Marco in southeastern Florida by Frank Hamilton Cushing in 1895.[5] In sharp contrast to objects such as this—prehistoric and probably ritualistic in nature—the audience was shown relatively new works of art, such as a gouache, depicting the Green Corn Ceremony, by Awa Tsireh of San Ildefonso Pueblo.[6] Done around 1922, this painting was from MOMA's own collection, courtesy of Abby Aldrich Rockefeller, who was one of the original founders of the museum (Rockefeller 1981:13). Indeed, the scope of exhibition was so vast, and d'Harnoncourt's installation designs so innovative, that the reviewer for Newsweek wrote that MOMA, with the most elaborate and ambitious exhibition in its history, surpassed itself again by placing Indian art "among the American fine arts" (1941:57–58).

As profoundly important as the exhibition proved to be, it was hardly the first, nor would it be the last, time that art of the "Other" was exhibited at the Museum of Modern Art. Its 1933 exhibition, "American Sources of Modern Art," had attempted to show an affinity between modern, Aztec, Maya, and Inca art. Following this, MOMA exhibited "African Negro Art"

in 1935, "Prehistoric Rock Pictures in Europe and Africa" in 1937, and "Twenty Centuries of Mexican Art" in 1940, which was organized by Nelson Rockefeller with assistance from Roberto Montenegro. In recalling "Indian Art of the United States," Alfred H. Barr, Jr., MOMA's founding director and himself a master of installation design, noted that despite the high quality of the exhibitions of primitive art held at the museum in the 1930s, they seemed "primitive themselves by comparison with René's magnificent later achievement" (MOMA 1968). D'Harnoncourt himself organized the 1946 exhibition "Art of the South Seas," which, according to Monroe Wheeler,[7] revealed "the aesthetic value of the cultural materials of Polynesia, Micronesia, and Australia, which had been considered in the past only as anthropological data" (MOMA 1968). In 1954 d'Harnoncourt collaborated with Wendell C. Bennett on an important exhibition at MOMA entitled "Ancient Art of the Andes." More recently, tribal art from Africa, Oceania, and the Americas was included in William Rubin's controversial 1985 exhibition "'Primitivism' in 20th Century Art."[8] However, none of these exhibitions radically altered the public's perception of a non-Western art tradition as did "Indian Art of the United States."[9]

To understand why this exhibition was so immensely popular with the art-going public, the critical press, and d'Harnoncourt's peers in the museum world, it is instructive to contrast it with the "Exposition of Indian Tribal Arts," which had been held at New York's Grand Central Galleries a decade earlier. Organized by artist John Sloan, anthropologist Oliver La Farge, and others, the 1931 exposition was a critical and commercial success, but it lacked the authoritative force and persuasive power that MOMA's institutional credibility was able to provide in 1941.[10] In a review of "Indian Art of the United States" which appeared in the New Republic, La Farge himself credited the "cachet of the museum" with preparing the public's mind (1941a:181). D'Harnoncourt, too, emphasized this when he commented in 1939 on MOMA's offer to sponsor the exhibition: "The importance of this offer lies . . . in the ability of the Museum of Modern Art to draw popular attention to the various subjects with which they are dealing" (d'Harnoncourt, IACB 4, 140.2). Furthermore, according to La Farge, while the exposition in 1931 had received rather tepid government support, federal resources made possible "the gathering of a magnificent selection" of Indian art at MOMA (1941a:181). Indeed, d'Harnoncourt's efforts relating to "Indian Art of the United States" were supported vigorously by John Collier, the Commissioner of Indian Affairs. Collier had

received a New Deal mandate from President Roosevelt's Department of the Interior to "promote the economic welfare of the Indian tribes . . . through the development of Indian arts and crafts and the expansion of the market for the products of Indian art and craftsmanship."[11] And finally, d'Harnoncourt was able to augment federal patronage of the exhibition with financial support and political influence issuing from his close personal relationships with such men as Rockefeller and Dr. Frederick P. Keppel, president of the Carnegie Corporation.[12]

It was, however, d'Harnoncourt's infectious enthusiasm, skill at organization, and especially his brilliant exhibition designs, which always managed to be both educational and entertaining, that made "Indian Art of the United States" an unparalleled success. In evaluating the exhibition, one cannot overstress the importance of d'Harnoncourt's meticulous attention to detail, his consideration of each object in relation to the whole, and his genuine concern for the audience's experience.[13] By all accounts, the results of his vision and energy were spectacular. This conclusion is supported by the critical reviews of the exhibition, most of which were effusively enthusiastic.[14] Almost all commented on the effectiveness of the unique installations. For example, writing in *Art News*, Jeanette Lowe described the exhibition as a brilliant dramatization of Indian artistic and spiritual values (1941:7). *Design Magazine* noted that "brilliantly colored backgrounds and ingenious methods of display are being used to present the thousand or more items of the exhibition" (1941:15). Barr, who in 1941 was both director of the museum and director of the Department of Painting and Sculpture, later recalled of d'Harnoncourt's exhibits: "He avoided both the purely aesthetic isolation and the waxworks of the habitat group. . . . The varied galleries seemed informal at first glance, but were calculated in size, perspective, sequence, color, light level, sometimes dramatic but never theatrical, and functional rather than decorative. The presentation of the works of art achieved both aesthetic and intellectual delight" (MOMA 1968). Even *Women's Wear Daily*, in a preview of the exhibition, commented on "d'Harnoncourt's sympathetic magic" (Crawford 1941:10; IACB 37).

In planning the spaces and settings in which to work his "sympathetic magic," d'Harnoncourt made a conscious decision to classify the objects and the installations for them in two distinct categories. In the first he included "the great Indian traditions of the past, including moundbuilder material, Bering Strait culture, and other Indian civilizations now dead" (d'Harnoncourt to Douglas, September 30, 1939: IACB 36, 300.36). These

objects were "to be shown only as art for art's sake." The second category consisted of historic materials, which d'Harnoncourt considered the art of living Indian culture. In contrast to the prehistoric material, every effort would be made to provide the historic objects with an authentic aboriginal ambience. As he explained to George Heye, founder of the Museum of the American Indian: "Since we are interested in showing Indian culture through Indian art, and not Indian art as an end in itself, we can never forget the place of each specimen in its native civilization and must consider many points that would be insignificant in an art-for-art's-sake display" (d'Harnoncourt to Heye, October 9, 1940: IACB 34). The contemporary art was to be contextualized also, but because the goal in this case was to show the potential contribution of Native arts and crafts to modern decorative arts, d'Harnoncourt found himself facing "an entirely new installation problem" (d'Harnoncourt to Barr, November 8, 1939: IACB 34). Since it was necessary to "emphasize the contemporary quality in both the Indian work and the display apparatus," the installations themselves "should be very contemporary and Fifth Avenue in the best sense of the word." This would make it possible to stress (the new) functional value and aesthetic qualities, as opposed to the original cultural connotations, of contemporary Native American crafts.

All these aspects of d'Harnoncourt's exhibition strategy—decontextualization of ancient art, contextualization of historic art, and recontextualization and aestheticization of contemporary art—are discussed at length below. However, it must be observed here that d'Harnoncourt's presentation of ancient art *as art* and not ethnographic material was, generally speaking, a continuation of the precedent established at the Brooklyn Museum in the early 1930s by Dr. Herbert J. Spinden.[15] More specifically, his unified plan for the entire exhibition was the mature formulation of (1) strategies for merchandising contemporary Native arts and crafts which he had developed over a period of years, first in Mexico and then later at the IACB, and (2) the successful exhibition techniques employed by the IACB under his direction in its presentation of Indian arts and crafts at the San Francisco Golden Gate International Exposition in 1939. Because d'Harnoncourt's conception of "Indian Art of the United States" was the logical outcome of years of thoughtful consideration and practical application, and because it is largely the model on which displays of primitive art are based today,[16] an examination of his early career is warranted before proceeding to a fuller discussion of the exhibition and its critical reception, as well as a contextual reading of its catalogue.

René d'Harnoncourt

Born in Vienna in 1901, d'Harnoncourt was an Austrian of Franco-Belgian extraction. His youthful interest in ancient and primitive art can be ascribed to having grown up in Graz, which has one of Europe's oldest collections of folk and primitive art. As an adolescent he had collected Old Master prints and as a teenager he and some friends had arranged the first showing in Graz of prints by Pablo Picasso and Henri Matisse. After studying philosophy and chemistry at the State University in Graz, he went to Vienna in 1922 to study chemistry at the Technische Hochschule. In 1924, his thesis completed and his family's economic fortune in decline, d'Harnoncourt traveled, via Paris, to Mexico. Unable to find employment as a chemist, he worked as a free-lance commercial designer and decorator of shop windows. In 1926 he went to work selling antiques for Frederick Davis, an American dealer whom he persuaded to handle pre-Columbian artifacts and contemporary folk art (MOMA 1968).

Since Davis's shop was a gathering place for the Mexican modernists who were rediscovering Mexico's indigenous cultural heritage, d'Harnoncourt became an active participant in the contemporary folk art revival led by Diego Rivera and Miguel Covarrubias.[17] In 1927 he organized an important exhibition of paintings by Rivera, José Clemente Orozco, and Rufino Tamayo. That same year d'Harnoncourt met and painted murals for Dwight Morrow, the American ambassador. Then, in 1928, acting on Morrow's suggestion, the Carnegie Corporation of New York invited d'Harnoncourt to organize an exhibition of Mexican fine and applied arts for circulation in the United States under the aegis of the American Federation of Arts. After the exhibition opened at the Metropolitan Museum in 1930, d'Harnoncourt spent the next two years traveling and reinstalling the twelve hundred objects of the exhibition in fourteen American cities (MOMA 1968).[18] According to Wheeler, this experience "was the basis of his incomparable mastery of the aesthetics of exhibitions" (ibid.). Likewise, Barr remembered that the exhibition was much admired by important museum people, including himself, "who were impressed as much by the installation as the art" (ibid.).

Following his marriage in 1932, d'Harnoncourt remained in the United States and worked in 1933-34 as director of "Art in America," the first nationally broadcast radio program on the subject, which was sponsored, once again, by the American Federation of Arts with Carnegie funds.[19] The first series, covering American art to 1900, was done in concert with

the Metropolitan Museum. The second series, which dealt with art since 1900, was done in cooperation with MOMA. It was at this time, 1933, that d'Harnoncourt first worked with Barr, who provided the scripts (d'Harnoncourt 1969:29). From 1934 to 1937 he taught art history at Sarah Lawrence College (MOMA 1968), and worked occasionally as a consultant to Keppel in the Carnegie Corporation's New York offices. During these years he also went to Mexico each summer to serve on the Committee on Cultural Relations with Latin America. According to d'Harnoncourt, the Mexican government sponsored these summer conferences because they were "terribly anxious to get intellectuals from the United States to try to give them a different picture" of Mexican culture (d'Harnoncourt 1969:35, 42).[20] At one such conference in 1936 d'Harnoncourt met Collier, Roosevelt's Commissioner of Indian Affairs, and the following September d'Harnoncourt was hired as assistant manager of the Indian Arts and Crafts Board. On June 15, 1937, d'Harnoncourt replaced Louis West as general manager of the board (IACB: 9, 103.01).

Merchandising the Affinity of the Primitive and the Modern

Through his IACB activities d'Harnoncourt both defined and refined his reasons and methods for combining authentic contextualization and contemporary recontextualization of Indian arts and crafts. His reasons, in the main, were inseparable from his responsibilities, as he perceived them, as the head of a federal board whose efforts he divided into "(a) Stimulation and organization of production, and (b) Assistance in merchandising" of arts and crafts (d'Harnoncourt to Barnett, 1940: IACB 4, 140.2). As for the work associated with the first category, he realized that the diversity of Native America called for field workers who were both ethnographically well informed and capable of making aesthetic judgments: "All jobs connected with the production program . . . call for a knowledge of the specific group of producers, and of their cultural and economic traditions, their working habits, their possibilities of communication with the outside world. . . . They also call for taste and knowledge of the proposed market for the particular merchandise, to enable the workers to select the most desirable articles and to suggest the necessary adjustments for such work as has merit in itself but must be modified to meet market demand" (ibid). Under the business of merchandising, d'Harnoncourt included "educational and promotional activities,

study of display, actual contact with the consumer, and . . . organization of practical business set-ups."

In a report outlining "Projects of Research in the Indian Arts and Crafts" d'Harnoncourt expressed concern that ethnological literature seldom considered either the aesthetic or economic value of Indian art. Furthermore, he noted that "almost none of the existing studies incorporate the maker's attitude to the artifact or the process of manufacture and the influence of the contemporary market on the present production" (d'Harnoncourt 1938: IACB 4,140.2).[21] He was convinced that studies of this nature would yield benefits to "the living Indian craftsman" and would inevitably produce a more complete image of the culture, with which the social scientist ought to be concerned. For example, he wrote, "Such subjects as motivations for adherence to a traditional production, the craftsman's criterion of quality, appreciation and remuneration as incentives for work, are certainly an essential part of a complete picture of any culture." It must be stressed here that his humanitarian concern for "the living Indian craftsman" was the impetus for d'Harnoncourt's commitment to sophisticated marketing strategies. He made it clear to his subordinates that "from the social point of view," arts and crafts were a means of what he described as human and economic rehabilitation of both the individual artist and the whole tribe (d'Harnoncourt to Young, 1940: IACB 4,140.2).

In seeking human and economic rehabilitation of Native American peoples, d'Harnoncourt had at least three strong motives. First of all, in political terms, as a New Dealer he realized that the poverty of Indians, coupled with the dominant culture's failure to enfranchise them, made for severe social problems which were not going to be resolved by the dissolution of Indian identity into an ethnic melting pot. His notes for a speech to the Indian Defense Association in San Francisco included the following: "The American Indian is alive today and will live tomorrow. He is steadily increasing in numbers and [is] right now in the middle of his greatest struggle to find his place in a civilization" (d'Harnoncourt 1938: IACB 32). Second, by promoting the value of Native crafts to contemporary life, he hoped to reverse what he felt was the last and worst injustice done to Indian peoples—their preservation "only on the dusty shelves of museums of Anthropology and in the books of James Fenimore Cooper" (ibid.). And third, like Collier, the painter John Sloan, and other advocates of Indian art and culture (Rushing 1989: 335–43), d'Harnoncourt firmly believed that Native American culture ought to be

stabilized and nurtured so that its values might be incorporated into the national consciousness: "I personally believe that the Indian artist has enough to contribute to American civilization to make it worth while to spend a great deal of time and effort to give him every chance for a free development of his potentialities. I sincerely believe that Indian art, if it is not smothered in its cradle, may become a powerful fresh factor in American art" (d'Harnoncourt to Allen, 1938: IACB 11, 030).

Even at the very beginning of his tenure with the IACB, d'Harnoncourt had already determined that the method for achieving these goals was to design exhibits whose combination of contextualization and recontextualization highlighted the compatibility of primitive and modern art. This paradigm of visual education would promote an appreciation of Indian cultural history. At the same time it broke down what d'Harnoncourt saw as the American public's unfortunate habit of thinking of "the American Indian in terms of the past only" (d'Harnoncourt 1938: IACB 32).

Within months of joining the IACB, d'Harnoncourt wrote a set of "Notes on an Exhibit of the Arts and Crafts of the American Indian at the New York Fair of 1936." He explained that although the plan was to present only such objects as would be useful in the contemporary world, "the emotion appeal . . . of their primitive background should not be entirely disregarded in any display of Indian arts, as it adds considerably to the public's interest in the subject" (d'Harnoncourt 1936: IACB 9, 300.35). Thus he was not at all unwilling to appeal to the Romantic sensibilities inherent in the cultural primitivism that had been (and continues to be) a constant characteristic of twentieth-century culture.[22] His proposed design consisted of two units: a modern house displaying Indian art in the modern world, and a Pueblo style building showing the background and production of Indian arts and crafts. It was his intention that the two units be situated closely together. As he explained: "By placing the modern house . . . in front of the building in pueblo style, the striking affinities between modern and primitive architecture become apparent; and the spectator, even before entering the exhibit, becomes aware of possibilities to fit the new and the very old together." D'Harnoncourt cautioned that the modern house should not be overtly an exhibition space, but a space built for living. The objects selected for this space were to be recontextualized and therefore not "displayed in groups chosen in accordance with their tribal origin, but in accordance with their use in a modern house." He went on to describe rooms that would combine a specific motif with particular kinds of Indian arts and crafts (e.g., a man's sporting

den, a room with traditional furniture and one with modern furniture, a library, a collector's den, and a girl's room).

The Pueblo style building was to contain demonstrations of the methods by which Native arts and crafts are manufactured. The objects displayed here were to be grouped by tribe, "so as to preserve as much as possible the character of the background of each piece." Not only would visitors see Indian artists at work, but they would have an opportunity to purchase their products. Building on the educational aspects of this space, d'Harnoncourt suggested that motion pictures, lectures, and various demonstrations could take place in the pueblo house. His plan also called for a passageway to connect the modern house and the pueblo house, "so that the visitor would automatically be guided from one to another." In this way, the audience would be forced, so to speak, to pass from an exhibit that aestheticized Native American arts and crafts by playing up their functional value as decoration in the modern interior into one that stressed the authentic primitive roots of the objects. As a marketing strategy it was really quite ingenious. After being shown the aesthetic, functional, romantic, and historical value of the objects, visitors could satisfy the desire for consumption thus established by purchasing directly from the artisan. As d'Harnoncourt's principal obligation at the IACB was to both create and satisfy market demand for authentic, high quality Indian crafts, it was a truly remarkable plan.

D'Harnoncourt hoped that along with exhibits at the fair, which would be both commercial and educational, the various museums in New York, such as the American Museum of Natural History, the Brooklyn Museum, and the Museum of the American Indian, would prepare exhibits from their point of view. Although there is no indication that his planned installation was realized in 1936, it nevertheless has historical significance. In its proposal to stress the affinity of the modern and the primitive and to combine an arts and crafts fair with a museum exhibition, this plan contained the prototype of the exposition d'Harnoncourt organized for the San Francisco fair of 1939. That show, although quite successful, was a prelude to "Indian Art of the United States."

Indian Art at the Golden Gate International Exposition

In 1937 the IACB was invited by the U.S. Commission for the Golden Gate International Exposition in San Francisco to organize an Indian arts and crafts exhibit for its opening in 1939.[23] The IACB was ini-

tially drawn into planning for the exposition by a group of San Francisco Indian art enthusiasts, headed up by Leslie Van Ness Denman, a collector of modern Pueblo painting and wife of William Denman, a judge on the U.S. Circuit Court of Appeals. Leslie Denman, who had proposed an exhibition plan of her own (Denman 1936:14–15, 31, in IACB 20), introduced d'Harnoncourt to Eleanor Roosevelt, thereby securing patronage of the highest order for his San Francisco exhibits (d'Harnoncourt to Creel, 1938: IACB 9, 300.33 and d'Harnoncourt 1969:47).[24] Government funds for the exposition were supplemented by grants d'Harnoncourt secured from the Rockefeller and Carnegie foundations (Schrader 1983:173–75, 180–81, and d'Harnoncourt 1968:47–48). The Rockefeller money was spent financing a publication produced in conjunction with the exposition by the American Museum of Natural History and written by George Vaillant, while the Carnegie money was used in part to pay for the services of Douglas, who oversaw the exposition's educational program (Schrader 1983: 174–75, 180–81, and d'Harnoncourt to Keppel: IACB 32).[25]

In August 1938 d'Harnoncourt wrote Keppel informing him that planning for the exposition was progressing satisfactorily. In his letter he clarified some of his motivations in selecting the work and preparing the displays: "We are now sure that we will be able to do all that we hoped to do, namely, to make this Exhibit not only representative of all the phases of American Indian culture but also to make it the first carefully planned visual presentation of the different stages of pre-mechanical civilization" (d'Harnoncourt to Keppel, August 19, 1938: IACB 12, 036). On another occasion d'Harnoncourt expressed to Keppel both his desire to present an experience the audience could absorb in a meaningful way and some of the methods for achieving that goal. For example, he observed that "the various aspects of primitive culture dealt with in this exhibit need definitely planfull [sic] coordination to be presented to the public in a readily digestible way" (d'Harnoncourt to Keppel: IACB 32). He then suggested three of the coordinating elements. First, maps would be used to orient the visitor, constantly relating each object or display to the entire geographic area portrayed in the exposition. Second, the transitions from one culture-area display to another would be accentuated in "dramatic visual form." And third, display methods would be devised which would relate "esthetic forms and choice of rawmaterial [sic] and production methods to the basic elements that condition the particular culture." Douglas, d'Harnoncourt explained, would help realize these plans as he "exploited" the material of the exposition.

In November 1939, as he anticipated the February opening of the exposition, d'Harnoncourt published an article in the government publication *Indians at Work*, in which he revealed, tacitly, his plan to use art as a way of focusing the public's vision on the past achievements, value to the present, and potential contributions of Native American peoples. The exposition would present "Indians—Indians of today and tomorrow . . . against a background of yesterday" (d'Harnoncourt 1939:10). This article, a combination press release and preview of the installations, promised that the fair would produce a new appreciation of "the proud Indian heritage." At the same time, it would demonstrate that contemporary Indians possessed values needed by modern civilization. Recognition of this, he predicted, would help Indians adjust to the contemporary world. And finally, he announced that "a trip through the exhibit will reveal to the visitor the amazing variety and vitality of the arts and cultures of Indian America."

When visitors toured the exhibit, they began in the Hall of Indian History where d'Harnoncourt used maps and "animated pictorial charts showing in a dramatic way" the development of the various Native American civilizations. From this room one proceeded through a series of culture-area galleries and displays, which were arranged in a horseshoe fashion around an open court: The Eskimo Hunters; The Northern Fishermen; Totem Poles; The Seed Gatherers of California; The Hunters of the Plains; The Woodsmen of the Eastern Forests; Indian Market; The Pueblo Farmers; The Desert Dwellers; The Navajo Weavers, Silversmiths, and Sandpainters; Gallery of Temporary Exhibits; and the Model Rooms and Salesrooms (pp. 10–13).[26] According to d'Harnoncourt, some of the most outstanding objects on display included the following: Plains buffalo hide paintings; ancient stone implements; a carved Alaskan war canoe; five monumental totem poles which decorated the facade; war helmets and ceremonial robes lent by the families of Alaskan war chiefs; and the finest Aleut baskets extant, which he noted were "much finer than the weaving in Panama hats" (d'Harnoncourt to Creel, August 21, 1938: IACB 21).

D'Harnoncourt's description of the Northwest Coast hall indicates just how elaborate and provocative were the settings he created for the objects (paintings, masks, paddles, blankets, clubs, and fishing implements). One passed from the "cold light of the Eskimo Hall" into a huge, darkened room meant to suggest the interior of a house in southeastern Alaska. The only illumination was provided by the glow from a fire pit in the center of the room. Thus the objects loomed "out of the darkness in the

firelight as they were once seen in their original setting." To further intensify the drama of this room, the far wall was torn open, revealing the next gallery where he had installed the "trunks of towering totem poles, and the monumental grave sculpture in a diffused gray outdoor light" (d'Harnoncourt 1939:10–11).

Despite his efforts at contextualization, d'Harnoncourt never lost sight of the fact that he was arranging objects that had "aesthetic value." As evidence of this, his planning notes for the Northwest Coast hall mention that paintings and carvings associated with the sea "will be carefully chosen and displayed for dramatic and organic unity" (d'Harnoncourt 1938: IACB 9, 300.33). D'Harnoncourt's interest in the objects as art did not go unobserved by the critics. Alfred Frankenstein, writing in the *San Francisco Chronicle*, pointed out that the exhibition's "main stress was upon esthetic values and the secondary stress was upon anthropology" (1940: IACB 20). Arthur Miller of the *Los Angeles Times* found much to praise in the exhibits. He wrote that every museum official in America could learn from d'Harnoncourt's "showmanship" and "imaginative installation," the latter being based on a cunning arrangement of the objects. Miller also observed that d'Harnoncourt gently guided the audience with directional architecture, while the displays were used to both establish tribal atmosphere and emphasize the objects (1939: IACB 20). No less an authority on Native American culture than Alfred L. Kroeber concluded that d'Harnoncourt's displays of Indian material were without question the finest he had ever seen. In a letter to Collier written shortly after the opening, he remarked that d'Harnoncourt had the "incredible faculty of giving his arrangements the supreme aesthetic touch as well as a complete originality." Kroeber found the installations authentic, reflective of the diversity of Indian life, and subtly effective (Kroeber to Collier, February 28, 1939: IACB 9, 300.33).

With these displays of ancient and historic Indian art d'Harnoncourt was priming the pump, so to speak, for as he noted, "all these exhibits will lead up to a presentation of the contemporary Indian" (d'Harnoncourt 1939:12). In the open courtyard, the IACB operated, in conjunction with the Covelo Indian Community from the Round Valley Reservation in California, a pan-Indian market of contemporary art (d'Harnoncourt 1939: IACB 4, 140.2). Realizing, finally, the plan he had originally drawn up for the New York World's Fair of 1936, d'Harnoncourt included in the market demonstrations by the artists themselves, and model rooms that proved "how effectively fine Indian products blend with contemporary back-

grounds, contributing new color and new forms to any modern home." This market, d'Harnoncourt believed, would "demonstrate that Indian art is not savage art" (d'Harnoncourt 1939:12). Collier, too, expressed a similar confidence to Secretary of the Interior Harold L. Ickes: "The month of February, 1939, may go down in Indian history as the end of the parasitic trinket-and-bauble-era of Indian ware and the rebirth of substantial interest in genuine Indian craftmanship" (Collier to Ickes, 1939: IACB 20).

In discussing his expectations for the Indian market, d'Harnoncourt expressed a sense of nationalism and a concern for parity in the marketplace for contemporary Native American arts and crafts. For example, along with a series of drawings showing how Indian art could be used in the modern home, d'Harnoncourt sent the following note to William Wright, director of the Magazine Division of the Golden Gate Exposition (November 29, 1939: IACB 14, 119):

> The affinity of primitive art was discovered twenty years ago when African carvings and Oceanic vessels were first used as accessories to modern interior decorations in Paris. Since then, the work of all primitive artists the world over has been used for the same purpose with the exception of the projects of the American Indian, that were regulated to museums and curio stores.

Relying on information provided, no doubt, by d'Harnoncourt or his staff, the press division of the exposition released a statement announcing that the experts agreed that Indian art was equal to that of "foreign artisans," whose work was eagerly absorbed by America's "quality market." In response to this, the federal government was going to use the exposition to secure a wider recognition, and therefore a greater market share, for the Indian artist. Once the adaptability of the Indian's "rigorously simplified designs to modernistic homes and personal decoration" was proven, he would acquire "economic self-respect" and be competitive with the "best importations for the luxury trade." Thus the IACB was going to replace the sad image of "the noble red man selling postcards on a depot platform" with that of the proud American producer of quality goods (IACB 21).

Collier held similar opinions, informing Ickes, for example, that the government was participating in the exposition for very definite purposes, not the least of which was "to demonstrate that nowhere else in the world is there to be found finer craftsmanship" than that of the Ameri-

can Indian. Collier insisted that consumers need not rummage about "in the corners of foreign countries" searching for the rare and exotic when they could purchase "within the borders of the United States" hand-crafted decorative arts that pleased even the most discriminating collector. Furthermore, he promised that the Indian market would destroy "the subversive trade influence" of those unprincipled manufacturers who passed off machine made goods as authentic Indian art (Collier to Ickes, 1939: IACB 20).

The Indian market was important also for providing d'Harnoncourt with an opportunity to conduct a controlled experiment in marketing. Of the two salesrooms he designed, one resembled a reservation trading post and the other was done "in the style of a modern gift shop." The purpose was to determine which kinds of objects sold only if displayed in a distinctly Indian-related setting. Since he was trying to make contemporary Indian arts and crafts fashionable, d'Harnoncourt no doubt was pleased with the results: "Our experiences during the first six months of the Fair has shown that almost all fine articles sell faster and at higher prices if they are shown in an establishment resembling a gift shop than in a setting resembling a curio shop" (d'Harnoncourt 1939: IACB 4, 140.2). He also learned that the consumer was more likely to be interested in an item if it appeared functional. Thus sales of partly beaded moccasins were greater than those of fully beaded ones. Furthermore, d'Harnoncourt reported that the sales of moccasins increased greatly when they were displayed on the leg of a mannequin—that is, when they were presented "in a manner such as one is accustomed to see while shopping for footwear."

D'Harnoncourt felt his test of the market demand for high quality Indian arts and crafts was an unqualified success. There was now ample proof that Indian artists could produce useful decorative arts and that the public was more than willing to purchase such objects (d'Harnoncourt, July 26, 1940: IACB 4, 140.2). The best evidence of this, according to d'Harnoncourt, was in the number of inquiries he had received from commercial establishments seeking a source of Indian art and by the plans being made by museums and art centers nationwide to host Indian art exhibitions (d'Harnoncourt 1939: IACB 4, 140.2). After representatives of the Museum Association and the Museum Directors' Association visited the exposition in San Francisco, six of the most important eastern art museums informed d'Harnoncourt of their plans to collaborate with ethnological museums in organizing dramatic exhibitions of Indian art.

These exhibitions, d'Harnoncourt wrote to Collier, would focus not on the ethnological significance of Indian materials but on their vitality and aesthetic value (d'Harnoncourt to Collier, July 6, 1939: IACB 9, 103.1).

In September 1939, d'Harnoncourt reported to the directors of the IACB that of the invitations given by eastern institutions to follow up the San Francisco exposition, the most important had come from the Museum of Modern Art. In addition, museums in various other cities, including Worcester, Buffalo, and Chicago, had offered to finance a traveling exhibition of Indian art organized by the IACB. He felt it was logical to combine these opportunities and present an exhibition at MOMA, which would then circulate throughout the United States. Along with MOMA's ability to provide an *art* audience, such an arrangement would allow the IACB to focus for a period of up to three years on the problems of production and merchandising, since MOMA would have assumed the responsibility of showcasing Native arts and crafts as "valuable and desirable contemporary products" (d'Harnoncourt, September 21, 1939: IACB 4, 140.2).

Indian Art of the United States: The Exhibition

When the exposition in San Francisco closed October 29, 1939, approximately 1.5 million people had seen the IACB's Indian exhibits and d'Harnoncourt had been at work for over a month preparing "Indian Art of the United States." Object files and photographs were being generated, field work on the reservations was under way, and Douglas, once again, was assisting d'Harnoncourt in his planning efforts (d'Harnoncourt, July 26, 1940: IACB 4, 140.2). D'Harnoncourt had already informed Douglas that the scope of the exhibition was going to be beyond what he had imagined possible: "The Museum is willing to turn over to us not only one floor, as I had hoped, but the entire building and its large court, for three or possibly four months next fall" (d'Harnoncourt to Douglas, September 30, 1939: IACB 36, 300.36).

The potential for a monumental exhibition, which MOMA's building and garden presented d'Harnoncourt, when coupled with the current political climate, encouraged him to think of the exhibition as an opportunity to highlight the essential Americanness of Indian art. He was encouraged in this sentiment by Francis Henry Taylor, director of the Worcester Art Museum, who wrote to him, concerning plans for "Indian

Art of the United States": "It might be a great relief and extremely popular to promote the Indian at this time when everyone is pretty well appalled and fed up with Europe" (Taylor to d'Harnoncourt, September 26, 1939: IACB 36). As mentioned above, d'Harnoncourt claimed Indian art solely for the United States.[27] This reference to the nation as "owner" of Indian art helps explain why the title of the exhibition shifted from "Indian Art in North America," as it was originally called by d'Harnoncourt,[28] to "Indian Art of the United States." In that time of intense prewar searching for national values, d'Harnoncourt was a sensitive instrument for Roosevelt's New Deal policies, which had stressed freedom for the arts. More than once, a not-so-latent nationalism was used by d'Harnoncourt as justification for celebrating the aesthetic achievements of Native America.[29] For example, in material he prepared for MOMA's Publicity Department he announced that his goal was to "create a new appreciation and a deeper understanding of a much-neglected art form that is nation-wide in its scope and truly American in style and concept." He was certain that the exhibition, with its tremendous variety of materials, techniques, and designs, would "demonstrate that American Indian art is as diversified as American landscape" (d'Harnoncourt to Sara Newmeyer, June 17, 1940: IACB 34). In his foreword to the catalogue, to which Eleanor Roosevelt signed her name,[30] he explained, "At this time, when America is reviewing its cultural resources, this book and the exhibit on which it is based open up to us age old sources of ideas and forms that have never been fully appreciated." He went on to say in the foreword that Indian art "constitutes part of the artistic and spiritual wealth of this country" (Douglas and d'Harnoncourt 1941:8). This message was not lost on the critics, one of whom, upon reviewing the exhibition, wrote that visitors to the show became highly conscious of their American heritage (Vaillant 1941:167).

The audience encountered the first of the many "aesthetic and intellectual delights" recalled by Barr, at the front door of the museum, where d'Harnoncourt had placed, flush against the facade, a thirty-foot totem pole carved in 1939 by Haida artist John Wallace. This striking juxtaposition of the so-called primitive with the modern prompted one critic to observe, "Other totem poles rise like a surrealist forest inside the museum" (*Parnassus* 1941:77). Jeanette Lowe also observed of this pole, "The carved raven, killer-whale and devil fish may strike that eye, more accustomed to such fauna in the world of Surrealism, as symbols of the unconscious mind" (1941:7). Thus the linkage of Native American art to

Surrealism and other modern movements, which was a common feature of the criticism of the exhibition, and which is discussed below, actually began in the rarefied air of West 53rd Street.

The exhibition began on the third floor in a series of galleries devoted to the prehistoric civilizations of North America wherein d'Harnoncourt displayed painting, sculpture, and ceramics selected "for their aesthetic value only" (d'Harnoncourt September 30, 1939: IACB 34). The displays for these objects were minimal, lending to the artwork "the type of dignity usually associated with the work of the Classics" (d'Harnoncourt to Barr, November 8, 1939: IACB 34). D'Harnoncourt made it a point to install these objects "as one would install any gallery of small sculpture using simple pedestals and cases standing before plain walls" (ibid.). For example, the displays for the selection of Mimbres pottery (fig. 33) were marked by neutrality, austerity, and a lack of textual information that encouraged a purely aesthetic encounter with the ceremonial bowls. Today, of course, museum-goers are acclimated to such reductive displays of Indian art, but not so the audience in 1941. Lowe therefore explained that because there was an inherent difficulty in evaluating new art forms outside their cultural context, the museum (i.e., d'Harnoncourt), "by its own arrangement . . . helped the spectator to grasp some of the essentials of the abstract pattern which are intrinsically Indian" (1941:7). She had observed, no doubt, that enlarged Mimbres designs, liberated from their original surfaces, were reproduced on the wall behind the bowls. The only cultural identifier—the word Mimbres—painterly and cursive, was isolated within a free-floating biomorphic shape, reminiscent of Joan Miró, which referred, once again, to the affinity of the primitive and the modern.

The only exceptions on the third floor to d'Harnoncourt's decontextualization of ancient Indian art were the introductory gallery, which had maps and other didactic materials, and a gallery consisting of a series of kiva-like spaces, lit, of course, only by a hole in the top of the chamber. As one moved through these darkened chambers, one saw reproduced on adobe panels a set of prehistoric Pueblo murals which had been excavated at Awatovi in northeastern Arizona by J. O. Brew of Harvard's Peabody Museum in 1938.[31] In this instance, d'Harnoncourt's design provided a compelling ambience that amplified one's encounter with the murals. Lowe reported in Art News, for example, that "the showing of murals in small, low rooms, dimly lighted, gives an idea of the caves

Figure 33. Mimbres pottery installed at "Indian Art of the United States," 1941.
(Courtesy Museum of Modern Art)

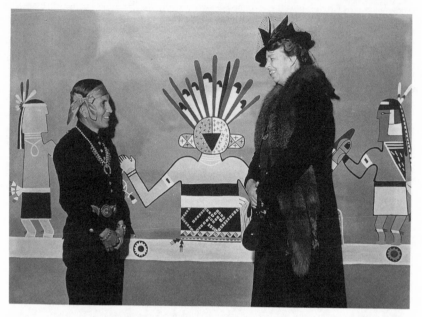

Figure 34. Hopi artist Fred Kabotie and Eleanor Roosevelt posing in front of a replica of an Awatovi mural at "Indian Art of the United States," 1941.
(Courtesy Museum of Modern Art)

in which they originally were" (1941:7). The murals had been recreated at the Haskell Institute in Lawrence, Kansas, by three high-school age (and now distinguished) Hopi artists—Charles Loloma, Herbert Komoyousie, and Victor Cootswytewa—under the supervision of Fred Kabotie, a highly acclaimed Hopi painter who was at that time an Indian Service employee.[32] One of the more memorable moments of the exhibition came when Kabotie posed with Eleanor Roosevelt in front of one of the murals (fig. 34).

Upon leaving these midtown kivas, one entered an expansive space lit by natural light, where d'Harnoncourt installed one of the exhibition's most dramatic objects: a full-scale (twelve and one-half by sixty feet) canvas mural reproduction of Basketmaker pictographs from Barrier Canyon in Utah (fig. 35). A photograph of the original site was included in the catalogue.[33] In contrast to the intimacy of the kivas, the giant mural, according to Vaillant of the American Museum of Natural History, cast the viewer "into the infinite expanse of time and space" (1941:168). Discussed favorably in almost every review of the exhibition, the pictograph replica was unique in being the only object on display not made

Figure 35. *Canvas mural reproduction of Basketmaker pictographs from Barrier Canyon, Utah, at "Indian Art of the United States,"* 1941.
(Courtesy Museum of Modern Art)

by Native American artists. It had been commissioned by the IACB— that is to say, by d'Harnoncourt—and made by artists working for the WPA's Federal Art Project. Funding for the special photographic expedition to Barrier Canyon, which was perhaps the single most expensive aspect of the exhibition, had been terribly complicated. The logistics, both bureaucratic and topographical, had proved even more problematic.[34] And yet d'Harnoncourt had maintained a steadfast commitment to the importance of this display, insisting that the wealth of design in Indian pictographs warranted serious attention: "Pictographs constitute a phase of Indian art that has so far been very much neglected both by the scientists and by the art world, in spite of the fact that a survey of the field shows that they compare favorably in quality and scope with those widely publicized rock paintings from Africa or Australia" (d'Harnoncourt to Thomas C. Parker, April 8, 1940: IACB 34, III-A-4). After much research d'Harnoncourt selected the pictographs at Barrier Canyon because they were "important aesthetically." Exhibiting this art form, he believed, was "a matter of nation-wide interest."

On the second floor d'Harnoncourt exhibited the art of historic Native

Figure 36. *Installation of Northwest Coast sculpture at "Indian Art of the United States," 1941.*
(Courtesy Museum of Modern Art)

American peoples under the heading "Living Traditions." Using a format similar to that of the San Francisco exposition, he sought in these displays to create the "atmosphere" of the cultural background of the objects and to direct the audience "from vista to vista" through a variety of impressions (d'Harnoncourt to Douglas, September 30, 1939: IACB 36, 300.36). For example, as photographs of the Northwest Coast exhibits demonstrate, d'Harnoncourt used intensely dramatic lighting to emphasize the plastic qualities of the sculptures and to suggest the dark forest interiors where they were created (figs. 36, 37). Some of the masks, however, were given their own singular space and lit from below, thus indicating their status as individual masterpieces. Vaillant must have had these in mind when he wrote in the *Art Bulletin* (1941:168): "This imposing aesthetic expression was cunningly shown, the spotlighted sculpture being the only illumination in an otherwise dark room. The supernatural forces, with whom the Indian has always been in such intimate contact, seemed dramatically concentrated here, overawing even the case-hardened New Yorker."

That Vaillant responded to the mysterious and dramatic lighting of this

Figure 37. *Installation of Northwest Coast sculpture at "Indian Art of the United States,"* 1941.
(Courtesy Museum of Modern Art)

particular installation is an indication of d'Harnoncourt's success in establishing the ritualistic (read instinctual, premodern) context for the masks on display. Evidence of d'Harnoncourt's desire to focus on the "intimate contact" between Indians and "supernatural forces" may be found in his description in the catalogue of the Northwest Coast tradition: "Beside the dark sea and forest there developed an art in which men, animals, and gods were inextricably mingled in strange, intricate carvings and paintings. Religion and mythology found their outlet in vast ceremonies in which fantastically masked figures enacted tense wild dramas" (Douglas and d'Harnoncourt 1941:146).

Even though it was d'Harnoncourt's intention to contextualize the historic art, some of the displays on the second floor reflected the clean, streamlined look of contemporary design. For example, on viewing a portion of the display of historic Pueblo art (fig. 38), one is struck by the generous spacing of the objects, the lack of textual clutter, and the *moderne* look of the backdrop, with its pristine white geometric shapes. What a contrast it must have been for those who had seen the claustrophobic cases uptown at George Heye's Museum of the American Indian.

Figure 38. *Installation of historic Pueblo art at "Indian Art of the United States,"* 1941. *(Courtesy Museum of Modern Art)*

The first floor, devoted to "Indian Art for Modern Living," was divided into three galleries: contemporary painting and sculpture, "Indian art as an object for study," and the "Indian contributions to modern decorative arts" (d'Harnoncourt to Barr, November 8, 1939: IACB 34). D'Harnoncourt felt that the gallery of painting and sculpture was a matter of aesthetic experience and needed no other justification. He was convinced that in and of itself the gallery of painting and sculpture would be the final element required to generate a sincere new interest in Indian art in both museums and schools. Furthermore, he believed that "some of the down-town galleries will swing into line and accompany our exhibit with sales exhibits that should create a new steady market for Indian paintings in the east" (d'Harnoncourt to Dietrich, December 23, 1941: IACB 36). Some of the artists represented in this section were Fred Kabotie, Oscar Howe, Harrison Begay, and Monroe Tsatoke.

The study gallery, however, focused on contemporary Indian art's "abstract contribution" to modern life and was a combination of objects, pictorial charts, and texts (d'Harnoncourt, December 1940: IACB 32, and d'Harnoncourt to Barr, November 8, 1939: IACB 34). This "abstract contribution" had two components that d'Harnoncourt wanted to point out.

The first was that Indian and other so-called primitive art provided the best opportunity for studying the role of art in the economic, social, and religious life of a community (d'Harnoncourt to Douglas, September 30, 1939: IACB 36). The second was the unity of technique, raw material, and form in a work of art. D'Harnoncourt felt this was an issue of public concern, and yet it was one "very difficult to grasp in the machine age, when the majority of the people are unfamiliar with the original raw material used and with the complicated production methods employed."

The section that focused on Indian contributions to modern decorative arts was, according to d'Harnoncourt, the single most important and vital part of the entire exhibition. To him, the enrichment of contemporary culture was Indian art's "concrete contribution" (d'Harnoncourt, December 1940: IACB 32). He was convinced that the public would realize the value of contemporary Indian art when they were shown that it harmonized with the artistic concepts of modernism (d'Harnoncourt to Newmeyer, June 17, 1940: IACB 34). Thus the objects and displays were coordinated to demonstrate that "the modern Indian ... can produce artistic things whose beauty and utility are keyed to modern life" (d'Harnoncourt in *Art Digest* 1941:17). Once again, d'Harnoncourt designed model interiors showing that Navajo rugs and blankets, Pueblo pottery, Eskimo carvings, recent Indian painting, and even Cherokee wastepaper baskets "fit perfectly into the contemporary scene" (Douglas and d'Harnoncourt 1941:197). Some of these objects, he explained, "find a place in our houses and wardrobes simply because of their decorative value, but many combine utility with aesthetic merit" (p. 198).

Along with displays promoting the use of Indian art as home furnishings, d'Harnoncourt's exhibits also suggested its use as personal adornment and fashion accessory. The former was easily accomplished with an outstanding selection of Navajo silver jewelry, but d'Harnoncourt's solution to the latter was far more innovative. He supplied Swiss fashion designer Fred Picard with articles of Indian manufacture to be used in Picard's line of women's wear, which was featured at the exhibition (d'Harnoncourt to Picard, October 21, 1940: IACB 34). Picard responded by using an Osage beaded and braided belt made in Oklahoma as trimming on a short evening cape. Also exhibited was an after-skiing suit designed by Picard that incorporated Seminole cotton patchwork and Navajo buttons of hammered silver (Douglas and d'Harnoncourt 1941:206–7).

But d'Harnoncourt did not believe it necessary to insist on the func-

tional value of all the art exhibited. In one portion of the first floor he displayed works of "such high aesthetic quality that they could be used as objets d'art, even though they were not intended for this purpose by their makers" (d'Harnoncourt to Douglas, September 30, 1939: IACB 36). Thus "Indian Art for Modern Living" was both contextualized, stressing function and adaptability, and aestheticized, making contemplative objects of material that originally had utilitarian or perhaps ceremonial function. And despite all these creative efforts to generate a market demand for contemporary Indian art, "Indian Art of the United States" (unlike the exposition in San Francisco) did not offer retail sales of contemporary Indian arts and crafts. D'Harnoncourt felt that more long-term benefits would be derived by introducing Native arts and crafts into New York stores that would continue to carry the merchandise after the exhibition closed than by a temporary sales room at MOMA. In fact, by July 1940—well in advance of the opening of the exhibit—he had secured promises from private individuals allowing IACB-sponsored Indian organizations to use office space on Fifth Avenue for a wholesale center. It was his intention to use the interest sparked by the exhibition to develop "permanent business contracts with established New York firms" (d'Harnoncourt, July 26, 1940: IACB 4, 140.2).

The Catalogue: The Critical Reception

The critics, including those who wrote for the popular press as well as for art magazines, agreed without exception that "Indian Art of the United States" was an unqualified success. According to Newsweek, the "fashionable opening-night throng which . . . wedged itself four-deep around the dramatically lit showcases testified to the brilliance of the exhibit" (1941:58). Frank Caspers, writing in the Art Digest, called the exhibition "the most significant recognition to date of the aesthetic gift of American Indian artists" (1941:27). La Farge noted in the New York Times that it was "a new chance for the real Indian—and a chance at last for the East to discover the realities of Indian civilization" (1941b:9). In Parnassus, a publication of the College Art Association, the show was described as the "largest and most representative exhibition of its kind ever assembled" (1941:77). Similarly, Art Digest also understood it to be the "definitive exhibition of Indian arts and crafts" (1941:17).

In reviewing the book-length catalogue of the exhibition, which was written primarily by d'Harnoncourt,[35] Florence Berryman noted in the

Magazine of Art that it was a superb exhibition, the most comprehensive revelation ever of Indian art (1941:218). She rightly observed that more than mere accompaniment, the book helped to prove the exhibition's thesis that Indian art was both vital and adaptable to modern life. Caspers, too, felt that the book, *Indian Art of the United States*, was the "most complete on its subject ever written" (1941:27). For him, it was a "compact, vital and absorbing record of America's indigenous civilization." Thus the book was itself an effective instrument for changing the public's perception of Native American art. So, too, was the abundant critical discourse that flowed like a textual river around both exhibition and book, reinforcing and extending d'Harnoncourt's ideas. Therefore, the book and the critical response to the show must be discussed together.

Since America was struggling in 1941 to emerge from a crippling economic depression and at the same time was being drawn inexorably into a European war, it is hardly surprising that d'Harnoncourt and the critics saw Native America's vital strength, resilience to adversity, and ability to adapt to change as a resource for the nation's future. Indeed, there were undeniable ideological and political rewards to be reaped from making Indian art generically American. To that end, d'Harnoncourt sought to link, in the public's mind, the power and *élan vital* of ancient America and the nation-state known as the United States of America. Thus he wrote: "This publication, as well as the exhibition on which it is based, aims to show that the Indian artist of today, drawing on the strength of his tribal tradition and utilizing the resources of the present, offers a contribution that should become an important factor in building the America of the future" (Douglas and d'Harnoncourt 1941:10).

Neither d'Harnoncourt's genuine appreciation of Indian art nor his commitment to the Indian's cultural rehabilitation and right to self-determination are denigrated by recognizing that the qualities of Indian art he stressed in the book could be described as quintessentially American: basic soundness, vigor, strength of tradition, unexplored wealth, and close relationship to the land (p. 197). Indian art was used, therefore, to remind the American public that what had made and would continue to make the nation strong was a constant ability to renew itself in the face of challenge by exploiting untapped resources with new technologies. D'Harnoncourt cited, for example, Navajo silversmithing and Plains horsemanship as evidence of the Indian's willingness to seize the opportunity to transform traditional culture. He found it only "natural that a new appreciation of these values by the authorities and by part of the

American public is now bringing to light in many places traditional customs and traditional thinking" (p. 10).

While reflecting on the success of "Indian Art of the United States" relative to the "Exposition of Indian Tribal Arts" (1931), La Farge extended d'Harnoncourt's idea of associating the values of Indian art with the United States. La Farge believed that the public's response to the earlier show was diluted by the fact that, unlike African art, Indian art in 1931 had not yet been endorsed by Paris (1941a:181). Likewise, he wrote that if the Awatovi murals had been discovered in the Old World, they would already be well known in America because the French would have valued them, thus "it would have been aesthetically respectable, even necessary, to appreciate them." It was important for La Farge to devalue Europe as a standard of cultural achievement, for he insisted that there were aspects of Indian civilization, "some material, some intangible, . . . that can stand comparison with skyscrapers or the present apex of white civilization in Europe." Furthermore, he recognized that Indian art was "the only art original to this land" and that its abstract forms equaled those of European art (1941b:9). In contrast to the exposition of 1931, the "double pleasure" of d'Harnoncourt's exhibition for La Farge was in seeing that Indian art was "still vigorous, still evolving" and that the public was finally waking up to the gifts of Indian art and culture. He noted that the great strength of Indian art was its ability to change and that this was its relevance for contemporary America (1941a:182).

The American aspect of the exhibition was also noted by Jean Charlot, who wrote in The Nation that the patriotic atmosphere then current in the United States would encourage recognition of Indian artists. In fact, he called them the "hundred-per-centers of American art, beside whom even Thomas Craven's roster of Americans acquires an immigrant flavor" (1941:165). Similarly, Vaillant, in his review of the exhibition, wrote chauvinistically about "the art of our own Indians." Yet he also described experiencing the exhibition as being in the presence of a "truly continental American art, one which we may hope some day to rival." As American art moves into the future, Vaillant wrote, it must seek its roots in the native environment of which Indian culture is such an important part (1941:167–69).

In the book, just as in the exhibition, d'Harnoncourt tried to synthesize contextualization, recontextualization, and aestheticization of the objects. In the first case, he explained that art-for-art's-sake was an un-

known concept in Indian cultures and that "the close relationship be-
tween aesthetic and technical perfection gives the work of most Indian
artists a basic unity rarely found in the products of an urban civilization"
(Douglas and d'Harnoncourt 1941:13). Likewise, he found the term *primi-
tive*—in both its literal and popular usage—unacceptable as a description
of Indian art. Instead, manifesting an understanding of folk art consistent
with the anthropological literature of the 1940s, he stated, "Traditional
Indian art can best be considered as folk art because it is always an inex-
tricable part of all social, economic and ceremonial activities of a given
society" (ibid.).[36]

This emphasis by d'Harnoncourt on the complete integration of art
and culture in Indian society underscores the fact that in the catalogue
and in many critical reviews of the exhibition one often encounters a lay-
man's version of C. G. Jung's idea of a consciousness, both collective and
archaic, still manifest in primitive art and folk traditions. This is hardly
surprising, since Jungian interpretations of "primitive" and primitivist art
were commonplace in the early 1940s (Rushing 1986:273–75).[37] For ex-
ample, d'Harnoncourt stated in the catalogue that Indian art was created
"within a collectively established scope of forms and patterns and always
serves . . . a spiritual purpose accepted by the entire group" (Douglas
and d'Harnoncourt 1941:12). Pueblo art, in particular, was cited as an art
tradition determined by centuries of collective activities and concepts.
Indeed, the concepts of the individual Pueblo artist were said to be iden-
tical with those of the group. Even contemporary Indian arts and crafts,
d'Harnoncourt wrote, continued to fulfill a variety of collective needs,
especially economic and religious ones (p. 197).

Ideas similar to these were expressed in various reviews. Lowe, who
saw in totem poles symbols of the unconscious mind, wrote that tradi-
tional Indian art "always served a definite utilitarian or spiritual purpose
accepted by the entire group of which it was an expression" (1941:7).
Furthermore, she stated that because tribal groups used repeatedly the
same combinations of form elements, it was "possible to define their col-
lective concepts and art styles." One of the most poignant aspects of the
exhibition for Lowe was the display of Northwest Coast masks. The con-
temporary audience, she wrote, could relate to the collective concepts
and psychological implications of such objects. In his review Charlot ex-
pressed the hope that contemporary artists would see the spiritual con-
tent of Indian art as a balance between the subjective needs of the indi-

vidual artist and the constraints of the tradition in which he worked: "the Indian artist manages to assert his greatness within an accepted frame of his tribal norms" (1941:166).

La Farge, too, revealed an awareness of certain aspects of modern psychology in his comments in the *New York Times* about the exhibition. For example, he felt that d'Harnoncourt's show was bringing Indian art "to the surface of our reluctant consciousness in a new and compelling way." And his description of Indian art as the result of the evolutionary process was perfectly compatible with the evolutionist component inherent to Jungian psychology. He explained that "it took a long while to develop the culture that produced" the objects on display. Likewise, he assigned "the rich complexity of pueblo life as we know it today" to a long, smooth evolutionary process. One result of such an evaluation was that America acquired a cultural antiquity, previously lacking, comparable to that of Europe, for as La Farge noted of the works exhibited, "The America out of which they came is 20,000 years old" (1941b:9).

The process of aestheticization—that is, the authoritative validation of the objects as intrinsically fine works of American art worthy of modern consideration—actually began with their placement in what Caspers referred to as "Manhattan's sleek Museum of Modern Art" (1941:27). As for decontextualization, influenced, no doubt, by formalist theories of modernism, d'Harnoncourt insisted that one could conduct "an aesthetic evaluation of the art of any group without being much concerned with its cultural background" (Douglas and d'Harnoncourt 1941:11). He further stated that a "satisfactory organization of lines, spaces, forms, shades and colors should be self-evident wherever we find it." But in the catalogue no less than in the exhibition, d'Harnoncourt sought to modify this decontextualization by offering a variety of contexts—religious, utilitarian, technical, and social—for the objects. In a certain sense, however, d'Harnoncourt's insistence on contextualization emphasized the audience's *aesthetic* experience: "Yet we know that increased familiarity with the background of an object not only satisfies intellectual curiosity but actually heightens appreciation of its aesthetic values" (ibid.). And although he admitted that the art on display issued from regional cultures, this knowledge apparently served as a defense of the catalogue's overt refusal to interpret specific symbols. Indeed, while Douglas's lengthy captions for the illustrations provide a plethora of information about the history, function, style, composition, materials, and techniques associated

with objects, there is almost nothing that could be construed as iconography, let alone iconology.

Like his installations on the first floor, d'Harnoncourt's discussion in the catalogue of contemporary art was clearly intended to stress its compatibility with modernism. He characterized the best of the new work as having an "economy rather than complexity of design" (ibid., p. 199). Furthermore, echoing the modernist dictum that form follows function, he wrote that "the close relationship between function and form are [sic] what bring Indian work so near to the aims of most contemporary artists and make it blend with any surroundings that are truly of the twentieth century." In particular, he saw the new Indian painting as being closer to the concepts of modernism than traditional art because it "replaced functional value with aesthetic ones" (p. 200).

Although it was perhaps not intentional, reviews of the show also contributed to the aestheticization of the objects by evaluating and praising them with the principles and language of modernism. Lowe, who found parallels between Surrealism and the totemic art of the Northwest Coast,[38] claimed that the ancient Woodland banner stones exhibited were "as bold in shape and as simplified as any form that ever entered the head of Brancusi" (1941:8). She described the Nootka house painting (fig. 34) as a "fascinating abstraction on the essentials of form." Similarly, she found some Indian masks "almost a pure abstraction of form," while others were reduced to an essential form, making them comparable to much contemporary sculpture. In his review, Caspers spoke of a spirit as modern as Paul Klee, which "designers are adapting to the demands of present-day fashion needs" (1941:27).

Several critics, including Charlot, compared Surrealist, Eskimo, and Northwest Coast art. For example, he reported that "orthodox surrealists" praised "the distorted spirit masks of the Eskimos," which were made under the influence of drugs or the stimulation of fasting (1941:165). Max Weber, one of the first American painters to appreciate American Indian art, wrote to Barr that the magnificent exhibition proved that "we have the *real* Surrealists right here in America" (Weber to Barr, February 1, 1941: IACB 34). Vaillant, who knew well the important collections of Eskimo and Northwest Coast art at the American Museum of Natural History, wrote that the small Eskimo masks chosen by d'Harnoncourt embodied "the imaginative concentrate of *surrealisme*" (1941:168). Before the exhibition opened, d'Harnoncourt had himself wondered how modern artists

who had seen Eskimo art could go on exhibiting: "There is really very little that the good Eskimo leaves unsaid in the line of whimsical conventionalization" (D'Harnoncourt to Miller, June 21, 1940: IACB 35).

Charlot was not surprised that MOMA would host such an exhibition, since "Indian crafts are one of the sources of our own modern style." Indeed, he claimed that it was "a fact that Chilkat blankets were admired by early Cubists as the living tradition on to which their own plastic inventions were grafted." He also quoted French painter and theorist Amédée Ozenfant, who playfully exclaimed that the Indians were imitating Picasso. And, comparable to the swings between abstraction and realism that had characterized twentieth-century Euro-American art, Charlot credited Indian artists with the "amphibian gift of moving at ease among abstract as well as realistic pursuits." In spite of this, he realized that "the deepest thrust of the Indian mind, the language it chooses to exalt its clan pride, wield magic power, or address the gods, is the language of abstract art" (1941:165).

Charlot also explained that even though each generation of avant-garde modernists might "flirt with what in the vast and complex body of aboriginal art approximates its fancy," the best Indian art always transcended "such modish standards" (ibid.). Concerning this relationship between modern and aboriginal art, the Washington Star quoted d'Harnoncourt as saying in an interview that because the affinity between traditional Indian art and modern art could not be explained by actual contacts, "we must concede the existence of human concepts that find expression in specific art forms." Modernism, d'Harnoncourt explained, had rediscovered forms that the Indian artist had never discarded. Thus the interviewer concluded that in some aspects modern art was completing a cycle begun by Indian artists (1941: IACB 32).

Conclusion

There was, then, in the exhibition, the catalogue, and the accompanying criticism, a lack of resolution between what appear to be conflicting conceptions of Native American art as either universal and understood aesthetically or culture specific and functionally responsive to societal needs. In retrospect, the weight of the evidence proves that d'Harnoncourt actually sought the rich provocation inherent in this paradox. If "Indian Art of the United States" could demonstrate that these conceptions were not mutually exclusive, then the potential audience for

Native arts and crafts, and commercial consumption of them, would increase. Furthermore, the complexity of the exhibition as an experience, as well as the catalogue's content, was in direct proportion to the intensity of d'Harnoncourt's belief that the rehabilitation of the Indian artist was a national moral responsibility. He was equally convinced that the slow and delicate process involved in staging such an exhibition was warranted by the enrichment of American life that it would engender (Douglas and d'Harnoncourt 1941:200).

Partly because of the elaborate interplay of contexts, including decontextualization, recontextualization, and aestheticization, the exhibition was extremely well received at all levels. One of the strongest indications of the exhibition's success is that it helped shape artistic practice. As I have demonstrated elsewhere, "Indian Art of the United States" had a profound and immediate impact on the development of avant-garde art in New York (Rushing 1986:273–91). The show was particularly popular with a number of incipient Abstract Expressionists, such as Jackson Pollock, who visited the exhibition often and expressed his fascination with the display of Navajo sand paintings (fig. 39). Partly as a result of seeing the exhibition, he incorporated into his paintings specific Indian images, such as the semi-abstract figures of Pueblo pottery, as well as dramatic Northwest Coast masks. Perhaps more important, his revolutionary drip paintings of the late 1940s owe much to the ideas, processes, and purposes associated with Navajo sand painting. Like Pollock, Adolph Gottlieb and Richard Pousette-Dart also made paintings in the early 1940s that responded to d'Harnoncourt's displays of pictographs and totemic sculpture.

There can be little doubt that the quality of d'Harnoncourt's installations, the depth of the catalogue, and the stature of the Museum of Modern Art were integral to the final results: in 1941, "Indian Art of the United States" was the most outstanding and unquestionably the most popular exhibition of Native art in American history. And yet the positive reception of the exhibition is inseparable from d'Harnoncourt's anticipation of the audience's "horizon of expectation." That is to say, "in its moment of historical appearance," the exhibition demonstrated an awareness of the audience's previous cultural, ethical, and aesthetic experience in relation to Native America.[39] D'Harnoncourt's acute awareness of the audience's "current expectations"—their readiness to have certain themes explored, certain questions answered, and certain beliefs revised—was an essential, if somewhat less tangible, element in his remarkable achievement.

Figure 39. *Navajo singers making a sand painting at the Museum of Modern Art, 1941.*
(Courtesy Museum of Modern Art)

Vaillant's final comment on the exhibition typifies the critical consensus that d'Harnoncourt had successfully visualized the audience's horizon of expectations: "We have preserved the work of the Indians as ethnology, let us also enjoy it as art" (1941:169).[40]

One would be remiss, however, not to mention once again the political and cultural rewards that were to be obtained from associating Indian art with the United States of America. More than ever, it seemed, the nation needed to find the taproot of its cultural strength. Certainly it had occurred to Charlot that the exhibition came at a time when Americans found themselves "stranded on their own continent in recoil from a beset world" (1941:165). And La Farge observed that at "this time when we are restudying America, restudying our resources, may be the day of its [Indian art] acceptance" (1941b:23). According to d'Harnoncourt, one of America's great cultural strengths was its sense of tradition. For example, he wrote, "To rob a people of tradition is to rob it of inborn strength and identity. To rob a people of opportunity to grow through invention or through acquisition of values from other races is to rob it of its future"

(Douglas and d'Harnoncourt 1941:10). This statement's polyvalence reflects both the exhibition and the catalogue. For although he was speaking ostensibly about Native American peoples, he was thinking, perhaps, about the racial oppression then occurring under totalitarian regimes in Europe. And since this nation's future just then was clouded by the darkness of fascist violence, it is plausible, even likely, that d'Harnoncourt was speaking about America itself, urging its people to find in Native American values a sense of inborn strength and identity.

Finally, when considered as an ideological construct,[41] "Indian Art of the United States" is necessarily understood as a manifestation of cultural primitivism. The call for a national aesthetic based on Native American art, frequently heard in the critical responses to the exhibition, underscores the fact that it was organized by a government agency and funded by powerful corporations. Thus, as a nationalist project, it is one of many examples of nation-states, in the period following rapid industrialization and urbanization, seeking to salvage and incorporate the traditions of their rural folk cultures. Such salvage projects had at least three components. The first was related to a romantic need to preserve—as with endangered species—a "primitive" state of cultural development, usually associated with agrarian life, which had not been tainted by the ill-effects of capitalism and secularization. The second component was a function of the first—a desire to provide a new, more stable economic base that would halt the disintegration of these traditional cultures. It was important, therefore, to develop markets and marketing techniques that would create a need for the objects outside the community of origin. D'Harnoncourt, as this essay has demonstrated, was extremely adept at fulfilling this aspect of his bureaucratic responsibilities. Furthermore, as his activities indicate, in this stage of interaction between Native (American) artists and their patrons (the IACB), the out-group consumer actually functions as a "form-creator."[42] And third, the folk or "primitive" culture, in this case Native American, and their aesthetic creations were appropriated and used as emblems of the nation-state itself.[43] In this context, d'Harnoncourt's statement that denying a people the "opportunity to grow . . . through the acquisition of values from other races is to rob it of its future" may be seen as a defense of the political instrumentality inherent in the nation's colonial appropriation in 1941 of Native American art.

1. The Museum of Modern Art was founded in 1929. This essay is derived from Chapter 5 of my doctoral dissertation, "Native American Art and Culture and the New York Avant-Garde, 1910–1950" (University of Texas at Austin, 1989). An earlier version of this essay was presented as a paper in a session on "Institutions and the Aestheticization of Primitive Art," chaired by Cecelia F. Klein at the Annual Meeting of the College Art Association in Houston, February 1988. I am grateful to Professor Klein for her support of my research on this topic. I also wish to acknowledge the gracious cooperation of the following individuals: Myles Libhart of the Indian Arts and Crafts Board; Richard Crawford of the National Archives; and especially Janice Ekdahl, assistant librarian at the Museum of Modern Art.

2. For a troubling defense of the continued use of the term primitive, see Rubin (1985:5–6, 74, n. 1). For an opposing point of view see Clifford (1985:176, n. 1). My use of the term in this essay should not be construed as a tacit acceptance of its disturbing historical connotations, but rather is intended to maintain the language of the period under consideration.

3. For an illustration of this object, see Douglas and d'Harnoncourt (1941:72).

4. Ibid., p. 174.

5. Ibid., p. 96.

6. Ibid., p. 45.

7. Monroe Wheeler had a long and distinguished career at the Museum of Modern Art. At its founding in 1929 he was named, along with Elizabeth Bliss Parkinson, Edward M. M. Warburg, Lincoln Kirstein, Philip Johnson, and Nelson Rockefeller, to the Junior Advisory Committee (Rockefeller 1981:13). As director of exhibitions in 1941 he must have assisted d'Harnoncourt and Klumb with their rearrangement of the museum to accommodate "Indian Art of the United States." Later in his career Wheeler was both creator and director of the museum's publishing program, as well as a trustee.

8. All of these exhibitions were documented with scholarly publications: Holger Cahill, *American Sources of Modern Art* (New York: Museum of Modern Art, 1937; reprint ed., Arno Press, 1969); James Johnson Sweeney, *African Negro Art* (New York: Museum of Modern Art, 1935; reprint ed., Arno Press, 1969); Leo Frobenius and Douglas C. Fox, *Prehistoric Rock Pictures in Europe and Africa* (New York: Museum of Modern Art, 1937; reprint ed., Arno Press, 1972); Roberto Montenegro with Nelson Rockefeller, *Twenty Centuries of Mexican Art* (New York: Museum of Modern Art and the Instituto de Antropologica e Historia de Mexico, 1940; reprint ed., Arno Press, 1972); Ralph Linton and Paul Wingert in collaboration with René d'Harnoncourt, *The Art of the South Seas* (New York: Museum of Modern Art, 1946; reprint ed., Arno Press, 1972); Wendell C. Bennett and René d'Harnoncourt, *Ancient Art of the Andes* (New York: Museum of Modern Art, 1954; reprint ed., Arno Press, 1966; and William Rubin, ed., *"Primitivism" in 20th Century Art*, 2 vols. (New York: Museum of Modern Art, 1985). Concerning the controversy surrounding the latter, see Hal Foster, "The 'Primitive' Unconscious of Modern Art, or White Skin Black Masks" (1985:181–208); Hilton Kramer, "The Primitivism Conundrum" (1984:1–7);

Thomas McEvilley, "Doctor Lawyer Indian Chief: 'Primitivism' in 20th Century Art at the Museum of Modern Art" (1984:54–60); William Rubin et al., "On 'Doctor Lawyer Indian Chief: "Primitivism" in 20th Century Art' At the Museum of Modern Art in 1984," part 1 (1985:42–51) and part 2 (1985:63–71); James Clifford, "Histories of the Tribal and the Modern" (1988:164–77, 215); Yve-Alain Bois, "La Pensée Sauvage" (1985:178–88); and Kirk Varnedoe, "On the Claims and Critics of the 'Primitivism' Show" (1985:11–21).

9. For a review of the historical consensus that "Indian Art of the United States" effectively changed the public's attitude toward Indian art, see Jonaitis (1981:4).

10. John Sloan and Oliver La Farge, eds., *Introduction to American Indian Art* (New York: Exhibition of Indian Tribal Arts, Inc., 1931). The "Exposition of Indian Tribal Arts" is discussed at length in Chapter 5 of my dissertation (see note 1 above).

11. Excerpted from the Indian Arts and Crafts Board Act of 1935 (Schrader 1983:299). I am indebted to Schrader's study for drawing my attention to archival materials that have been invaluable in preparing this essay.

12. Rockefeller and d'Harnoncourt, who shared a passion for Mexican folk art, met in Mexico in the mid-1930s (O'Neill 1986:2). Rockefeller was voted president of MOMA's Board of Trustees in 1939 (Rockefeller 1981:13), the same year the museum invited d'Harnoncourt and the IACB to organize "Indian Art of the United States." It is inconceivable that Rockefeller's admiration for d'Harnoncourt and his position at the museum were not prime factors in the decision to host the exhibition. D'Harnoncourt had received Carnegie support for his curatorial activities as early as 1928 (MOMA 1968 and d'Harnoncourt 1969:2). Keppel was instrumental in securing Carnegie funding for d'Harnoncourt for the IACB's "Exposition of Indian Arts and Crafts" at San Francisco's Golden Gate International Exposition (d'Harnoncourt to Keppel, August 1938: IACB 12, 036).

Once the plans for the 1941 exhibition were under way, d'Harnoncourt was able to assure MOMA director Barr that he had "talked again with the Foundation's people and found their reactions so enthusiastic and encouraging that I have little doubt that we can obtain what we need" (d'Harnoncourt to Barr, October 20, 1939: IACB 19, 534). D'Harnoncourt was confident enough of these personal connections to write his collaborator Douglas, concerning the loan of objects from the Field Museum of Natural History: "I have not sent this request yet and will not do so until I see some of the New York people, because I have a hunch that I can get word to certain key trustees through influential friends, which would, I imagine, help more than any amount of official correspondence" (d'Harnoncourt to Douglas, September 6, 1940: IACB 34). And, indeed, Clifford C. Gregg, director of the Field Museum, responded that although they did not normally loan the material in question, they would be glad to cooperate on this particular occasion (Gregg to d'Harnoncourt, November 11, 1940: IACB 35).

13. For example, d'Harnoncourt wrote to Barr concerning his own first sketches of the floor plan, expressing a desire to simplify the layout "to eliminate some of the sudden changes in direction that are apt to give the visitor a feeling of confusion and restlessness." The entire plan, he explained, had been designed "in terms of visitor's vistas." Thus he included a series of sketches, each representing

"a vista seen by the visitor standing in the circle with corresponding number and looking in the direction of the arrow" (d'Harnoncourt to Barr, November 8, 1939: IACB 34).

14. The lone exception appears to be a minor complaint about the lighting made by Jean Charlot (1941:165).

15. According to Ira Jacknis, former research associate in the Department of African, Oceanic, and New World Art at the Brooklyn Museum, when the museum was reconstituted as an art museum (1931–33), Spinden redefined and reinstalled ethnographic material as masterpieces of primitive art (pers. comm., 1986). Spinden's papers at the museum bear this out. For example, in 1934 he wrote that "a carefully considered plan of reinstallation on the ground floor of the Museum provides for a coordination of the fields of primitive art in the Old World and New, with special emphasis on Ancient American Art" (1934:1). And of his efforts in 1935 he observed: "The principal event of the year as regards this department was the opening of the series of halls devoted to primitive art and the early American civilizations . . . to emphasize scientific and educational values. . . . But over above all this the problem was to find installation methods which would pick out the artistic merits of the individual specimens and broad effects in fresh color which would pull the entire exhibit into an esthetic unity" (1935:1).

16. Wheeler observed that d'Harnoncourt's "installations were world famous" and that he "established juxtapositions and sequences that illuminated certain universals and interrelationships between one culture and another, and inheritances from generation to generation." Wheeler added that "this method, which all exhibition directors now practice, but in which he pioneered and excelled, was especially applicable to themes shows" (MOMA 1968).

17. Concerning the Mexican folk art revival, d'Harnoncourt recalled "trying to help some of the craftsmen to try to keep on doing quality work in spite of the decadence forced on them by the tourist trade" (1969:1).

18. The Metropolitan Museum accepted the Mexican show only after a great deal of pressure was applied by Keppel at the Carnegie Corporation and by the American Federation of Arts. D'Harnoncourt remembered that one of the Metropolitan curators described the folk art as "the most atrocious lot of truck" ever seen and that it was feared that the exhibition would destroy the museum's reputation. It was on this visit that d'Harnoncourt first met Keppel, whom he referred to as his American godfather (1969:3, 8, 13).

19. This job in broadcasting and d'Harnoncourt's immigration visa were obtained through Keppel's good offices (d'Harnoncourt 1969:13–14).

20. On d'Harnoncourt, Nelson Rockefeller, and the politics of cultural exchange with Latin America in the late 1930s and early 1940s, see Klein (1989:4).

21. For early consideration of the aesthetic value of Native American art, see Berlo, Jacknis, and Schevill in this volume. Despite the early ethnoaesthetic studies that they document, this was still a relatively limited area of study, as d'Harnoncourt suggests. Detailed scholarly investigations of the economic issues relevant to artistic production were not undertaken until recently. See, for example, Brody

(1976:70–84); Parezo (1983); and Edwin L. Wade, "The Ethnic Art Market in the American Southwest, 1880–1980," in Stocking (1985:167–91).

22. Cultural primitivism and twentieth-century Euro-American interest in Native American art are discussed in chapters 1–3 of my dissertation (Rushing 1989). For a definition and discussion of cultural primitivism in more universal terms, see Arthur O. Lovejoy's comments (Lovejoy and Boas 1935:6–9).

23. For a discussion of the IACB exposition at the San Francisco fair in 1939 see Schrader (1983:163–98).

24. Eleanor Roosevelt noted her enthusiasm for d'Harnoncourt's models for the San Francisco fair in her column "My Day," in the Washington Daily News, Monday, February 28. In a letter to Secretary of the Interior Harold Ickes, Fair Commissioner George Creel observed that both President and Mrs. Roosevelt were deeply interested in the Indian arts and crafts exhibit that d'Harnoncourt was planning (Creel to Ickes, February 25, 1938: IACB 9, 300.33).

25. The text Vaillant produced was the well-known Indian Arts in North America (Vaillant 1939). The Carnegie grant also funded pamphlets, lectures, salaries for exposition guides, and installation personnel (Schrader 1983:181).

26. For an illustration of d'Harnoncourt's floor plan of the exposition, see Schrader (1983:187).

27. This appears to have been more a matter of ideology and political expediency than personal conviction. D'Harnoncourt was perfectly willing to exhibit historic Indian art made by Canadian tribes. Furthermore, he had insisted on occasion to George Heye that "political frontiers are meaningless in the definition of Indian cultures" (d'Harnoncourt to Heye, October 9, 1940: IACB 35).

28. On September 30, 1939, d'Harnoncourt made a detailed outline entitled "Outline of the Content of the Exhibition Indian Art in North America" (1939: IACB 34). The first documented use by d'Harnoncourt of the title "Indian Art of the United States" appears October 21, 1940 (d'Harnoncourt to Fred Picard: IACB 34). In December 1940, however, he referred to the show simply as "Indian Exhibit, Museum of Modern Art, New York City" (IACB 32). And as late as June 17, 1940, in correspondence with MOMA's Publicity Department, he again referred to the "Indian Exhibit at the Museum of Modern Art" (d'Harnoncourt to Sara Newmeyer: IACB 34).

29. According to Jonaitis, "Indian Art of the United States" was motivated as much "by the political concerns of the United States government" as it was by any "sudden awareness of an intrinsic esthetic merit in the art itself" (1981:6). This is true, as is the fact that d'Harnoncourt was clearly aware of the ways in which the exhibition might serve national political interests. However, it is equally true, as this essay demonstrates, that his awareness of Indian art's aesthetic merit was long-standing.

30. Mrs. Roosevelt acted in d'Harnoncourt's behalf in submitting a request to the president that he sign the foreword to the catalogue (d'Harnoncourt to Eleanor Roosevelt, December 19, 1940: IACB 34, 300.36). Although the president declined, d'Harnoncourt was pleased that he was willing for the first lady to do so

(d'Harnoncourt to Eleanor Roosevelt, January 2, 1941: IACB 36).

31. For an illustration of this reproduction, see Douglas and d'Harnoncourt (1941:23).

32. See Fred Kabotie to d'Harnoncourt, November 12, 1940: IACB 34; and d'Harnoncourt to G. Warren Spaulding, October 9, 1940: IACB 34. D'Harnoncourt felt that the rather free manner of copying used by the Hopi artists was compensated for by the fact that "their pictorial tradition has survived almost without change." Furthermore, Brew supplied the original drawings of the excavated murals and other information that helped "insure authenticity of color and design" (d'Harnoncourt to Barr, November 8, 1939: IACB 34).

33. See Douglas and d'Harnoncourt (1941:114).

34. There was a good deal of interagency conflict about who would pay for which particular aspect of the expedition. And there was much to be paid for, including special cameras. The Department of the Interior carried the WPA team of six artists to the brink of the canyon, but because the canyon had been washed out, it was necessary to go the last five miles of rough terrain on foot with the equipment (lumber for scaffolding) on pack horses. Furthermore, the nearest drinkable water was some distance from the site itself, so arrangements had to be made to have water hauled in by the Civilian Conservation Corps.

35. There are two documents that indicate that d'Harnoncourt was probably the principal author of the book. The first is a letter written by d'Harnoncourt to Herbert J. Spinden of the Brooklyn Museum stating that Douglas was to write the "captions in the catalogue" (July 27, 1940: IACB 35, 300.36). The second is a planning document entitled "Collection of Material for Publication," including an incomplete page-by-page list of contents, which shows d'Harnoncourt to be the author of the introductory essays, "Tribal Tradition and Progress," "Indian Art," and "Indian Origins and History" (IACB 34). The point of view expressed in the last section, "Indian Art for Modern Living," is unquestionably d'Harnoncourt's. Furthermore, based on Douglas's entries in the catalogue's bibliography, it is not unreasonable to assume that while he contributed to the discussions on ethnography, material culture, and artistic technique, d'Harnoncourt was responsible for those on aesthetics, cultural tradition, and world view. This is again supported by the documents cited above and by Barr's recollection that it was d'Harnoncourt who planned the catalogue (MOMA 1968). Ira Jacknis observed that Douglas was trained as an artist and knew artists' materials quite well, but was not interested in anthropological theory (pers. comm., 1986). Thus, with this evidence as a guide, all the quotations used in my discussion of the catalogue may be attributed to d'Harnoncourt quite safely.

36. D'Harnoncourt's concept of folk art and culture is perfectly compatible with Robert Redfield's 1947 characterization of the folk society "as small, isolated, nonliterate, and homogeneous, with a strong sense of group solidarity" (1947:316). Redfield explained that among such societies, such as the Papago Indians, "All activities, even the means of production, are ends in themselves, activities expressive of the ultimate values of the society" (p. 325). Furthermore, Redfield observed that folk societies have a tendency to regard objects as sacred. This latter is predi-

cated on the fact that in the folk society cultural activity is a unity of experience that does not differentiate between sacred and secular (pp. 325, 319). As Elman R. Service pointed out, Redfield was defining "a polar, ideal construct having characteristics opposite to an urban society" (1971:504). More recently the notion of folk culture has been associated with rural, peasant villages which are subcultures of urban cultures (ibid.). Thus, d'Harnoncourt's characterization of Indian art as folk art was theoretically correct in 1941. Whether such a definition of contemporary "traditional" Indian art is accurate today remains open to question. For a discussion and bibliography on the recent radical critique of the current art-historical use of the term *folk art*, see Wanda Corn (1988:205–6).

37. See also the in-depth discussion of this phenomenon in my article, "The Impact of Friedrich Nietzsche and Northwest Coast Indian Art on Barnett Newman's Idea of Redemption in the Abstract Sublime," *Art Journal* 47 (Fall 1988): 187–95.

38. On the Surrealist's primitivism and interest in Native American art from the Northwest Coast, see Cowling (1978:484–99), Jonaitis (1981:8, 13–15), and especially Maurer (1985:541–84).

39. The idea of a "horizon of expectations" derives from Hans-Robert Jauss's description of an "aesthetics of reception and impact" (1970:9). My comments follow Susan R. Suleiman's discussion of Jauss (1980:35–36).

40. Similarly, La Farge wrote that Indian art "is very much our own, but we have not yet made it part of us." He also argued that since America was not going to be given back to the Indians, "perhaps we shall have sense enough to give the Indians back to America" (1941b:23).

41. Thomas McEvilley has written persuasively about the idea of art exhibitions as ideological constructions: "The exhibition appropriates the viewer into its mute but focused system of definitions, implications, and propositions. The appropriation of the viewer is performed not strictly by the artist or other maker of exhibited objects, who may have been articulating an individual sense of selfhood without appropriative motives, but by the exhibition organizer or curator, who transposes the objects . . . to [the] exhibition space, from private to public sphere, positioning them for their entrapment of the viewer" (McEvilley 1989:8).

42. On consumers of Native arts as "form-creators," see Brody (1976:71).

43. According to Nelson H. H. Graburn, among modern nations there is an "almost universal proclivity . . . to collect and display the art of their present and past minority peoples as symbols of national identity" (Graburn 1976:28).

BIBLIOGRAPHY

Note: All references to the Records of the Indian Arts and Crafts Board (IACB) appear at the end of the Bibliography.

Art Digest
1941 "All-American Art," Art Digest, January 1, p. 17.

Berryman, Florence
1941 "Indian Art of the United States," *Magazine of Art* 34 (April): 216, 218.
Bois, Yve-Alain
1985 "La Pensée Sauvage," *Art in America* 73 (April): 178–88.
Brody, J. J.
1976 "The Creative Consumer: Survival, Revival and Invention in Southwest Indian Arts," in *Ethnic and Tourist Arts*, Nelson H. H. Graburn, ed., pp. 70–84. Berkeley: University of California Press.
Caspers, Frank
1941 "Indian Art of the United States," *Art Digest*, March 1, p. 27.
Charlot, Jean
1941 "All American," *The Nation*, February 8, pp. 165–66.
Clifford, James
1985 "Histories of the Tribal and the Modern," *Art in America* 73 (April): 164–74, 215.
1988 *The Predicament of Culture: Twentieth-Century Ethnography, Literature, and Art.* Cambridge: Harvard University Press.
Corn, Wanda
1988 "Coming of Age: Historical Scholarship in American Art," *Art Bulletin* 70 (June): 188–207.
Cowling, Elizabeth
1978 "The Eskimos, the American Indians, and the Surrealists," *Art History* 1 (4): 484–500.
Crawford, M. D. C.
1941 "Exhibit of Indian Art," *Women's Wear Daily*, January 10, p. 10.
Denman, Leslie Van Ness
1936 "A Presentation of Indian Cultures and Their Arts," *Women's City Club Magazine* 10 (July): 14–15, 31.
d'Harnoncourt, René
1939 "Indian Exhibit at San Francisco World's Fair Nears Completion," *Indians at Work* 6 (November): 10–12.
1941 "Living Arts of the Indian," *Magazine of Art* 34 (February): 72–77.
1969 *René d'Harnoncourt Oral History.* New York: Columbia University Oral History Research Office.
Douglas, Frederic H., and René d'Harnoncourt
1941 *Indian Art of the United States.* New York: Museum of Modern Art.
Foster, Hal
1985 *Recodings: Art, Spectacle, Cultural Politics.* Port Townsend: Bay Press.
Frankenstein, Alfred
1940 "The Art of the Indian," *San Francisco Chronicle.* [Undated clippings in IACB 20]
Graburn, Nelson H. H.
1976 *Ethnic and Tourist Arts.* Berkeley: University of California Press.

Jauss, Hans-Robert

1970 "Literary History as a Challenge to Literary Theory," *New Literary History* 2:7–37.

Jonaitis, Aldona

1981 "Creations of Mystics and Philosophers: The White Man's Perceptions of Northwest Coast Indian Art from the 1930s to the Present," *American Indian Culture and Research Journal* 5(1):1–48.

Klein, Cecelia

1989 "Gaining Respect: Native American Art Studies and the Humanities," *Native American Art Studies Association Newsletter* 6:3–6.

Kramer, Hilton

1984 "The Primitivism Conundrum," *New Criterion* 3 (December): 1–7.

La Farge, Oliver

1941a "Indians at the Museum of Modern Art," *New Republic*, February 10, pp. 181–82.

1941b "The Indian as Artist," *New York Times*, January 26, pp. 9–10, 23.

Lovejoy, Arthur O., and George Boas

1935 *Primitivism and Related Ideas in Antiquity.* Baltimore: Johns Hopkins Press.

Lowe, Jeanette

1941 "Lo, the Rich Indian: Art of the American Aboriginals," *Art News*, 39 (February 1): 7–8, 20.

McEvilley, Thomas

1984 "Doctor Lawyer Indian Chief: 'Primitivism' in 20th Century Art at the Museum of Modern Art," *Artforum* 23 (November): 54–60.

1989 "Opening the Trap: The Postmodern Exhibition and Magicians of the Earth," *Journal of Art* 1 (June/July): 8–9.

Maurer, Evan

1985 "Dada and Surrealism," in *"Primitivism" in 20th Century Art*, vol. 2, ed. William Rubin, pp. 541–84. New York: Museum of Modern Art.

Miller, Arthur

1939 "The Art Thrill of Last Week," *Los Angeles Times*, April 23, p. 8.

Museum of Modern Art

1968 *René d'Harnoncourt 1901–1968: A Tribute.* New York: n.p. (Contributions by Alfred H. Barr, Jr., Monroe Wheeler, et al.)

Newsweek

1941 "20,000 Years of Indian Art Assembled for New York Show," *Newsweek*, February 17, pp. 57–58.

O'Neill, Annie

1986 "Nelson A. Rockefeller: The Collector," in *The Nelson A. Rockefeller Collection of Mexican Folk Art*, pp. 1–6. San Francisco: Mexican Museum.

Parezo, Nancy

1983 *Navajo Sand Paintings on Boards: From Religious Act to Commercial Art.* Tucson: University of Arizona Press.

Parnassus

1941 "Indian Art of the United States," *Parnassus* 13 (February): 77–78.

Redfield, Robert

1947　"The Folk Society," reprinted in *Readings in Anthropology*, ed. Morton Fried, pp. 311–31. New York: Thomas Y. Crowell, 1971.

Rockefeller, Nelson

1981　*The Nelson A. Rockefeller Collection: Masterpieces of Modern Art*. New York: Hudson Hills Press.

Roosevelt, Eleanor

1938　"My Day," *Washington Daily News*, February 28.

Rubin, William, ed.

1985　"Primitivism" in 20th Century Art. 2 vols. New York: Museum of Modern Art.

Rubin, William, Kirk Varnedoe, et al.

1985　"On 'Doctor Lawyer Indian Chief: "Primitivism" in 20th Century Art' at the Museum of Modern Art in 1984," part 1, *Artforum* 23 (February): 42–51; part 2, *Artforum* 23 (May): 63–71.

Rushing, W. Jackson

1986　"Ritual and Myth: Native American Culture and Abstract Expressionism," in *The Spiritual in Art: Abstract Painting, 1890–1985*, pp. 273–95. Los Angeles: Los Angeles County Museum of Art.

1988　"The Impact of Friedrich Nietzsche and Northwest Coast Indian Art on Barnett Newman's Idea of Redemption in the Abstract Sublime," *Art Journal* 47 (Fall): 187–95.

1989　"Native American Art and Culture and the New York Avant-Garde, 1910–1950," Ph.D. dissertation, University of Texas at Austin.

Schrader, Robert Fay

1983　*The Indian Arts and Crafts Board: An Aspect of New Deal Policy*. Albuquerque: University of New Mexico Press.

Service, Elman R.

1971　*Profiles in Ethnology*. New York: Harper and Row.

Spinden, Herbert J.

1934　"Annual Report of the Department of Primitive and Prehistoric Art," Brooklyn Museum Archives.

1935　"Annual Report of the Department of Primitive and Prehistoric Art," Brooklyn Museum Archives.

Stocking, George W., Jr., ed.

1985　*Objects and Others: Essays on Museums and Material Culture*. Madison: University of Wisconsin Press.

Suleiman, Susan R.

1980　"Varieties of Audience-Oriented Criticism," in *The Reader in the Text*, ed. Susan R. Suleiman and Inge Crosman, pp. 3–45. Princeton: Princeton University Press.

Vaillant, George

1939　*Indian Arts in North America*. New York: American Museum of Natural History.

1941　"Indian Art of the United States," *Art Bulletin* 23 (January): 167–69.

Varnedoe, Kirk

1985 "On the Claims and Critics of the 'Primitivism' Show," *Art in America* 73 (May): 11–21.

Washington Star

1941 "Back to the Indian," *Washington Star*, February 23.

Records of the Indian Arts and Crafts Board (IACB)
(National Archives Record Group 435):

Collier, John

1939 (Press Release) Letter to Harold L. Ickes, February; box 20.

Creel, George

1938 Letter to Harold L. Ickes, February 25; box 9, file 300.33.

d'Harnoncourt, René

1936 "Notes on an Exhibit of the Arts and Crafts of the American Indian at the New York Fair of 1936"; box 9, file 300.35.

1938 "Projects of Research in the Indian Arts and Crafts"; box 4, file 140.2.
 "Notes: Indian Defense Association"; box 32.
 Typescript of notes for San Francisco Exposition; box 9, file 300.33.
 Letter to Joseph Allen, December 6; box 11, file 030.
 Letter to George Creel, January 31; box 9, file 300.33.
 Letter to Frederick Keppel, August 19; box 12, file 036.
 Letter to George Creel, August 21; box 21.
 Letter to Frederick Keppel, n.d.; box 32.

1939 "Outline of the Content of the Exhibition Indian Art in North America," September 30; box 34.
 "Proposed Activities for the Fall and Winter," July 26; box 4, file 140.2.
 "Report on the Activities of the Indian Arts and Crafts Board for the Fiscal Year 1938–39"; box 4, file 140.2.
 "Suggestions for Future Activities of the Indian Arts and Crafts Board," September 21; box 4, file 140.2.
 Letter to John Collier, July 6; box 9, file 103.1.
 Letter to Frederic H. Douglas, September 30; box 36, file 300.36.
 Letter to Alfred H. Barr, Jr., October 29; box 19, file 534.
 Letter to Alfred H. Barr, Jr., November 8; box 34.
 Letter to William Wright, November 29; box 14, file 119.

1940 "Collection of Material for Publication"; box 34.
 "Indian Exhibit, Museum of Modern Art, New York City"; box 32.
 "Report on the Activities of the Indian Arts and Crafts Board," July 26; box 4, file 140.2.
 Letter to Joseph Y. Barnett, January 12; box 4, file 140.2.
 Letter to Young, April 5; box 4, file 140.2.
 Letter to Thomas C. Parker, April 8; box 34, file III-A-4.
 Letter to Sara Newmeyer, June 17; box 34.

Letter to Miller, June 21; box 35.

Letter to Herbert J. Spinden, July 27; box 35, file 300.36.

Letter to Frederic H. Douglas, September 6; box 34.

Letter to G. Warren Spaulding, October 9; box 34.

Letter to George Heye, October 9; box 34.

Letter to Fred A. Picard, October 21; box 34.

Letter to Eleanor Roosevelt, December 19; box 34, file 300.36.

1941 Letter to Eleanor Roosevelt, January 2; box 36.

"Indian Exhibit, Museum of Modern Art—New York City," December; box 32.

Letter to M. Dietrich, December 23; box 36.

Gregg, Clifford C.

1940 Letter to René d'Harnoncourt, November 11; box 35.

Kabotie, Fred

1940 Letter to René d'Harnoncourt, November 12; box 34.

Kroeber, Alfred L.

1939 Letter to John Collier, February 28; box 9, file 300.33.

Taylor, Francis Henry

1939 Letter to René d'Harnoncourt, September 26; box 36.

Weber, Max

1941 Letter to Alfred H. Barr, February 1; box 34.

CONTRIBUTORS

Janet Catherine Berlo is professor of art history at the University of
Missouri–St. Louis. She received her Ph.D. in the history of art at Yale Uni-
versity (1980), and has taught at Yale, the Rhode Island School of Design,
and UCLA. She is author or editor of several volumes, including *Art, Polity,
and the City of Teotihuacan* (in press, Dumbarton Oaks), *Mesoamerica After the
Decline of Teotihuacan* (Dumbarton Oaks, 1989), *The Art of Ancient Mesoamerica:
An Annotated Bibliography* (G. K. Hall, 1985), and *Text and Image in Pre-Columbian
Art* (BAR, Oxford, 1983). She has also published on Inuit and Plains Indians
graphic arts.

Marvin Cohodas is associate professor of fine arts at the University of
British Columbia. He received his Ph.D. in 1974 in the Department of
Art and Archaeology at Columbia University. A specialist in Maya art and
archaeology as well as Native American basketry, he is the author of *The
Great Ballcourt at Chichen Itza, Yucatan, Mexico* (Garland, 1978) and *High on the
Rivers: The Basketry Art of Elizabeth Hickox* (Southwest Museum, 1990), as well
as numerous articles on Maya art and Native American basketry.

Diana Fane is curator of African, Oceanic, and New World art at The
Brooklyn Museum. She was educated at Radcliffe College and Columbia
University, where she received an M. Phil. in art history. She is coauthor
(with Ira Jacknis and Lise M. Breen) of *Objects of Myth and Memory: American
Indian Art at The Brooklyn Museum* (University of Washington Press, 1991).

Ira Jacknis is associate research anthropologist at the Lowie Museum of
Anthropology, University of California, Berkeley. He is the author of *The
Storage Box of Tradition: Museums, Anthropologists, and Kwakiutl Art, 1881–1981*
(Smithsonian Press, forthcoming) and coauthor of *Objects of Myth and Mem-
ory: American Indian Art at The Brooklyn Museum* (University of Washington
Press, 1991). His special interests are art and aesthetics, visual anthro-
pology, museums, the history of anthropology, and Native Americans
(especially Northwest Coast and California).

Aldona Jonaitis is vice president for public programs at the American Mu-
seum of Natural History in New York City. She has published extensively
on Northwest Coast Native art, including *Art of the Northern Tlingit* (Univer-
sity of Washington Press, 1986), *From the Land of the Totem Poles: The Northwest*

237

Coast Indian Art Collection at the American Museum of Natural History (American Museum of Natural History and the University of Washington Press, 1988), and Chiefly Feasts: The Enduring Kwakiutl Potlatch (American Museum of Natural History and the University of Washington Press, 1991). In press is A Wealth of Thought: Franz Boas on Native American Art (University of Washington Press).

W. Jackson Rushing is assistant professor of art history at the University of Missouri–St. Louis. He received his Ph.D. in art history at the University of Texas at Austin (1989) and taught previously at the University of Maine. His essays and art criticism have appeared in Artspace, Art New England, Art Journal, New Art Examiner, and several exhibition catalogues. His study of modernist primitivism is forthcoming: Native American Art and Culture and the New York Avant-Garde, 1910–1950 (University of Texas Press). His current book project is entitled Tradition and Transformation in Native American Art Since 1960 (forthcoming, University of New Mexico Press).

Margot Blum Schevill is an anthropologist, musician, and weaver. She specializes in New World ethnographic textiles, as well as writing about women anthropologists who specialized in textiles, and about women fiber artists. Schevill was assistant curator at the Haffenreffer Museum of Anthropology, Brown University, and is currently senior museum scientist at the Lowie Museum of Anthropology, University of California at Berkeley. Her publications include Evolution in Textile Design from the Highlands of Guatemala (Lowie Museum, 1985) and Costume as Communication (Haffenreffer Museum, 1986). She has just completed the manuscript of Maya Textiles of Guatemala, based on the Gustavus A. Eisen Collection in the Lowie Museum of Anthropology.

Swanton, John, 6, 23, **25**, 34; and "salvage" ethnology, 27–28; research on Haida, 28–39, 46, 49

Taylor, Francis Henry, 206
Teit, James Alexander, 9, 141, **143,** 168, 176; work with Boas, 142–44
Textiles of Highland Guatemala (O'Neale), 179
Thomas, Martha, 165, 166
Thompson, Robert Garris, 16n10
Thompson Indians, 139, 176; basketry, **135**. *See also* Teit, James Alexander
Trachtenberg, Alan, 41
Traditionalism. *See* "Salvage" ethnology
Tsatoke, Monroe, 214
Tsireh, Awa, 13
Tyler, Stephen A., 26, 50

U.S. National Museum, 91, 136
University Museum, Philadelphia, 71
Vaillant, George, 201, 212, 224
Van Loan, C. E., 97, 100, 103, 121
Vanderwagen, Andrew, 71, 73–74
von Sydow, Eckart, 14
Vroman, Adam Clark, 142

Wallace, Fred, 80n5
Wallace, John, 80n5, 207
Washburn, Dorothy, 11, 168
Washoe, 92. *See also* Keyser, Louisa
Weaving, 12
Weltfish, Gene, 181
Wheeler, Monroe, 193, 228n16
Wolf, Eric, 16n9
World fairs, 41, 43. *See also* St. Louis World's Fair
"Wrapping." *See* Jameson, Frederic
Writing Culture: The Poetics and Politics of Ethnography (Clifford and Marcus), 26

Yurok. *See* Klamath River Native Americans; O'Neale, Lila Morris
Yurok-Karok Basket Weavers (O'Neale), 152, 163–64, 178, 181

Zuni, **69;** destabilizing influence of collecting activities among, 3; and Cushing, 65–77; dance shield, **76;** exhibition at Brooklyn Institute, 77; mask, 78, **79;** and "salvage" ethnology, 78
Zuni Folk Tales (Cushing), 71
The Zuni Indians (Stevenson), 6